graphic agitation

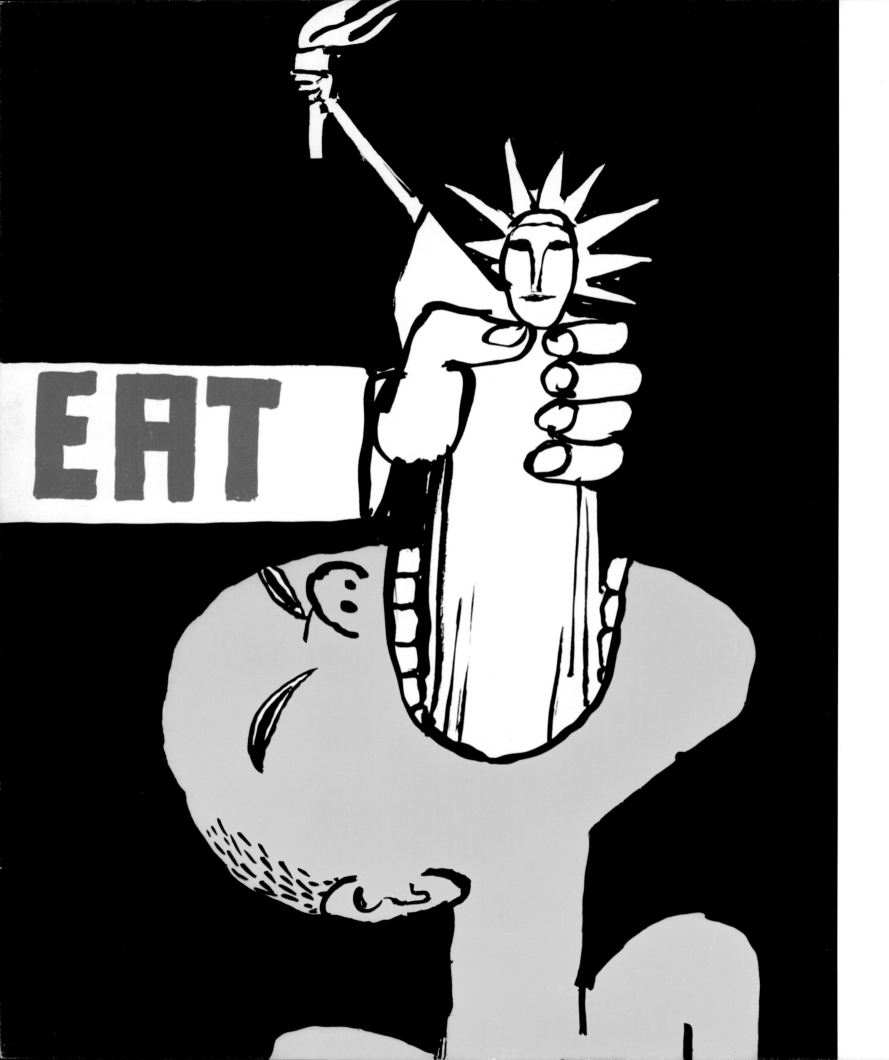

graphic agitation

Social and Political Graphics since the Sixties

Liz McQuiston

Phaidon Press Ltd
140 Kensington Church
Street
London W8 4BN

First published 1993

© Phaidon Press Limited

ISBN 0 7148 2878 5

A CIP catalogue record for
this book is available from
the British Library.

Printed in Hong Kong

Frontispiece
'Eat': anti-Vietnam War
poster by Tomi Ungerer,
1967.
Cover Photograph
by Julian Lee

Acknowledgements
The author wishes to give
special thanks to the
following for consultation
and generous assistance
in the making of this book.

Rene Andrew
Joseph P. Ansell
Phil Bicker
Frances Bloomfield
John Campbell, ACT UP
 London
Estelle Carol, Barbara
 Bejna, Shirley Jensen
 and Julie Zolot of the
 Chicago Women's
 Graphics Collective
Julia Church
Dr Hazel Clark, Hong Kong
 Polytechnic
Yiannis Frangoulis
Jude Harris
Sue Herron
Steve Jeppesen, Course
 Director, and the
 students of the
 Commercial Art Dept of
 The American College in
 London (Eva Chiu, Gioia
 Francella, Andre Pang,
 Gabriella Pucsok and
 others)
Barry Kitts
Wolfgang Kreile
Mrs N. Levenstein
Tom and Tina Maxwell
Edward McDonald
John McKay, Ravensbourne
 College of Design
 and Communication
George E. McQuiston
Victor McQuiston
Chris Holmlund, Baldwin
 Lee, Susan Metros and
 the Art Dept, University
 of Tennessee/Knoxville
Mary V. Mullin, ICOGRADA
William Owen
Suzanne Perkins
Sue Plummer
David Reeson
Viv Reid, Newham Drugs
 Advice Project, London
Mike Sheedy
Michelle Thomas
Mrs Jacqueline Thompson
Teal Triggs
Professor Michael Twyman,
 Dept of Typography
 and Graphic
 Communication,
 University of Reading
Shelley van Rooyen
Dan Walsh, Liberation
 Graphics
Carol A. Wells, Center for
 the Study of Political
 Graphics.

Publishers' note
This work is intended as a résumé of the growth of political and social agitation
via graphics since the 1960s. The publishers wish to make it clear that the views
expressed in the images contained in this publication are not their own but those
of the individuals and organizations that created them. The publishers do not
consider that these views are necessarily justified, truthful or accurate.

The materials included demonstrate the utilization of graphic art by individuals
and bodies with differing aims. Those employing graphic means to spread their
views are of varying repute, and range from governments through to terrorist
organizations and include, amongst others, various pressure groups and
commercial institutions. This book depicts the many graphic methods used and
portrays the lengths to which people will go in order to communicate their views
to the public. The inclusion of such work is for the purpose of criticism and review
of the use of the graphic medium and in no way indicates that the publishers
agree with the sentiments expressed therein, nor that the targets of any of the
illustrations are deserving of such treatment.

Contents

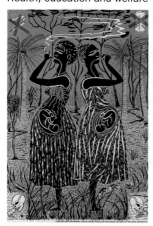

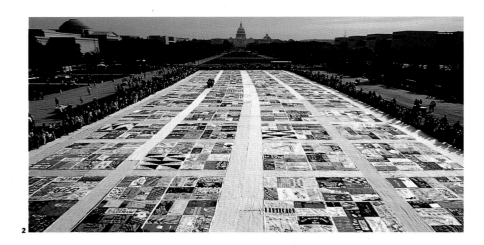

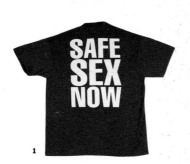

Introduction
Three decades of graphic agitation

The term 'political graphics' sets off a flood of images and impressions. Angry protest posters or banners for demonstrations may spring to mind, or the razzmatazz and hard-sell of political party campaigns. The 'newspeak' of war propaganda, subversion through the underground press, caricatures in daily newspapers, graffiti sprayed on walls and pavements or badges and t-shirts shouting slogans within a crowd: all represent the graphic 'voice' of propaganda, protest and agitation. And although the forms may be ephemeral, the effects are not. Press images and posters become icons of an era, marking turning points in past history, while media campaigns and billboards influence the present, bearing images and slogans that become engrained in our personal politics.

This book takes a broad look, over the past three decades, at the use of graphics for propaganda and protest. It deals with both the official graphic voice of the Establishment as well as the unofficial voice of dissenters and agitators. For both are part of the political landscape and exert an influence over society's attitudes and opinions both belong to an on-going context of power struggles; and both have generated graphic innovations over the decades.

The nature of the work contained here is extremely varied. The term 'graphics' is used to describe a wide range of graphic statements – from the crudest amateur t-shirt or wall graffiti to the most elaborate professional media campaign. 'Graphic design' in itself describes a broad-based field of activity, encompassing design for print, advertising, moving graphics for film and TV, and all manner of visual communication and design. Graphic designers often work across a variety of disciplines and media, and at the same time much interesting graphic work has emanated from artists in other areas of visual communication. To reflect this broad scenario, the net has been cast widely and freely to include projects from professional graphic designers (also fine artists, stylists, fashion designers and so on) as well as influential amateur contributions. All however will be discussed within a design-related context, looking at graphic roles, techniques and traditions.

Political and social issues are also assigned broad meaning here, for both have undergone substantial change and redefinition over the past decade, particularly in relation to the visual arts and design. Up to the mid-1980s, 'politics' usually inferred party politics. But with the build-up of 'awareness' activities – including charity rock events such as Live

Aid, pressure groups campaigning for new attitudes towards peace and the environment and style magazines promoting activism and human rights – the term politics has grown more and more to signify popular movements relating to social issues. This has evolved into the 1990s trend towards 'personal politics', an individual awareness and concern for world problems, and a sense of responsibility to self, friends and family, society and the planet as a whole – perhaps as a sign of growing disillusionment with governments and political parties unable to get to grips with today's global problems and crises. In the light of such developments, the many and varied forms of graphic design remain an important instrument for political – and personal – expression.

The 1960s provide a useful starting point for this collection, both socially and graphically. Many of the social revolutions that have moulded contemporary life were staged in the Sixties. A decade of turbulence and social change, the era lives on as one of our greatest modern-day myths. But it was equally a creative watershed. The energy of change also surged through the art and design worlds, bringing innovations in graphics, fashion, film and photography. In addition, many of the anti-establishment statements of that time were made through a graphic medium. The US poster boom, which reflected the mounting anti-war feeling, and the psychedelic graphics surrounding drugs and music, were all part of a communication link between the young, the protesters, the drop-outs. The ensuing visual language with its colours and fantasies was soon drawn into the mainstream and spread round the world, and the notion of graphics as a tool for popular expression – a means of speaking out and being heard – has been a vital facet of rebellion and youth culture ever since.

This is not however a history book; there is no attempt to provide a comprehensive historical survey of political events over 30 years – either in individual countries or within an international scenario. Neither is the intention to provide in-depth coverage on any particular issue, movement, group or individual. The interests and concerns of this book are design-led: chapter headings appear as broad themes, and the book's emphasis lies in the depiction of an on-going flux of struggles and concerns, and the part that graphics can play in expressing such struggles. For example, rather than concentrate campaigns and projects relating to anti-racism all in one place, they are in fact sited within sections relating to national politics, liberation movements, human rights and so on. Their reappearance throughout the book highlights the continuing and endemic nature of racial struggles, how they differ from country to country and culture to culture, and the different forms of graphic expression they have generated over the years.

Various themes recur throughout the book. First and foremost is the theme of power. Politics is essentially about power and control, and most of the graphic material in this collection is discussed as part of a struggle for, or against, power. Often the power struggles are between the Establishment or ruling party and the person in the street. The notion of 'the street' appears throughout as a symbol of the public domain, a forum or arena for the 'masses' and their graphic statements.

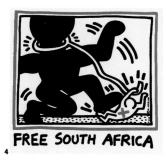

FREE SOUTH AFRICA

4

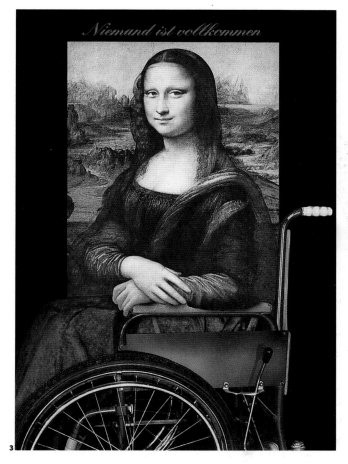

Niemand ist vollkommen

3

Social comment takes many graphic forms. 1 T-shirt design by fashion stylist Judy Blame, Britain 1992. 2 The NAMES Project quilt created in memory of people who have died of AIDS, photo by Marc Geller, USA 1987. 3 'Nobody's perfect', postcard by Klaus Staeck designed in the International Year of the Disabled, West Germany 1981. 4 Anti-apartheid poster by Keith Haring, USA 1985.

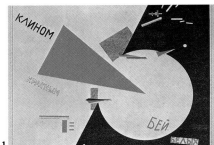

1

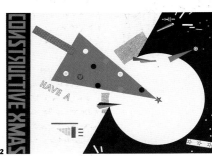

2

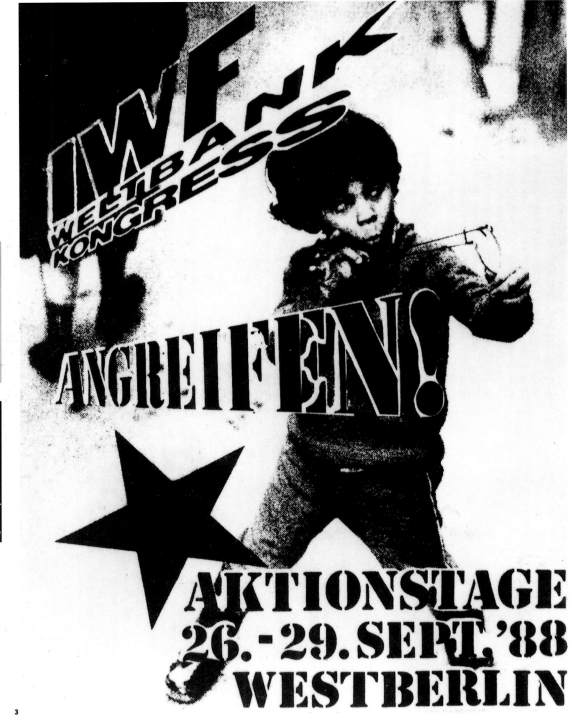

3

Censorship and levels of tolerance – whether by the ruling party or the public itself – are issues that vary greatly between the countries represented, and allow interesting visual comparisons to be made. Visual satire and other forms of graphic criticism and abuse tend to be most highly developed in those countries that have a long democratic tradition of freedom of speech and freedom of the press, such as America, Britain, Germany and France, although degrees of tolerance vary. (The billboard showing Margaret Thatcher hanging by a noose on page 49 lasted only a few days in Britain, but it is unlikely that its equivalent would ever have been displayed in America.) In the creative communities of these countries, freedom of expression is viewed as a basic right to be preserved and defended, with parameters that must be continually challenged and stretched. Censorship of any kind is consequently a matter of great debate, and a relatively sophisticated battle of policies and protests. It is a far cry from the death penalties and disappearances experienced in some areas of the world. In Ceausescu's Romania, for example, any critical comment against government or leader was confined to a scribble of graffiti on the wall (page 69), whilst many former Iron Curtain countries are only now beginning to understand and deal with the effects of many years of Communist state control and artistic censorship.

Visual language and graphic language are phrases often used when discussing work. These refer to a combination of elements – style, symbolism, typography, atmosphere or tone, historical and artistic references and so forth – which communicate a message in a particular way, or with particular emotion or force. Graphic symbolism plays an especially interesting role in communicating the ideals and aspirations of struggles, in that events or entire causes may be reduced to a simple graphic shape, or collection of objects, which embodies their essence or meaning. A favourite among graphic designers (and the subject of much pastiche, as shown here) is El Lissitzky's 1919 abstract composition 'Beat the Whites with the Red Wedge', a modernistic battlefield of shapes, and powerfully symbolic in its show of Bolshevik strength over the White Russians. More recently, in the 1989 uprising in Romania the emblem for the Popular Revolution was derived from cutting the centre out of the country's flag (removing the old regime's emblem), a gesture that was quickly crystallized into a graphic symbol of anger and suffering.

Media and technology can also have great effect on the meaning and resonance of the message. The more direct, or cruder, methods of image-making and duplicating (handwriting, stencilling, photocopying, hand-stamping) can provide immediacy and emotional impact. Silkscreen remains a favourite medium for low-run prints and is still difficult to rival for boldness and 'bite', as well as for economy and low-tech convenience. Offset litho liberated the 1960s underground from the constraints of silkscreen and letterpress and played a substantial role in the graphic revolutions of that era, whilst the new technology of the 1980s and 1990s possesses its own in-built visual language. Bitmap typefaces, electronic colours, pixellated textures, special screen

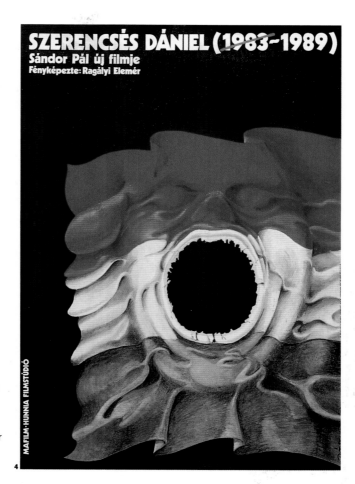

4

5

1 & 2 'Beat the Whites with the Red Wedge', poster by El Lissitzky, Soviet Russia 1919; Christmas card pastiche by South Atlantic Souvenirs, Britain 1980s.
3 'Attack!', poster by a group protesting against the World Bank and highlighting the cause of Third World aid and human rights, West Germany 1988.
4 'Lucky Daniel', poster by Péter Pócs for a Hungarian film concerned with the post-1956 emigration to the West. The image refers to the period of October/November 1956 when the insurgents cut the hated Russian-style herald out of the Hungarian flag. The poster was banned in 1983, then reprinted in 1989 (hence the two dates).
5 First Day Cover printed envelope and franking stamp (1990) commemorating the Romanian popular revolution of December 1989.

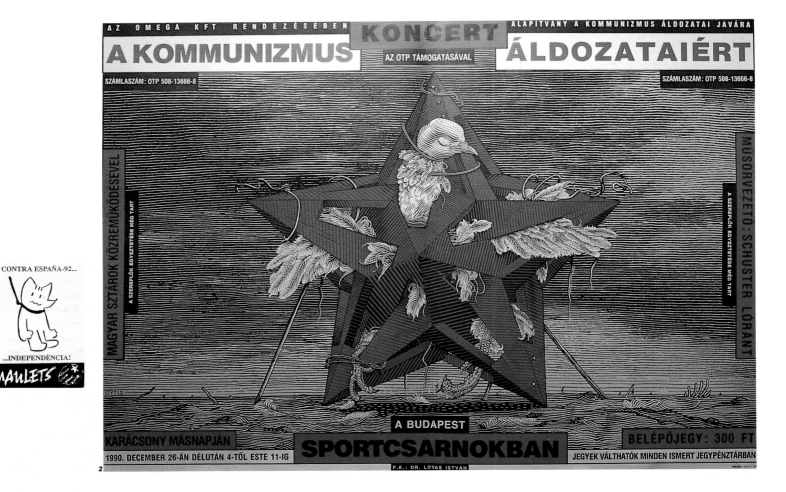

effects and various genres of icons conjure up high-tech societies, future worlds and real or imagined military operations, an issue exploited in the comment on the Gulf War shown on page 60.

Finally, the book examines important issues centring around the concept of 'format' – that is, the form that carries a graphic image or message. (The medium of print, for example, encompasses many different formats, such as books, billboards and magazines.) Format, media and visual language all work together to define the size and scope – and ultimately the impact – of the graphic statement.

The roles and functions of traditional formats such as posters or billboards can be traced throughout the different chapters. Posters, for example, function best when communicating a simple idea, in a way that is visually arresting. Along with film and radio they are highly suited to the role of propaganda, as they can travel fast and be changed frequently. Because of their instant impact, posters can function amidst a large amount of conflicting information and visual 'noise', or in a place where people must read quickly such as streets or busy stations; they can also communicate to a non-literate audience or an audience not happy or accustomed to reading. One of the poster's greatest roles

has been as a political tool in the revolution and reconstruction of socialist societies (such as the Soviet Union, China and Cuba); the poster also played an important role in solidarity and consciousness-raising in the liberation movements of the Sixties and remains to this day a crucial format for popular movements and educational organizations. The Center for the Study of Political Graphics in Los Angeles, for example, currently prepares exhibitions of its political poster collections for display in public places – such as university libraries, galleries, government buildings and theatres – with the educational aim of providing an alternative to interpretations of current events presented by the mainstream media. All exhibitions are fully annotated, and include interpretative essays, translations and contextual information. The Center therefore strives to continue the agitational tradition of the protest poster, while relating it to a current audience and context.

But at the same time traditions are being expanded and uprooted: formats and their roles are changing. The 1990s are about participation, interactivity and activism. Stars of the fashion and music industry contribute to causes ranging from AIDS to the rainforest; style

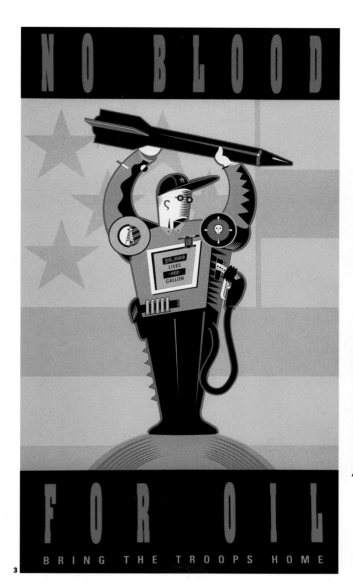

3

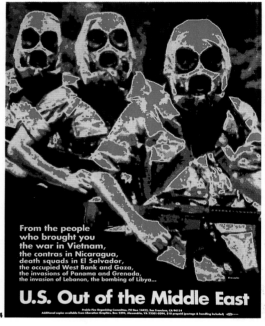

4

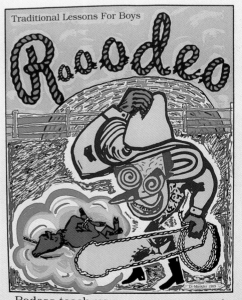

5

Examples of the many roles of posters.
1 Spontaneous street graphics: the Catalan Independence Movement lynches the Olympic games mascot Cobi in this poster, a sign of resentment towards the focus given to the 1992 summer games in Barcelona.
2 Keeping the memory of past tragedies alive: poster for a concert for the victims of Communism, designed by István Orosz, Hungary 1990.
3 & 4 The Center for the Study of Political Graphics promotes a modern educational role for protest posters. Two posters from the Center's collection are shown here, both opposed to the 1991 Gulf War: 'No Blood for Oil' by Keith R. Potter and Steven Lyons, USA 1990, and 'US Out of the Middle East', by Fireworks Graphics Collective, USA 1990.
5 'Rodeo', poster by Doug Minkler criticizing aspects of educational and social programming, USA 1992.

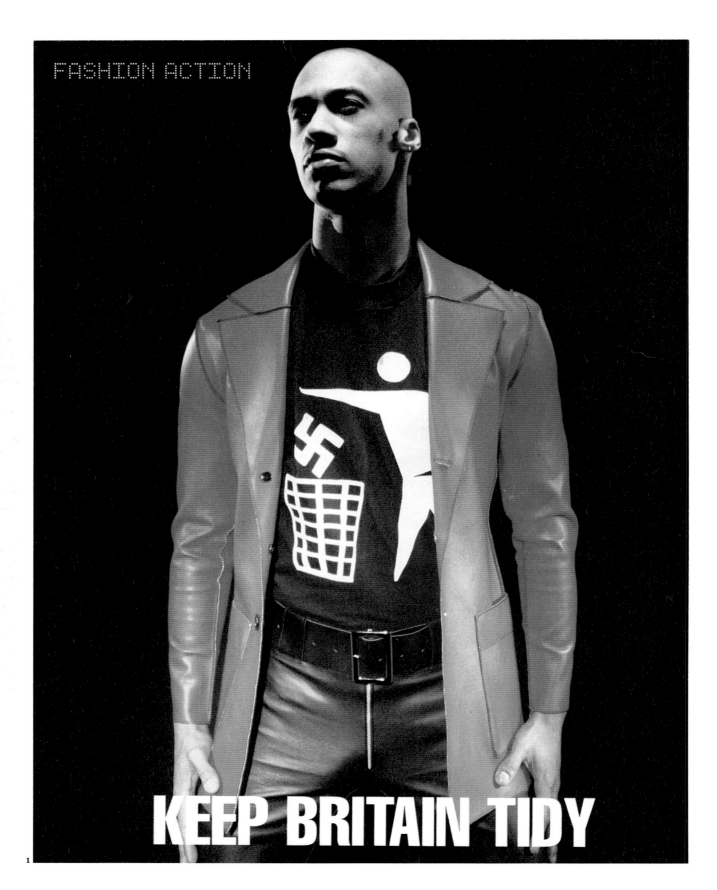

1

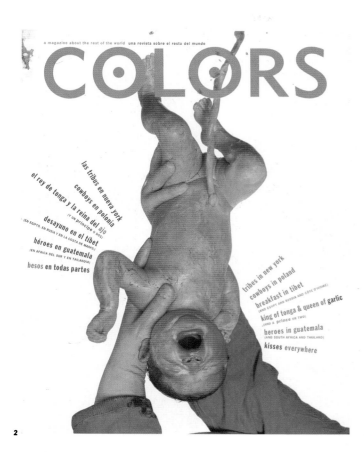

a magazine about the rest of the world una revista sobre el resto del mundo

COLORS

las tribus en nueva york
cowboys en polonia
el rey de tonga y la reina del ajo
(Y UN PRINCIPE O DOS)
desayuno en el tíbet
(EN EGIPTO, EN RUSIA Y EN LA COSTA DE MARFIL)
héroes en guatemala
(EN AFRICA DEL SUR Y EN TAILANDIA)
besos en todas partes

tribes in new york
cowboys in poland
breakfast in tibet
(AND EGYPT AND RUSSIA AND COTE D'IVOIRE)
king of tonga & queen of garlic
(AND A PRINCE OR TWO)
heroes in guatemala
(AND SOUTH AFRICA AND THAILAND)
kisses everywhere

2

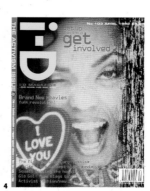

3

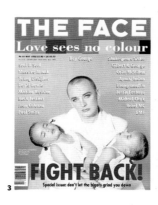

4

magazines confront racism and fascism; corporate magazines and press campaigns ask young people to write in and say what's on their mind (see Benetton and Esprit on pages 204-5); fashion and style have become vehicles for self-awareness, cultural identity and pride. Street formats with traditional commercial roles – signs, billboards, stickers, fly-posters – have become platforms for questioning, moralizing or arguing in the public domain.

The roles of mainstream communication formats, traditionally based on distance and authority, are now breaking down and being redefined towards involvement and participation. The information industries have brought social dilemmas and global concerns within our reach. People are now in touch with the world, and have the technology and the means to confront the big issues such as poverty, homelessness, racism, right-wing extremism, the threat of AIDS and the destruction of natural resources – and in coming years, will no doubt find ever more imaginative and creative ways to deal with them. Political graphics look set to continue to be transformed through new media and technology, as people take their destiny into their own hands, unite against the world's problems, and make their voices heard.

5

Social and political issues expand into style and fashion.
1 'Keep Britain Tidy', t-shirt designed by fashion stylist Judy Blame, with a graphic inspired by the International Tidy Man symbol (model: Mark Lawrence; photographer: Pierre Rutschi). From a style essay in the Activism issue of *i-D* magazine, Britain, April 1992.
2 *Colors*, Benetton's combined youth magazine and clothes catalogue, 1991.
3 & 4 British style magazines *i-D* and *The Face* explore the themes of anti-racism and anti-fascism in 1992.
5 Malcolm X earrings, a small part of the large collection of clothes and accessories generated by the films of Spike Lee and sold through his shop Spike's Joint in New York City, 1992.

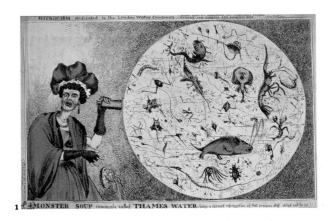

1

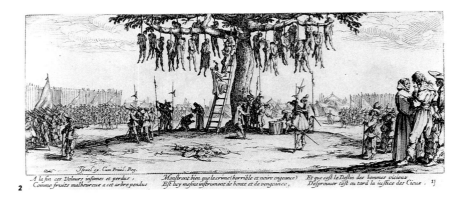

2

Propaganda and protest graphics
A brief historical outline

Propaganda and protest through the graphic arts have a long and turbulent history that stretches far back over the centuries, and shadows developments in print technology. Social satire, political cartooning, pamphleting, graffiti and other types of agitation in current usage all have roots in the very distant past.

Street graphics date back to Roman times; early displays of a politicized graphic voice have been cited in the 'graffiti' of Pompeii, where political slogans and commentary were written, painted and carved onto city walls. Later, during the Renaissance, placards carrying political comments were hung on public statues; it was also possible for a dialogue to develop between a number of these 'talking statues' or *pasquinades*. Both examples mark the beginnings of a tradition of street debate – between the public, its parties and leaders – that still finds form in present-day activities such as graffiti, fly-posting and organized marches and rallies. Talking back and arguing (graphically) in the streets is evidently one of our longest traditions.

The spirit of agitation found its true form, however, in printed multiples. The invention of various print techniques during the mid- to late 1400s – most notably, Gutenberg's invention of movable type –

allowed early German prints to reflect public opinion and peasant life, while spreading new ideas. Enlisting the help of satire and humour, print quickly became the vehicle of the man in the street, with illustrations acting as the new mass language.

Martin Luther's Reformation movement (1520-21) was spread through print and particularly leaflets illustrated by German artists working in woodcut or wood engraving, including Albrecht Dürer, Lucas Cranach, Mathias Grünewald and Hans Holbein the Younger. In a wave of solidarity graphic artists also recorded the horrors of the Peasants' War, which ended in 1525. By the mid-1500s political prints and illustrated leaflets were widely available, sold by roving street sellers. Opposition to the church in Rome and nobility were two main themes.

For much of Europe the 1600s were years of constant armed struggle: religious wars, territorial wars, uprisings and revolutions were rife. Not surprisingly, this gave rise to a war artist tradition. Vast numbers of engravings were produced to document the battles, glorify the victors and justify the carnage, brutality and butchery. Jacques Callot, working in the early part of the century, was one of the most important chroniclers of the European wars, and exceptional for his

concentration on horrors and destruction. He produced a large series of engraved prints entitled *The Miseries of War*, which depicted the mass hangings, sackings, pillaging and other brutalities of that gruesome era. The positive side of such devastation was that it sparked the rebellion of peasants and workers against the aristocracy. This atmosphere of growing criticism was to find vibrant form in the graphic satire of the next century.

The age of satire and social comment

The 1700s brought a new role for political graphics. No longer a recording device confined to lamenting on the sidelines, graphics were now charged with influencing and expressing public opinion. British satire led the way; its golden era began with the engraver William Hogarth (1697-1764), a pioneer of stinging social criticism and responsible for establishing the tradition of caricature in England.

Also from this period came the wealth of prints generated by the French Revolution and by the split between Britain and its American colonies. Furthermore, the invention of lithography by Aloys Senefelder in 1796 in Germany allowed greater freedom in drawing straight onto a surface, while also dramatically increasing the number of copies it was possible to produce.

The 1800s were essentially the years of visual satire, caricature and comic art. British satire flourished in the early 1800s through the work of Thomas Rowlandson, James Gillray, Isaac Cruikshank (and his sons Robert and George) and many others. In addition to scathing social and political satire, they found an extremely popular target in Napoleon, the first international figure in caricature. Caricaturists throughout Europe

made 'Boney' a legend in his own time, transferring his image and tales from country to country and revelling in his defeat and decline.

But away from the courts and the centre stage of world power-games, the massacres continued. Francisco Goya's series of etchings *The Disasters of War* depicted the horror and brutality taking place in the background of the battlelines, while Spain fought a war of independence against French-Napoleonic domination (1808-13). No battle scenes, glorious or otherwise, were shown; only a despairing realism and depiction of human suffering and waste.

By 1830, Britain's golden era of graphic satire was over, for public taste had grown more conservative and less tolerant of visual abuse. The focus immediately shifted to France, where the French newspapers began their spirited fight with censorship. The liberal revolution of 1830 brought the elected King Louis-Philippe to power and, by his own proclamation, freedom of the press. Three months later Charles Philipon founded the satirical weekly *La Caricature*, and almost immediately overshot the mark. His famous representation of the king as a pear-head (for which he was hauled to court in 1831, but then acquitted) was the first of many sensations. His daily paper *Le Charivari* was launched in 1832; by 1834 *La Caricature* was banned; by 1850 two more papers had been launched. Amid such enterprise and devilry, Philipon furthered the development of lithography and fostered a team of remarkable satirical artists that included Honoré Daumier, Paul Gavarni, Charles-Joseph Traviés, Jean-Ignace Grandville, and Henri Bonaventure Monnier – as well as a very young Gustave Doré.

The French golden era of political caricature lasted from 1830 until 1835, when general censorship was re-introduced. From thereon

1 *Monster Soup*, an etching by 'Paul Pry' William Heath, Britain 1828.
2 *The Hanging Tree*, an engraving from the series *The Miseries of War* by Jacques Callot, 1633.
3 *Maniac Ravings* or *Little Boney in a Strong Fit*, print by James Gillray, 1803.
4 Two pieces from Francisco Goya's series of etchings *The Disasters of War*, published in 1863 and depicting the Spanish resistance to Napoleonic domination. Shown here are (top) *Que valor*! (What courage) and (below) *No se puede mirar* (I can't bear to look).

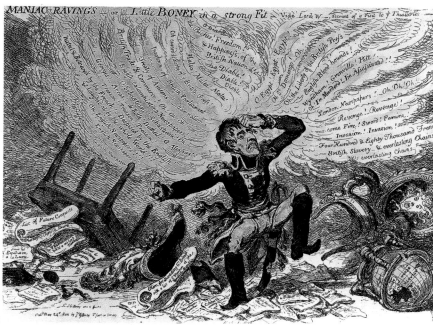

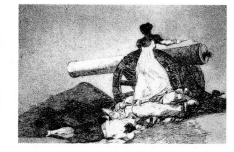

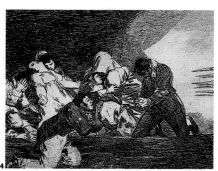

French satire and caricature had to steer away from officials in government, and so instead targeted society and its mores. No one was safe – rich or poor, high or low – and the commentaries were produced in abundance for the daily deadlines of journals and newspapers. Well-known and widely copied in other countries, the artists involved were the undisputed leaders of sophisticated, graphic wit. (Doré for example grew to be famous in both England and France, producing book illustrations, paintings, and other works, as well as extraordinary social documentaries of the London poor.) Throughout the 1800s French comic papers would thrive in great numbers; *Le Rire* (1895) and *Le Sourire* (1899) count among the most famous.

Improvements in printing press design meant that mass-circulation illustrated newspapers were possible by the mid-1800s. In the latter half of the century both education and newspapers were entering their heyday. In both Europe and America, printing processes could now supply a growing literate readership and thus influence public opinion and votes. Cartoons appeared in newspapers and magazines, which were considered important vehicles for political debate and discussion.

Leading cartoonist and caricaturist Thomas Nast visualized the political forces of America as battles between good and evil, and also invented the party symbols of the Democrats (the donkey) and the Republicans (the elephant). Nast took political art into new investigative territory, and held considerable influence on the voting public. His greatest victory on this score came in 1871 when he used his visual skills to expose the corruption of the New York City administration and the Tammany Hall Ring, led by 'Boss' Tweed (William Marcy Tweed). Nast's relentless graphic campaign against Tweed, which ran in

Harper's Weekly magazine, portrayed Tweed in ever-worsening forms, and eventually turned the public against him. As a result, both the Ring and Tweed met their downfall, causing Tweed to make his famous lament about 'them damn pictures'.

America's satirical weekly *Puck*, which catered for a wide range of graphic humour, set off a deluge of periodicals that flooded America in graphic humour and cartooning. *Life* was one of the most influential, and home to Charles Dana Gibson's famous invention, the Gibson Girl. In the later part of the century, cartoons and comic strips were indeed the main carriers of political comment in America.

Also operating at that time was the great Mexican artist and printmaker José Guadalupe Posada. Considered to be the prime carrier of the spirit of the Mexican people, his prolific output – estimated to be over 15,000 prints – included numerous illustrations for the popular press: broadsheets, posters and street gazettes. Posada's graphics dealt with politics and social satire as well as providing a journalistic coverage of the latest news events. He was perhaps best known for his macabre and humourous *calaveras* – the dancing skeletons of Death, derived from folklore and ceremonies such as the Day of the Dead – which he used to represent his contemporaries, both friend and foe alike. But his work also provided an intense documentary of the period leading up to the Mexican Revolution of 1910.

Posada died in 1913, and was revered by other artists of that revolutionary period – particularly Diego Rivera, who became known for his public murals and political themes during the 1920s and 1930s. Both Rivera and his wife, the painter Frida Kahlo, were active members of the Mexican Communist Party and influential artists of the time.

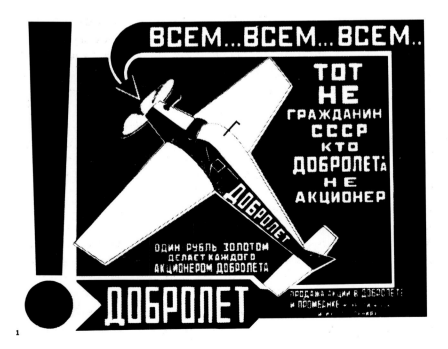

1

2

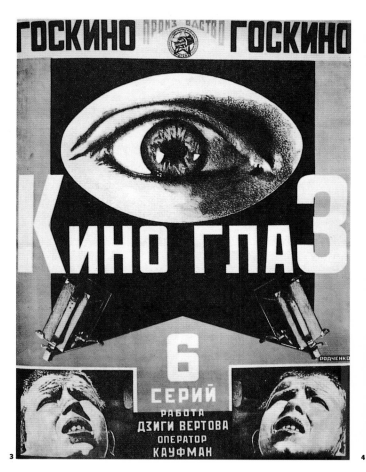

3

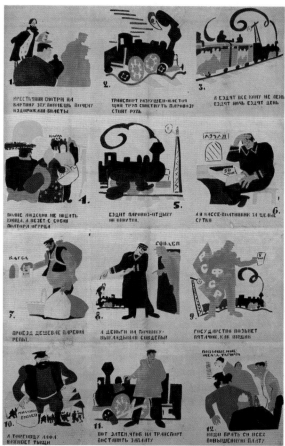

4

1 Poster promoting
the purchase of shares
in the state merchant
air service, designed by
Alexander Rodchenko,
1923.
2 Spread from *For the
Voice*, a book of poems
by Vladimir Mayakovsky,
designed by El Lissitzky,
1923.
3 Poster for Dziga
Vertov's film *Kino
Glaz* (Cinema Eye),
designed by Alexander
Rodchenko, 1924.
4 Railways
advertisement by
Vladimir Mayakovsky,
in the form of a
serialized window
poster as pioneered by
ROSTA, *c*.1920.

The avant-garde and World War One

On the other side of the Atlantic, meanwhile, the sharp edge of satire had gone soft. *Punch: The London Charivari*, founded in 1841, was influential throughout the second half of the 1800s but with a much less acidic form of graphic humour than its French counterpart; and the caricatures of the popular *Vanity Fair* were placid and pretty. But the Germans soon changed all that with the founding in 1896 of *Simplicissimus*, the sharpest and most influential satirical journal of them all (discussed on page 21).

The new century brought Europe advances in industrialization and new expectations for the union of art and industry. It also brought a rejection of the old traditions and social order, and an explosion of intellectually-based avant-garde art movements that embraced a new vision of an industrialized world. With the Futurist manifesto of 1909, the Modern Movement was born and spread like wildfire across countries as well as disciplines, involving writers, artists, designers and architects. In 1915 Kasimir Malevich invented Suprematism in Russia, which acted as the foundation for Constructivism. Dadaism, a protest against the First World War and all established values, followed in

Switzerland in 1916 and spread to New York, Paris and Berlin. Soon after, De Stijl was born in Holland, led by theorists Theo van Doesburg and Piet Mondrian. A new visual language grew out of the manifestos, journals, posters and other published works of these movements – created from 1910 to 1930 – which still has a strong influence on the visual arts today.

Constructivism is perhaps the best example of politics and revolution expressed directly through art and design, resulting in the creation of a new visual language. It was derived from Russian Suprematism, a purely abstract form of art utilizing simple geometric shapes. In the early 1920s the Constructivists rejected Suprematism's purely artistic and spiritual intentions and applied Suprematist forms across a broad range of applied arts and design including industrial design, furniture, textiles, theatre sets and graphics. Both movements worked in the service of the 1917 Bolshevik Revolution towards the 'construction' of a new society, creating everyday products and utility items for the new proletariat.

The painter and sculptor Alexander Rodchenko was one of Constructivism's leading artists. He produced a wide range of two- and

three-dimensional work including graphic design for journals, film posters, advertisements (for state goods and services) and books – often working in collaboration with his friend, the poet Mayakovsky. Rodchenko's work most typifies the graphic language of Constructivism. His experiments with photomontage and his use of spatial dynamics, geometric forms and flat, bright colours produced a bold, utilitarian graphic style that encapsulated the sense of energy and optimism for the Soviet future.

El Lissitzky was another key artist in the Constructivist movement and the person most responsible for spreading its principles across Europe through lecturing, travelling and writing. In this way he also became one of the main links between the different avant-garde movements, for he collaborated on projects with many of their leading personalities and became involved in the important art publications of the time. He developed the concept of Constructivist typography, which soon became known as the New Typography and was then developed by László Moholy-Nagy and Herbert Bayer at the Bauhaus. Lissitzky's work equally embodies the spirit of the revolution, but with an underlying intellectualism and more delicately balanced sensitivity. Consequently Lissitzky produced the real landmarks of Constructivist graphics such as the propaganda poster 'Beat the Whites with the Red Wedge' in 1919, and the designs and illustrations for Mayakovsky's book of poems *For Reading Out Loud* (also known as *For the Voice*) in 1923.

The Constructivist movement had many remarkable qualities. The artists involved were in the extraordinary position of being able to turn their private abstract experiments into socially-orientated public art and design, as part of the Bolshevik revolutionary machine. Another

important aspect was the way in which the new visual language was played out in many different disciplines, including architectural work by Vladimir Tatlin, theatre sets by Alexander Vesnin and costume and textile designs by Varvara Stepanova and Ljubov Popova.

In addition, the propaganda tools of this period were highly innovative. ROSTA, the Russian Telegraph Agency, used a system of numbered posters to disseminate news and propaganda to a largely illiterate population. Each poster carried a group of pictures with captions arranged in a manner similar to a strip cartoon. Stencilled copies were made at great speed by families or small collectives, then forwarded to all the regions and placed in the windows of shops, railway stations or business premises – often replacing the old poster number and continuing the sequence. 'Agitprop' trains, painted with bright colours and political slogans and loaded down with printing presses, film newsreels, artists, film-makers and writers, ploughed their way to the distant corners of the country, spreading the word of revolution. Soviet cinema was also developing at this time in the hands of such directors as Dziga Vertov and Sergei Eisenstein, and played a crucial role in the political climate.

Perhaps most remarkable was the short time period in which these events occurred. By the end of the 1920s, roughly 12 years after the revolution, it was all over. Stalin outlawed abstract art and design in 1932, and Socialist Realism was introduced. But Constructivism was to cast a heavy influence through the years, and for many today it still embodies the spirit of revolution in visual form.

Avant-garde movements such as Constructivism naturally play a large part in any historical survey, in that they broke away from previous

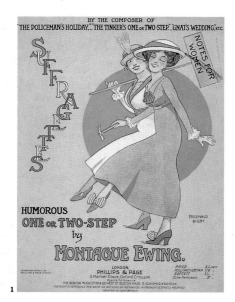

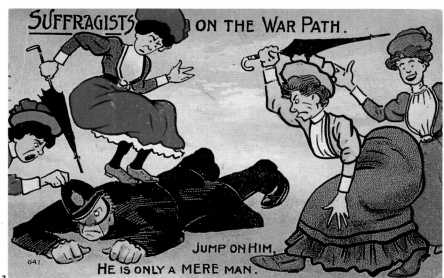

graphic conventions and gave birth to the modern forms and concepts that we use today. But the significance of other graphic developments should not be overlooked.

At the turn of the century, the modern poster was established as a highly persuasive commercial advertising tool as well as an outstanding popular art form. The campaign for women's suffrage was probably the first to borrow the styles and techniques of commercial advertising posters to serve a distinct political cause or anti-establishment viewpoint. In the campaign's most militant years, from 1900 to 1920, advertising techniques were used to influence the electorate, and the stylized realism of art nouveau, so prevalent at the time, served to undermine the 'ugly suffragette' theory and keep the tone soft yet persuasive. Many of the suffrage posters avoided political confrontation, or the display of an antagonistic attitude to men; this was particularly the case with American posters, where persuasion often took the form of a 'civilized' appeal to men for reform and justice. The British movement, on the other hand, was highly publicized for its aggressive militancy, and consequently its posters were more assertive.

Suffrage posters were published privately or by local and national organizations such as the National Women's Suffrage Association (NAWSA) in New York, and the Women's Social and Political Union (WSPU) or Artists' Suffrage League in London. Banners and signs also played an important part in suffrage marches and meetings, and a mass of inventive popular ephemera and graphic imagery surrounded the movement. Women's suffrage and equality was also very much an international movement and consequently imagery was generated in many countries around the world.

The campaign for women's suffrage took different graphic forms on each side of the Atlantic. While American imagery stylishly swayed its audience, the British equivalent was generally more militant.

1 'Suffragettes', sheet music with illustration by Reginald Rigby, Britain 1913.
2 'Suffragists on the War Path', postcard, Britain c.1910.
3 'Votes for Women', poster by B.M. Boye, USA c.1913.

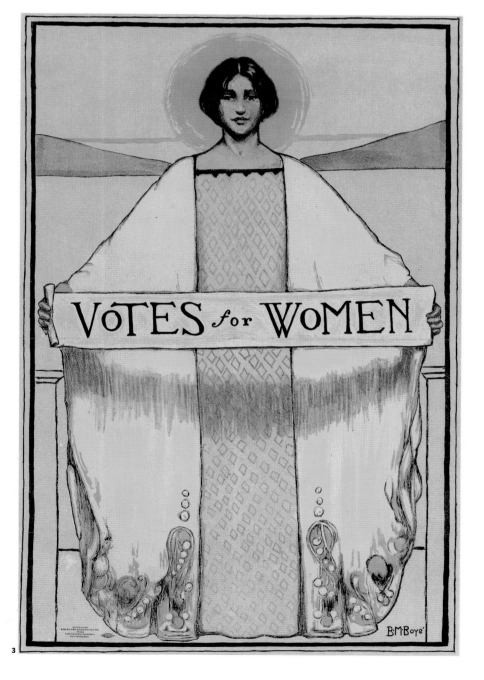

3

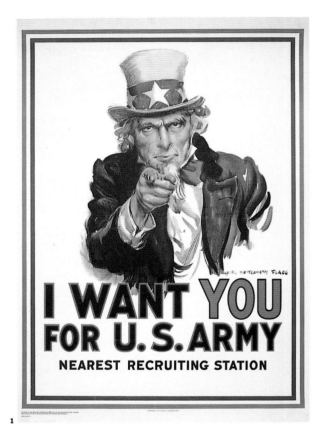

1

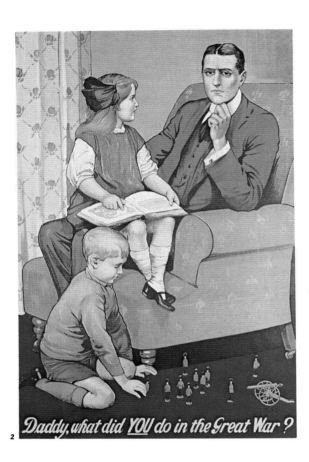

2

The use of a popular, commercial art form – the poster – for political purposes was developed in a much grander style in World War One. For governments faced with the problem of selling a war to their public – and sustaining it with the consequent drain on money, supplies and human life – the obvious solution was to approach the professionals who knew how to sell ideas and products: commercial artists. In this fashion the modern advertising poster became the main vehicle for sustaining one of the most devastating wars in history.

World War One posters, produced by participating countries, were characterized by a wide variety of talent and approach. The German war posters boasted master artists of world renown such as Ludwig Hohlwein and Lucian Bernhard, and conveyed the patriotic idealism of heroics and sacrifice. British posters had a much tougher psychological grip on their audience. Britain entered the war with no conscription and relied on volunteers, and consequently British posters often employed scare tactics (claiming atrocities committed by the enemy) or attempted to shame men into volunteering with implications of cowardice and loss of honour. A good example of the use of shaming and guilt was the poster by Saville Lumley that posed the question

'Daddy, what did YOU do in the Great War?', asked by a child sitting on her father's knee. The most successful British recruitment poster was Alfred Leete's famous depiction of Lord Kitchener, pointing an accusing finger at the viewer and demanding 'Your country needs YOU'.

The Americans rallied with a populist approach, derived from well-known magazine and book illustrators of the time. Names such as Charles Dana Gibson and Howard Chandler Christy were drawn into the war effort. Appeals were made through realistic representations of ordinary people or popular symbols such as Uncle Sam and the Statue of Liberty; images of women were often used to supply sex appeal and glamour. But the Americans also succumbed to scare tactics and accusatory pointing fingers, supplying their own version of 'I Want You' (with Uncle Sam) by James Montgomery Flagg in 1917. Most impressive were the numbers involved: posters printed in editions of 10,000 to one million copies each flooded the cities and towns.

With a wide variety of approaches extending across all the different countries, World War One saw the modern poster at the height of its power and influence, with all the strategies and tactics of modern advertising being put to the test.

Economic crisis and the rise of Fascism

Throughout the 1920s the American economy boomed, but the Wall Street Crash of 1929 set off a world economic crisis and America plunged into the Great Depression. During those painful years, federal programmes tried to revitalize the country. In the early 1930s, artists hard hit by the Depression were employed by the Federal Art Project as part of the Works Progress Administration or WPA. This fostered a variety of new directions in art, among them the move towards an expression of American identity which gradually developed into the Social Realist movement. Social Realism depicted the misery of the poor, particularly in the mid- and western rural regions of the country, and committed artists such as Ben Shahn worked to combat social injustice and prejudice. His memorial drawings of Sacco and Vanzetti (Italian emigrant workers wrongly sentenced to death) provided one of the best examples of his work's emotional power, as well as displaying Shahn's distinctive use of text and lettering.

World War One had also left in its wake a distressed and exhausted Europe. While the idealism of Constructivism was flourishing in Russia, the Weimar Republic was struggling to deal with reparation payments owed from the war. It spiralled into unemployment and inflation, which peaked in 1923 with the collapse of the currency. Thereafter the economy began to recover and industrial production was on the rise; but so was nationalism and Adolf Hitler. The US stock market crash of 1929 plunged Germany into economic crisis once more, and paved the way for takeover by Hitler's Nazi Party. In 1933 he took up office as German chancellor.

Chronicling this process was *Simplicissimus*, the tough satirical weekly with the distinctive bulldog symbol (drawn by Thomas Theodor Heine, co-founder and contributor to the magazine). It was launched in 1896, and over the next three decades *Simplicissimus* was the world leader in biting satire. The chief artists were Olaf Gulbransson and Karl Arnold, and their use of a sophisticated and at times decorative outline style, to make aggressive and often vicious comment, was revolutionary at the time and influenced generations of artists thereafter. The paper's favourite targets for ridicule were capitalism, the ruling classes, and (eventually) Hitler; and it was consequently forced to close in 1933.

There were others operating in the shadow of Fascism. John Heartfield's scathing photomontages denounced Hitler, Göring and other Nazi bosses with shocking and bloody imagery, often published as the front covers of the Communist magazine *AIZ* (*Arbeiter Illustrierte Zeitung*, meaning Workers' Illustrated Paper). Both Heartfield and *AIZ* were forced to leave Germany and continued working in Prague, where Heartfield produced his best and most disturbing imagery; he finally fled to England in 1938.

Other graphic artists whose drawings and prints depicted the reality that surrounded them also suffered: Otto Dix was barred from exhibiting and jailed; George Grosz, fearing for his life, fled to America. Käthe Kollwitz, whose graphic art had for years been dedicated to exposing the poverty and oppression of the German working class and the wider

3 IF IT HAD NOT BEEN FOR THESE THING, I MIGHT HAVE LIVE OUT MY LIFE TALKING AT STREET CORNERS TO SCORNING MEN. I MIGHT HAVE DIE, UNMARKED, UNKNOWN A FAILURE. NOW WE ARE NOT A FAILURE. THIS IS OUR CAREER AND OUR TRIUMPH. NEVER IN OUR FULL LIFE COULD WE HOPE TO DO SUCH WORK FOR TOLERANCE, FOR JOOSTICE, FOR MAN'S ONDERSTANDING OF MAN AS NOW WE DO BY ACCIDENT. OUR WORDS–OUR LIVES–OUR PAINS NOTHING! THE TAKING OF OUR LIVES–LIVES OF A GOOD SHOEMAKER AND A POOR FISH PEDDLER–ALL! THAT LAST MOMENT BELONGS TO US– THAT AGONY IS OUR TRIUMPH.

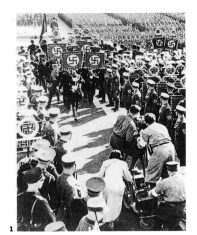

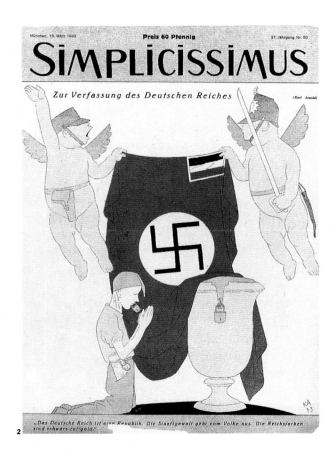

despair of war, was dismissed from teaching at the Berlin Academy in 1933. She remained working in Germany despite official persecution.

Further casualties included the Dutch jobbing printer Hendrik Werkman, now hailed as one of the great pioneers of modern typography. He produced experimental typographic compositions and his own periodical entitled *The Next Call*, which he sent to friends and colleagues in the avant-garde scene around the world. From 1940 to 1944 he also printed 40 issues of the clandestine publication *The Blue Barge* – which urged readers to keep up a 'spiritual resistance' to the German occupation – as well as other secret publications. In 1945 he was arrested and shot by the German secret police, only a few days before the liberation of Groningen. Much of his work was destroyed.

In Vienna, Otto Neurath and Marie Reidemeister (later, Marie Neurath) pioneered the Isotype system of pictorial symbols, a means of presenting vital social statistics on housing, health and other issues to the population of post-war Austria. They were forced to leave their base in Vienna in 1934, moving first to Holland and then to England. Meanwhile the Modern Movement's prime educational experiment, the Bauhaus – established in 1919 by Walter Gropius – had been forced to close. Having moved from Weimar to Dessau and finally to Berlin, it was shut down by the Nazis in 1933 and its staff and students scattered.

The radicalism of the avant-garde was considered anti-German and decadent. Its members were seen as supporters of Marxism or the Bolshevik Revolution (a severe threat to the Nazis' power grip), its institutions deemed to be occupied by foreigners and Jews. The products and concepts of Modernism were denounced as 'cultural Bolshevism', and the art movements derived from Cubism as 'degenerate art'. Ironically some unexpected good did come of the avant-garde's expulsion from Nazi Germany, for it served to spread their ideas and influence around the world.

Modern art and the avant-garde were at times extremely active in the fight against Fascism, most notably during the Spanish Civil War (1936-9). Picasso's painting *Guernica*, one of modern art's most powerful political statements, was an expression of outrage at the bombing of a Basque town in 1937. Exhibited that same year at the Paris World Exhibition as a memorial of the tragedy, it placed the standard of the modern art movements firmly on the Left. As political art, it marked the end of an era, for the political role of the war artist

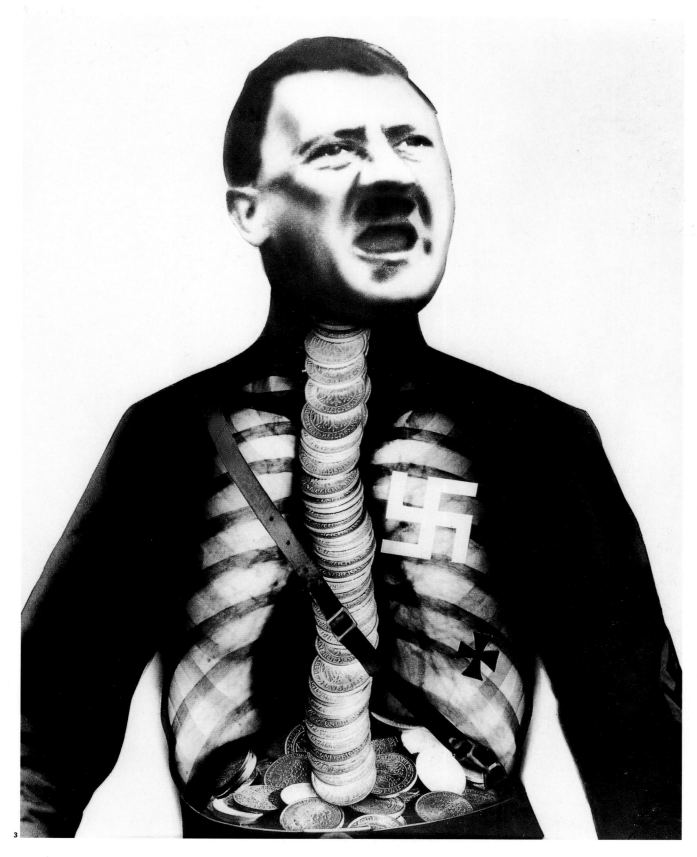

1 Photograph showing
Leni Riefenstahl filming
Triumph of the Will
(Germany, 1936),
the archetypal Nazi
propaganda film.
2 One of the last covers
of the German satirical
journal *Simplicissimus*
(March 1933), showing
an illustration by Karl
Arnold.
3 'Adolf the Superman:
swallows gold and
spouts trash',
photomontage by John
Heartfield, Germany
1932.

3

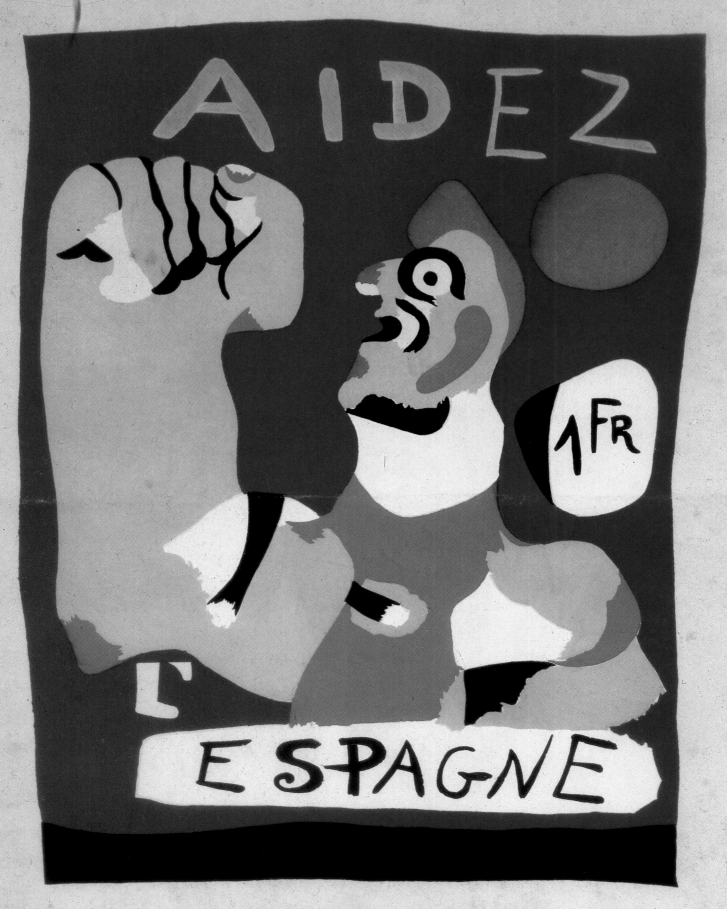

Dans la lutte actuelle, je vois du côté fasciste les forces périmées, de l'autre côté le peuple dont les immenses ressources créatrices donneront à l'Espagne un élan qui étonnera le monde. Miró.

1

was soon to be superseded by photography. From World War Two onwards it was photographs that were to affect people's politics, not paintings.

Fascist intervention in Spain also brought international aid and volunteers to back the Spanish Republican forces. Posters such as Joan Miró's 'Aidez l'Espagne' were produced to encourage international supplies and aid, and to condemn the fascist bombings in the eyes of the world. The posters of this struggle exploited the prevailing styles and influences of the time. Their use of symbolism and simplification of forms and figures was borrowed from Surrealism and the advertising art of Cassandre, Carlu, McKnight Kauffer and others. Symbolic objects were often grouped together; Cubist-influenced figures or forms were highly simplified and cropped to show dramatic detail, and images – often photographic – were juxtaposed and montaged to poignant effect. This use of graphic symbolism, as opposed to realistic representation, heralded a new form of modern political poster.

World War Two and the Cold War years

World War Two placed graphic design in some of its most challenging roles, working for both good and evil. It occupied a central place in Hitler's empire-building, and for the Allies generated solidarity and support in war effort projects and information design services aimed at the public good.

Hitler's design strategy for the Third Reich was one of the most powerful and threatening national identities the world has ever experienced, and benefited from the thoroughness applied to any tough corporate identity programme. He outlined his initial ideas on the art of propaganda in *Mein Kampf*, written while he was in prison; this included the use of stereotypes, strategies, and target audiences – as well as praise for the British, who, as Hitler noted, treated propaganda as a weapon in its own right. Once in power, the transformation was systematic: a new flag and emblem (the swastika) were employed immediately; non-serifed typefaces were replaced by traditional gothic black-letter typefaces known as Deutsche Schrift; and Goebbels was appointed State Minister for Propaganda and People's Entertainment, with the mission of co-ordinating the all-important media of film, broadcasting and print to promote a 'Greater Germany'.

From thereon followed a massive strategy of image and information manipulation: co-ordinated colours, slogans, emblems, and uniforms; vast and meticulously staged rallies and demonstrations; and an outpouring of anti-Semitic and racist material. Still photography, newsreels and documentaries, carefully edited to present the success of the Nazi 'New Europe', were a crucial part of Nazi indoctrination and an everlasting reminder of the ability of such media forms to distort reality. The design 'machinery' was difficult to fault; the content, aims and motives have remained among the greatest horrors of all time.

On the Allied side, government propaganda, in the form of public information and morale-boosting, was the main function of the graphic arts. Britain's Ministry of Information (MOI) issued morale posters that

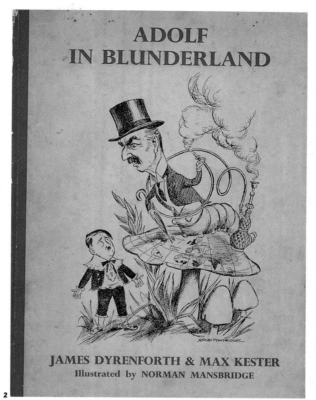

2

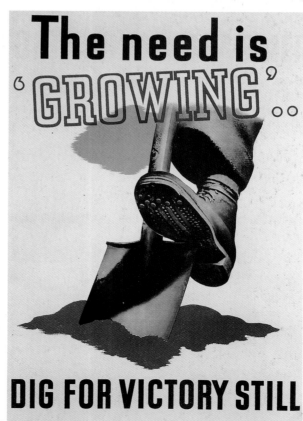

3

1 'Aidez l'Espagne', design for a French anti-Fascist pamphlet by Joan Miró, 1937.
2 Front cover of the political parody 'Adolf in Blunderland' (the published script of a radio broadcast), illustrated by Norman Mansbridge, Britain 1939.
3 Poster from the British 'Dig for Victory' campaign (artist unknown).

1 Poster by the British
designer FHK Henrion
for the United States
Office of War
Information, 1944.
It was designed to
be shown on the
continent after the
D-Day liberation.
2 Poster supporting
the fight for the four
freedoms of Western
democracy, as
illustrated by Norman
Rockwell, USA 1939-45.

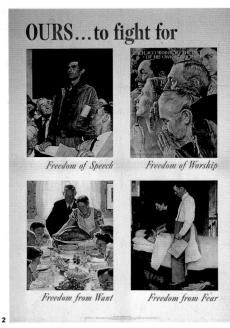

; help in aiding factory production and guarding national
examples were the 1940 'Careless Talk Costs Lives' and
campaigns.) The MOI also made heavy use of public
ted by well-known designers of the time such as FHK
s Hasler, George Him and Jan Le Witt. In addition, the
uced posters and educational/instructional material;
much of their best work was created by graphic designer and poster
artist Abram Games.

The end of the war brought a significant reconstruction problem
for Britain. Efforts to encourage post-war recovery and keep the public
going despite rationing of food and clothing led to the creation of events
such as the 'Britain Can Make It' exhibition at the Victoria & Albert
Museum in 1946, and culminated in the greatest morale-raising
exercise of all: the Festival of Britain in 1951.

America once again relied on posters as the primary medium for war
propaganda, and the United States Office of War Information (OWI) and
other government departments drew the nation's best popular artists
and illustrators into action. American war posters mainly aimed to
encourage the purchase of war bonds, build public morale and keep up
production. Their overriding characteristics were large production runs,
high-quality printing and a diversity of graphic styles that ranged from
home-town realism to modernist experimentation. They included
posters by Norman Rockwell (whose paintings, reproduced in *The
Saturday Evening Post*, championed America's values, freedoms and
way of life); Social Realist painters such as Ben Shahn and Bernard
Perlin; and refugee artists such as Jean Carlu, who was working for the
Free French cause and supporting the American war effort.

The advent of the Cold War in the 1950s saw America rise to its
highest levels of world power and consumer power. But the deepening
divisions between Eastern socialism and Western capitalism were
reflected in waves of conformism on both sides of the line. For the
West, the heroic peasant-worker imagery of Communist state
propaganda began to take on the face of totalitarianism and world
domination; the image of the 'evil empire' loomed. An extreme reaction
came in the form of the anti-Communist hysteria of McCarthyism in
America. The nuclear arms race that began also formed part of the
distrust, and fear of nuclear war and 'the Bomb' sparked off campaigns
for world peace that still continue to this day.

But the materialistic emphasis of mass consumerism also brought
discontent from within America. Flaws began to show: inequalities
between racial groups, between the 'haves' and 'have-nots' became
evident. Civil rights activities simmered throughout the Fifties, one of
a number of issues of power and equality that were soon to extend to
other domains. At the same time, international inequalities started to
surface as colonialism began to see its day. Triggered by crises such as
the Bay of Pigs, Algeria and the Cuban Missile Crisis, it all exploded in
the Sixties in waves of anger, protest and re-direction. The explosion
was to resonate around the world and echo down through the decades,
as shown in the graphic protests that follow.

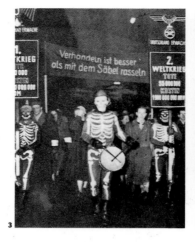
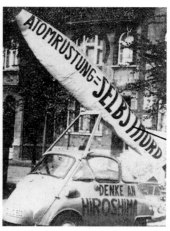

3 Photographs from the West German 'Ban the Bomb' movement of the 1950s, which had strong support from the Social Democrats as well as renowned scientists, theologians and artists. The skeletons carry a banner saying 'Negotiations are better than sabre-rattling', and the dummy-bomb mounted on top of the bubble car reads 'The Bomb is suicide: Remember Hiroshima'. The vehicle was stopped several times by the police on its journey to Bonn, and was confiscated just before it could reach its destination.
4 The first Campaign for Nuclear Disarmament (CND) march from London to Aldermaston, Britain 1958.

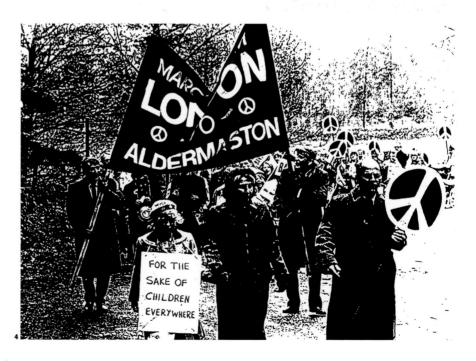

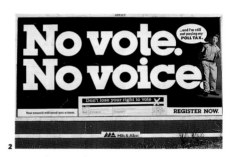

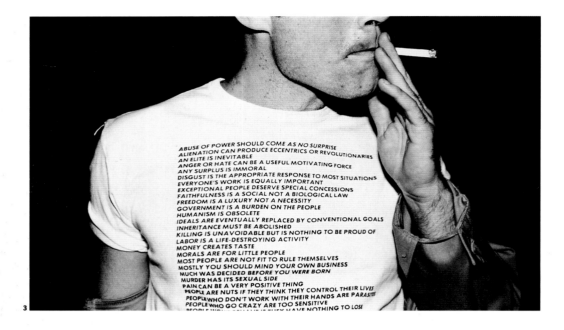

National politics

Political parties, governments and leaders

The national politics of virtually any country comprises a mass of internal power struggles. The 'graphic voice' that emanates from those struggles has two forms: the official voice, and the unofficial voice. The official voice belongs to 'the establishment': governments, leaders and institutions that operate systems of control (political, economic or social), and define societal values and priorities. The unofficial voice belongs to those who question, criticize or even reject those systems and structures as well as the motives of the people behind them. The struggles may at times be waged over quite specific laws or taxes, such as Britain's poll tax, or they may be arguments over broader principles, such as the financing of AIDS research in America or the rise of neo-Nazi extremism in Germany. In the end, however, all of these struggles relate to power: either fighting for it, or against it.

This chapter does not aim to provide a comprehensive survey of different countries and their political graphics, but instead concentrates on a selection of significant graphic movements and projects. The examples shown illustrate the direct and confrontational roles that graphics can play in struggles of national import (as in the street posters of the Atelier Populaire in Paris or the resistance posters of South Africa) as well as the equally important indirect roles such as consciousness-raising, generating aid or finance, or slowly eroding public support through graphic satire or abuse. In many cases this work reflects the social concerns and popular movements of particular countries, or recent historical changes that have taken place within them. The primary focus, however, is on particular graphic roles, techniques and traditions rather than historical sequences of events.

Both the official voice and the unofficial voice are represented graphically, for both are integral parts of the political landscape; even when the unofficial voice is stifled, its very absence is significant. Moreover both voices rely on propaganda techniques, even if the level of production and distribution differs greatly. The official voice usually has command of substantial funds and institutionalized methods of production and distribution: governments for example often produce heavily-financed media campaigns distributed through established channels. The unofficial voice may have motives that are equally propagandistic, but is often forced to resort to less extravagant (and potentially less effective) methods such as distributing home-made pamphlets by hand, or sticking up illegal posters at night.

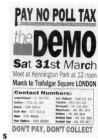

5

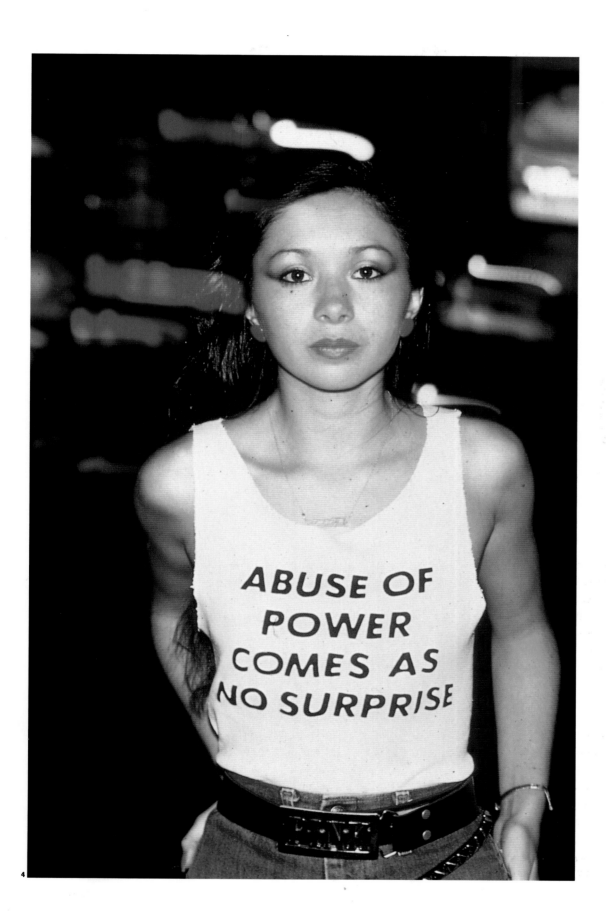

4

The 'unofficial' voice
of protest and social
comment.
1 Anti-fascist postcard
by Egon Kramer, West
Germany 1980.
2 Reworked billboard
(the original speech
bubble was blank)
protesting against the
poll tax, by 'visual
interventionists'
Saatchi & Someone,
Britain 1990.
3 & 4 Jenny Holzer's
series of 'Truisms':
t-shirts worn by John
Ahearn and Lady Pink,
New York City 1983.
5 Handbill announcing
the anti-poll tax
demonstration in
Trafalgar Square in
March 1990. A rally
of around 40,000
people, it turned into
one of Britain's worst
examples of civil
upheaval in recent
years.

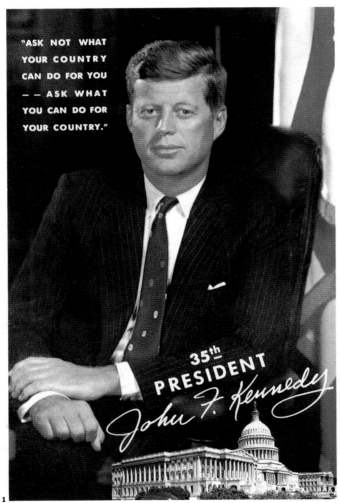

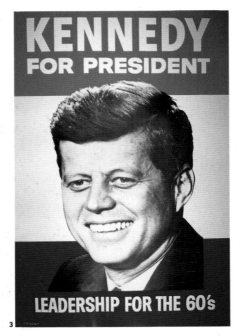

But the unofficial voice does have certain advantages. The fight to give 'power to the people', or to protest and be heard, draws upon the resourcefulness and ingenuity of individuals, the solidarity value of collective teamwork, and the emotional strength of commitment or resistance. Thus individual acts, as well as the work of small organized groups, can have substantial impact in the struggle against a much greater force. When American artist Robbie Conal sites his agitprop posters at very particular street junctions and at exactly the right height for captive viewing from a car (in Los Angeles, a city where no one walks), he is feeding more care and attention into his guerrilla tactics than most official bodies would lend to an average media campaign, because he knows that he must get maximum effect from economy of means. He is committed to getting his message across. He may not match the 'reach' of a televised campaign, but his effectiveness per square inch of image is probably just as high, if not higher.

The wealthier Western countries dominate the chapter in terms of the amount of imagery shown, for here the social and political roles of graphics are most complex, being heavily enmeshed in the workings of governments, economies and society as a whole. Both propaganda and protest techniques have been able to develop to an unparalleled level of sophistication, largely through an abundance of materials, new technology, and an audience accustomed to responding to newspapers, TV news, cartoons and other forms of open visual debate.

Party politics: propaganda and public image

Party politics present one of the most blatant uses of propaganda graphics and manipulative media techniques, particularly during election campaigns. The USA and Britain are used here as examples of highly developed but differing approaches to electioneering and visual debate. Both elected governments rely heavily on media publicity to win votes and explain party policies.

America has traditionally focussed on the electoral candidate as a personality: the projection of a 'public image' and use of supporting paraphernalia plays a large part in campaigning. Television has also played a crucial role in the development of this public image. Eisenhower may have been the first to employ an advertising agency or make TV commercial 'spots' to win an election, but Kennedy was the first truly to exploit the TV medium. His famous televised debate with Nixon was believed to have secured his narrow victory in the 1960 election, and from thereon he became the first presidential TV personality. Much of his popularity was based on the American public's ability (through TV) to get to know him – or rather his 'image' – personally, and to form judgements based on appearances.

Nixon however has been credited as having first engaged the controlled use of the TV medium (in the 1968 election), by tinkering, distorting and manipulating to the point where the 'image' was totally separate from the man. His strategy centred on the principle that the 'image' is what the voter psychologically 'buys' like any commodity. It heralded a new era in politics, where politicians and advertising went

hand in hand and the 'image' that would win votes was no longer a matter of personality but a distortion created by media experts.

The campaigns conducted in America since then have taken this focus on public image and used it to wage an all-out media war. 'Sleaze tactics' are now commonly used to taint the opponent's image; issues are often lost in ambiguous manufactured TV messages; and candidates and their campaigns are moulded according to 'cultural strategies' and image-formulas, in other words, getting the production and the stage props right.

Britain, on the other hand, tends to wage electoral battles over parties and their policies, although Margaret Thatcher built up an international image in her own right throughout the 1980s. Televised interviews and party political broadcasts are a heavy part of the electronic media overload in the run-up to a national election, and great pains are taken to preserve the democratic notion that all is conducted with a sense of balance, lending equal media time to the airing of opposing views.

Great attention is also given to poster campaigns, which take the arguments directly to the man in the street. The famous Saatchi & Saatchi dole queue billboard of the 1979 election campaign (page 49) is considered to have been a contributing factor to the Conservative party's victory. Over ten years later, in the 1991 election campaign that threatened to dislodge Conservative Prime Minister John Major from office, the two main parties (Conservative and Labour) waged a battle of the billboards which reached comic proportions. No sooner was one poster unveiled by one party than a counter-poster would be rolled on by the other. So it continued at an impressive pace, sometimes drawing new retorts almost overnight in true argumentative style.

But no matter how frenetic or misguided the tactics may seem at times, an essential feature of both countries and their party politics (whether in campaigning mode or not) is the freedom to criticize and to present an opposing view. Propaganda plays an important role in this competitive scenario. It is part of the official voice that aims to win votes and to set policies; but it is also part of the unofficial voice that protests against the established order or encourages dissent. Both of these voices are allowed to vie for public attention, and both are allowed to manipulate the crowd.

Centralized government: propaganda and censorship

In societies with centralized power, propaganda and manipulation are exercised by one official voice. A prime example existed in the socialist graphics of the former Soviet Union and the Iron Curtain countries of Europe, where for many years propaganda strategies (such as media censorship) imposed authoritarian doctrines with complete intolerance of opposing views.

The Communist philosophy was reinforced through decades of Soviet image-building: the constant presence of Lenin in statues and portraits; the symbolic red of socialism on banners, flags and other elements of display; party slogans on buildings and posters; the

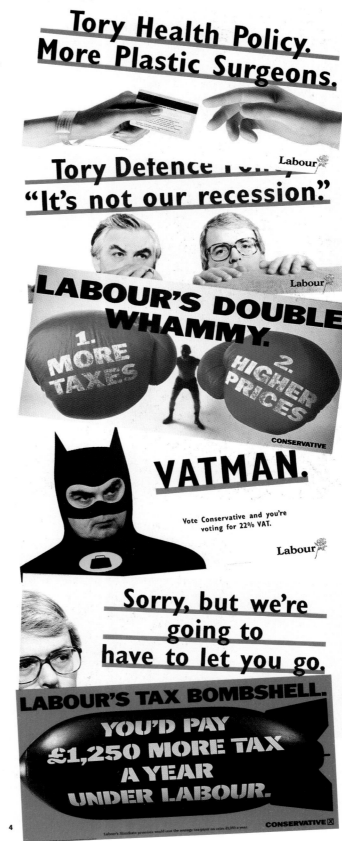

1 Postcard memorial of John Fitzgerald Kennedy, USA 1992.
2 Pack of matches, USA 1960s.
3 Presidential campaign poster for J.F. Kennedy, 1960.
4 Political sparring, British-style: Labour and Conservative billboards from the general election of 1992.

4

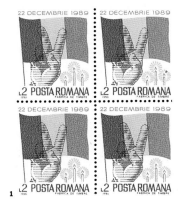

1

HOMMAGE À ROMANIA 1989

1 Postage stamps from Romania, 1990, commemorating the Popular Revolution of December 1989.

2 'Comrades, ADIEU', poster by István Orosz, Hungary 1989, commenting on the occupying Soviet army leaving Hungary.

3 Poster by Péter Pócs of Hungary, a memorial to the victims slaughtered during the Romanian Revolution of 1989; printed at the artist's own expense, 1989.

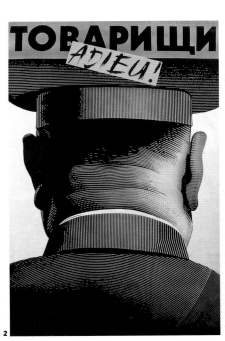

2

3

ubiquitous hammer and sickle emblem; and the officially promoted heroic peasant/worker imagery. The philosophy also found form in decades of poster art and other graphics that spoke with one ideological voice, and in the accepted style of Soviet Socialist Realism (originally introduced in the 1930s by Stalin). It is not surprising that the lifting of restrictions through glasnost and perestroika brought an immediate surge of poster work (one of the most popular art forms). Many of the posters were critical of society and its leaders; it was the release of decades of pent-up anger and criticism.

A centralized ideological voice also drove the propaganda graphics of Mao Tse-tung's Cultural Revolution in China (1966-76). With the aim of building a unified workforce, imagery was produced (in a hyper-Socialist Realist style) that projected the revolutionary spirit of collectivism and co-operative labour, led by the national hero figure of Mao and guided by his Little Red Book. Stereotyped representations of the masses, and heroic individuals demonstrating socialist ideals, became part of the graphic formula which taught people what to think and how to conduct themselves, while also eliminating individualism and other 'counter-revolutionary' elements.

Throughout the 1960s and 1970s, the graphic activities of both socialist revolutions suffered greatly from restricted artistic expression, the isolationist policies of their regimes and the dulling effect of producing repetitive idealized imagery that was divorced from the drama and reality of daily life or real people. Although both visual cultures contained interesting aspects – such as the monumental quality and stylized poses of the Soviet heroic-worker imagery, or the dynamic energy of the Cultural Revolution's depiction of the masses –

any fascination is mitigated by the hollowness of the message, and a recollection of the repressive aspect of the regimes the graphics represented. The imagery is a far cry from the colour, vitality and emotion of the poster graphics belonging to the 1960s socialist revolution in Cuba, which also spoke for a central ideology. But in Cuba, the spirit of internationalism was central to the revolution's aims, and artistic expression was not only encouraged but enlisted as a communicative tool for the revolution.

The Pro-Democracy protests

The liberation posters on pages 64-67 provide lasting memories of the Pro-Democracy movement of the late 1980s which swept Central and Eastern Europe. The strikes in 1980-81 that created Poland's independent trade union, Solidarity, provided an early rumbling of things to come. (The Solidarity logo was the first persistent symbol of the growing desire for democratic reform in Europe.) As the decade moved on, Gorbachev's policies of glasnost and perestroika placed the USSR on the road to economic reform and a free market economy – and inevitably led to the decline and break-up of the Soviet bloc. By the end of the decade, Eastern Europe was subjected to a wave of popular revolutions and uprisings – some quiet, some bloody. In highly simplified terms, the wave peaked in 1989 and encompassed Hungary, Poland, East Germany (accompanied by the opening of the Berlin Wall), Bulgaria, Czechoslovakia and Romania. It was followed in 1990 by the gradual break-up of Yugoslavia, and the controversial reunification of Germany. The year 1991 saw the collapse of the Soviet Union, and the independence of the Baltic States (Latvia, Estonia, Lithuania).

4 Painted banners from the Central Academy of Drama in Beijing, created for the Tiananmen Square protest of May 1989. **5** The Goddess of Democracy statue built by protestors in Tiananmen Square, May 1989.

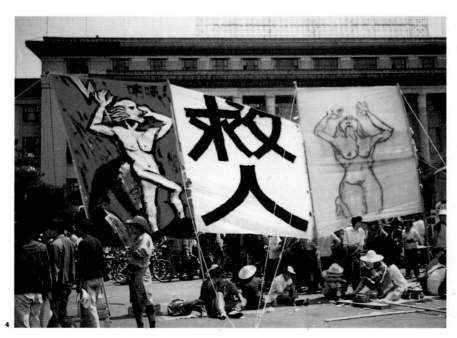

In graphic terms, the mood of openness and change (and eventually revolution) from the mid-1980s onwards allowed heavily censored cultures to emerge from behind the Iron Curtain. They exercised their new freedom in a wide range of extraordinary graphic statements: the historical resentment and social critique of the Russian perestroika posters; symbolic references to the removal of Communism, such as emblems cut or torn out of flags; clearly-expressed fears of the effects of Westernization and the dangers of embracing its 'hamburger culture'; as well as the proud but virulent imagery present on stamps and other documents from Romania's violent revolution.

Makeshift posters, signs, banners and other graphic ephemera also played a direct role in many of the uprisings, flooding the streets and plastering vehicles, walls and windows with the call to join in the struggle. The aftermath witnessed the gradual discrediting and dismantling of the Soviet State's visual identity. The hammer and sickle, red flags, party slogans and portraits of Lenin were seen to crumble with Gorbachev's reputation. The Communist Party was banned and Lenin's statues were torn down; by 1992 the USSR itself ceased to exist. Irreverence set in, and it wasn't long before the hammer and sickle adorned everything from bracelets to bustiers.

Out of the range of graphic statements released by the fall of the Iron Curtain, the most eloquent (and least damaged artistically) belonged to those countries – Latvia, Hungary, Poland, Czechoslovakia – whose poster traditions, although censored, had still managed to grow and maintain a life-line with the international art scene through poster comp-etitions such as the Brno Biennale in Czechoslovakia and other forms of cultural exchange. Their poster artists had become skilled in bypassing censorship by the use of visual metaphor and symbolism, or had avoided it altogether by printing small editions at their own expense for entry into competition. This was in contrast to countries such as Romania, where resources and creativity had been sapped by a brutal regime.

In the period leading up to the revolutions in Europe, a Pro-Democracy event was staged on the other side of the world: the month of demonstrations held in May 1989 in Beijing's Tiananmen Square, where students, workers and intellectuals protested for the right to a voice in the government, only for many of them to be killed on 4 June by

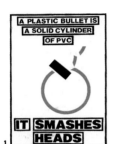

troops from the hardline Communist regime. It was an event that interfaced old-style graphic methods with globe-shrinking new technology. The daily demonstrations employed makeshift banners and placards; students from the Central Academy of Art produced varied types of handbills and posters, often by means of simple woodcuts printed by hand, which were then pasted to walls and windows; and the Central Academy of Drama produced large banners painted with emotive figures of people pleading for help.

This was not the usual two-way dialogue between protestors and leaders, however: the Tiananmen demonstration was addressed to the world. There was live television coverage, and (at first) a festive sense of street theatre, with students addressing the crowds with loudspeakers and banners waving in the background. Fax and telex machines shot messages out to the rest of the world. And the world responded with high-tech solidarity, as shown by the Fax for Freedom project described in Chapter Two. The TV coverage of the demonstration produced immediate media icons: the Goddess of Democracy statue, the row of tanks stopped in their tracks by one lone protestor, and later, the horror of the injured and dying sprawled across the square.

In the Tiananmen Square demonstration new technology and TV were used to connect the demonstrators with the rest of the world and to invite viewers across the globe to be active and participate in the protest. Later, with the Gulf War, new technology and TV were used to do the exact opposite: to cloud activities, to encourage passive acceptance and to distance the viewer from real events and any association with death and destruction.

Graphics and war

Wars and conflicts have been more or less continuous over the past three decades, and Chapter Two deals with the general topic of war and militarism from a global perspective. This chapter, however, views wars as power struggles waged by particular governments, or by rival factions within a country. Such wars may extend beyond the boundaries of the country, or be fought from a distance, but the decision to wage war (and sustain it) rests with the government at home. The conflict becomes part of the internal workings of that country, and can generate intense protest from within.

America's anti-Vietnam War poster movement is represented here, along with other ephemera and projects that fuelled the American public's anti-war feeling and eventually forced the withdrawal of US troops. Protest posters of the 1991 Gulf War, however, were few and far between; indeed the ephemera of the time demanded support for the troops, so as not to repeat some of the mistakes of Vietnam (when American soldiers had difficulties re-integrating back into society). The Gulf War protests produced in other participating countries such as Britain involved general calls for peace, or centred on the horror of hi-tech, sanitized warfare and gloating media coverage.

Britain's military presence in Northern Ireland has generated little in the way of protest posters or exhibitable graphics, but a great deal of

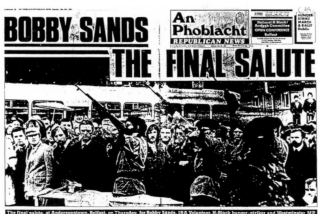

The final salute, at Andersonstown, Belfast, on Thursday, for Bobby Sands, IRA Volunteer, H-Block hunger-striker and Westminster MP

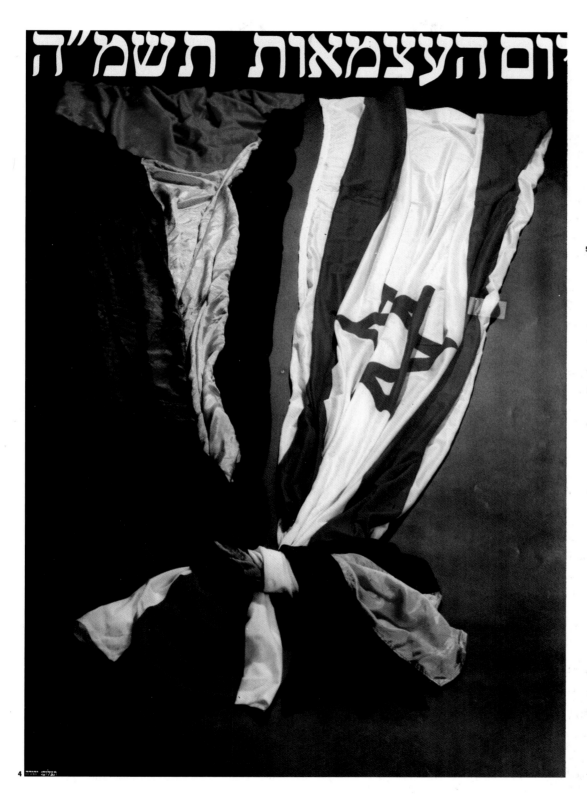

1 Postcard by the
Campaign Against
Plastic Bullets (design:
Stephen Dorley-Brown),
Britain 1980s.
2 Badge, Britain 1980s.
3 Front and back page
of *An Phoblacht* (May
1981), a Republican
newspaper published
in Belfast. This issue
appeared at the time
of the hunger strikes
in the early 1980s.
4 'Independence Day',
poster entwining the
Israeli and Palestinian
flags, calling for
reconciliation in the
Arab-Israeli conflict.
Designer unknown,
Israel 1988.

5 Poster for an
exhibition of masks,
by Israeli designer
David Tartakover, Israel
1989. The words that
appear are from a Purim
children's song: 'There
is no joy and happiness
like me – the mask, ha
ha!'. Pictured are a
masked Palestinian
sending a missile, an
Israeli soldier wearing
a protective mask,
another Palestinian
masking his face with
a picture of Yasser
Arafat and, at the
bottom, a baby girl
who was shot in the
eye by a rubber bullet,
masked with bandages.

'The Falklands Cards':
from a series of
postcards produced
during the crisis in the
Falklands by radical
postcard press South
Atlantic Souvenirs
(Rick Walker and
Steve Hardstaff),
Britain 1982.

grassroots comment and criticism in the form of TV documentaries, films and ephemera such as pamphlets and postcards protesting against the use of plastic bullets by British armed forces in Northern Ireland. Certain artists, designers and cartoonists rallied against the war in the Falklands, producing some of Britain's most intense anti-war statements. These included postcards by the radical press South Atlantic Souvenirs, and illustrator Raymond Briggs' children's book *The Tin-Pot Foreign General and the Old Iron Woman* (obvious caricatures of Argentina's General Galtieri and Britain's Margaret Thatcher).

The Palestinian-Israeli conflict has generated many powerful political posters over the past three decades, reflecting the hard-fought struggle for Israeli independence as well as the intensity of Palestinian resistance. Appeals for understanding, reconciliation and peace have emerged from artists on both sides, particularly since the 1980s, resulting in eloquent universal graphic comments on pain and suffering.

Africa: anti-apartheid and reconstruction

It would be impossible to represent graphically all the conflicts and disasters that have beset the African continent over the past 30 years. The wave of African nationalism that brought de-colonization and independence for many new states in the 1960s also brought bloodshed and prolonged periods of instability. Wars between rival factions, apartheid policies, famine and other disasters have ensured that the plight of Africa and its people has never been away from our headlines for very long. There have been many artistic statements of support; many projects dealing with alternative technology and indigenous design issues; many aid appeals involving graphic art. Rather than encompass the broad spectrum, this chapter concentrates on two areas of concern where graphic design has played a very specific role in the social and political developments taking place.

The first area of concern is apartheid. Despite the rapid changes incurred elsewhere by African nationalism in the 1960s, the Republic of South Africa resisted and further entrenched itself in the separatist system of apartheid: the policy of white minority power over the black majority, involving racial segregation, economic exploitation, and the denial of basic rights to blacks, as well as Indians and people of mixed race. The years that followed represent a catalogue of despair and sacrifice: the attempted relocation of blacks onto Bantu homelands; the Sharpeville Massacre (1960); the banning of the African National Congress (1960-90) and imprisonment of its leader Nelson Mandela (1963-90); Steve Biko and the Black Consciousness movement (late 1960s and 1970s); and many other important events and protests, reinforced by economic sanctions and solidarity from the international community at large.

The turmoil culminated in a decade of intense mass resistance in the 1980s, and an extraordinary number of resistance posters and other graphics produced by screenprinting workshops and activists within South Africa. These acted as important tools for motivation, consciousness-raising and solidarity in the popular democratic struggle.

The second concern of this chapter is reconstruction after the damage of war. An example of the use of graphic design as a force for social development and change is shown in the work of the Maviyane Project in Zimbabwe. With the end of the war for independence in 1980, Zimbabwe (formerly Rhodesia) embarked on the building of a new socialist state. The Maviyane Project joined this movement wholeheartedly and their work mirrors many of the concerns and crises of the time, at both national and local level. These include the re-integration of guerrilla fighters from the war back into society; the need to raise literacy levels; worries over the disappearance of indigenous culture; and how to combat the ever-present spectre of apartheid. The project also represents an important attempt to find a graphic voice relevant to the black community, one which would challenge the dominating white voice of Western culture and thus provide the ideological revolution with a visual revolution.

The subjects of apartheid and solidarity appear often in the Maviyane Project's work. Apartheid's effects were far reaching. The apartheid regime's attempts to retain a dominant position by de-stabilizing its neighbours (the 'Frontline States', including Zimbabwe) took the form of South African-backed wars and terrorism, as well as the crippling social effects that they bring. Consequently solidarity amongst the Frontline States has been important both as a survival tactic and in order to foster the sense of 'shared destiny' cultivated by many of the African countries struggling to establish their own identity.

Africa has been the battleground on which many global problems and issues have been waged: the rebellion against exploitative multinational interests, the rise of nationalism and independence movements, human rights abuses, displaced and refugee populations, the battle against natural elements. The continent's national struggles therefore embody international significance, and have given rise to some of our most important solidarity efforts, such as the international anti-apartheid movement and the Live Aid appeal for famine relief, both of which appear in the next chapter.

Social change and home politics

Internal politics and protest relating to economic and social issues – such as civil unrest, workers' strikes, anti-racist campaigns and tax protests – provide this chapter with a variety of poster workshops, radical presses and other progressive publishing activities. Many have achieved international fame; all continue in the tradition of using graphics as a tool for revolution and social change.

The Cuban political posters of the 1960s were by far the most influential movement, and inspired grassroots poster workshops and art activists around the world. They were conceived as ideological tools for both the Cuban socialist revolution and the international (Third World) socialist revolution. Produced by a number of agencies, government departments and publishing houses within Cuba, they were distributed worldwide by an international propaganda agency. Unlike the cultural efforts of the USSR and China at that time, Cuba's posters were not

Powerful social comment can be found in low-budget community productions as well as high-tech repro.
1 Poster for 'Culture in Another South Africa', making use of sophisticated colour printing. It advertises a conference held in Amsterdam in December 1987 which featured over two hundred South African artists in exile. Designed by Wild Plakken (Frank Beekers, Lies Ros, Rob Schröder), Holland.
2 A simple but highly effective film poster by Alfredo Rostgaard for an anti-American documentary on the Vietnam War. Published by ICAIC, the film bureau of the Cuban government, 1967.

banal products of central party ideology but carriers of political education founded in the creativity of the people. In purely graphic terms, they provided a model of visual power and directness.

Other influential revolutionary tools included the street posters of the Atelier Populaire of May '68 in Paris which were similarly powerful in their directness and even more economical in their means and messages; they often consisted of nothing more than one image and a slogan, both carefully chosen and produced as a simple stencil, then screenprinted. The resistance posters, banners and t-shirts of South Africa that represented the popular struggle against the apartheid regime in the 1980s also carried the immediacy of relatively crude imagery and low-tech screenprinting. So did the Nicaraguan revolutionary posters produced during the 1980s by the Sandinista government and other agencies and dedicated to building a new society and fighting poverty, disease and illiteracy while also organizing people to political action and defence against the US-backed Contras. Australia has since the early 1970s harboured a fine tradition of graphic workshops that have not only serviced the labour movement and social concerns, such as education and health, but have also given a graphic voice to the plight of that country's Aboriginal people.

Revolution can take even more unusual or ephemeral forms. Guerrilla graphics, such as the night-time postering of Robbie Conal or the Guerrilla Girls in the USA, kept a protest undercurrent alive in America during the Reagan/Bush years. Meanwhile radical presses and community workshops in 1980s Britain worked persistently to challenge authority, promoting the peace movement and feminism through posters, postcards and other statements of graphic solidarity.

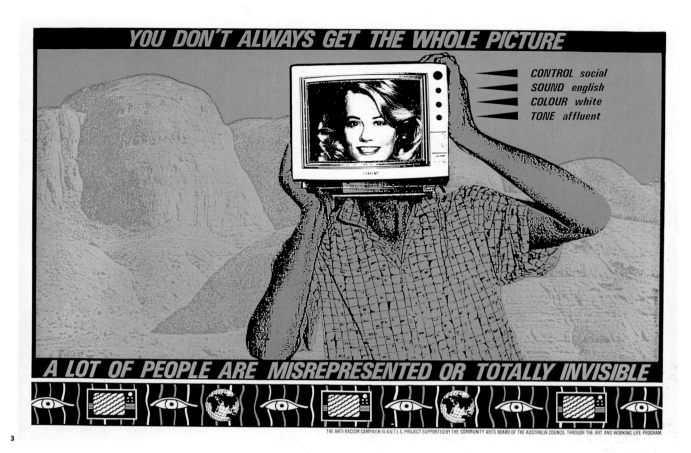

YOU DON'T ALWAYS GET THE WHOLE PICTURE

CONTROL *social*
SOUND *english*
COLOUR *white*
TONE *affluent*

A LOT OF PEOPLE ARE MISREPRESENTED OR TOTALLY INVISIBLE

THE ANTI-RACISM CAMPAIGN IS A.U.T.L.C. PROJECT SUPPORTED BY THE COMMUNITY ARTS BOARD OF THE AUSTRALIA COUNCIL THROUGH THE ART AND WORKING LIFE PROGRAM.

3

3 Low-tech screen-printing is used to powerful effect in this poster by Jayne Amble for an anti-racism campaign. Produced for the South Australian United Trades and Labour Council, Australia 1987.

The revolutionary activities described rely to a great extent on a powerful, direct statement produced by economy of means, often accompanied by low-cost, low-tech production methods such as screenprinting, photocopying or cheap offset litho. But powerful social comment is not exclusive to low-budget production. Germany, Holland and Japan all produce political comment and social critique that can be intellectual, surreal or drily witty, while also taking advantage of the best photographic and print production processes in the world.

Germany's Klaus Staeck has made sharp political comment in slickly-produced photomontages since the 1960s. Drawing references from advertising, his high-gloss imagery is often mated with contradictory text, which jars to make an acerbic comment about a rich, overfed, industrialized society and its excesses. The high-quality finish adds to the ironic wit of many of his statements. High-quality reproduction and attention to detail are also an integral part of Japanese visual language. Shigeo Fukuda's visual jokes and asides, for example, are short, sharp and meticulous. Japan is also responsible for glossy annual design exhibitions on ecology and peace, which have produced extremely beautiful social comment over the years (see the

Hiroshima Appeals in Chapter Two). Finally, Holland's design group Wild Plakken can expect skilled printing to match the surrealistic effects used in some of their anti-apartheid statements – also helped greatly by the fact that the government has over the years supported and financed the anti-apartheid movement.

Developments in mass media and technology since the 1960s have meant that problems or movements occurring at national level now have the ability to grow into global movements. The Pro-Democracy movement in Poland, the peace movement in Britain, the anti-apartheid struggle of South Africa and the anti-fascist movement in Germany all started as national struggles, which then gathered solidarity to form international networks or found that similar organizations already existed in other countries. Graphic symbols, logos and other visual forms have aided the progression to internationalism in that they have the powerful facility to overcome language barriers, engage the emotions, and rally people to their cause. With graphics playing an instrumental role, we are gradually leaving the era of internal struggles and isolated protests, and are entering a new era of international movements and large-scale activism.

Personalities and paraphernalia

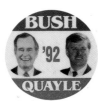

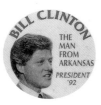

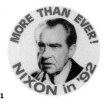

1

At the very heart of the American concept of democracy lies the principle of free elections. It is no surprise then that America stages its elections – at all levels – with a sense of celebration, flag-waving and showtime.

The identity of political parties and the direction of their election campaigns have traditionally centred around the candidate as a personality: the person in whom the electorate is placing their trust. Consequently, candidates' faces tend to appear on everything from posters to buttons.

Out of this emphasis on the candidate grew the modern concept of 'selling an image'. John Fitzgerald Kennedy was the first to exploit the TV medium to this end, and his televised debate with Nixon was believed to have secured his narrow victory in the 1960 election. Thereafter his charisma and youthful appearance won him great public support and provided an early example of television's ability to sway public opinion.

Because of the practice of 'backing' an individual, paraphernalia plays a large part in campaigning; buttons, badges and bumperstickers all allow the general public to take sides and feel involved. The personal touch also colours the conduct of the campaign trail: smear tactics are common, as are personal attacks and insults.

Whilst many artists, actors and writers lend their influence in support of election candidates, it is even more common for artists – both well-known and unknown – to generate protest against politicians and their policies.

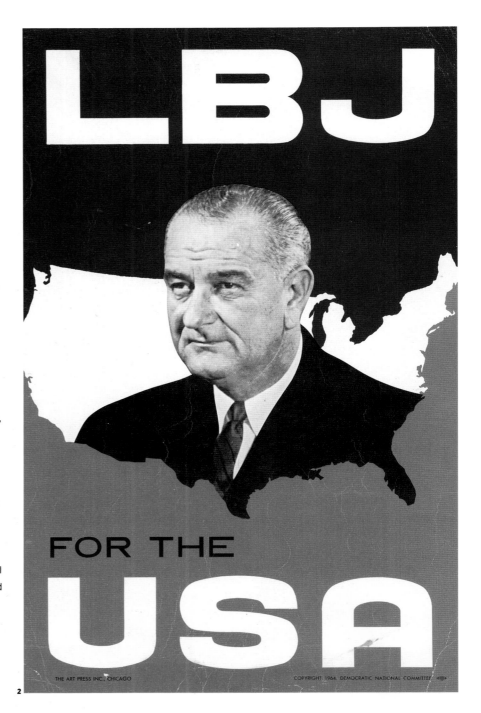

2

4

MILHOUS I

5

3

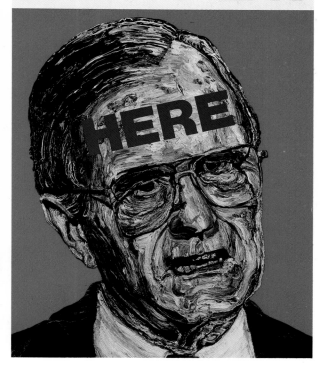

1 Assorted campaign
badges from
Presidential election
year, 1992.
2 Presidential campaign
poster for Lyndon
Baines Johnson, 1964.
3 Two posters by
guerrilla artist Robbie
Conal, commenting on
the more questionable
issues relating to
Presidents Ronald
Reagan and George
Bush, 1987-8.
4 Back-page ad from a
January 1968 issue of
the left-wing American
magazine *The New
Republic*.
5 'Milhous I', portrait of
Richard Milhous Nixon
by Edward Sorel for *The
Washington Post Book
World*, USA 1973.

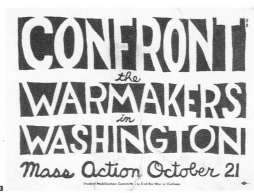

Protesting against the war in Vietnam

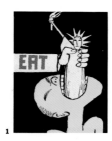

From the day that President Lyndon Baines Johnson ordered American troops into Vietnam in 1965, until their final withdrawal in 1973, the protests and demonstrations from within America were bitter and relentless.

Internal dissent and anti-war activities took myriad forms: there were citywide referendums, campus demonstrations, marches, sit-ins, strikes and draft card burnings. As involvement escalated, so did the anger and the protests. Campus unrest hit a peak in 1970, when four students were shot and killed by the National Guard in an anti-war demonstration at Kent State University.

American artists and designers poured out a prolific mass of anti-war posters, cartoons and other graphics, exemplified by the work of Seymour Chwast, Tomi Ungerer, Jules Feiffer and the Art Workers' Coalition – a large militant group of artists which, in addition to other activities, published the 'Q. And babies?' poster on page 44, an extraordinary piece of protest graphics.

Vietnam was the first broadcast media-covered war, and the influence of press and media was all-important. With constant live TV coverage and the emotional war photography of Tim Page, Sean Flynn, Don McCullin, Philip Jones Griffiths and others filling daily newspapers, magazines and books, there was no escaping the reality of the devastation. It fuelled public opposition to the war and made cries for withdrawal ever stronger: a pressure considered to have been instrumental in the eventual withdrawal of American troops.

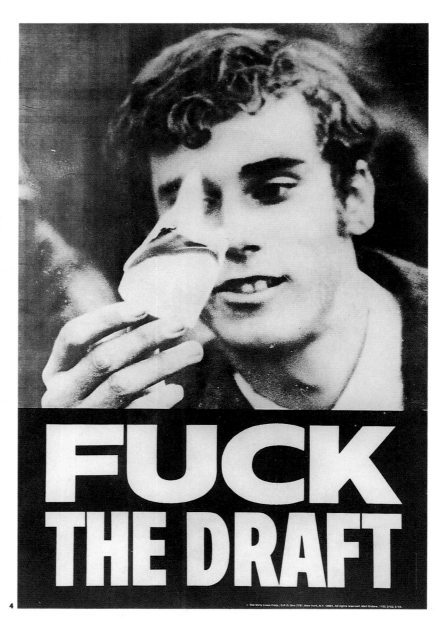

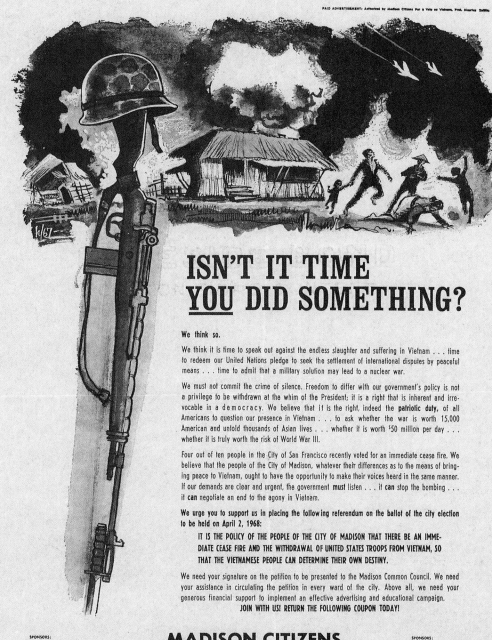

ISN'T IT TIME YOU DID SOMETHING?

We think so.

We think it is time to speak out against the endless slaughter and suffering in Vietnam . . . time to redeem our United Nations pledge to seek the settlement of international disputes by peaceful means . . . time to admit that a military solution may lead to a nuclear war.

We must not commit the crime of silence. Freedom to differ with our government's policy is not a privilege to be withdrawn at the whim of the President; it is a right that is inherent and irrevocable in a d e m o c r a c y. We believe that it is the right, indeed the **patriotic duty,** of all Americans to question our presence in Vietnam . . . to ask whether the war is worth 15,000 American and untold thousands of Asian lives . . . whether it is worth $50 million per day . . . whether it is truly worth the risk of World War III.

Four out of ten people in the City of San Francisco recently voted for an immediate cease fire. We believe that the people of the City of Madison, whatever their differences as to the means of bringing peace to Vietnam, ought to have the opportunity to make their voices heard in the same manner. If our demands are clear and urgent, the government **must** listen . . . it **can** stop the bombing . . . it **can** negotiate an end to the agony in Vietnam.

We urge you to support us in placing the following referendum on the ballot of the city election to be held on April 2, 1968:

IT IS THE POLICY OF THE PEOPLE OF THE CITY OF MADISON THAT THERE BE AN IMMEDIATE CEASE FIRE AND THE WITHDRAWAL OF UNITED STATES TROOPS FROM VIETNAM, SO THAT THE VIETNAMESE PEOPLE CAN DETERMINE THEIR OWN DESTINY.

We need your signature on the petition to be presented to the Madison Common Council. We need your assistance in circulating the petition in every ward of the city. Above all, we need your generous financial support to implement an effective advertising and educational campaign. **JOIN WITH US! RETURN THE FOLLOWING COUPON TODAY!**

MADISON CITIZENS FOR A VOTE ON VIETNAM

MADISON CITIZENS FOR A VOTE ON VIETNAM
610 Langdon Street, Madison, Wisconsin 53703
Phone: 231-2852

☐ I wish to sign the petition.
☐ I wish to help circulate the petition.
☐ I wish to contribute $..........

Name ..
Address ..
City State Zip

SPONSORS:
THOMAS ADAMS
DOUGLAS ANDERSON
PROF. MICHAEL N. BLEICHER
MONSIGNOR ANDREW BREINES
FATHER JOSEPH BROWN
DR. GEORGE CALDEN
DAVID CHENEY
HENRY CLARENBACH
DONALD EATON
FRANK EMSPAK
PROF. EDGAR FEIGE
PROF. TED FINMAN
MR. AND MRS. LAWRENCE FUELLEMAN
JAMES L. GREENWALD
FATHER JOSEPH HAMMER
MR. AND MRS. PAUL H. HASS
MRS. MARIANNE HOBBINS
DR. WILLIAM B. HOBBINS
REV. PAUL Z. HOORNSTRA
FATHER FREDERICK KREUZICER
RICHARD KROOTH
REV. JAMES LA RUE
ROBERT LEVINE

SPONSORS:
ROBERT M. McCORMICK
REV. LOWELL MESSERSCHMIDT
JACK VON METTENHEIM
FATHER RICHARD OESTREICH
DR. GEORGE E. ORSECH
DR. AND MRS. H. K. PARKS
R. R. PAUNICK, JR.
MRS. LESTER RADKE
CLIFFORD ROBERTS
MR. AND MRS. GILBERT S. ROSENBERG
ADAM SCHESCH
RABBI GERALD SCHUSTER
DR. ADDIE SCHWITTAY
MR. AND MRS. IRA SHOR
WILLIAM SKAAR
PROF. AND MRS. WILLIAM STONE
RABBI MANFRED SWARSENSKY
MRS. MARY THOMPSON
GEORGE VUKELICH
LAURENCE A. WEINSTEIN
DR. AND MRS. PETER WEISS
RABBI RICHARD W. WINOGRAD
DR. ZAIN WOODRING
PROF. MAURICE ZEITLIN

1 Poster by renowned artist and illustrator Tomi Ungerer from a series of anti-war posters which he published privately, 1967.
2 Cover of *Young Socialist* magazine, USA 1968.
3 Sticker for a mass demonstration to be held in Washington DC, produced by the Student Mobilization Committee to End the War in Vietnam, 1968.
4 Poster showing young American burning his draft card, by the Dirty Linen Corp., New York City, late 1960s.
5 Handbill from Madison, Wisconsin calling for a city-wide petition and referendum to end the Vietnam War, 1968. Referendums were one of many forms of internal dissent over the war.

1

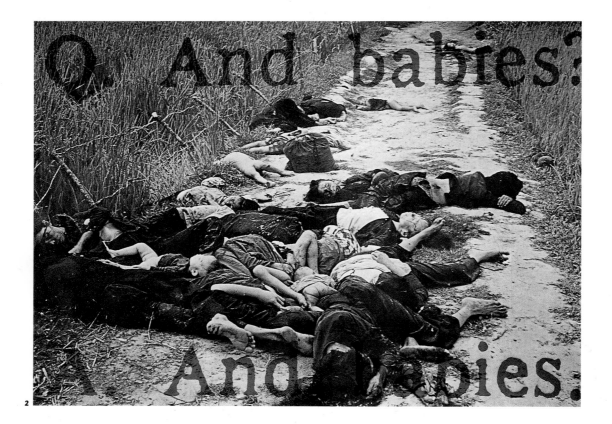

2

3

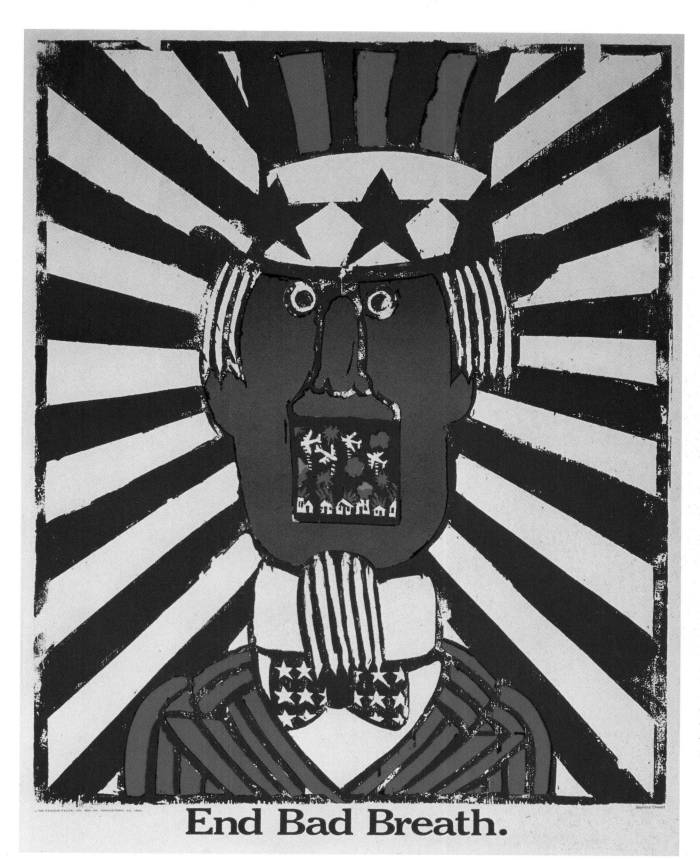

End Bad Breath.

1 Cover and inside spreads from the book *Vietnam Inc.* by photographer Philip Jones Griffiths, and the cover of *The New Soldier* by John Kerry and Vietnam Veterans Against the War, 1971.
2 'Q. And Babies? A. And Babies'. Offset litho poster by the Art Workers' Coalition (photo: R.L. Haeberle), New York, 1970.
3 Christmas card from Vietnam: a sarcastic note from an embittered generation (produced and posted by US servicemen while in Vietnam), Christmas 1970.
4 'End bad breath', anti-Vietnam War poster created in 1967 by Seymour Chwast, co-founder of Push Pin Studios. An undesirable war was depicted as Uncle Sam's bad breath; the title refers to sales-talk used to advertise toothpaste and mouthwash.

Taking sides again: America in upheaval

1

Discontent and anger shifted beneath the surface of a decade of conservatism with Reagan and Bush in the 1980s, producing isolated pockets of protest and agitation. As the decade progressed, the tensions increased and in some cases erupted. By the 1990s many of the protests had sharpened their bite, some had become full-blown movements, and all were employing visual formats as never before.

Jenny Holzer's 'Truisms' (1978-87) and other poetic messages appeared on everything from massive electronic signs in Times Square to t-shirts and phone booth labels. Enigmatic, sharp-edged, amusing or disillusioned, they became icons of modern culture. In addition, Barbara Kruger's use of text and image posed questions about consumerism, sexuality and societal values. Her haunting poster 'Your body is a battleground' was a call to arms in 1989 for the March on Washington for abortion and a woman's right to choose (page 141).

Robbie Conal produced a steady stream of caustic poster-portraits of 'bad guys' (politicians and public figures) that were wheatpasted on city walls across America. In addition AIDS activism, a movement born out of the gay community's anger at government inaction in the AIDS crisis, grew to be a formidable force – particularly through the demonstrations of ACT UP (AIDS Coalition to Unleash Power) and its effective use of propaganda graphics, created by art activist group Gran Fury and others.

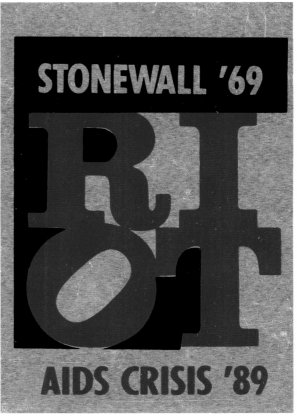

2

3

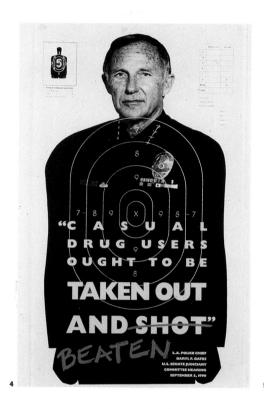

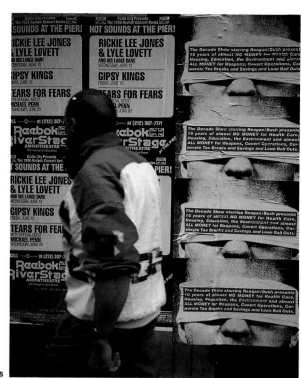

1 Badge and
bumpersticker
produced during the
Gulf War, USA 1991.
2 Sign message from
the 'Survival' series
by Jenny Holzer,
New York City, 1983.
3 'Riot' sticker by
the AIDS activist art
collective Gran Fury,
produced on the
twentieth anniversary
of the Stonewall Riots
(the beginning of the
Gay Liberation
movement), 1989.
4 Poster portrait of Los
Angeles police chief
Daryl Gates, by Robbie
Conal, 1992. The
altered text refers to
the Rodney King affair,
when four LA police
officers were tried for
the beating of black
motorist Rodney King.
5 Poster by Barbara
Kruger commenting
on some of the
inadequacies of the
Reagan/Bush years,
USA 1990.
6 Criticism of President
Bush's show of action
in the Gulf War and
inaction in the AIDS
crisis, designed by Gang
for ACT UP, 1992.

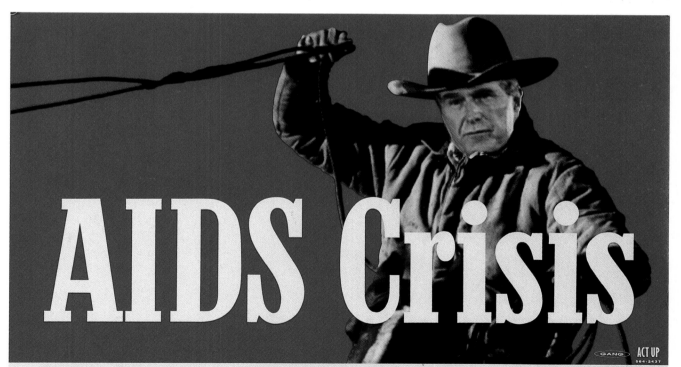

WARNING: While Bush spends billions playing cowboy, 37 million Americans have no health insurance. One American dies of AIDS every eight minutes.

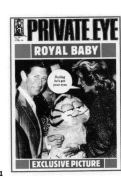
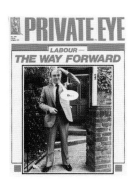

1

British politics: satire and restraint

The 'satire boom' that struck Britain in the
early 1960s was indicative of the social
upheaval taking place at the time –
highlighted by peace protests, the Pill, the
Profumo Affair, the Beatles, and other signs
of change. It brought a new wave of malicious
humour and entertainment, as exemplified
by the London review 'Beyond the Fringe',
the fortnightly magazine *Private Eye* and the
television programme 'That Was The Week
That Was' (or TW3). Many felt that it was not a
new movement, but simply a return to the
grand old satire tradition of Rowlandson and
others. Whatever the case, it revelled in abuse
and controversy aimed at public figures, the
government, class distinction, royalty and
religion, and set new standards of
outspokenness, subversion and public
humiliation that have been exploited by artists
and the media ever since.

Nevertheless, Britain's national election
campaigns tend to fight a 'clean' fight over
parties and their policies, taking great pride in
giving both sides equal time to make their
argument in televised debates or interviews.
Billboard campaigns, for example, are
considered to be a 'proper' form of argument
that takes place at the level of the man in the
street. Opposing parties often manipulate
each other's slogans and can act at great
speed in order to counter an attack. Although
messages and methods may be hard-hitting,
the opponents are still reasonably behaved.

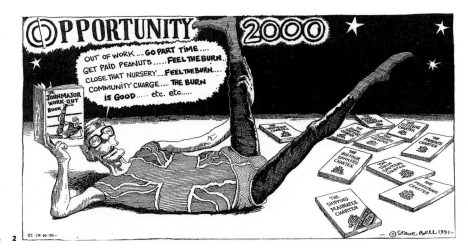

2

However, outside this formal structure of democratic and restrained election sniping lies chaos. Throughout a normal year, the British public is accustomed to receiving its daily dose of politics, government and the economy, with heavy interlacings of irreverence, abuse and scandal. All British politicians can expect to be mercilessly mimicked and lampooned – and the agents of assault take many forms. Political cartoonists such as Steve Bell thrive in the national newspapers; satirical journals such as *Private Eye* (with its outrageous front covers) survive despite continual legal battles and attempts to restrain them; advertising agencies produce increasingly daring imagery; and the wickedly funny latex puppets of the weekly programme 'Spitting Image' ensure that the boundaries of good taste are stretched to the limit on television screens across the country.

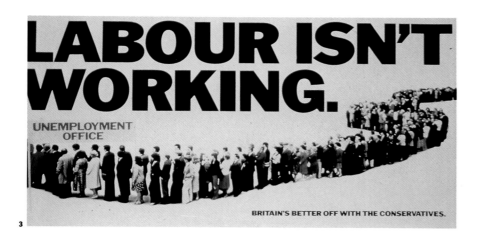

3

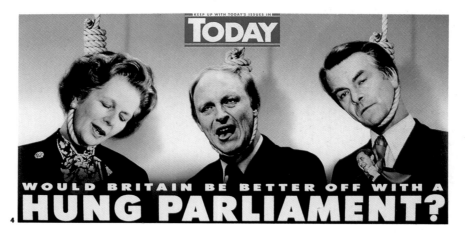

4

1 Particularly known for the brazen jokes on its front cover, the satirical magazine *Private Eye* has for decades pushed both public and legal tolerances to the limit.
2 Prime minister John Major, by political cartoonist Steve Bell, 1991; published in the *Guardian* newspaper. 'Opportunity 2000' was an industry-led equal opportunities initiative; Major was criticized for having no women in his cabinet when it was introduced, and is shown mimicking a Jane Fonda workout.
3 The campaign billboard that helped contribute to the Conservative party's election victory in 1979 (during a period of high unemployment), by ad agency Saatchi and Saatchi.
4 Margaret Thatcher, Neil Kinnock and David Owen. Created by Yellowhammer ad agency during the 1987 election year, aiming to increase sales of *Today* newspaper. It received record complaints, and did not remain on view for very long.

1

1 Spread from *The Tin-Pot Foreign General and the Old Iron Woman*, written and illustrated by Raymond Briggs. A children's storybook on the follies of war, it appeared in the wake of the Falklands crisis, Britain 1984.

2 'Maggie Regina', photomontage by Peter Kennard inspired by Margaret Thatcher's call for a return to Victorian values (such as hard work, duty and self-reliance) and making use of a well-known portrait of Queen Victoria. Produced as the front cover of the *New Statesman* magazine in 1983, and later as a poster and postcard.

3 The British political satire tradition comes to life in *Spitting Image*, the television show where politicians, royalty and other public figures appear as caricature puppets – and malicious humour rules. The puppets, created by Peter Fluck and Roger Law, originated as 3D models photographed for use as illustrations in magazines. Once given motion, they achieved fame as one of Britain's most popular TV series in the late 1980s.

2

3

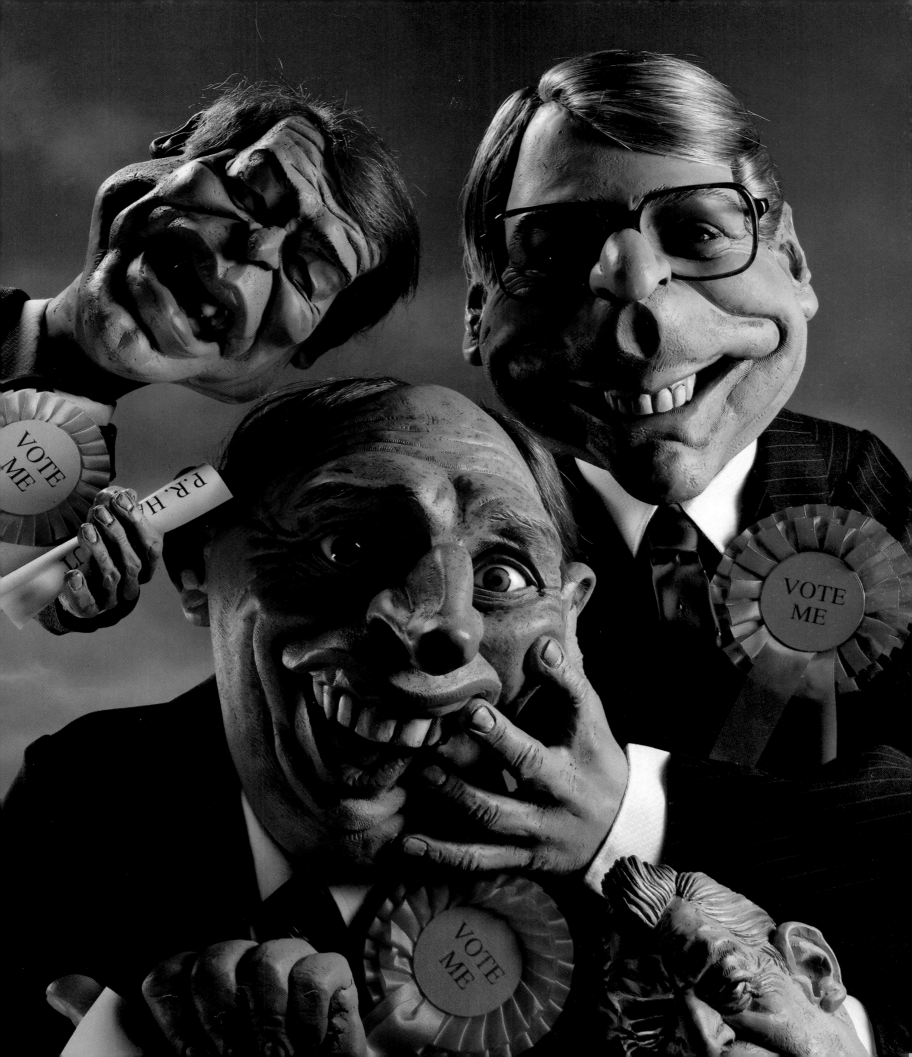

2

3

Home issues and youth politics

1

4

In the recession atmosphere of the 1970s, Britain's own particular method of fusing grassroots politics and the creative arts emerged in 1976 with Rock Against Racism, a group protesting against racism in the pop music industry. Originally consisting of people from the visual arts (graphic design, advertising, fashion and photography) they staged concerts, dances, demonstrations and other activities. The Anti-Nazi League was formed not long after, and both groups targeted their efforts on quelling the rising activities of the neo-fascist National Front party. Although tiny in comparison, Rock Against Racism paved the way for later global concerts such as Live Aid and the Nelson Mandela 70th Birthday Concert.

The 1980s brought attempts to breathe new life into the Labour Party by extending its appeal to the young, particularly via the efforts of young designers associated with the new breed of 'style magazines'. The decade also saw the strengthening of popular movements and the notion of 'personal politics' through the global charity concept of Live Aid, the Green activism of Greenpeace and Lynx (the anti-fur trade campaigners), and the continuing themes of anti-racism and anti-apartheid. By the 1990s, youth politics and consciousness-raising were communicated through music and visual culture, via rock stars, films, fashion, style magazines and other vehicles.

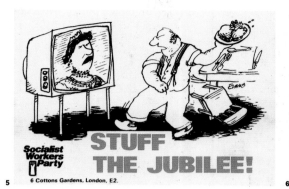

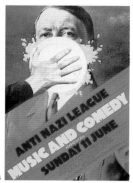

5　6 Cottons Gardens, London, E2.

6

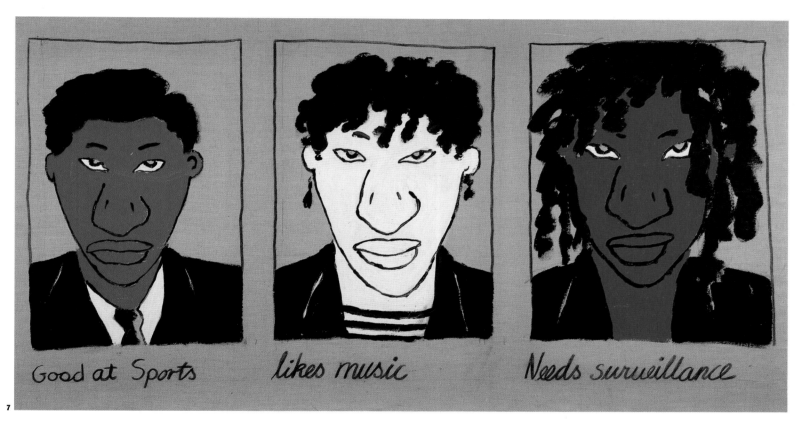

Good at Sports　　　likes music　　　Needs surveillance

7

1 Logo for Red Wedge, a group of young people allied to the Labour Party. Designed in the early 1980s by Neville Brody.
2 Promotional literature, part of the visual identity designed by Neville Brody for *New Socialist*, 1986.

3 Cover for *New Socialist*, the Labour Party's monthly magazine, January 1987, designed by Phil Bicker.
4 Poster for Boy George's 'No Clause 28' single; designed by Jamie Reid and Malcolm Garrett, 1988.

The poster was part of a campaign against Clause 28, a new parliamentary bill outlawing the 'promotion' of homosexuality.
5 Sticker produced during the Queen's Silver Jubilee celebrations, 1977.

6 Poster for a fundraising concert on behalf of the Anti-Nazi League by Mervyn Kurlansky of Pentagram, Britain 1979.
7 'UK School Report', billboard and postcard by artist Tam Joseph, Britain 1983-4.

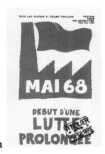

1

The Atelier Populaire

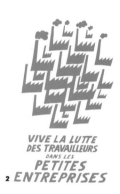

VIVE LA LUTTE
DES TRAVAILLEURS
DANS LES
PETITES
2 ENTREPRISES

Paris became a focal point for the revolutionary Sixties in May 1968 when workers and students joined forces to stage a general strike. Factories, offices and schools were occupied, and civil unrest shook the city in the form of demonstrations and riots in a massive protest against the Gaullist government and an education system that upheld old traditions and values.

The Ecole des Beaux Arts went on strike, and students occupied the studios and print workshops. Under the title Atelier Populaire, they worked 24 hours a day producing a mass of posters and wall newspapers that were pasted up in the streets. By all accounts, it was a very organized operation. Atelier members met each day in a general assembly for the discussion and choice of poster designs and slogans, while also debating current political developments. The posters were produced in several of the workshops by silkscreen, lithography or stencilling and distributed all over Paris by student and worker representatives.

The ultimate aim was the rejection of bourgeois culture and the development of a popular culture at the service of the people. In this sense the Atelier became a guiding light. The workshop and its posters, with their crude vitality, have inspired students, poster groups and print workshops around the world, and their example of direct action remains an influence on the students and professionals of art and design today.

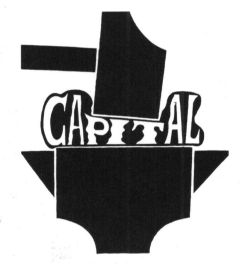

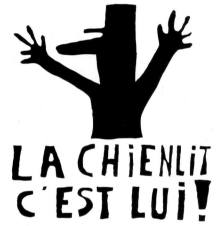

LA CHiENLiT
C'EST LUi!

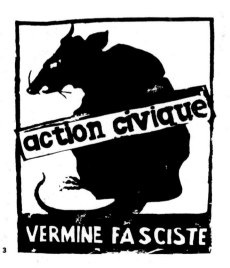

action civique

VERMINE FASCISTE

3

INFORMATION
LIBRE

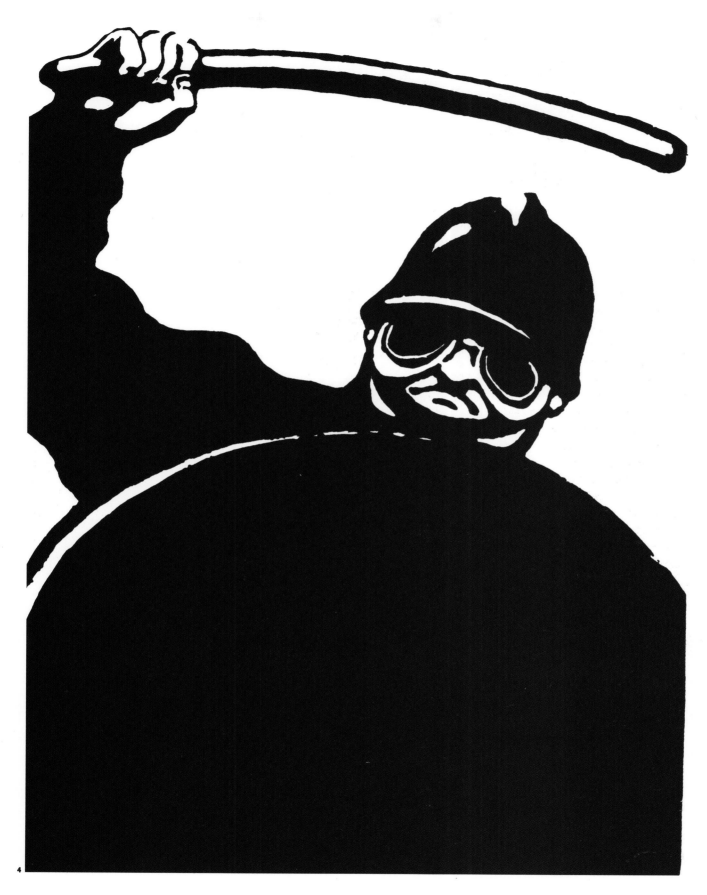

1 'The beginning of a long struggle': the recurring factory motif which appeared on the cover of a book produced by the Atelier Populaire, designed for use as a learning tool and to encourage other postermaking activities, 1969.
2, 3 & 4 Poster images from the Atelier Populaire workshop of May 1968.

Children of the revolution: Grapus

No book on political graphic design in recent years would be complete without mention of Grapus. An offspring of the May '68 student revolt, Grapus design collective was founded in 1970 by Pierre Bernard, Gerard Paris-Clavel and Francois Miehe. They were joined in 1974-5 by Jean-Paul Bachollet and Alex Jordan; with Miehe's departure in 1978, the main core was set.

All members of the French Communist Party (PCF), they concentrated their early efforts on the new society visions of the Left, producing cultural and political posters for experimental theatre groups, progressive town councils, the PCF itself, the CGT (Communist trade union), educational causes and social institutions. At the same time, they rejected the commercial advertising sphere, with its principles of power and control and its constraints on creative freedom.

For 20 years they provided inspiration to graphic design students all over the world, with their idealistic principles (of bringing culture to politics, and politics to culture), and their highly distinctive form of image-making: an accessible and unpredictable mixture of child-like scrawls, bright colours, sensual forms and high-spirited visual pranks.

Throughout their history, Grapus remained Communists and idealists and continued to operate collectively: all work left the studio signed 'Grapus' even when their studio numbers had grown to around 20, operating in three separate collectives. They finally disbanded in January 1991, splitting into three independent design groups.

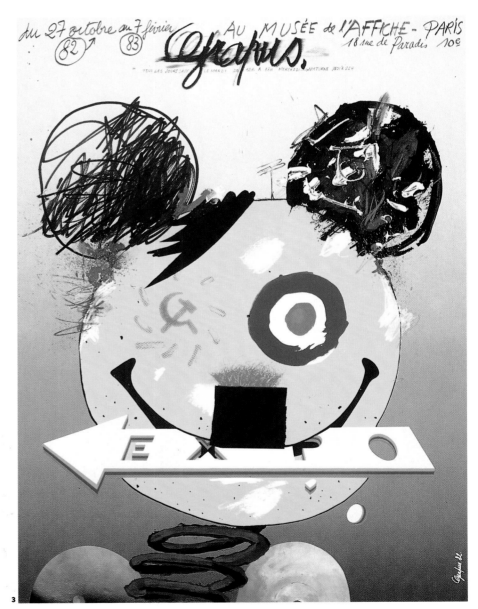

The Polish poster influence in France

France also acted as a haven for graphic artists who emigrated from behind the Iron Curtain during the 1960s, and who consequently thrived in the less restrictive climate of the West. Among these was Roman Cieślewicz, a representative of the second generation of Polish poster artists (heavily influenced by the father of Polish poster design, Henryk Tomaszewski). Cieślewicz left Poland to live in Paris in 1963, and has worked there ever since. He is particularly known for surreal photomontages which are intellectual, intriguing, and often broadly social or political in character.

Another famous emigrant from Poland was Jan Lenica, who also settled in Paris in 1963. Initially a poster artist who worked with the great Tomaszewski, he was soon drawn into experimental film-making and in the 1950s became one of the pioneers of animated film. His subjects often dealt with the struggles and fears of the individual in modern society such as loss of identity, and mistrust of technology and power politics, illustrated here by a graphic sequence from 1960.

The work of both Cieślewicz and Lenica underlines the tremendous influence of the Polish poster school and, in particular, the teaching of Henryk Tomaszewski at the Warsaw Academy of Fine Arts. Furthermore, two members of Grapus (Bernard and Paris-Clavel) had also travelled to Poland to study with Tomaszweski in the early 1960s.

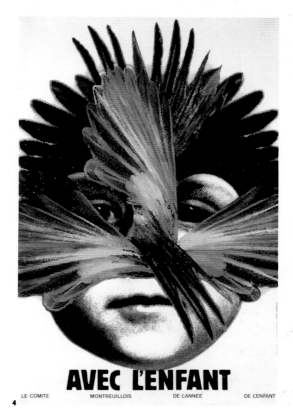

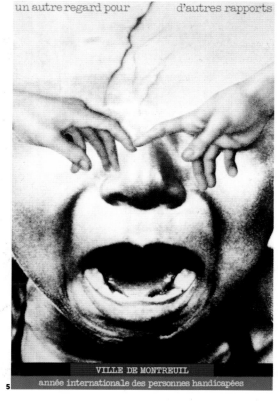

4 Poster for the International Year of the Child by Roman Cieślewicz, France 1979.
5 Poster for the International Year of the Disabled by Roman Cieślewicz, France 1981.
6 Graphic sequence by Jan Lenica showing a rise in status and position in a bureaucracy bringing loss of identity and humanity, Poland 1960.

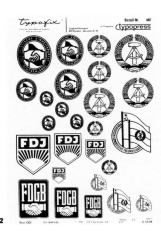

Germany: postcards, politics and popular movements

Germany's Klaus Staeck has been a major name in political graphics since the 1960s. His biting photomontages, produced in both postcard and poster form, have been known to spark off controversy and provoke anger among German conservatives. Images are matched with contrasting text or witty captions, usually with jarring results, and the high-quality production (often full-colour) enhances the comment. They owe much to the gloss and authority of advertising, but their power lies in subverting the viewer's sense of security.

Germany's Green politics and the peace movement have been well serviced by sympathetic artists and designers. But it is the web of issues surrounding reunification (the drain on the economy, the rise of neo-Nazi extremism and attacks on immigrant communities) that have recently provoked a ground swell of graphics and other activities generated by the popular movement against fascism and racism. This has included national media campaigns, anti-racist charity albums and videos, youth magazines and newsletters, and a large number of poster campaigns, demonstration announcements, and other ephemera produced by independent anti-fascist groups, individual activists and football supporters' clubs.

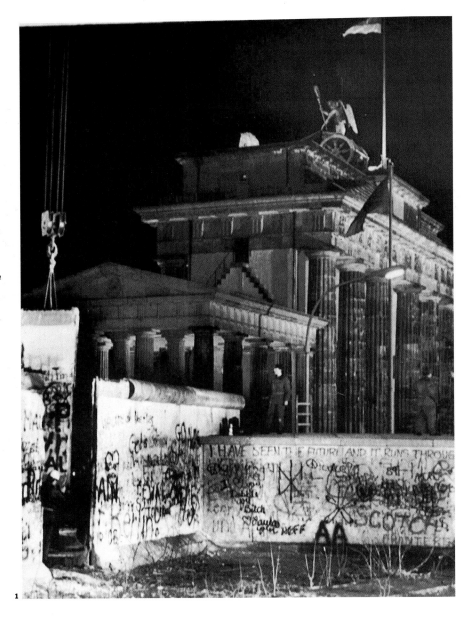

Konturen eines Amtsarsches
(Prototyp)
Gewidmet Herrn/Frau/Frl.
.....................................

3

Ich bin der geistige Führer
in diesem unserem
krisengeschüttelten Land

4

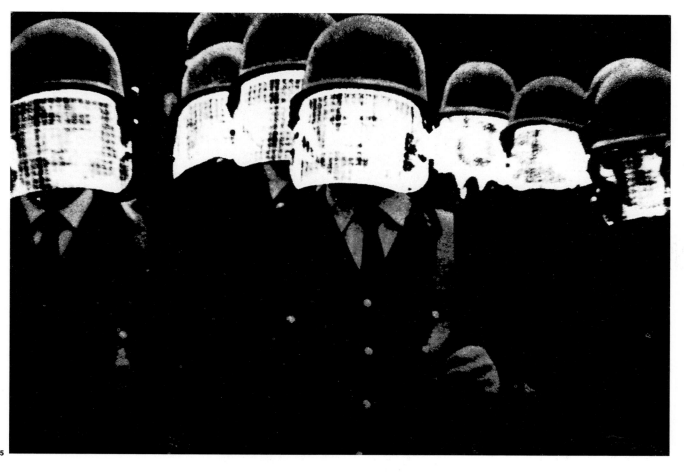

5

1 Opening a breach in the graffiti-covered Berlin Wall at the Brandenburg Gate, December 1989.

2 Dry transfer sheet carrying the symbols of socialism and the old German Democratic Republic, and now a relic after the fall of the Iron Curtain in 1989.

3 'Outline of a Bureaucrat's Arse (prototype), Dedicated to Mr/Mrs/Miss...', postcard by Klaus Staeck, West Germany 1974.

4 'I am the intellectual leader of this our troubled land', postcard by Klaus Staeck, West Germany 1982. The pear is used here as a symbol for 'head'; apparently the text was supposed to mimic the speech style of Chancellor Kohl.

5 'Law and Order', postcard by Klaus Staeck, West Germany 1970.

1

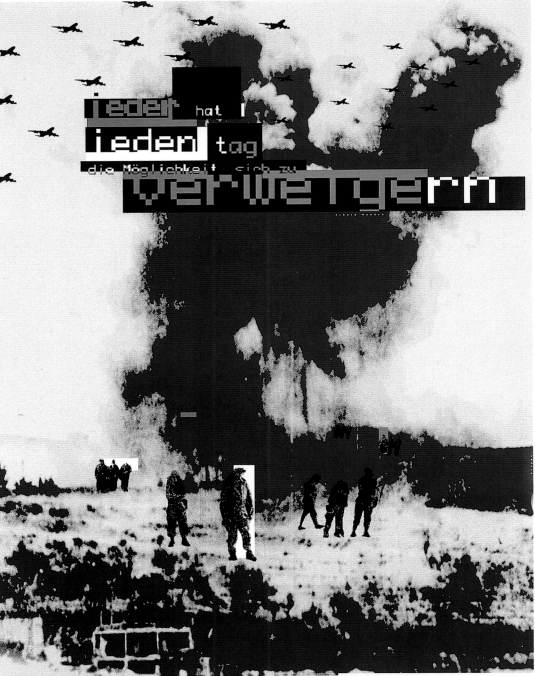

2

5

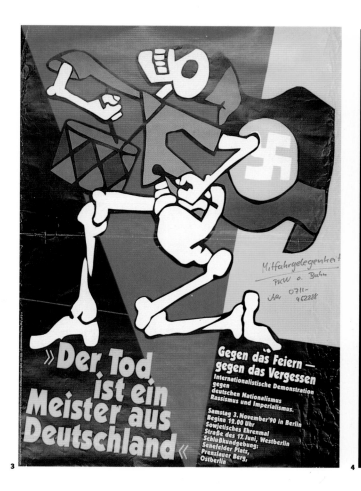

3

4

Thomas Gottschalk Marius Müller-Westernhagen Wim Wenders Peter Maffay Carlo Thränhardt Ulrich Wickert Alfred Biolek Witta Pohl Steffi Graf Jürgen Flimm City Otto Waalkes Wolfgang Lippert Günther Jauch Uli Hoeneß Die Toten Hosen Herbert Grönemeyer Götz George Helga Hahnemann Scorpions Paul Breitner Michael Gross

ICH BIN EIN AUSLÄNDER

1 Bolt of cloth showing a fantasy vision of 'Happy Germany' and European union: a far cry from reality, 1992.
2 'Each day brings everyone the opportunity to refuse', an anti-war poster by Daniela Haufe and Detlef Fiedler which used bitmapped typefaces and cursor effects as a reference to the technology of the Gulf War in 1991.
3 'Death Rules OK in Germany', poster for a demonstration against fascism and racism held in Berlin, 1990.
4 & 5 'I am a foreigner', a nationwide anti-racist campaign initiated by Herbert Gronemeyer which brought together radio and graphic design in the form of posters, ads and t-shirts by ad agency Jagusch and Partner, Hamburg 1992.

Radical design in Holland

Holland's liberal society has allowed substantial freedom for political movements to express themselves. For example, the government has over the years subsidized the anti-apartheid movement, which also receives heavy support from the public due to the past Dutch connection with South Africa. In addition, a long tradition of social and political design has centred around the Gerrit Rietveld Academy in Amsterdam because of its early connections with radical groups and movements such as De Stijl, Constructivism and the Bauhaus.

Jan van Toorn (professor of graphic design at the Gerrit Rietveld Academy, 1968-85) has been a constant radical voice in the Dutch design community. For three decades he has explored the theme of media manipulation and its social and political implications, as well as the ways in which graphic designers can challenge the packaging and transmission (through the media) of 'official culture'.

During the 1960s he was involved in movements pioneering a socially-relevant role for art, and in the 1970s designed calendars for the printing firm Mart Spruijt which were icons of their time. His collages of political events, politicians and ordinary people posed questions about media presentation – questions of fantasy versus real people, photographic manipulation as 'truth' and so on – while also making overt political statements. He continues to pursue issues surrounding perception and the media through his complex collages.

The original members of the Wild Plakken design collective – Frank Beekers, Rob Schröder and Lies Ros – met as students at the Gerrit Rietveld Academy's graphic design department. They worked together from 1977 until 1988, when Beekers departed. Other members have come and gone since then, but Schröder and Ros still remain. The name 'Wild Plakken' (roughly translated as 'wild pasting') can refer to making layouts in an unconventional manner, as well as to the illegal pasting of political posters on city walls.

Wild Plakken have worked mainly for cultural and political causes, designing a wide range of graphic materials. Their projects for the AABN (the Dutch anti-apartheid movement) are particularly powerful, demonstrating the group's commitment to a shared ideal of helping to change society through their work.

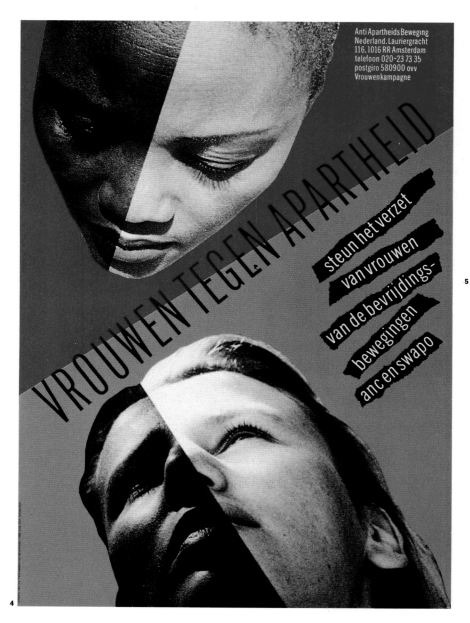

Anti Apartheids Beweging Nederland. Lauriergracht 116, 1016 RR Amsterdam telefoon 020-23 73 35 postgiro 580900 ovv Vrouwenkampagne

5

1 '75 years of the ANC', poster celebrating the 75th anniversary of the African National Congress, designed by Wild Plakken for the Dutch anti-apartheid movement (AABN), 1987.
2 Jan van Toorn's series of commemorative stamps honouring past Dutch politicians: P.J. Troelstra, P.J. Oud and A.F. de Savornin Lohman. Their political orientation is suggested by colour and by their positioning against the depicted chair of the Speaker of the House in the Dutch parliament. (Troelstra, for example, was a socialist and is depicted on the left of the chair.)
3 'The trade union', postage stamp encouraging workers' participation. Designed by Wild Plakken, 1988-9.
4 'Women Against Apartheid. Support the struggle of the women of the liberation movements ANC and Swapo.' Poster by Wild Plakken for the AABN, Holland 1984.
5 Page from a calendar for the printing firm Mart Spruijt, 1974-5, by designer Jan van Toorn, showing Henry Kissinger and a bevy of beauty queens (all dubious showcase 'diplomats') as a comment on the Middle East situation.

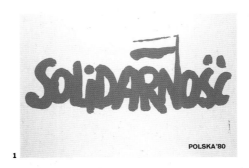

1

POLSKA '80

The Pro-Democracy movement in Europe

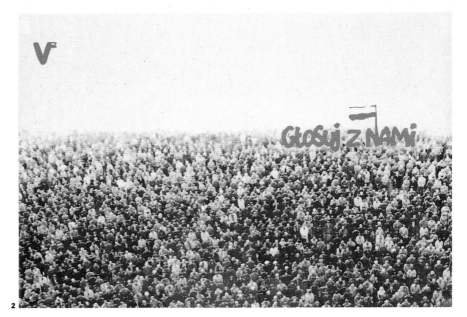

2

The logo for Solidarity, Poland's independent trade union, appeared in the heat of the strikes staged under the leadership of Lech Walesa in the Gdansk shipyard in 1980. Designed by Jerzy Janiszewski, it quickly became the emblem of the national workers' movement. The logo was soon published worldwide, hailed as the symbol for unity, collective strength and the spirited resistance of the Polish people. A persistent and highly identifiable image, it helped to focus and sustain international sympathy throughout the decade for a struggle which finally achieved its goal of free elections in 1989.

It also signalled the beginning of unrest in Central and Eastern Europe. By 1989 a wave of popular revolutions and uprisings was sweeping across Europe, encompassing Hungary, Poland, East Germany, Bulgaria, Czechoslovakia, Romania and later Yugoslovia and the Baltic States (Latvia, Estonia, Lithuania). Makeshift street graphics in the form of posters, flags, handbills and handheld signs accompanied many of the demonstrations and uprisings. They carried symbols to rally around, names scrawled in anger, calls to action and protest, or messages telling people where to meet.

In addition, artists created posters during this period – for revolutionary groups, new political parties, international competitions or simply as personal statements – that provided insight into the many-layered bitterness that extended far beyond the TV news reports received by the West. The new climate of

change, and the freedom to criticize, brought a variety of new poster messages. Disillusionment with the Communist Party and its officials was expressed in their portrayal as broken objects, red animals (muzzled or chased out of town), or other sinister metaphors. The ghost of Stalin's image persisted, with all Soviet leaders viewed as a manifestation of Stalin. Reminders of past struggles and sacrifices were prevalent, particularly in the light of Soviet attempts to rewrite the history of occupied countries, but also to show the current struggles as part of a continuum. (The posters surrounding Czechoslovakia's Velvet Revolution in 1989, for example, make constant reference to the

Soviet invasion of Prague in 1968.) There were also images tinged with uncertainty over the future, showing fear of Westernization, or fear of the return of repression: a resounding remark on the fragile stability of many of the 'new dawns'.

The uprisings of Central and Eastern Europe did not occur in isolation, and neither did their visual manifestations. Poster artists involved in creating oppositional graphics in their home country travelled to add their visual support to revolutions in other countries and to help document the events as they occurred. The rage against the Communist regimes was common to all, and proved to be a powerful force of solidarity.

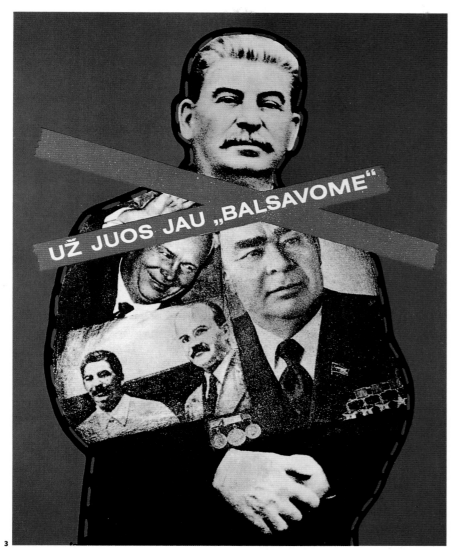

1 'Solidarity – Poland '80', logo and poster by Jerzy Janiszewski, Poland 1980.
2 Poster from the Solidarity headquarters in Cracow showing a variation on the Solidarity logo, 1989.
3 'We've already "voted" for them' by Jonas Varnas, Lithuania 1989. Independence poster commenting on Lithuania's loss of vote when it became a Soviet republic in 1940, with a collage of Soviet leaders (Stalin, Molotov, Khrushchev and Brezhnev).

4 'We know! We dare! We do!', poster triptych created by Péter Pócs in 1990 for the Kecskemet SZDSZ (Alliance of Free Democrats) to promote the election of the three pictured candidates to the Hungarian Parliament. The candidates strike a pose that is intentionally opposite to the classical three monkeys (hear nothing, see nothing, speak nothing). Instead they mime 'I hear, I see, I speak' to accompany the text of the title. In the foreground are symbols as they apply to each candidate: anti-Communism (a muzzled red dog), the withdrawal of Russian troops, and the right way forward to a new future.
5 'May Day – SZDSZ, 1989', poster designed by Krzysztof Ducki for the SZDSZ, Hungary 1989. The poster represents the compulsory Communist May Day celebrations as a fork with broken teeth.

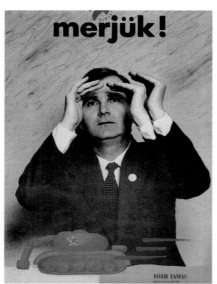

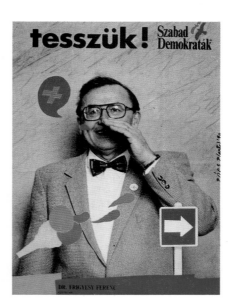

Images of solidarity and support.

1 Badge showing the symbol for the Civic Forum (OF: Obcanské Fórum), the movement for democracy in Czechoslovakia in 1989. Symbol designed by Pavel Stastny, Czechoslovakia.

2 'Civic Forum – Havel', poster by Rostislav Vanék, Czechoslovakia 1989.

3 'Civic Forum – Prague 1989', poster by S. Slavický and M. Cihlář, Czechoslovakia.

4 'Students 69-89', poster designed by Dusan Zdímal (Czechoslovakia) in 1989, in memory of students injured by armed police during the demonstrations of 1968 as well as the Velvet Revolution in 1989 in Czechoslovakia.

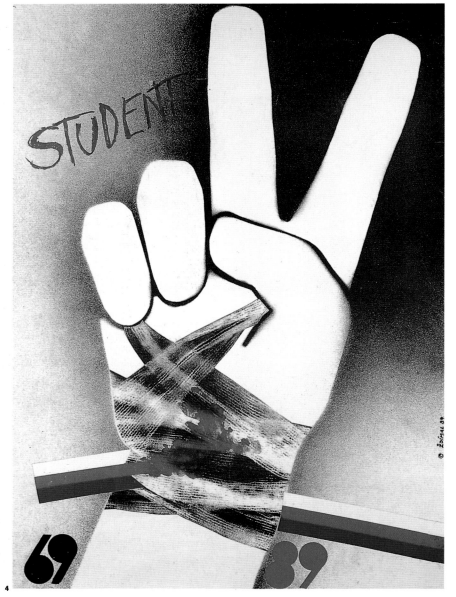

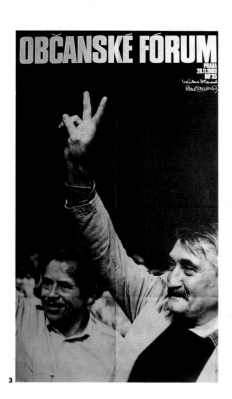

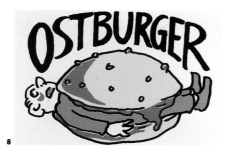

8

9

5

VÍTĚZNÝ ÚNOR 1948

6

7

5 'Prague '68', poster designed in 1989 by Krzysztof Ducki of Hungary (present in Prague when the Velvet Revolution occurred) which recalls the Warsaw Pact tanks of the 1968 invasion of Czechoslovakia.

6 'Victorious February 1948', poster designed in 1980 by Radomír Postl (Czechoslovakia), commemorating the date the Soviet Union established itself as an occupying force. The poster is a model of ambiguity; the powerful fist could be read as popular support for the red flag – or an overwhelming desire to overthrow it.

7 'Hero City', poster by Feliks Büttner, East Germany 1990, commemorating the Leipzig demonstrations of 1989 which were instrumental in the downfall of the East German State.

8 'Eastburger' by Thomas Gübig, East Germany 1989; a depiction of the fear of being eaten up by the capitalist West, as well as associated fears of inheriting its culture.

9 '1989-?', poster designed by Péter Pócs of Hungary in 1989 which represents the mass emigration of people from East Germany in 1989; the Communist emblem on the GDR flag has been cut out and replaced with a symbol for travel.

2

The graphics of Romania

1

Romania's regime, and its consequent revolution, was one of the most brutal. The despot Nicolae Ceausescu kept an iron grip on the population through fear, hunger and the victimization of ethnic minorities. Having isolated the country from Moscow's rule, Ceausescu drained its resources for his own end, leaving nothing for the people and depriving them of all but the most basic necessities.

The graphics generated by that country depicted two contrasting faces: the full-colour 'folksy' image for export (accompanied by the extravagant personality cult of the dictator), and the internal reality of a drab and miserable daily existence where survival was the most important task. Resistance or criticism was not tolerated, but the brave sometimes managed to scribble a few words of hate on a wall.

When the uprising finally took place there was much bloodshed and Ceausescu was executed. The revolutionary demonstrations displayed the Romanian flag with the old regime's emblem cut out of it: a suitably harsh and emotive image that became the symbol of the Popular Revolution, and appeared in graphic form for a long time after.

3

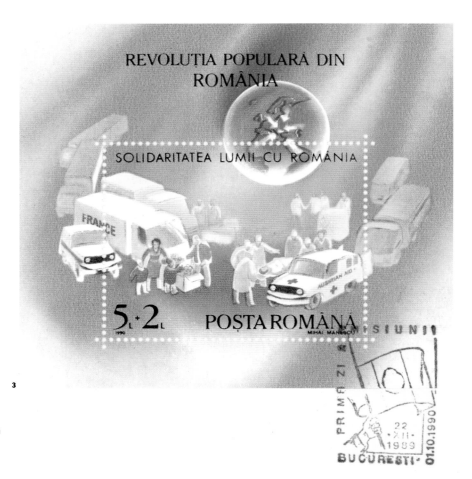

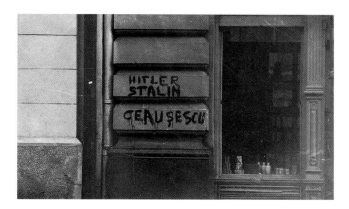

5

4

1 Front cover of magazine showing the face of Romania for export, 1975.
2 Inside cover of a Romanian travellers' guide; Ceausescu's portrait appeared at the beginning of all books.
3 Postage stamp from 1990 commemorating the 1989 Popular Revolution; the franking stamp shows the flag with a hole in the centre, where the old regime's emblem was cut out.
4 Anonymous poster-drawing of the dictator Nicolae Ceausescu, with added graffiti from an angry public, 1989.
5 Wall graffiti in Bucharest: 'Hitler Stalin Ceausescu', 'Liberty and Bread', 'Down with the Cobbler'. (Ceausescu was a cobbler before his rise to power.) Photographs by Sue Herron.

1, 2 & 3 Lapel button,
badge and coin,
USSR 1980s.
4 'The Victory of
October!', greetings
card, USSR 1986.
5 Desk calendar,
USSR 1987.
6 'More light, let the
party know...(Lenin)',
poster by Sachkov,
USSR 1988.

Soviet state graphics and the posters of perestroika

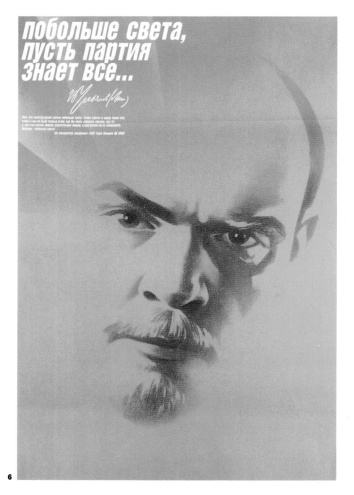

The Western view of the Russian 'evil empire', particularly during the 1960s, was heavily influenced by the visual display of the Soviet propaganda machine. Due to border restrictions and media censorship, the West could only capture a rare glimpse beyond the Iron Curtain – of military parades with red flags flying, of slogans, statues and portraits of Comrade Lenin adorning every building and boulevard, of official imagery of heroic peasants and workers, and the powerful USSR hammer and sickle emblem. These ingredients combined to create a picture of repression: a population locked in service to the state, where individuality and basic freedoms were denied.

There was in fact a great poster tradition to be upheld, stretching back to the powerful posters of the Bolshevik revolution. But avant-garde artistry had long since been suppressed by the Soviet Realism of Stalin. Without freedom of expression, the Russian poster had remained an ideological tool in the service of the state machine, carrying the cheerful stereotypes and bland slogans of 'official art'. Plakat, the Communist Party's official poster press, was the main producer of this official art and also held massive biennial poster competitions on approved subjects such as international peace.

When the policies of glasnost (openness) and perestroika (restructuring) were introduced in the mid-1980s, the Russian poster was one of the first art forms to embrace the new philosophies and act as a

mouthpiece for a society struggling to come to terms with new freedoms. Within a few years, the Russian 'posters of perestroika' were exhibited and published in book form in the West. They reflected the political changes taking place inside the USSR, as well as expressing the views of their creators; social criticism, and a call to build personal opinions and a sense of self, were prevalent.

In addition, many of the artists chose to create their posters as original works of art – not only because of the lack of photo-mechanical and other production facilities, but also due to an inherent suspicion of mass-produced or published posters (still associated with the official art of the past). Such limitations, or the confusion of some of the poster messages, only added to the potency of an art form struggling to find a new footing amid massive societal changes. A new era had begun for the Russian poster as an instrument of the people once again.

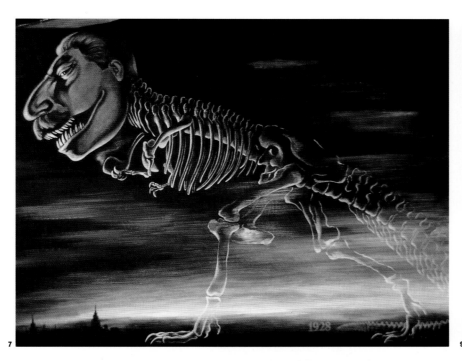

7

9

ЗАБВЕНИЕ ПРОШЛОГО ГРОЗИТ ЕГО ПОВТОРЕНИЕМ!

8

ЧТОБЫ СЛОНА НЕ ДЕЛАТЬ ИЗ МУХИ,
ГЛАСНОСТЬ НУЖНА,
А НЕ СПЛЕТНИ И СЛУХИ.

10

7 Poster designed by A. Kazhburskii, suggesting that Stalin's ghost still stalks Russia, 1989-90.
8 'Soviet Literature', poster by Kvadrat design firm in Moscow, 1989-90, a comment on the USSR's censorship and banning of books.
9 'To forget the past risks repeating it', poster by Alexander Faldin, Russia 1987, showing Brezhnev's dress uniform (Brezhnev awarded himself many medals of heroism in the 1970s).
10 'Don't make a mountain out of a molehill. We need glasnost and not gossip and rumours.' From the Russian saying 'Don't make an elephant out of a fly' – a man is shown buzzing and gossiping into an ear; poster by Zhmurenkov, USSR 1988.

Gorbachev: the fallen idol

1

The rise and fall of Mikhail Gorbachev occurred roughly within a six-year period. Elevated to Party Chairman in 1985, he set the USSR on the road to a free market economy – a move which began the fast but inevitable decline of the Soviet empire. His economic reforms took their toll, and incurred the wrath of the Russian people. By 1991 he had lost his position of leadership; the Communist Party was banned; and by 1992 the USSR itself had ceased to exist.

But at the height of glasnost and perestroika, Gorbachev was hailed as the man who brought the USSR out of the dark ages. He became an international celebrity and a media star, which led to the inevitable merchandising of his image. 'Gorbi-mania' had struck, as had a realization that on the slow road to change, the East would acquire some distinctly Western features such as fast food, and the desire to 'make a quick buck'. By the time Lenin's statues were falling to the ground, the symbols of state socialism had begun to appear on everything from fashions to board games, and its relics were being sold to the highest bidder.

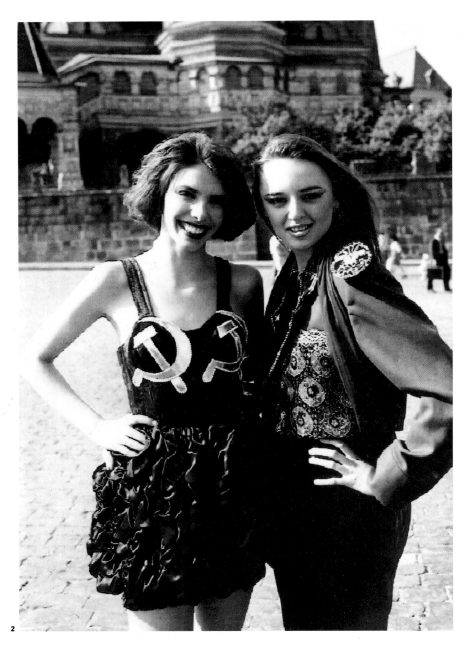

2

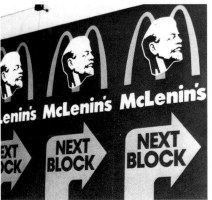

3

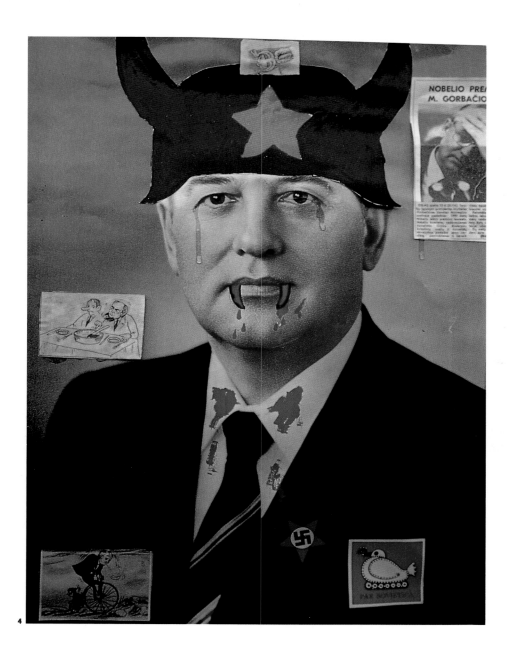

1 'I Love Gorby', t-shirt
by British fashion
designer Katharine
Hamnett, 1989.
2 An irreverent new use
for the hammer and
sickle: fashion models
posing in Red Square,
1992.
3 'McLenin's' poster,
part of an exhibition of
Soviet dissident art on
show in the Lenin
Museum in Red Square,
Moscow 1992.
4 A poster of Gorbachev
disfigured during the
August coup that
marked his downfall.
Moscow 1991;
photograph by Abbas,
Magnum.
5 Front cover of Central
Committee report (free
handbook available to
all), Moscow 1986.

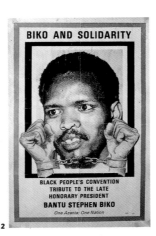

BIKO AND SOLIDARITY

BLACK PEOPLE'S CONVENTION
TRIBUTE TO THE LATE
HONORARY PRESIDENT
BANTU STEPHEN BIKO
One Azania: One Nation

2

1 Albertina Sisulu, one
of three joint presidents
of the United
Democratic Front and
one of 16 UDF leaders
charged for treason in
1985. South African
women have been a
powerful force in the
mass struggle against
apartheid.
2 Poster tribute to Black
Consciousness leader
Steve Biko who died in
detention, 1977.

3 Poster portrait of
Nelson Mandela while
he was still in prison,
painted from the
descriptions of his
visitors (publishing the
photograph of a prisoner
was illegal). Offset litho;
produced by the
Congress of South
African Trade Unions
(COSATU), Johannesburg
1989.

Apartheid: the graphics of resistance

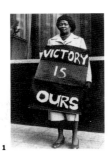

1

The tide of African nationalism that swept
through the 1960s created many new
independent states. It continued to bring
change and turmoil throughout the 1970s
as the new states struggled to stabilize
themselves and assert their own identity.
Within this scenario the foundations of black
resistance against the South African system of
apartheid were laid: through Steve Biko and
the Black Consciousness movement, the
imprisoned Nelson Mandela, and many
examples of protest and sacrifice that
generated worldwide support and sympathy.

The 1980s therefore became the decade
of mass organization, and graphics played a
direct role in the course of events. Resistance
posters (as well as t-shirts, banners, badges
and other ready-made graphics) became a
vital part of the popular struggle. They
publicized meetings, promoted support for
organizations and consciousness groups,
memorialized events or crises and, most
importantly, visualized the outrage and
determination of the people. Resistance
posters were produced throughout the 1980s,
by silkscreen workshops, collectives and
activists – often in secret and despite the
threat of detention, beatings, or even death.
They provided the visual bonding and solidarity
that carried the democratic popular
movement to its peak with the Defiance
Campaign of 1989, and achieved the
beginning of the dismantling of apartheid with
the unbanning of the ANC and the release of
Nelson Mandela in 1990.

3

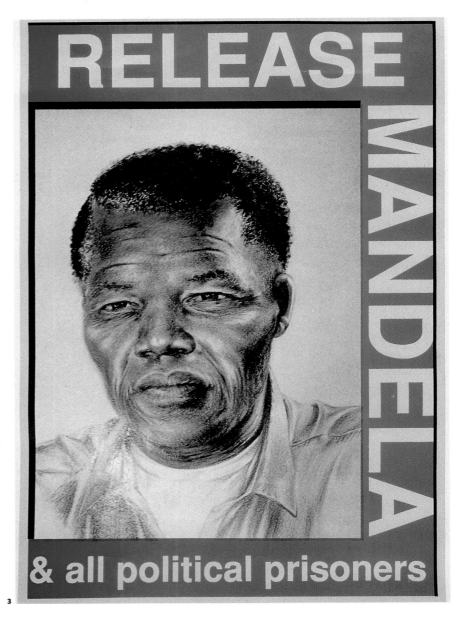

RELEASE MANDELA
& all political prisoners

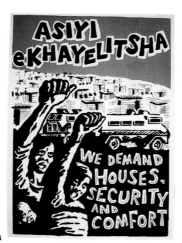

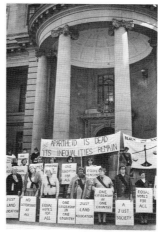

5

6

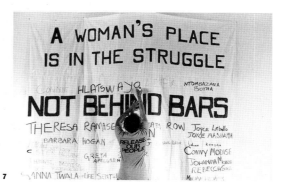

4 Poster commemorating the tenth anniversary of Soweto Day (16 June) when students made a stand against Bantu education and the apartheid system. Offset litho; produced for the UDF, Transvaal 1986.

5 'We are not going to Khayelitsha' (slogan of resistance used when the state forced people in Cape Town's black areas to leave their homes), silkscreened poster, Cape Town 1986.

6 A demonstration in 1991 on the steps of Johannesburg city hall by the members of the Black Sash, a women's organization devoted to the protection of human rights and parliamentary democracy since it was founded in 1955. The organization's name dates from early years, when members draped black sashes over their right shoulders to mourn the 'killing' (violation) of the constitution by Nationalists. Photograph by Gill de Vlieg.

7 Friends write the names of prisoners and detainees on a solidarity banner dedicated to women in the struggle against apartheid, at the last meeting of the DPSC (Detainees' Parents Support Committee) before it was banned in February 1988. Photograph by Eric Miller.

4

7

The graphics of reconstruction: the Maviyane Project in Zimbabwe

As in many African states, the move towards independence brought war to Zimbabwe (formerly Rhodesia) followed by a period of reconstruction. An example of the use of graphic design as a tool for social development is shown here in the work of the Maviyane Project in Harare.

At the end of the guerrilla war for independence in 1980, Zimbabwe embarked on the building of a new socialist state. The Maviyane Project, founded by graphic designer Chaz Maviyane-Davies in Harare, involved itself in many aspects of this reconstruction process. Consisting of a small team of designers and a photographer, they challenged the existing Western visual culture (produced by white-dominated advertising agencies) which they felt patronized the black community not only in the handling of images of black people, but in the attitudes and strategies employed to sell them products.

The Maviyane Project consequently aimed to create a new graphic language that would not only serve the communication needs of a new modernized society, but which would also be relevant to the black community,

respecting the strong indigenous visual culture present mainly in their traditional arts and crafts. The Project also addressed a wide range of issues accompanying social development, designing wallcharts that encouraged the preservation of indigenous culture and its artefacts, printed matter on contraception and health issues, and literacy materials and aids used to teach the history of the people's struggle.

Their cover designs for *Moto*, a current affairs magazine banned during the colonial period, depicted many of the social concerns of the time at both national and local level. These included the widening divisions between rich and poor, the existence of capital punishment (carried over from the previous white regime), election results, and the ever-present struggle against apartheid. Solidarity with the struggles of other African countries was a continuing theme in their work, stemming from a philosophy of determination and 'shared destinies', and was particularly important to the Frontline States (including Zimbabwe) battling against apartheid and South African aggression.

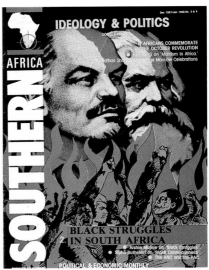

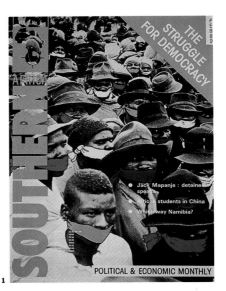

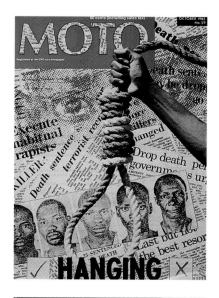

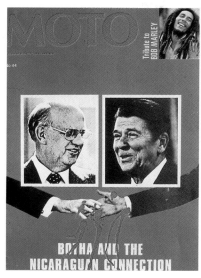

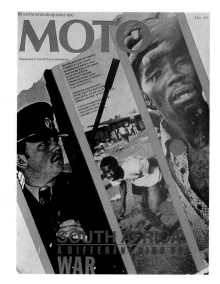

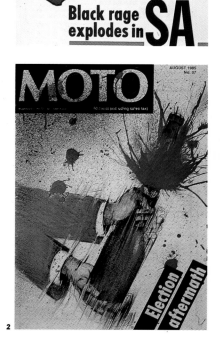

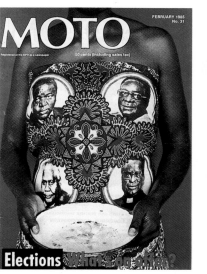

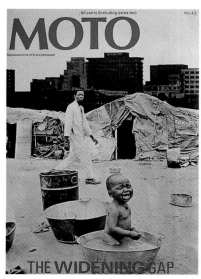

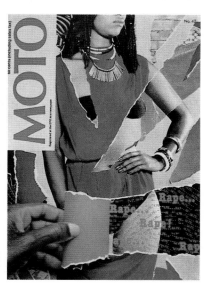

1 Covers of *Southern Africa*, a monthly political magazine aimed at an academic audience; design by Chaz Maviyane-Davies, illustrations by Fiona Paterson, Zimbabwe 1987-9.

2 *Moto* magazine covers, created in 1985-6 by the Maviyane project based in Harare, Zimbabwe (Chaz Maviyane-Davies, Ruhi Hamid and Navin Nagar; with photographer Alex Joe and others). 'Moto' means 'fire' in Shona, one of two major Zimbabwean languages, and was a monthly magazine covering political issues affecting the country at a fundamental level.

3

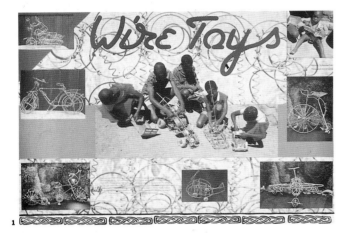

1

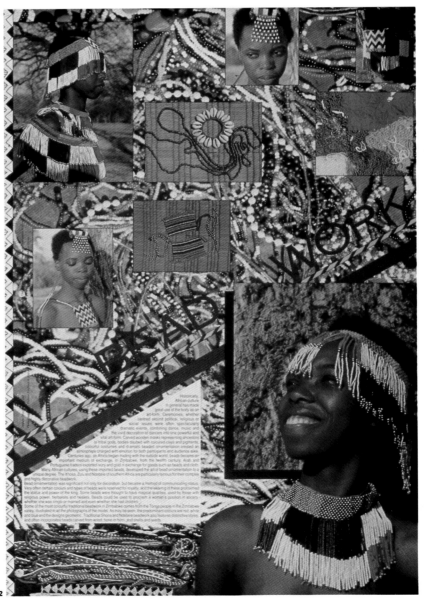

2

The Maviyane project addressed a wide range of social development issues after Zimbabwean independence in 1980.
1 & 2 A series of educational broadsheets aimed at reviving (and preserving) Zimbabwe's indigenous art and craft culture, such as the making of wire toys and beadwork; designed by Ruhi Hamid, 1985.
3 Poster protesting against misinformation by the press (and an analogy for a new country struggling to keep its footing); design

by Chaz Maviyane-Davies, photograph by Alex Joe, Zimbabwe 1984. The poster carries a quotation from Pablo Neruda: 'How is the blind man supposed to live when the bees are constantly bothering him?'. As a result of his critical comment the designer was black listed by the media for five years.
4 Front cover from *Another Battle Begun*, a book on the co-operative movement in Zimbabwe; designed by Ruhi Hamid, photography by Bruce Paton, 1985.

5 A series of posters designed by Ruhi Hamid (showing photographs from *Another Battle Begun*) that were used to teach reading skills and the history of the co-operative movement. Each poster concentrates on a reconstruction issue. Shown here are No. 6, Education; No. 7, Industry and Work; No. 10, Agriculture.
6 Pages from a 1988 Solidarity Calendar in support of displaced Mozambiquens; designed by Chaz Maviyane-Davies with various photographers.

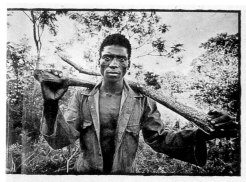

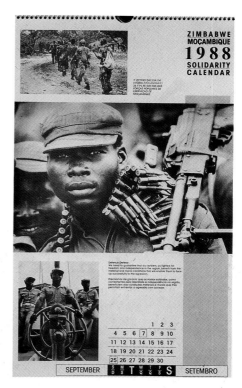

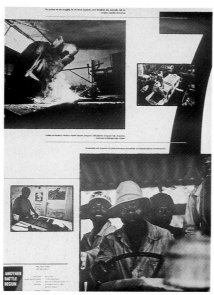

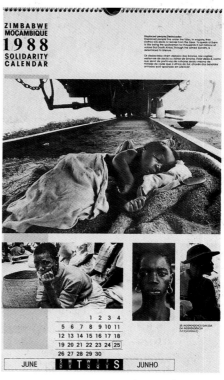

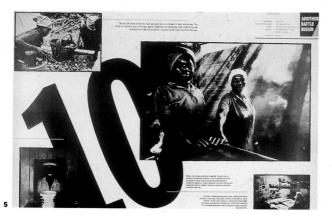

Palestine and Israel

The creation of the state of Israel in 1948 has been followed by four decades of Arab-Israeli border disputes (at times escalating into full-blown war) and terrorist tactics by Palestinians. The on-going turmoil, fed by various instances of international intervention and aid, has made the Middle East a focal point of international tension since the 1960s.

There have been many and varied graphic statements related to the conflict over the years. During the 1960s and 1970s, posters commemorating the struggle for Israeli independence were optimistic and uplifting; the Palestine liberation movement's appeals for revolution and resistance were much rougher in their execution.

Since then anti-war statements and calls for reconciliation have emanated from the artistic communities on both sides, showing widespread distress and fatigue after so many decades of fighting, and the use of graphic symbolism has produced eloquent pleas for a future of peaceful co-existence. But it is the humanitarian messages that directly confront pain and suffering that strike hardest, as illustrated by the posters of Tel Aviv designer David Tartakover (see also page 35).

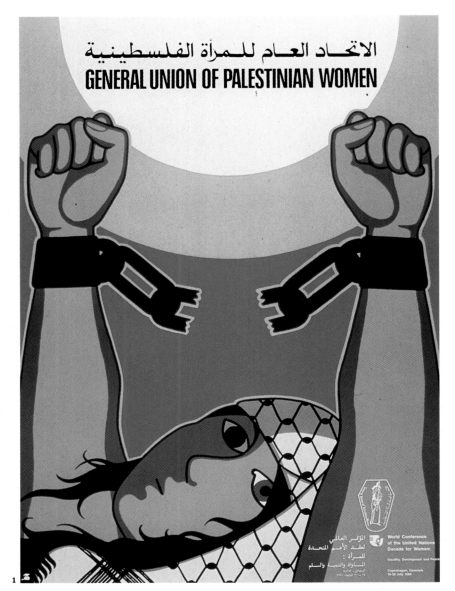

1

4

5

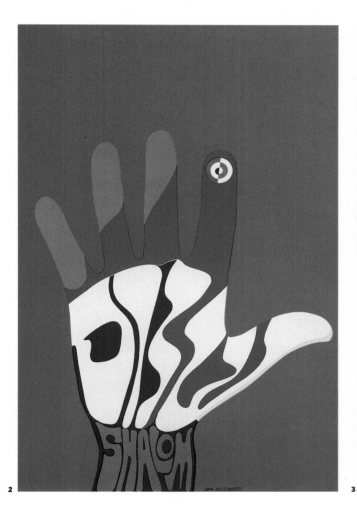

2

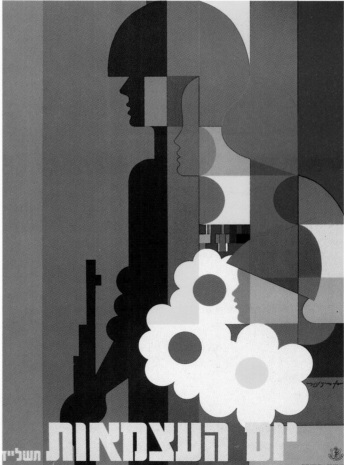

3

1 Poster for the General
Union of Palestinian
Women, by Palestinian
artist Jihad Mansour.
Designed for the World
Conference of the
United Nations Decade
for Women, 1980.
2 'Shalom' (Peace),
poster by Dan Reisinger,
Israel 1965.
3 'Independence Day',
poster designed in 1974
by Dan Reisinger for
Israel's 26th
anniversary.
4 & 5 Anti-war posters
by Israeli designer David
Tartakover make a
humanitarian plea.
Left: 'Mother', showing
an Israeli soldier
walking past a
Palestinian woman – a
comment on the duality
of soldiers and mothers
as sons and mothers,
regardless of
nationality, allegiance
or cause. Photograph by
Jim Hollander/ Reuters,
Israel 1988. Right:
'Happy New Year',
showing a cola bottle
as a molotov cocktail.
Photograph by Oded
Klein, Israel 1987.

China's Cultural Revolution and the Pro-Democracy movement

1

The image of Mao Tse-tung was the central unifying feature of one of the world's most extensive national campaigns: the propaganda of China's Cultural Revolution (1966-76). The Revolution aimed to turn a vast, unstable population into a unified workforce, and at the same time establish a national culture.

In keeping with the spirit of collectivism, all artistic activity was created, produced and assessed by groups; individualism was discouraged, i.e. eliminated. Style and content were rigidly set, and Socialist Realism, borrowed from the USSR, was pushed to a further extreme of hyper-realism and utopian vision. Heroic stereotypes dominated, with endless representations of enthusiastic masses and the arm-in-arm comraderie of workers, peasants and soldiers. Heroic individuals dedicated to socialist ideals and glorified for deeds of merit were depicted as inspirational role-models, as of course was the all-knowing hero-figure of Mao with his Little Red Book.

The overall rigidity produced extremely banal imagery. The most impressive aspect was the manner in which revolutionary zeal was transferred through this vast media campaign. Demonstrations and banners filled Tiananmen Square in Beijing. Stereotyped imagery appeared everywhere: on outdoor billboards and posters; in books, magazines, newspapers, flyers; on lapel buttons and other ephemera; on household objects and

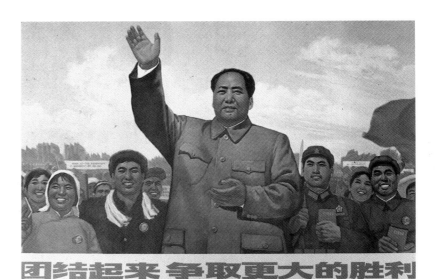

团结起来 争取更大的胜利

2

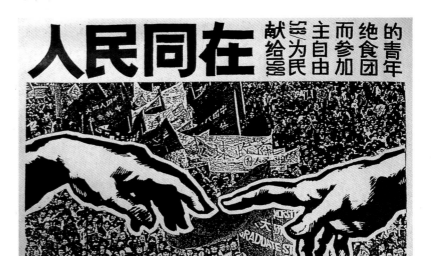

3

domestic products. Revolutionary image-saturation was total, and completely devoted to educating the masses on how to think and behave, and to the destruction of all 'counter-revolutionary' bourgeois elements.

In May 1989, over a decade after the Cultural Revolution ended, Beijing's Tiananmen Square was the site of demonstrations for the Pro-Democracy movement, where students, workers and intellectuals demanded a greater hand in the government and the end of corruption. It was a highly visual demonstration that reached out to the world through broadcast media and technology, and the world sat stunned at the massacre that followed – a grim reminder that in spite of popular protest, some regimes remain impervious to change.

1 Badges paying homage to Chairman Mao, and declaring the people's gratitude.
2 'Unite and Win a Greater Victory', an image of Mao from the Cultural Revolution period in China, 1971.
3 'The People Are With You', Pro-Democracy poster, May 1989, Central Academy of Fine Art, Beijing.
4 Large demonstration banners painted by students of the Central Academy of Fine Art, Beijing, for use in the Tiananmen Square protest of May 1989.
5 Painting the demonstration banners. Photo: Fei Da-wei.
6 'Give Me Back Human Rights', Pro-Democracy poster May 1989, Central Academy of Fine Art, Beijing.
7 '1989 June 4', an image of China's national emblem defaced, created in protest against the massacre in Tiananmen Square. (The large red star represents the Communist Party, and the four small stars denote the people.)

VICTORY 1945

Japan: the spirit of revolution and internationalism

In the 1960s Japan joined the world in anti-Vietnam War protests and campus unrest. Strikes and riots took place in the universities as a new generation rebelled against the conservative elders and their institutions. This spirit of revolt was represented in a post-war generation of designers – including art director Eiko Ishioka, poster artist Tadanori Yokoo and fashion designer Issey Miyake – who travelled the world for new influences. They broke taboos, and rejected clichéd images of Japanese culture, or existing attempts to merge Western Bauhaus or Swiss design philosophy with a traditional Japanese approach, and in so doing created a new image for contemporary Japan.

Tadanori Yokoo became one of the leading print and poster designers during the 1960s and 1970s; his surrealistic posters were as recognizable as the psychedelia of the USA. Shigeo Fukuda, whose posters also became world renowned in the 1960s, transcended the mould by creating his own unconventional form of design using visual puns, illusions and sculptural 3-D tricks.

An important event that furthered the use of graphic design to address global issues occurred in the early 1980s, when the Japan Graphic Designers Association launched its poster series 'Hiroshima Appeals' (see pages 98-99). It was accompanied by an annual exhibition of posters on peace which has continued ever since, expanding its message in the 1990s to include another crucial survival issue: the environment.

2

1 'Victory 1945', poster by Shigeo Fukuda, whose work makes powerful use of visual puns and illusions, Japan 1975.
2 Poster by Shigeo Fukuda for the 1992 Peace and Environment Poster Exhibition entitled 'I'm Here', held by the Japan Graphic Designers Association (JAGDA).

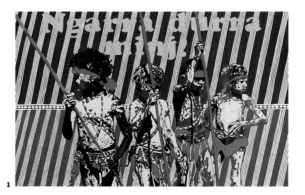

1 'We are still strong', poster by Chips Mackinolty, 1987. 'We are still strong', a modern-day rallying cry of Aboriginal people, appears on this poster in the Rembarrnga language of Central Arnhem Land, emphasizing the struggle for the continuation of Aboriginal tribal culture.

2 'Citizenship', poster by Aboriginal artist and writer Sally Morgan, 1987 – one of many unofficial art projects created for the Australian Bicentennial. (It was not until the referendum of 1967 that Aboriginals were conferred full citizenship rights.)

Australia's graphic arts workshops

Australia was also caught up in the wave of change in the 1960s that brought a broad questioning of establishment values, anti-Vietnam War activities, new liberation movements, and awareness and activism on the part of oppressed minorities.

One of the products of the new age was the start in the early 1970s of a modern tradition of posterwork and community art produced by graphic arts workshops using low-tech, low-cost screenprinting. They were dedicated to creating a socially-committed community art and expressing the politics of the Left, in addition to focussing on Australia's cultural diversity and the needs of the Aboriginal community.

The most influential workshop in the 1970s was the Earthworks Poster Collective established by Colin Little in 1972 and based at the University of Sydney Art Workshop, better known as the Tin Sheds. Initially under the heavy influence of psychedelic graphics, the workshop gradually became more politicized as the decade moved on. When it disbanded in 1979 its members spread throughout Australia to help form the next generation of workshops in the 1980s. The new generation included Redletter Community Workshop and Another Planet Posters (now combined to form Red Planet), Redback Graphix and many others. This new breed called upon elements of modern urban culture

such as the graphic style of Punk and modern music, advertising, mass media and technology as well as the symbolism and signs of Aboriginal culture.

The Australian Bicentennial of 1988 placed a sharp focus on Australia's contemporary cultural divisions, eliciting a grassroots movement that called for historical reassessment (as opposed to national celebration) in the light of the mistreatment of Aboriginal people. Many of the issues were eloquently expressed in unofficial art projects, exhibitions and poster-making. The call for an end to the oppression of the Aboriginal people continues to be a major theme for the graphic workshops and their oppositional art.

2
In 1944 Aborigines were allowed to become "Australian Citizens." Aboriginal people called their citizenship papers "Dog Tags." We had to be licensed to be called Australian.

3

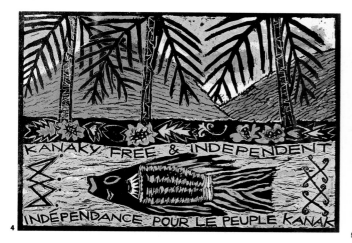

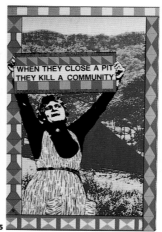

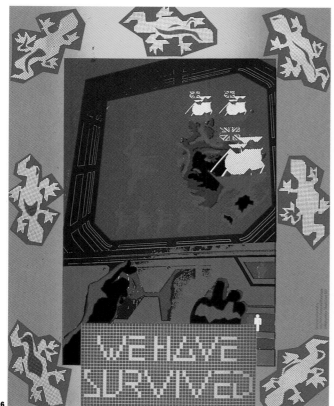

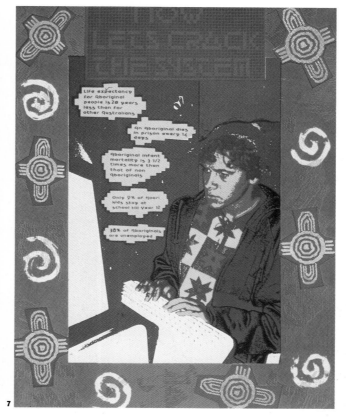

3 'History', poster by Pam Debenham, 1987, a fabric-like collage of past and present.
4 'Kanaky Free and Independent', poster by Dianne Wells of Red Planet arts workshop in support of the indigenous people of New Caledonia, 1988.
5 'KCC Women's Auxiliary', poster by Redback Graphix (designer and printer: Alison Alder) for KCC Women's Auxiliary, Wollongong 1984.
6 & 7 A collaborative project between an Aboriginal and non-Aboriginal artist: 'We have survived' and 'Now let's crack the system', two posters by Alice Hinton-Bateup (Aboriginal Program artist) and Marla Guppy (artist in residence) at Garage Graphix community arts group, 1987. The group is based in Western Sydney, where Aboriginal interests have long been neglected, and where survival means fighting back with information and education as well as being armed with new technology.

Posters of the Cuban Revolution

Propaganda posters played a central role in the Cuban Revolution and its attempts to build a new society following Fidel Castro's takeover in 1959. As revolutionary tools, these posters were charged with the mission of communicating socialist ideology to the Cuban population. But unlike the cultural revolutions of the USSR and China, there was no attempt to stifle artistic expression and individual style in favour of repetition and dull stereotypes; art was seen as an aid to the Revolution.

The subjects were familiar: worker solidarity, cultural identity (especially in celebration of a world-renowned film industry), social development (education, literacy, health care), agricultural self-sufficiency and the emulation of heroes, most notably the charismatic guerrilla fighter Che Guevara. But the graphic influences reflected developments in film, fine art and graphic art in Europe and beyond. Hence the Cuban posters eloquently communicated the revolutionary spirit and colourful passion of their society, and did so with a boldness and economy that has been admired by generations since.

As internationalism was central to the Cuban Revolution's philosophy, posters were also used to promote the international (Third World) revolution. The propaganda agency OSPAAAL (The Organization of Solidarity with Asia, Africa and Latin America) distributed posters worldwide, providing a communication network of information and solidarity.

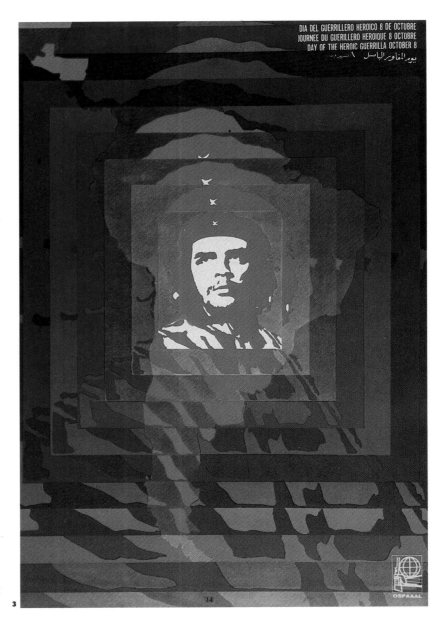

1 Cuban posters became symbols of revolution around the world; this Cuban poster was reprinted by the Chicago Women's Graphics Collective, USA, in 1972-3.
2 'El Salvador, Against Imperialist Intervention!', poster by the international propaganda agency OSPAAAL, Cuba *c.*1981.

3 'Day of the Heroic Guerrilla October 8', poster published by OSPAAAL, Cuba.
4 'Literacy, converting the darkness into light', poster produced by the Nicaraguan Ministry of Education in 1980, as part of the Sandinista government's national literacy campaign.
5 'Second Continental Congress for Study

and Plenary Assembly, Against the Arms Race and Imperialist Domination in Central America and the Caribbean'. Poster produced by the Christian Conference for Peace in Latin America and the Caribbean, and the Christian Movement for Peace, Independence and

Progress for the People; Nicaragua 1982.
6 'No intervention in Central America; victorious Nicaragua will neither sell out, nor surrender'. Poster produced by CEPA, the Agrarian Education and Promotion Centre which created peasant organizations to engage in political action, Nicaragua *c.*1985.

Nicaragua's Sandinista posters

Posters were also employed for political education and consciousness-raising by the Sandinista Revolution in Nicaragua. After the overthrow of the Somoza dictatorship of 1979, over fifty per cent of the population could neither read nor write. As in Cuba, posters were integral to the Sandinista government's struggle for literacy, health care and agrarian reform, and were used to strengthen cultural identity and commemorate heroes from the Revolution.

They also encouraged people to mobilize and defend themselves against the US-backed Contras aiming to destabilize the country. In addition, they often carried a broader call for solidarity with other Central American countries and for resistance to American intervention in Central America, as experienced in El Salvador in 1982, or the West Indian island of Grenada in 1985.

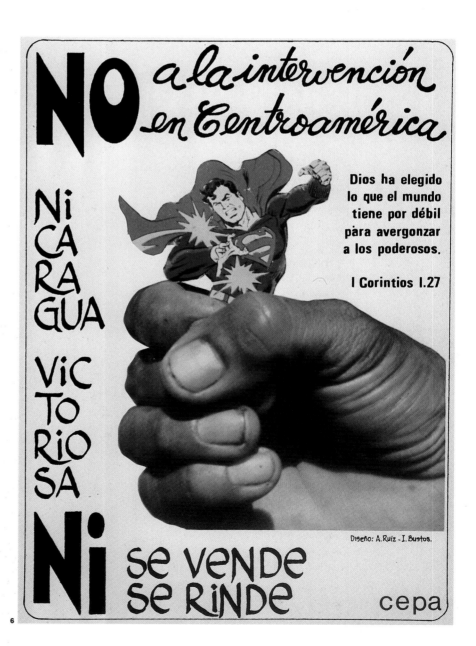

1

Chapter two

STILL LIFE

2

Global issues
Struggles for power, struggles for peace

The past three decades have been characterized by divisions and contrasts: the accompaniments to a shifting world map. We have witnessed the rise and fall of the Iron Curtain, symbol of the Cold War and of the ideological divisions between Eastern socialism and Western capitalism. Its chief manifestation, the Berlin Wall, has come and gone; East and West Germany have been reunited. The Soviet Union itself has moved from superpower to disintegration, and the collapse of the Communist empire has left in its wake a flood of weak economies, unstable governments and ethnic rivalry. As a result, the political and geographical map of Eastern Europe is now in a state of flux.

There has also been the overriding division of developed and underdeveloped. In the 1950s and 1960s the 'world order' consisted of two main superpowers and their associated blocs of countries, struggling against each other, while de-colonization took place in Africa, Southeast Asia and elsewhere. Many of the new states paid dearly for their independence with further internal conflicts, ethnic tensions or even war; few have managed to fulfill their hope of sharing the world's power and wealth. Now in the 1990s a new world order is envisaged, but it is an unstable and constantly changing one.

The underlying theme of power thus continues, and this chapter looks at the graphics generated by power struggles that have acquired an international perspective. It is therefore not concerned with specific wars, but rather with the general issues of war vs. peace, big vs. small, strong vs. weak, rich vs. poor, white vs. black, developed West vs. Third World. The chapter reflects the continuing instabilities and injustices presented by old scourges (such as multinational exploitation and racist policies) and new ones such as the global epidemic of AIDS.

This chapter also focusses on the ability of graphic art and design to communicate worldwide, transcending political and cultural boundaries through emotive and evocative imagery, and the faith that creative artists themselves often have in the ability of their art to make a difference in the way that people think.

The peace movement
After four decades of the nuclear arms race and strained relations between East and West, a new era of peacemaking and openness began in the 1980s with the Soviet policies of glasnost and perestroika, and the disarmament treaties struck between Reagan and

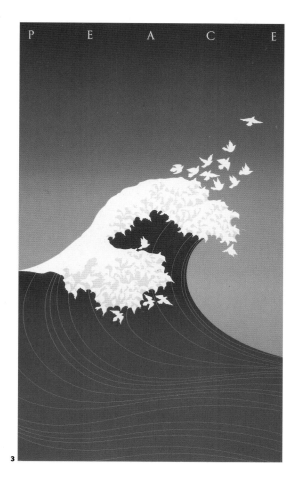

3

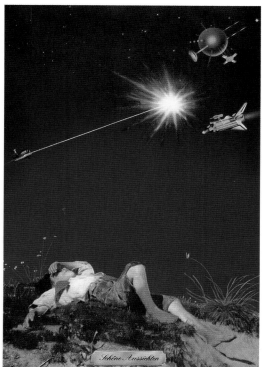

4

Gorbachev. But the subsequent euphoria didn't last long. Since then the Gulf War and the civil war in former Yugoslavia have served to remind us that after decades of a flourishing world arms trade, it is impossible effectively to gauge where military power lies, or what will be done with it. Peace can be broken at any time, from any direction.

The wish for world peace is consequently as fragile and pertinent as ever, and it remains an enduring theme for artists and designers everywhere. One of the most inspiring graphic design demonstrations for peace was the Hiroshima Appeals poster series, created from 1983 to 1990 and organized by the Japan Graphic Designers Association (JAGDA). Each year on behalf of the citizens of Hiroshima an appeal was made to the world – to remember the lesson of Hiroshima and to work for the survival of mankind – through the creation of an annual peace poster designed by a prominent Japanese graphic designer. The poster was distributed worldwide and exhibited in and around Hiroshima on the anniversary of the bombing of 6 August 1945. The series was launched in 1983 with Yusaku Kamekura's eloquent depiction of burning butterflies (page 98). Other JAGDA members added their own statements, printed at their own expense – marking the birth of an annual voluntary peace poster exhibition. (The annual exhibition still exists but has now been expanded to encompass a broader view of survival, including peace and the environment.)

There were other equally important offshoots. As a form of response and goodwill and to commemorate the fortieth anniversary of the Hiroshima bombing, a corresponding peace project was undertaken in 1985 in America by renowned designer and educator Charles Helmken, who died in 1989. (Helmken was also founder and head of the Shoshin Society, a group devoted to the exchange of design ideas between the US, Japan and Korea.) Seeing the potential for a worldwide campaign, Helmken organized the creation of a selection of original peace posters by America's best graphic designers, in co-operation with JAGDA. Under the collection title of 'Images for Survival', simultaneous exhibitions were staged in Hiroshima, Washington and New York. Helmken's project was not only a memorial to peace and a tribute to Japanese culture, it was also dedicated to the idea that graphic design can have an impact and 'make a difference'. (Driven by his belief in the efficacy of design, Helmken created a second project on AIDS posters under the title 'Images for Survival II' in 1989. (Both projects were published in book form by the Shoshin Society.)

Another significant visual contribution to the peace effort can be found in the graphics surrounding Britain's Campaign for Nuclear Disarmament (CND), founded in 1958 in protest against the nuclear bomb testing of that decade. The CND symbol – the circular peace sign, also adopted by the hippie movement in the 1960s – quickly became an international sign for peace. CND demonstrations in themselves achieved an international profile during the 1960s, and rose again in double strength in the early 1980s to protest against the housing of American Cruise missiles in Britain. This second wave was equipped with a highly visible profile provided by the skilful photomontages of

The international peace movement of the 1980s conveyed a powerful message in new and unusual ways.
1 'Impending Image', poster and postcard by Christer Themptander, Sweden 1984.
2 'Still Life', anti-war poster by David Tartakover, Israel 1989.
3 'Wave of Peace', poster created by McRay Magleby to mark the 40th anniversary of the bombing of Hiroshima. (The poster formed part of Charles Helmken's Images for Survival project.)
4 'Beautiful Prospects', postcard by Klaus Staeck recalling Ronald Reagan's Star Wars defence project earlier in the decade, West Germany 1987.

Peter Kennard, whose work was so prolific and popular at the time that he was labelled Britain's 'unofficial war artist' by the media.

Although global nuclear war and militarism are not in themselves a laughing matter, as products of human folly they offer a grand subject here for satirical comment. These include Christer Themptander's tendency to collage missiles in all the wrong (or rather, right) places, and Ronald Reagan playing Rhett Butler to Margaret Thatcher's Scarlett O'Hara while the world explodes in the background (pages 100-101). Humour provides a well-known release for anger and frustration, and has the invaluable asset of communicating across cultures. But it fulfills yet another role here, offering a lively variation on what are inevitably well-worn graphic clichés.

Peace posters and other anti-war graphics are constantly in danger of becoming redundant and ineffective through the use of tired symbols such as peace signs, missiles, gas masks, tearful children or wilting flowers. The variety of imagery included here demonstrates that in the 1980s and 1990s there has been a strong desire to avoid the old clichés – or at least to revitalize them. To this end, missiles are shown being shot down with sling-shots, painted into the English countryside or presented with heavy phallic associations – and then chopped in half. Women and children do not stare out at the viewer with tearful eyes. They are shown dancing in rings around peace camps, or making sarcastic remarks about financing military might with bakesales. The stiff, chubby, symbolic 'peace dove' so often depicted in the 1950s and 1960s makes only one brief, fluttering appearance on page 99 – and doesn't survive the trip. It is blasted by some unseen weapon or force, casting doubt over a future of peace in a dramatic gesture that warns society to come to its senses.

In today's modern graphic environment – where war and violence are often romanticized – the urgent call for peace provides artists and designers with one of their greatest challenges. Moreover the call is dependent on a constant turnover of fresh ways of approaching the subject, as an important means of counteracting the equally constant militaristic programming of the dominant cultural milieu.

Solidarity movements

Due to advances in modern communication media, our contact with the rest of the world has increased dramatically since the 1960s: it is possible to read and hear about hostages, political prisoners, injustices and discrimination around the world, or to see revolutions, civil wars, famine and drought. In the age of on-the-spot news coverage, solidarity projects have become an important means of connecting with – or supporting – the struggles of other peoples and countries.

Solidarity projects utilizing graphics have two major roles to play. They may offer general support for an issue, as in the posters supporting African nationalism and independence in the 1960s and 1970s. Or they may perform a more instrumental role, focussing attention on particular injustices such as the apartheid system in South Africa, disappearances and torture in South American countries, or hostages in the Middle East, and spurring people to take action that will apply pressure to the government or group at fault. Solidarity graphics are a particularly important tool for any situation where protest or resistance within the country itself is not tolerated.

In the global 'one world' spirit of the 1980s and 1990s graphic artists and designers have become increasingly involved in consciousness-raising projects and competitions, working in the belief

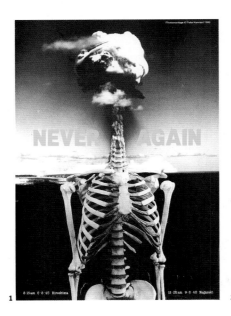

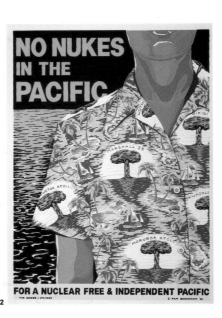

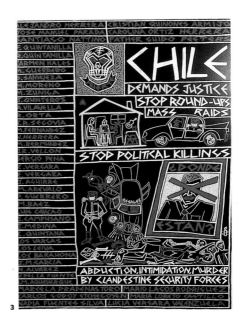

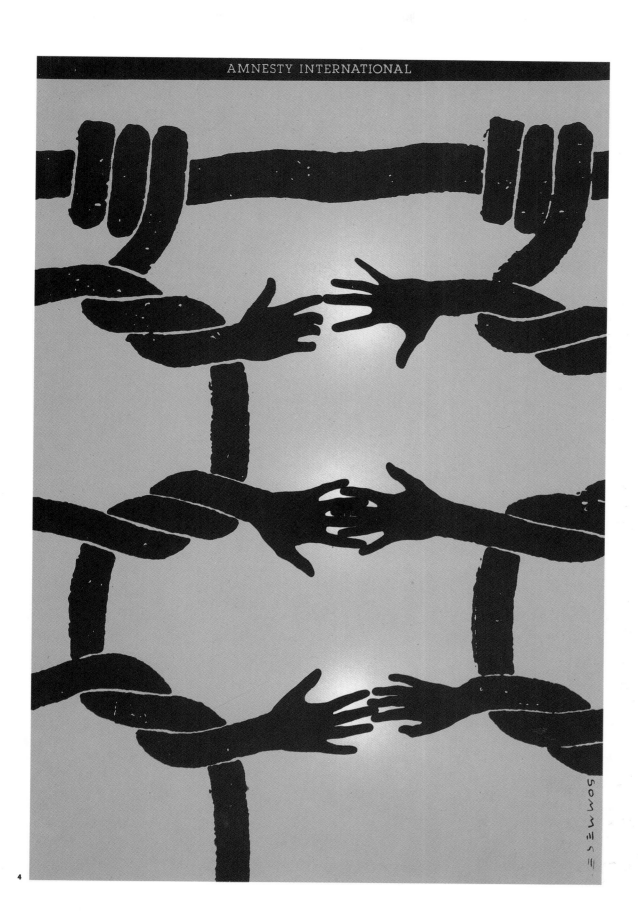

AMNESTY INTERNATIONAL

1 'Never Again',
photomontage poster
by Peter Kennard, one
of many anti-nuclear
posters he created
for the Greater London
Council, 1983.
2 Poster by Pam
Debenham on the theme
of no nuclear testing
in the Pacific Islands;
Australia 1984. It was
inspired by a 1950s
Hawaiian shirt depicting
a bomb blast, produced
to commemorate the
first Bikini Atoll tests.
In Debenham's shirt,
Pacific resorts are
replaced by the names
of nuclear test sites.
3 'Chile', poster
protesting against
political killings,
by Redback Graphix
(design: Michael
Callaghan; printers:
Alison Alder, Osmond
Kantilla) for Amnesty
International,
Australia 1987.
4 Human rights poster
for Amnesty
International by
Lanny Sommese,
USA 1980s.

4

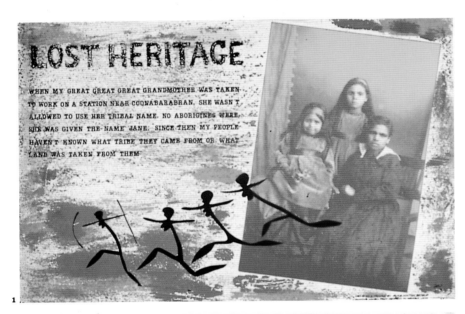

1

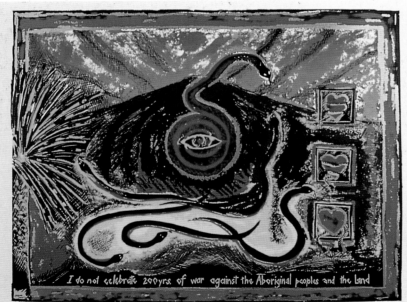

2

that such efforts educate and lead to greater understanding, and in the long run can make a difference to the way the world behaves. Such projects also give designers the chance to take direct action as opposed to being passive observers of world events. Amnesty International, one of the best known organizations campaigning for human rights, has been a favourite design collaborator and inspiration of countless exhibitions, competitions, posters and other graphic works of solidarity.

Three projects are shown which present different approaches to the subject of human rights. The first project is from Paul Piech (Taurus Press), who has produced an impressive amount of graphic work on human rights issues through the medium of the lino-cut. His imagery and comments are extremely tough and raw-edged. Examples are shown here from the 'Abolish Torture' exhibition which Piech produced in collaboration with Colombian-born photographer Gustavo Espinosa in 1987. The exhibition strikes hard at the human conscience by combining expressionistic lino-cut imagery, fragments of photographed reality, and snippets of disturbing text. All elements work together to construct symbolic visions of the unseen and the unknown.

The second project is an exhibition for the 1989 Bicentenary of the French Revolution (produced by Artis 89), when the French poster group Grapus invited 66 internationally-known designers to produce posters on the 'Rights of Man' theme. The project is particularly significant in that it sparked off a new wave of international 'designer-exhibitions', usually involving large groups of designers producing work in order to give exposure to a cause. (Such exhibitions don't necessarily always show designers at their artistic best, but they do underline a socially committed role for design.) Unlike the 'Abolish Torture' project, the Artis 89 exhibition dealt with human rights in the broadest sense, and some of its best contributions cut through the vague universality of the subject to make one distinct and simple statement, as in Grapus' scribbled version of 'rich shits on poor'. Others make obscure or abstract comment, or present intriguing symbolic compositions as in Jan van Toorn's complex comment on the political shift to the right.

The third project shown here is an international designer-exhibition organized by Gallery Wabnitz in Holland in 1991. It celebrates 30 years of Amnesty International, and features a definite search for a new visual approach to the subject of human rights offences. A number of the compositions completely side-step the normal visual clichés, demanding participation and hard thought on the part of the viewer. Images and definitions derived from modern lifestyle are used to create soul-searching statements that are extremely effective. For example Edward McDonald's poster uses the modern obsession with logos (as marks of personal identity) to question the viewer's stance or personal sense of justice. Design group Hard Werken's contribution is more obscure: a photograph of an island paradise suggests the wishful thoughts of a prisoner. Along with other examples shown on pages 111-113, both explore new directions in poster communication as well as helping Amnesty International's humanitarian cause.

There has been a slow and steady stream of international solidarity movements related to the imperialism of the superpowers, racism, oppressed communities, or the injustices of particular regimes. This has included, for example, protest against US intervention in Central American countries (particularly strong in the early 1980s), and outcry against the repressive regimes of South America and 'disappearances' in Argentina, Brazil, Chile, Guatemala and elsewhere.

Anti-racism has been a powerful and continuing theme, with many variations. The international anti-apartheid movement has produced some of the strongest imagery to emanate from individual designers and groups. It has not only directed protest against the atrocities committed under the apartheid system in South Africa, but has also acted as a focus for the broader racial issues which are endemic to many countries. With the rise of neo-Nazi extremism in Germany in the early 1990s (and the threat of fascist groups active in other countries as well), there has been a recent popular ground swell of anti-racist activity in Europe – particularly generated by the young. Old campaigns have been resurrected (Britain's Anti-Nazi League has been revived, for example), and new campaigns and demonstrations have produced a wealth of anti-fascist and anti-racist material. Germany, once again, is clearly in the lead here.

In 1992, land-snatching and the plight of indigenous peoples were brought into sharp focus in protests concerning the 500th anniversary celebrations of Columbus's discovery of the New World. As had been the case with the Australian Bicentennial of 1988, the celebration of a history that represents one culture crushing another produced a surge of grassroots activism, often expressed in graphic form. The Columbus celebrations, for example, receive harsh attack from Doug Minkler's sinister posters in the style of children's games, an appropriate vehicle for questioning what children are taught to believe, shown here and on page 121. (The unofficial art produced for the Australian Bicentennial is discussed on page 86.)

Global connections and the Third World

Corporate relations with the Third World have provided another controversial theme for artists and designers, sparked off especially by the climate of social responsibility in the 1970s. This chapter includes the pioneering work of Hans Haacke, known particularly for his persistent explorations into the relationship between corporate power, art institutions, the media and the public. Haacke has made harsh comment on the 'unseen' activities of multinational corporations that have attempted to present an acceptable public face through funding of the arts. But his 'attacks' have always been executed in the style and language of corporate advertising and graphics (accompanied by the ever-present corporate logo). As art pieces and installations they turn media propaganda and rhetoric back on itself, presenting an unsettling view of the corporation and its interface with the public, as well as casting a shadow on the ethics of the creators of corporate image: the advertisers, PR men and graphic designers.

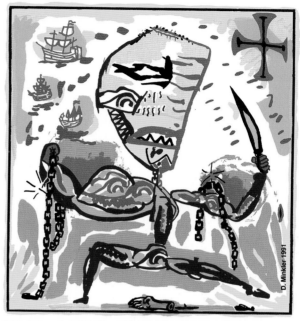

DRAW COLUMBUS
Liar Slaver Murderer Thief

3

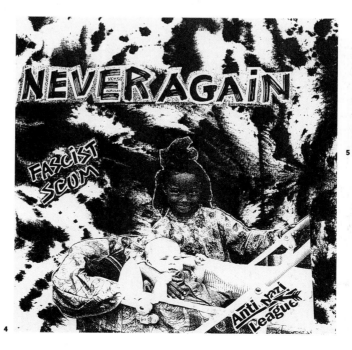

4

5

1 'Lost Heritage', screenprinted poster by Alice Hinton-Bateup, Aboriginal Program artist at Garage Graphix community arts group in Western Sydney, Australia 1983.
2 'I do not celebrate 200 years of war against the Aboriginal peoples and the land', screenprinted poster by Jan Fieldsend, Australia 1987. The poster depicts the ancient Aboriginal symbol of the Rainbow Serpent, the creator of the Earth and a representation of the Earth's life and power.
3 'Draw Columbus', poster in the style of a children's game by Doug Minkler, USA 1991.
4 'Never Again', artwork by Jamie Reid for a CD and album cover in support of the Anti-Nazi League, Britain 1992.
5 Front cover of the *Antifaschistisches Infoblatt*, an anti-fascist magazine from Berlin, Germany 1992.

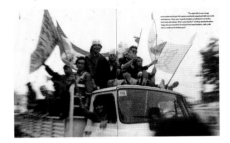
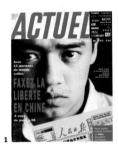
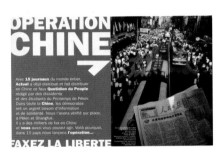

1

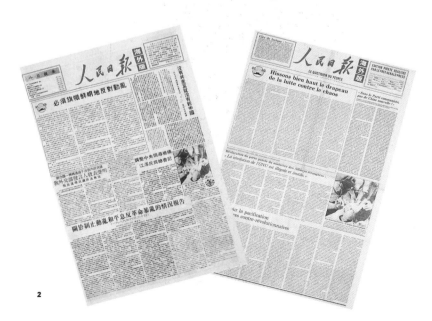

2

Corporate 'nasties' and Western wealth are often best attacked in their own visual language. The photomontages of Sweden's Christer Themptander and Germany's Klaus Staeck (page 124) rely on the technique of making awkward juxtapositions of media imagery to achieve a greater symbolic message, and also demonstrate the extent to which corporate logos are now symbolically 'loaded'. Certain types of visual assault have had their casualties, however. The British charity War on Want employed an advertising agency to communicate its humanitarian messages, most of which were insulting to Western businesses with Third World interests. The result: the ad agency received a great deal of hype and applause from the media, while the charity found its existence under threat due to complaints and pressure by the companies concerned.

In a visual essay that he constructed for Britain's *i-D* magazine, stylist and designer Judy Blame has taken the theme of imbalances of power and wealth into a totally different expressive dimension, using style and fashion to present complex social and political contradictions. Like Staeck and Themptander he makes awkward juxtapositions, placing fashion models and imagery with text that contrasts the price of designer-label items with their equivalent in terms of humanitarian aid. But the fashion photographs are in themselves loaded images, posing pertinent questions relating to global power games and the West's entanglements with the Third World.

ACT UP (AIDS Coalition to Unleash Power), the AIDS activist group, has taken hold of the visual power-language of corporate design and advertising to fight government inaction on AIDS issues. A distinctive visual strategy lies at the centre of their political movement. They use propaganda graphics for group identification on demonstrations, for reinforcement and education on issues, and for 'keeping the pressure on', making sure that AIDS remains in the public vision as a live issue. They also exploit the possibilities of merchandising, using t-shirts, badges and other items to strengthen group identity while at the same time encouraging a personal political stance. Their symbol (Silence = Death) has come to be a sign for AIDS activism itself, and represents the ultimate modern-day challenge.

ACT UP's adoption of visual power-language however is a matter of professionalism and strategy. They know what they are up against; they know exactly who or what the enemy is: governments, bureaucracy, conservatism. Theirs is a struggle to get power back into the hands of the ordinary people: to change 'official' attitudes and policies. So they need to operate at the same level of sophistication, in terms of visual propaganda, as government departments, drug companies, insurance companies and financial institutions. Added to that, ACT UP is very much a global movement, committed to fighting the worldwide epidemic of AIDS. In the same way that multinationals employ global visual strategies through logos and corporate identities, so ACT UP relies on the strength of its graphics to keep their identity and profile intact, despite being translated into different languages or being subjected to the 'creative licence' exercised by different city chapters.

ACT UP also represents an important development in the trend towards 'personal politics', and the use of art and design for that political expression. Disillusionment with governments and political parties unable to deal with global crises has helped to generate grassroots involvement and activism, often through the popular vehicle of the creative arts and particularly through youth formats. The Live Aid rock concert of 1985 was a watershed: it proved what the creative arts could do to generate concern and caring for international causes (in this case, famine relief for Africa). In reality, Live Aid could only bring momentary relief – not solve the actual problem – but it did serve to magically shrink the world in an all-day 'global concert' which took place simultaneously in Philadelphia and London and was broadcast by the largest satellite link-up ever. It allowed people in many different countries to show solidarity over a common cause, and inspired a new young generation to action and involvement.

Live Aid also opened up politics and global issues to a wide range of art and design media and technology, again often exploited by the younger generation. Artists and designers have cast a creative but critical eye on the information and computer technologies, as shown in Keith Piper's anti-racist computer-based video installation *Surveillances* (page 130), while at the same time attempting to harness the new technology for direct action.

'You have the technology to change history' was the rallying cry printed in *The Face* magazine in Britain, as it encouraged its readers to take part in the Fax for Freedom, a protest-by-fax in support of the Tiananmen Square protestors. The protest was organized by *Actuel* magazine in France and involved 16 magazines around the world. The magazines all carried a cut-out manifesto and a multitude of fax numbers belonging to offices and institutions within China, so that readers could bombard them with the Fax for Freedom. *Actuel* also organized the production of a pirate edition of China's *People's Daily* newspaper. Written by students who had escaped to the West, it carried information about the democratic movement and was spread, secretively, in and around Beijing by French and German reporters.

The role of youth formats in the shift towards a new era of 'personal politics' has therefore been significant. Charity or 'awareness' rock concerts are now fairly common. Fashion items are used for a wide variety of causes, with t-shirts still operating as one of the best methods for parading personal politics (and one that is timeless in its appeal). Rap records and videos promote black awareness; football 'fanzines' attack fascism. Youth-orientated style magazines devote entire issues to activism and anti-racism, while ecology and Green issues have invaded beauty products, clothing, children's books and Saturday morning TV cartoons. All of these (and more) have become the expressive vehicles for the politics of a new generation. They have cut through the divisions and barriers existing in conventional attitudes and power structures, and have offered people (both young and old) the opportunity to be active and involved. In short they have all, in their way, brought power – and politics – back to the people.

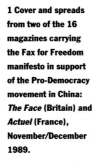

3

1 Cover and spreads from two of the 16 magazines carrying the Fax for Freedom manifesto in support of the Pro-Democracy movement in China: *The Face* (Britain) and *Actuel* (France), November/December 1989.

2 Pirated edition of China's *People's Daily* written by students who had escaped to the West.
3 'Step into the Arena', stills from Keith Piper's computer/video installation which explores gender and racial stereotyping

through the symbolic framework of a boxing ring, Britain 1991. Its four monitors represent the corners of a ring.
4 Poster announcing a demonstration (the hand sign symbolizes keeping death away) by the Dutch chapter of ACT UP, 1992.

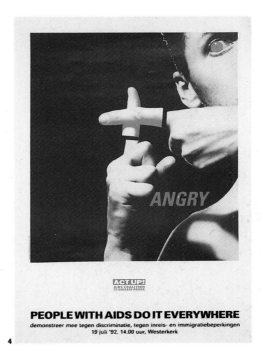

ANGRY

ACT UP!
AIDS COALITION
TO UNLEASH POWER

PEOPLE WITH AIDS DO IT EVERYWHERE
demonstreer mee tegen discriminatie, tegen inreis- en immigratiebeperkingen
19 juli '92, 14.00 uur, Westerkerk

4

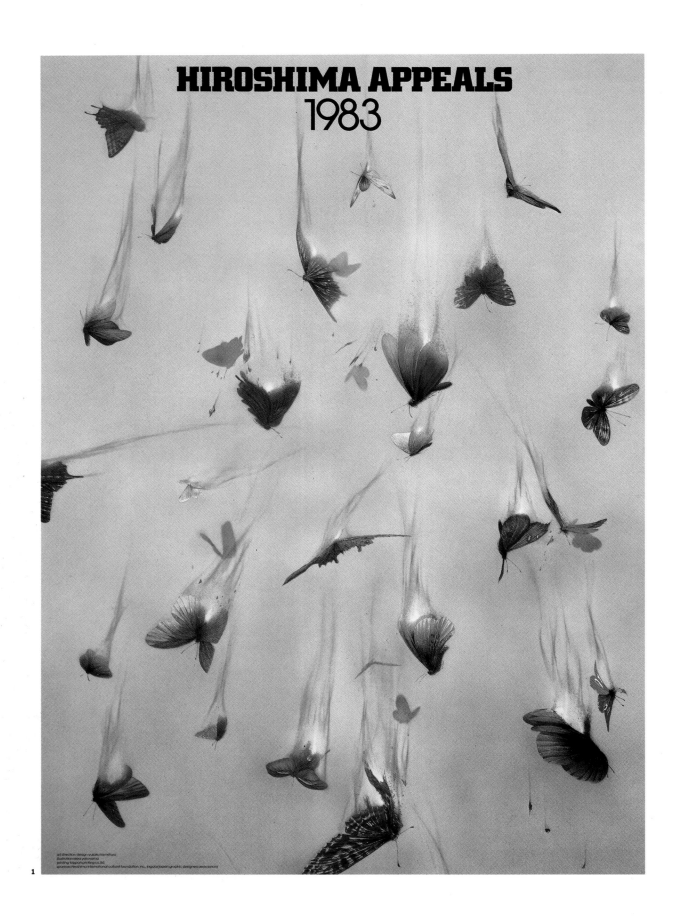

2

**Three posters from
the annual Hiroshima
Appeals poster series,
1983-90.
1 Yusaku Kamekura,
1983.
2 Kazumasa Nagai,
1987.
3 Shigeo Fukuda, 1985.**

The Hiroshima Appeals poster series

The Hiroshima Appeals poster series was one of the graphic design world's most emotional calls for peace. From 1983 to 1990 an annual appeal was made to the world – on behalf of the people of Hiroshima – to work against the threat of nuclear war, and for the cause of peace. Each year a poster was created by one of Japan's top designers, then distributed worldwide and exhibited in and around Hiroshima on the anniversary of the bombing of 6 August 1945. The series was organized by the Japan Graphic Designers Association (JAGDA), who then complemented it with an annual peace poster exhibition – a voluntary affair made possible by the enthusiasm of JAGDA's members, which still continues to this day. Other inspired offshoots included the 'Images for Survival' (I and II) poster exhibitions initiated by Charles Helmken in America, described on page 91.

Three of the Hiroshima Appeals peace posters are shown here. Yusaku Kamekura's 1983 poster launched the series with its tragic rendition of burning butterflies. Shigeo Fukuda, designer of the 1985 poster and known for his amusing visual puns and illusions, created an unusual and witty statement about keeping the world intact. In 1987 Kazumasa Nagai depicted a frozen moment of horror, as beauty and peace (symbolized by the wings of a white bird) were destroyed by some unseen force or weapon.

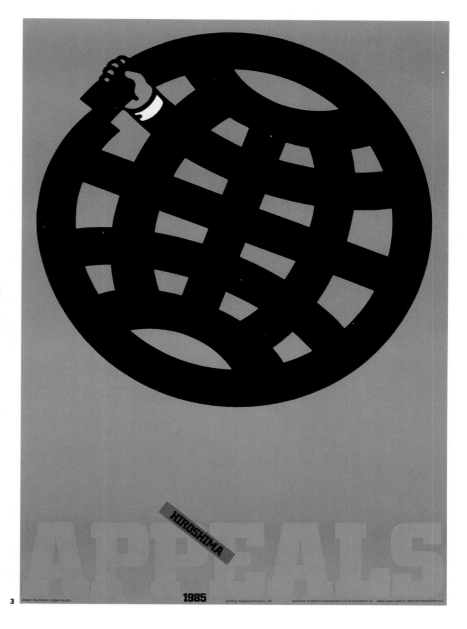

3

1985

World peace: humour and satire

1

Humour and satire have provided the peace movement with a much-needed release for tension and anger over the years. This was particularly true during the early 1980s when the housing of American missiles in Europe was becoming an increasingly topical issue, and the close political relationship between Ronald Reagan and Margaret Thatcher was making peaceniks on both sides of the Atlantic extremely nervous, at the same time as providing an inspiring subject for cartoonists and satirists.

The 'Gone with the Wind' poster shown here was a distinctive graphic icon in Britain at that time, appearing in various radical haunts and highly indicative of the mood of popular protest. Other examples are much broader in scope. The Swedish photomontagist Christer Themptander, for example, has produced a large body of anti-militaristic collage work over two decades, all of it beautifully executed, and highly expert in capturing the lunacy of military matters.

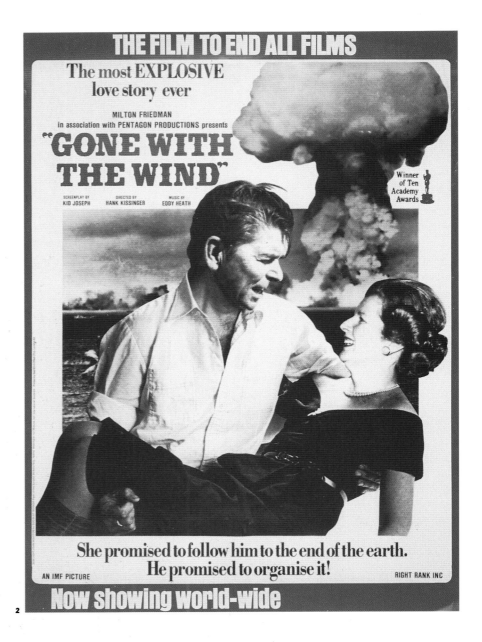

2

1 Photomontage by
Egon Kramer, showing
West German
Chancellor Helmut Kohl
playing to the tune of
American supremacy in
the arms race, 1985.
2 'Gone with the Wind',
poster and postcard
by Bob Light and John
Houston, Britain
c.1984.

3 'Attention!', poster
and postcard by
Christer Themptander,
Sweden 1981.
4 'The Seducer' by
Christer Themptander,
Sweden 1984.

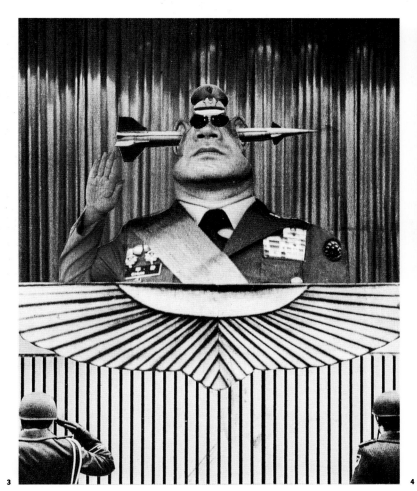

3

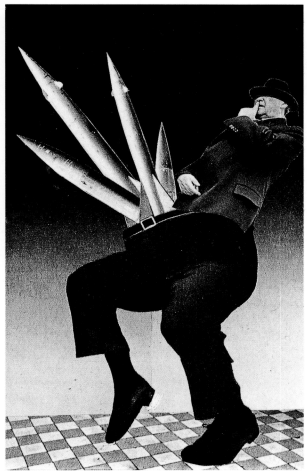

4

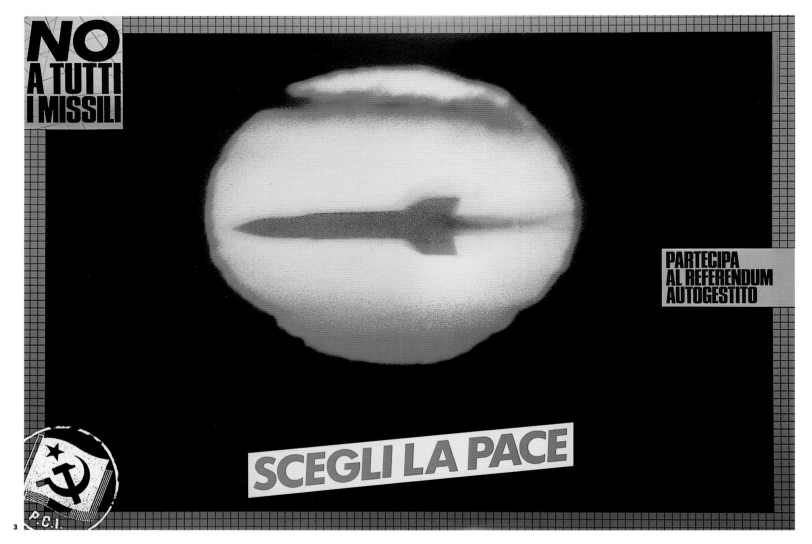

6

The 1980s and the international peace movement

5

In the early 1980s the move towards NATO rearmament and the deployment of short and medium-range nuclear missiles in Europe (the US Cruise and Pershing, and Soviet SS20) brought the international peace movement roaring back to life. For many people, the missiles brought with them a fearful vision of Europe as a potential arena for a 'limited' nuclear war.

Britain's Campaign for Nuclear Disarmament (CND), which had achieved an international profile in the 1960s, rose again with a powerful and prolific visual campaign supplied by the political artist Peter Kennard; his immensely popular photomontages were seen on billboards, in the press, at demonstrations and on posters in the street. At the same time, the Women's Peace Camp at Greenham Common (established in 1981) made the international headlines, supplying a model for political activism and other peace camps. While protests and demonstrations swept across Europe, the USSR and Iron Curtain countries produced equally emotive statements through competitions such as those staged by the Communist Party poster press (Plakat), for international peace was one of the Party's 'approved' subjects during those pre-glasnost years.

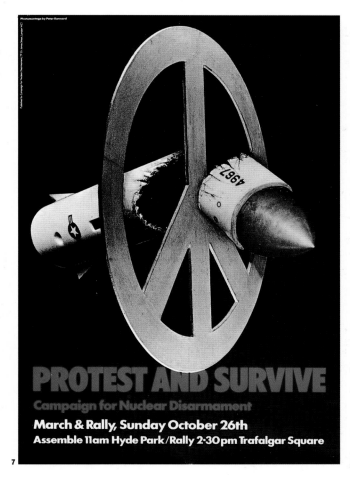

7

PROTEST AND SURVIVE
Campaign for Nuclear Disarmament
March & Rally, Sunday October 26th
Assemble 11am Hyde Park/Rally 2·30pm Trafalgar Square

1 Peace badges, USSR 1986. Both simply read 'No' (missiles).
2 Peace poster for the French Communist youth movement by Grapus design collective, France 1981.
3 'Choose peace', poster designed by Stefano Rovai of Graphiti studio in Florence, for the Italian Communist Party, Italy 1983.
4 'Year Two of Disarmament', poster for the Mouvement pour la Paix, Paris. Designed by Andrea Rauch of Graphiti studio, Italy 1989.
5 Nuclear disarmament symbol designed by Gerald Holtom in 1956, and adopted by Britain's Campaign for Nuclear Disarmament (CND) in 1958.
6 Photomontage poster by Peter Kennard which combines cruise missiles with John Constable's painting *The Haywain*. The poster was widely reproduced by the Greater London Council and also by the Labour Party; Britain 1980-83.
7 Badge and poster showing Peter Kennard's 'Protest and Survive' visual campaign, the result of a brief to revitalize the British CND symbol (and public image) for use on the first big march of the new 'revived' CND in 1979.

2

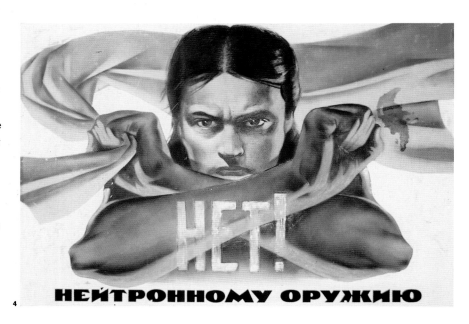

3

Peace protests: women and children

1

Women played a strong role in the protests of the 1980s. The Women's Peace Camp at Greenham Common led the way, in a protest that saw women camped outside the gates of a US missile base in Britain from 1981 to the early 1990s. The camp came to symbolize the strength of women united in a cause and their ability to subvert male military power.

The Greenham experience involved a good deal of theatre and visual symbolism. Many direct actions were staged (such as 'Embrace the Base', when in 1982 over 30,000 women travelled to Greenham to link hands around the base); banner-making enjoyed renewed popularity; photo-journalists visited from far and near. It inspired books, songs, print portfolios and even a fashion collection by Katharine Hamnett. The perimeter fence remained a potent symbol: it was damaged or pulled down during large demonstrations, but was more often decorated with paint and paper doves, pictures, dolls, photographs and other momentos of humanity, womanhood and childhood.

Greenham and its fighting spirit set the tone for much of the imagery of that decade. Women appeared often in the media and were depicted as a source of strength, unafraid to stand up for their rights, demand a future of peace, or even to confront the military machine.

4

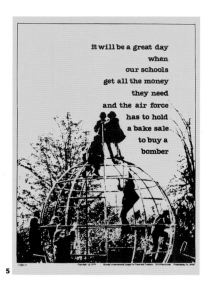

5

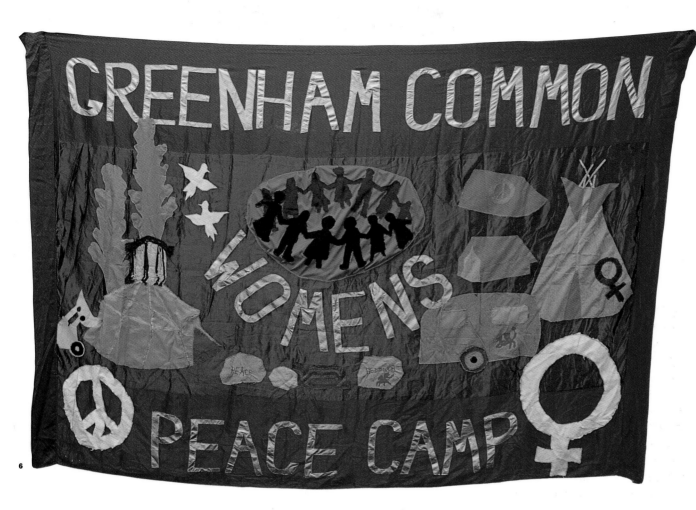

6

7

1 One of a series of 16 'Post-Atomic' cards promoting an exhibition of 'postable art' on disarmament. Designed and printed by the exhibition organizers, the Fallout Committee (Michele Braid, Julia Church, Bob Clutterbuck and others); Australia 1984.
2 'Children ask the world of us', poster for Women's Action for Nuclear Disarmament (WAND) designed by Lance Hidy, with text by Margaret Wilcox, USA 1984.
3 Peace poster by Margus Haavamägi, Estonia 1986.
4 'No Neutron Weapons', poster (designer unknown), USSR *c.*1980.
5 Poster produced by the Women's International League for Peace and Freedom, USA 1980s.
6 Banner made in 1983 by Thalia and Jan Campbell and Jan Higgs, celebrating the 'Women for Life on Earth' Action for Peace at Greenham Common (27 August 1981 to 12 December 1983), Britain.
7 Cover and inside spread from *The Greenham Factor*, a newsheet and solidarity tool produced to document and raise funds for the Women's Peace Camp at Greenham Common, Britain 1983-4.

Graphics for human rights: Abolish Torture

Graphic artist Paul Peter Piech is internationally known for his expressionistic lino-cuts. His Taurus Press (founded in 1959) has generated a prolific output of radical comment over the years, born out of his passionate concern for the cause of human rights. Piech, his press and his collaborations represent the extraordinary potential and power of an individual voice.

Shown on this spread are selected pieces from 'Abolish Torture', an exhibition of works created for Amnesty International by Piech and Colombian-born photographer Gustavo Espinosa. It communicates the fears and horrors of its subject through the use of symbolic imagery and fragmented text. The juxtaposition of two very different graphic techniques – photography and lino-cut – is also extremely effective. The starkly symbolic photo-images emphasize the fear that lies behind unknown actions or reality; the primitive quality of the lino-cut text lends a dramatic edge to the thoughts and words. Both forces combine to create a disturbing and haunting call to action.

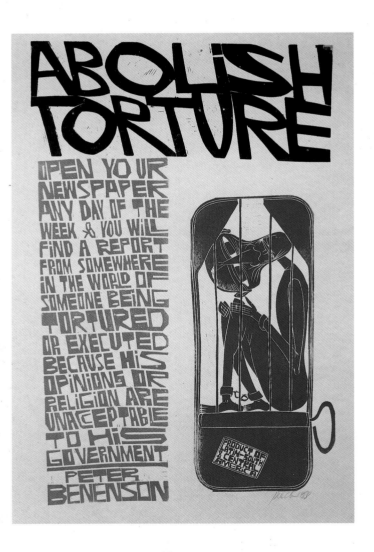

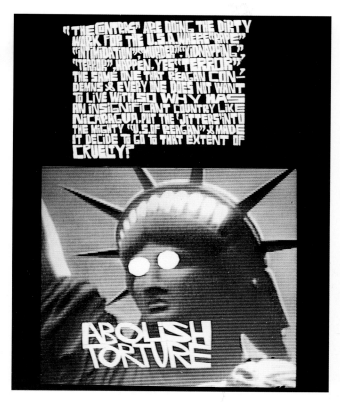

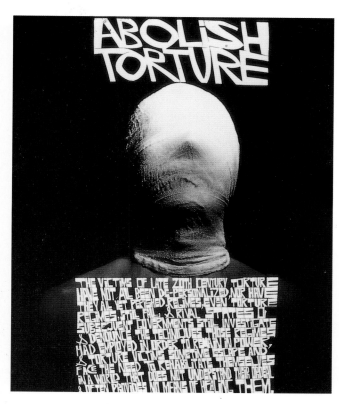

Selected prints from 'Abolish Torture', a touring exhibition of collaborative works created for Amnesty International by graphic artist Paul Peter Piech and Colombian-born photographer Gustavo Espinosa, 1987.

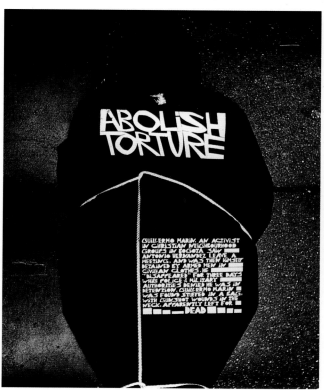

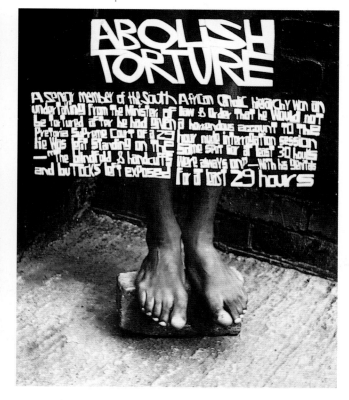

Posters for the Bicentenary of the French Revolution, 1989

The issue of human rights was the subject of an exhibition organized by French poster group Grapus for the 1989 Bicentenary of the French Revolution. Sixty-six well-known designers from around the world were invited to produce a poster on the theme of the Declaration of the Rights of Man and of the Citizen. The collection was then exhibited and published in the book *For Human Rights* (produced by Artis 89).

The collection featured broad interpretations of the subject, and a wide range of graphic approaches. Some posters distilled the all-embracing theme into one simple statement, as shown in Masuteru Aoba's 'we shall overcome' or Grapus' 'rich shits on poor'. Others dwelled on complexity: Jan van Toorn's rendition of 'the struggle continues' depicts confusion, contradictions, media-babble and other forces moving to the political right.

The exhibition also had its controversies, including a poster by Australian designer Julia Church which criticized the French nuclear presence in the South Pacific. The poster was an attempt by Church to question the exclusivity of the French government's interpretation of the 'Rights of the Citizen', and also represented the strained relations between France and nations of the Pacific Rim. It was one of a number of posters in the exhibition which caused certain French government officials concern, and provoked (failed) attempts at censorship.

The exhibition also sparked off a new genre of 'designer-exhibitions', where well-known designers were asked to create an original piece of work in order to aid a cause. In addition to creating some interesting collections of work, these exhibitions also helped to encourage the modern notion of design and style as politics.

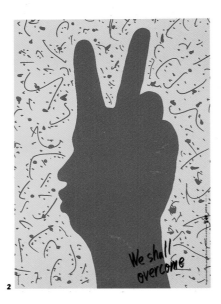

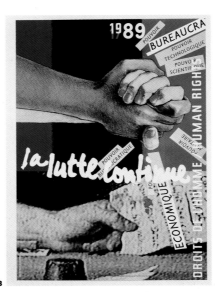

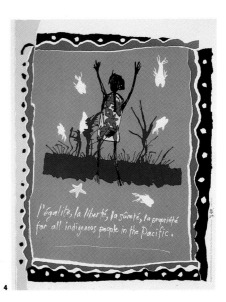

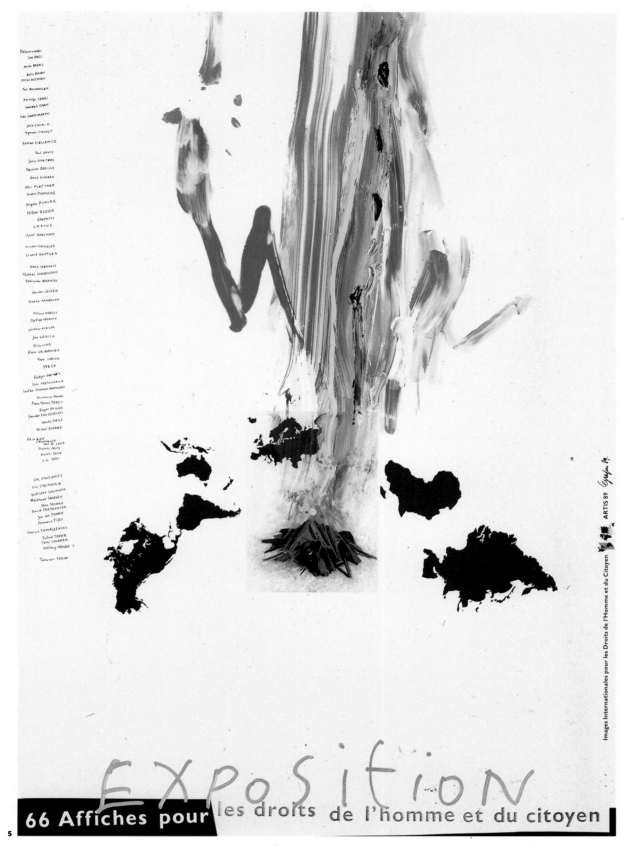

Posters from the human
rights exhibition
organized by Grapus
for the Bicentenary of
the French Revolution,
1989.
1 Grapus, France.
2 Masuteru Aoba,
Japan.
3 Jan van Toorn,
Holland.
4 Julia Church,
Australia.
5 Poster by Grapus,
announcing the
exhibition.

5

Poster exhibition: 30 years of Amnesty International

In 1991 the Poster Gallery Wabnitz in Arnhem, Holland, initiated a 'designer-exhibition' to celebrate 30 years of human rights campaigning by Amnesty International, with 50 well-known designers from around the world taking part. In addition to promoting a worthwhile cause, the collection featured new approaches to the subject of human rights.

The old clichés of prison bars and chains are forsaken for intriguing statements that demand thought on the part of the viewer, or that play with aspects of modern lifestyle. The notion of freedom appears in curious symbolic forms: a saw by Melle Hammer; a hellish vision of keys by Neville Brody; or a prisoner's wishful thinking, conjured up as an island paradise by design group Hard Werken.

Edward McDonald's resounding composition 'your choice is your identity' uses the modern obsession with logos and self-identity to pose questions of conscience; Rik Comello's conversational 'fuck justice' compresses an extraordinary amount of passion into a relatively small number of words; while the brash 'I am nasty' by Linda van Deursen and Armand Mevis highlights the hidden evils of the business world by using a camouflage of pinstripes. The visual language employed in all of the posters mentioned is rooted in the style and technology of today's society, with references to press photography, advertising, the quest for status, and other trappings of current lifestyles. Therein lies their strength and endurance: they use modern language to condemn modern evils.

to those *lusting for power:*

FUCK JUSTICE

(And she'll give birth to
Abuse & Despair
two sons who will kill
Integrity, Beauty & Truth,
your favourite brother
and 2 most beloved sisters.
Believe me,
THEY WILL!)

thirty years amnesty international

30 JAAR AMNESTY INTERNATIONAL

4

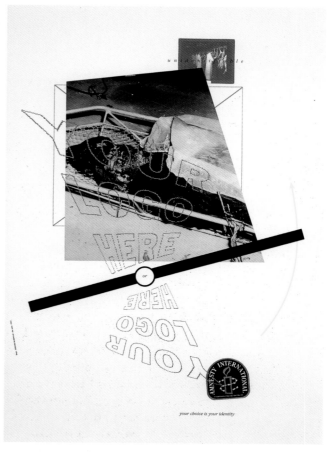

5

Posters from the
exhibition '50 poster
designs/30 years
Amnesty International',
organized by Poster
Gallery Wabnitz of
Holland in 1991.
1 Holger Matthies,
Germany.
2 Rik Comello, Holland.
3 Hard Werken, Holland.
4 Gunter Rambow,
Germany.
5 Edward McDonald,
USA.

2

3

4

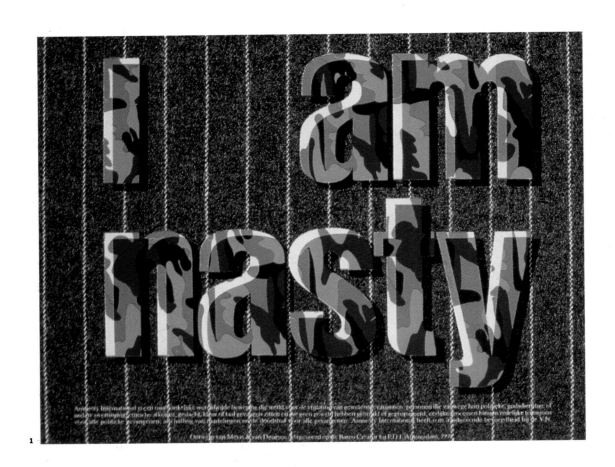

1

A further selection of
posters from the 1991
Amnesty International
exhibition.
1 Linda van Deursen
and Armand Mevis,
Holland.
2 Lex Reitsma, Holland.
3 Plus x (Melle
Hammer), Holland.
4 Hans Bockting,
Holland.
5 Neville Brody, Britain.

5

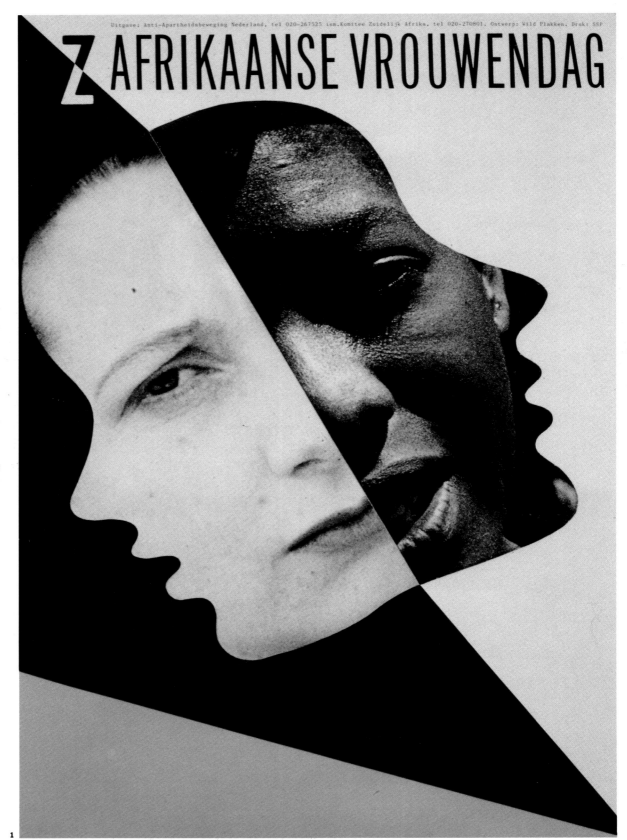

1 Poster celebrating
'South African Women's
Day' on 8 August 1988
by Wild Plakken (Frank
Beekers, Lies Ros, Rob
Schröder), for the Dutch
anti-apartheid
movement.
2 'Apartheid', self-
sponsored poster
by Wild Plakken,
Holland 1986.
3 & 4 Cover and inside
spread from the
handbook *How to
Commit Suicide in South
Africa*, with text by Holly
Metz and illustrations
by Sue Coe, USA 1983.

3

Fighting apartheid: solidarity graphics

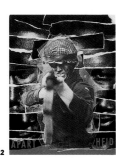

2

The anti-apartheid movement has inspired graphic work from designers in many countries. Activity was strongest during the 1980s when the popular resistance movement within South Africa itself was at its height (see National Politics, pages 74-5). International solidarity included such actions as campaigning for Nelson Mandela's release from prison, support for economic sanctions, and 'divestment', the withdrawal of public funds from companies investing in South Africa, in order to challenge apartheid. The projects shown here are highlights from a long and continuing stream of graphic support.

The handbook *How to Commit Suicide in South Africa* was an expression of outrage. Published by Raw Books and Graphics (New York 1983), it was created by artist Sue Coe and journalist Holly Metz after reading about people who died or 'committed suicide' in detention in South Africa – especially Black Consciousness leader Steve Biko (d. 1977). The book contained researched information concerning racism in South Africa – historical timelines, statistics on foreign investment and so on – and was illustrated by Sue Coe's expressionistic imagery. It was an important consciousness-raising document in both

Britain and America, and was used as an organizing tool on American campuses when divestment became a big issue.

Also shown here are posters from Wild Plakken design group in Amsterdam, who have made many anti-apartheid statements in photo-collage form, and imagery surrounding the Nelson Mandela 70th Birthday rock concert in London in 1988. These include Keith Haring's energetic cartoon-figures, and 'Hope and Optimism', an extremely popular lino-cut from one of Southern Africa's leading artists John Muafangejo, who had died the preceding year.

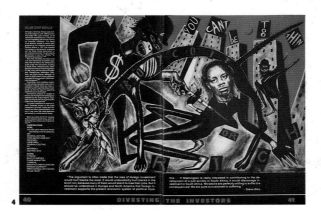

4

1

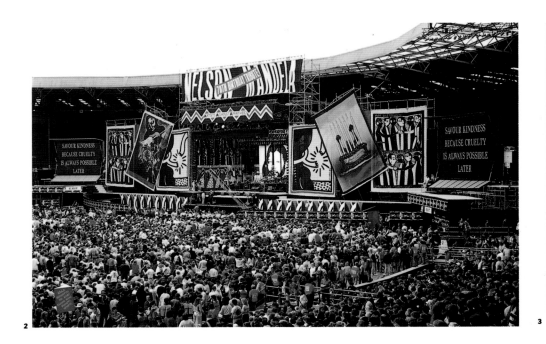

2

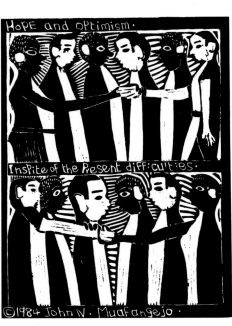

3

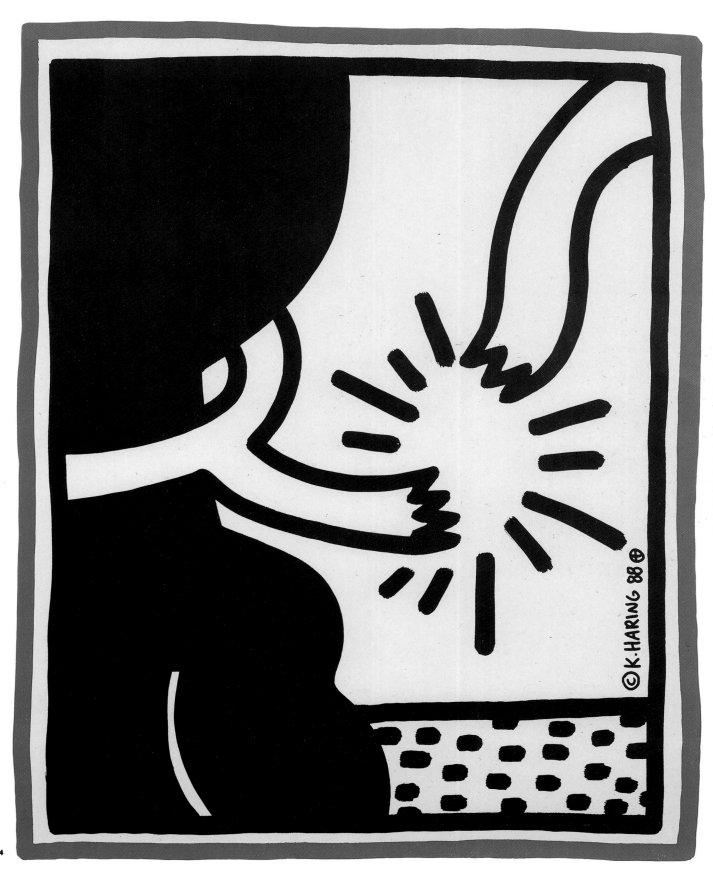

1 Badges from the British anti-apartheid movement, 1980s.
2 Nelson Mandela 70th Birthday Concert, Wembley Stadium, London 1988. The concert was performed before a backdrop of work by artists Keith Haring, Jenny Holzer, John Muafangejo and others.
3 'Hope and Optimism', lino-cut by John Muafangejo, Namibia 1984.
4 'Untitled', poster by Keith Haring, USA 1988.

4

2

Solidarity with oppressed peoples of the world

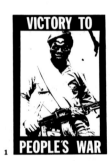

1

The oppression of indigenous peoples in many countries around the world has been an on-going subject for graphic protest and focus for the past three decades. There have been many solidarity movements and individual protests along the way, some of them continuing in strength to this day. A selection is shown on the following pages, ranging from the national liberation struggles in Africa in the 1960s and 1970s, to the continuing struggles of the Aboriginal nation of Australia.

The 1990s however have brought further developments: new views and definitions of history, and new multicultural perspectives, reflecting the roles of women and ethnic minorities. Myths and legends surrounding historical 'heroes' have been subjected to scrutiny, and a fair amount of debunking. Attempts to celebrate the 'discovery' of new lands or new nations, which inevitably involved one culture 'civilizing' or conquering another, have continued to generate protest – as shown earlier in the Australian Bicentennial of 1988 (pages 85-6) and in the recent celebrations of the 500th Anniversary of Columbus's discovery of the New World, represented on page 95 by Doug Minkler's cynical historical lesson on Columbus.

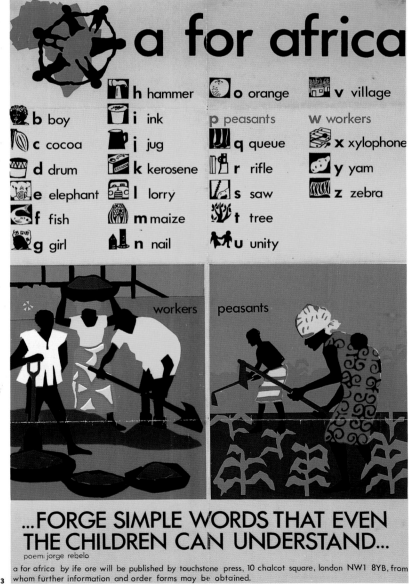

3

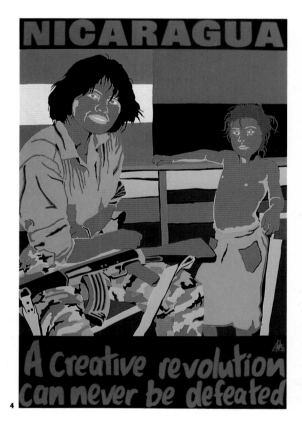

4

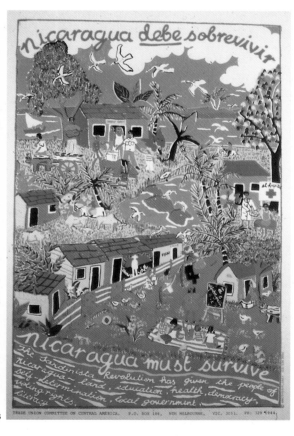

5

1 Poster in solidarity with the national liberation struggles in Africa, by The Poster Collective, Britain 1970s.
2 Poster in support of Guinea-Bissau independence, by Chicago Women's Graphics Collective, USA 1973.
3 Poster promoting the book 'A for Africa' written by Ife Ore; the poster was also a popular African solidarity image. Created by The Poster Collective, Britain mid-1970s.
4 'Nicaragua', poster by Redback Graphix (designers and printers: Michael Callaghan, Gregor Cullen) for the Committee in Solidarity with Central America and the Caribbean (CISCAC), Wollongong, Australia 1984.
5 'Nicaragua must survive', poster by Julia Church (with Another Planet Posters) for the Trade Union Committee on Central America based in Melbourne, Australia 1986.

1 'We'll never forget Wounded Knee', postcard and poster by Christer Themptander in solidarity with the cause of the Native Americans (and widely distributed in the USA), 1971. The title refers to the massacre of Sioux Indians by US troops at Wounded Knee in 1890.
2 'Night of Sorrow, 1492', a screenprinted poster by Pamela Branas of Red Planet arts workshop, Australia, contrasting the struggle of the indigenous peoples of the Americas and the historical view of the conquistadores. Produced in 1992 (the 500th Anniversary of the Conquest of the New World).
3 'Columbusters', poster in the style of a children's game by Doug Minkler, and an acerbic comment on the Columbus celebrations, USA 1992.
4 Screenprinted poster by Marie McMahon (Australia) designed in 1981 in solidarity with the people of the Tiwi Islands and in support of national Land Rights legislation.

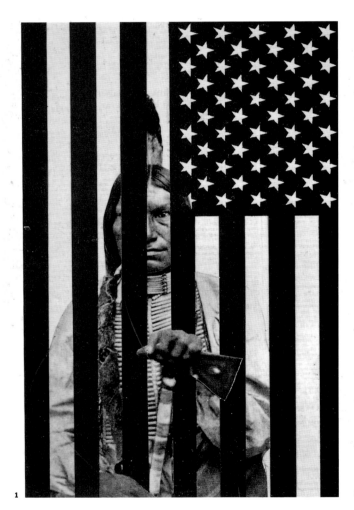

1

2

COLUMBUSTERS

RULES: Spin Columbus, move to designated color.

Give back all native land.

Lose all slaves.

Receive molten gold throat treatment to relieve treasure lust.

Busted for incompetence. Go back to Spain.

Cholera Infected blankets meant for native people kills all your soldiers.

Alcohol meant to stupefy native peoples intoxicates crew, your ship sinks.

Forced on white reservation for own good.

GOAL: Try to get from 1492 to 1992 keeping the mythical vision of brave Columbus the discoverer locked in your mind. The winner receives an American flag, and a Support the Troops bumper sticker.

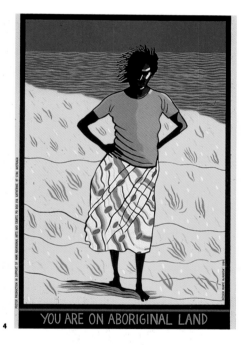

4

3

1

1 The writers of the
Band Aid song: Midge
Ure and Bob Geldof
wearing a Feed the
World t-shirt (with
daughter Fifi), 1984.
2 & 3 The Band Aid
single (and cover
sleeve) recorded in
November 1984. The
Feed the World logo
was conceived by Bob
Geldof; sleeve artwork
was created by artist
Peter Blake.
4 Cover of Fashion Aid
programme; logo design
by Ostrich Graphics,
programme produced
by Concessions,
Britain 1985.
5 Cartoon by Pat
Oliphant commenting
on the charity-at-home
effort 'Hands Across
America', USA 1986.

2

3

Band Aid and Live Aid: famine relief

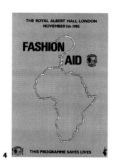

Two events of the mid-1980s changed the Western world's concept of charity, particularly in relation to the Third World, and at the same time inspired a young generation to action and involvement. They were the recording and release of the Band Aid pop single in November 1984, and the Live Aid rock concert held in July 1985. Both events were conceived and engineered by Irish musician Bob Geldof.

Sales of the Band Aid single 'Do They Know It's Christmas?', involving over 40 different pop singers and with record sleeve artwork by pop artist Peter Blake, produced over £10 million for Ethiopian famine relief in the winter of 1984. It was followed in the summer of 1985 by a sister event: the internationally-broadcast Live Aid rock extravaganza, an all-day 'global concert' which took place simultaneously in Philadelphia and London and was broadcast to 152 countries by the most ambitious satellite link-up that had ever been attempted.

Whereas Band Aid caught the imagination of the British public, Live Aid appealed to the hearts of the world. There were complaints at the time that it only supplied temporary relief and that it failed to solve Ethiopia's real problems, but there was no denying the effect the event had on its global audience. It provided people in numerous countries with the opportunity to unite on an issue of goodwill, and showed the astonishing rallying power of rock music and the possibilities of mass communication media.

Live Aid also produced a legacy of charity events, both in Europe and America. These included Fashion Aid, Cartoon Aid, and Artists' Aid, all of them trying to recapture that precious feeling of goodwill, some more successfully than others. America, for example, used the wave of goodwill as an opportunity to scrutinize its own poverty and homelessness, and staged 'Hands Across America', a Hollywood-style symbolic joining of hands across the country (with Ronald Reagan included). The event was heavily publicized, but relatively ineffective.

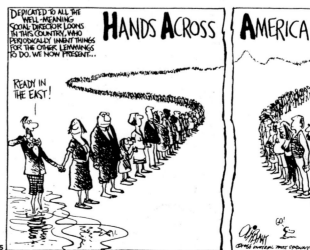
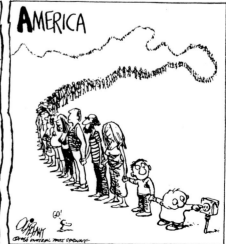

The balance of wealth and power

The West's relations with the Third World, and the imbalances of power and wealth contained therein, have been long-standing themes in the art and design world. Attempts have been made to promote aid, or support indigenous projects: the climate of social responsibility in design in the 1970s, for example, created interest (and action) relating to alternative technology and Third World design needs. But there has also been a very large amount of on-going art and design activity devoted to attacking the instruments and causes of the imbalances.

Artist Hans Haacke's pioneering work purported to expose the 'concealed activities' of multinationals, particularly those using funding of the arts to create a presentable public face. Significantly, he conducted his attacks in the style of corporate advertising and graphics, thereby turning the rhetoric and propaganda back on itself. Christer Themptander, Klaus Staeck and others have also manipulated a wide range of symbols such as corporate logos, boardroom tables and fat men in business suits, to pose questions about commercial power and control. Other innovative approaches to the subject include Judy Blame's use of fashion and style to make cost equations between designer lifestyles and humanitarian aid, while also exploring themes of financial power, racial prejudice and industrial exploitation: all aspects of the global power games scenario.

1

marknadsanpassad

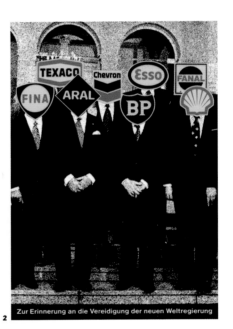

2

Zur Erinnerung an die Vereidigung der neuen Weltregierung

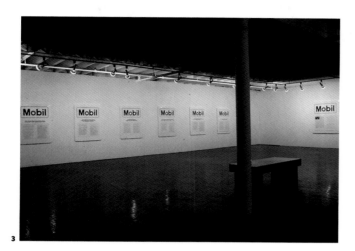

A selection of Hans Haacke's projects concerning Mobil.
3 'The Good Will Umbrella', 1976. A series of six panels displaying a speech delivered to a conference of advertising agencies in New York, outlining the company's new strategy to ensure that company concerns are seen in a good light.
4 'Mobil: On the Right Track', silkscreen print and photo-collage, 1980. Showing four liberal senators, all of whom were defeated when Reagan was elected, it alludes to Mobil's financial support of Republican candidates.
5 'Creating Consent', oil drum with television antenna, 1981. A comment on oil companies' financial support of TV networks.
6 'MetroMobiltan', fibreglass construction, three banners and photo-mural, 1985.

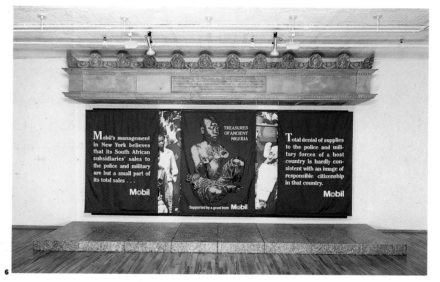

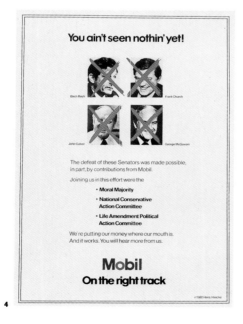

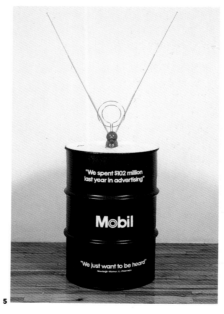

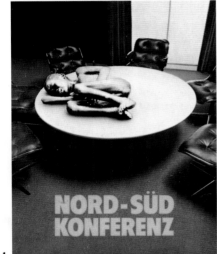

1

NORD-SÜD
KONFERENZ

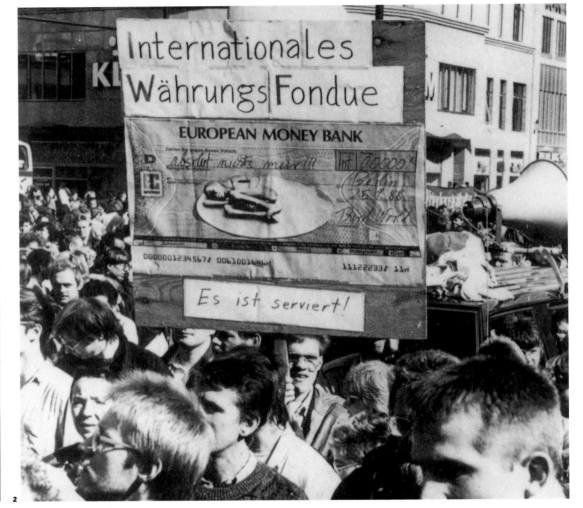

2

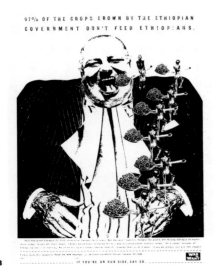

97% OF THE CROPS GROWN BY THE ETHIOPIAN
GOVERNMENT DON'T FEED ETHIOPIANS.

3

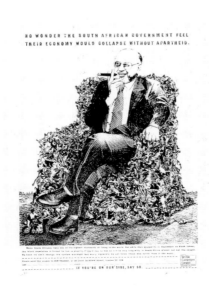

NO WONDER THE SOUTH AFRICAN GOVERNMENT FEEL
THEIR ECONOMY WOULD COLLAPSE WITHOUT APARTHEID.

4

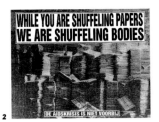

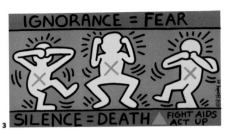

ACT UP and the graphics of AIDS activism

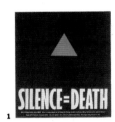

The powerful presence of AIDS activism since the late 1980s owes much to the efforts of ACT UP (AIDS Coalition to Unleash Power). ACT UP describes itself as 'a diverse, non-partisan group of individuals united in anger and committed to direct action to end the AIDS crisis'. Founded in New York City in 1987 as a result of US government inaction to the AIDS crisis throughout the 1980s, the coalition's anger encompasses a wide range of issues including government funding for research, the drug approval process, access to treatment and care, inaccuracies in reporting the AIDS crisis and the lack of safe sex education.

Within five years ACT UP had become a large network of independent city chapters with an international reach. With approximately 180 chapters spread through two dozen countries, it is now a global grassroots movement determined to combat a global epidemic, and committed to making an impact on national governments and the way they approach AIDS issues.

The genre of AIDS activist graphics was created by ACT UP, as visual propaganda and design strategies have been central to their operation as an organized movement. ACT UP's strong graphic identity has helped the network to 'connect' nationally and globally, while graphics have played a major role in demonstrations in the form of slogans and signs that highlight issues and target government officials. ACT UP's emblem 'Silence = Death' operates with an authority

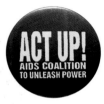
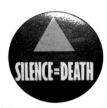
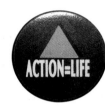
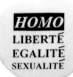

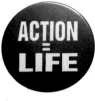

normally assigned to corporate graphics. The pink triangle is a symbol of historical oppression: it originally marked gay men in Nazi concentration camps, but was positioned with the pink triangle pointing down. The triangle's inversion by ACT UP is a sign of resistance against new forces of oppression and annihilation.

Another graphic strength lies in the organization's use of the visual techniques and hard-hitting language of advertising, sometimes to the point of actually

manipulating existing advertising images. They consequently force the propaganda of commercial culture to strike back at itself, targeting government departments, public health care authorities, drug companies and other institutions. Such turnaround tactics have been perfected by art activist groups such as Gran Fury (who started out as ACT UP's visual propaganda team) and have come to characterize the new and uncompromising genre of AIDS activist graphics.

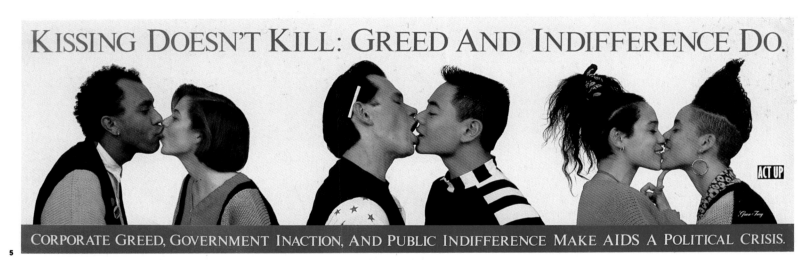

5

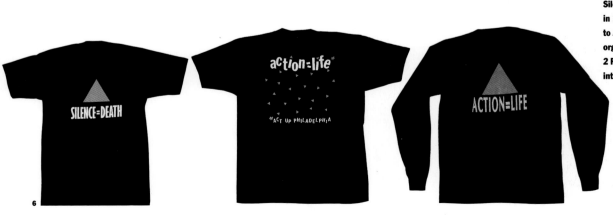

6

1 'Silence = Death' emblem and poster, the visual identity of ACT UP (the AIDS Coalition to Unleash Power). The original emblem was designed by the members of the Silence = Death Project in 1986, who then gave it to ACT UP on the organization's formation. 2 Poster from an international AIDS conference in Amsterdam, 1992. 3 Poster for ACT UP by Keith Haring, USA 1989. 4 ACT UP badges. 5 'Kissing Doesn't Kill', bus ad which ran in San Francisco and New York. By the AIDS activist art collective Gran Fury, USA 1989. 6 ACT UP t-shirts, with emblem variations by different chapters.

1

Combating racism and fascism in the New Europe

2

Worries related to the rise of racism and fascism have disrupted the once harmonious vision of the 'New Europe'. In Germany the overwhelming costs of reunification have given fuel to neo-Nazi extremists directing their anger at a heavy influx of refugee populations from Eastern Europe. Caught in the grip of global recession, the rest of Europe has also been experiencing a renewed strengthening of hard-right political groupings.

There has been a strong popular reaction against these developments, employing extremely varied graphic formats as highlighted by the examples shown here. In Germany, anti-fascist groups have offered continued resistance, producing a mass of information and printed material to announce meetings, accompany demonstrations and keep a strong voice of resistance alive. Artists have grappled with anti-racist themes: British artist Keith Piper's computerized photomontage/video piece *Surveillances* warns against the possible use of computer technologies and multi-media for the control and surveillance of aliens and non-Europeans, or any 'undesirables', within the structures and institutions of the New Europe.

Youth style magazines such as Britain's *The Face* and *i-D* have produced special editions on anti-racism and activism, pooling the artistic resources of an international collection of rock stars, artists, stylists, photographers and fashion designers. An English-speaking fax magazine called *Germany Alert*, published in Amsterdam and

3

New York, was set up by a young German-born rapper to fax reports on the mounting racism and anti-Semitism in Germany to news media and other readers throughout the world. Football supporters' clubs in countries across Europe, meanwhile, have combined anti-fascist politics with a love for football. They produce 'fanzines', banners and stickers with the aim of combating racial abuse and a neo-Nazi presence at football games.

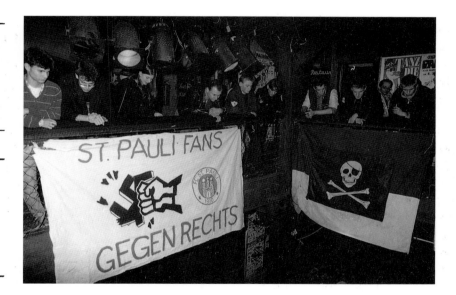

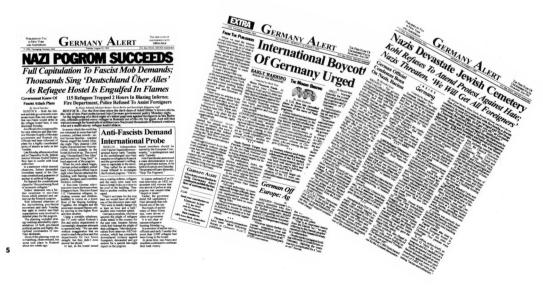

1, 2 & 4 Anti-fascist/anti-racist material produced by football supporters' clubs and groups in Europe, including the *Marching Altogether* fanzine for young people produced by Leeds Fans United Against Racism and Fascism (Britain), and stickers and banners produced by Millerntor Roar!, the St Pauli football supporters' club (Hamburg, Germany), 1991-2.

3 *Surveillances: Tagging the Other*, stills from Keith Piper's computer animation/video installation on the theme of control systems and Euro-racism, Britain 1992.

5 *Germany Alert*, an English-language anti-racist fax magazine, 1992.

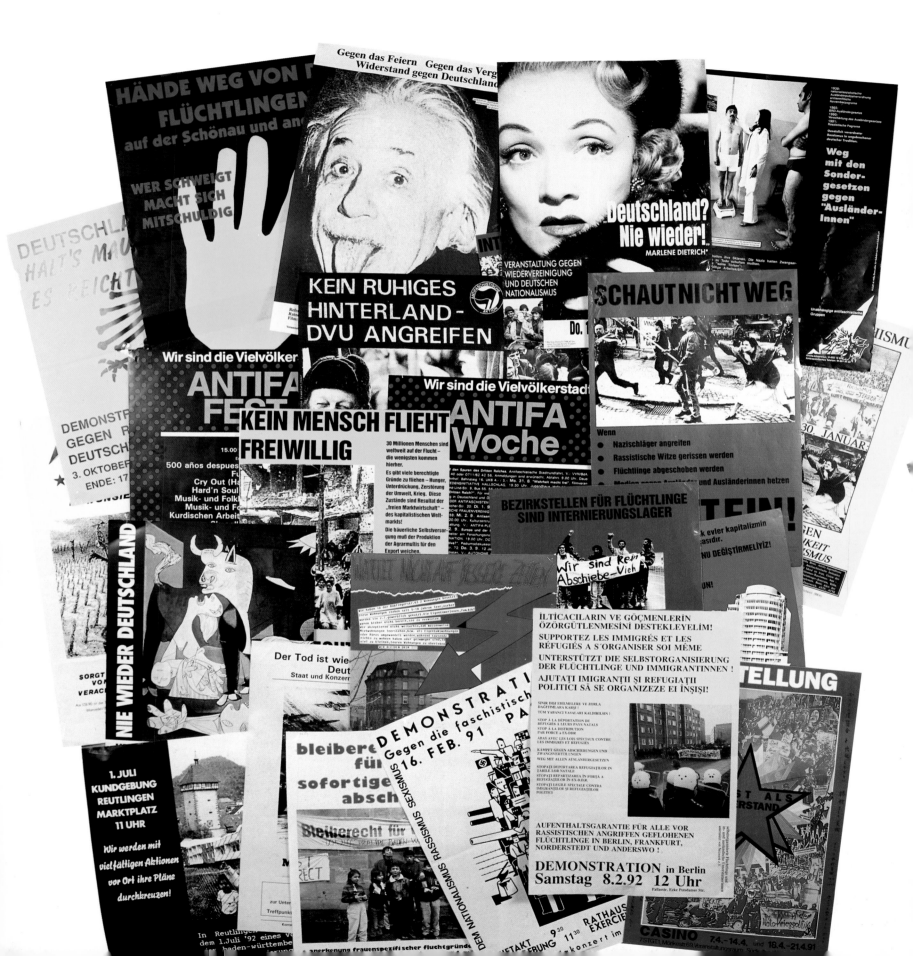

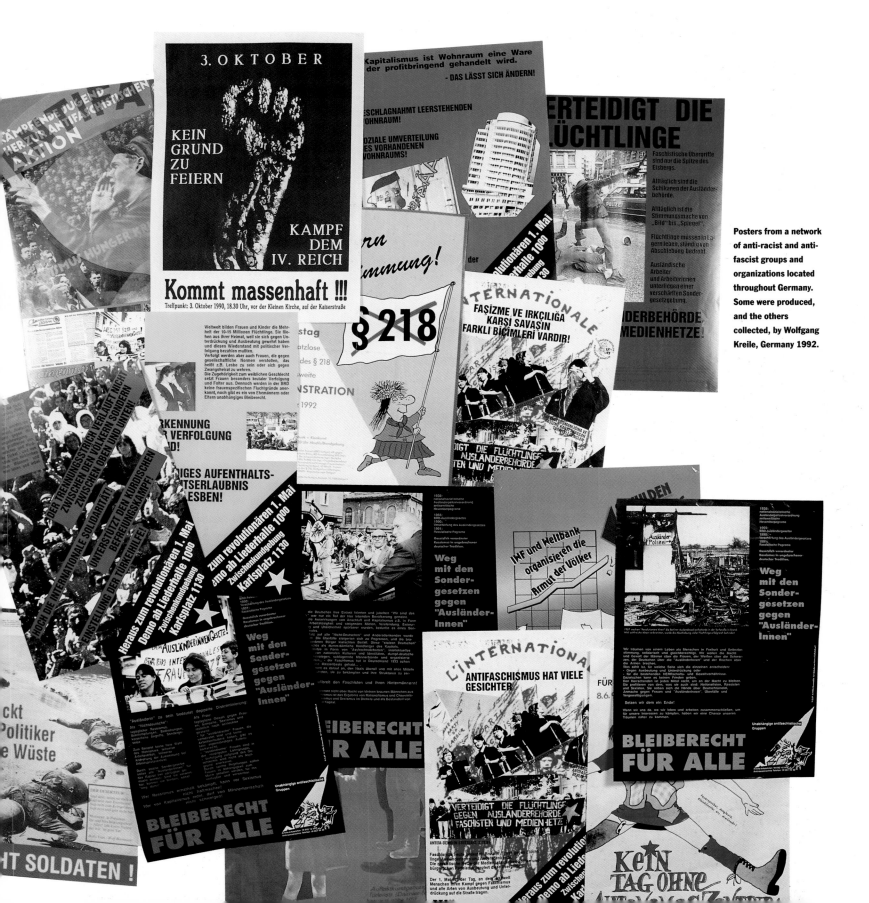

Posters from a network of anti-racist and anti-fascist groups and organizations located throughout Germany. Some were produced, and the others collected, by Wolfgang Kreile, Germany 1992.

Chapter three

STOPP

Students To Organize
Peace Politically

2

AMERIKA IS DEVOURING ITS CHILDREN

3

STRIKE because they murder
students STRIKE against the war
STRIKE to stop oppression
STRIKE because
the system lies STRIKE because they
want you to be murderers STRIKE to give
the people power STRIKE to make your country
more human STRIKE before your life
is over STRIKE

1

Shocks to the system
Alternative, anti-establishment and liberation movements

Many of our current popular movements have their roots in the ground-breaking activities of the anti-establishment and liberation movements of the 1960s and 1970s. Within a relatively short period of time (ten to fifteen years), youth challenged the old social order and its traditions and values; Feminism challenged the structures that determined women's expectations in life; the Civil Rights movement took the lid off racial tensions and set the streets ablaze; and gays and lesbians asserted their pride in a spirited call for their rights. The result was a changed world, both socially and culturally.

Extraordinary changes were in fact taking place internationally during this period: the Cultural Revolution in China, the independence movements of Africa and so on. But the graphic innovations that embodied this spirit of change to a great extent grew out of the social upheaval and youth revolutions of America. They spread to Britain, the rest of Europe, and beyond – and the graphic design industry has been under their influence ever since. However, the consciousness-raising and search for identity did not stop there. The youth movements and upheavals continue to this day, and views and protests are expressed in ever more inventive ways. This chapter is divided into two graphic 'eras':

the first comprises graphics produced by the upheavals and revolutions of the 1960s and early 1970s; the second includes both the graphic legacy of those revolutions and the new movements of the late 1970s, 1980s and 1990s.

The power struggles encompassed in this chapter relate to the fight for equality and recognition, which is essentially a fight against authority in the form of 'the establishment' or 'the system'. Some aspects of these struggles may be intensely personal, incorporating a search for individual identity, or for new aspirations and new values. But they are also about questioning the balance of power, and claiming it back for ordinary people. 'Power to the people' thus becomes an underlying theme throughout, regardless of the decade.

Whereas the chapters on National Politics and Global Issues invite a broader perspective – and sometimes grander formats for protest or concern – the revolutions of this chapter tend to be staged at street level. The struggles of the 1960s started the changes that would eventually grow into the 'personal politics' of the 1990s, and addressed themselves to essentially personal issues: sexuality, race, lifestyles, clothing and appearance, enjoyment and pleasure.

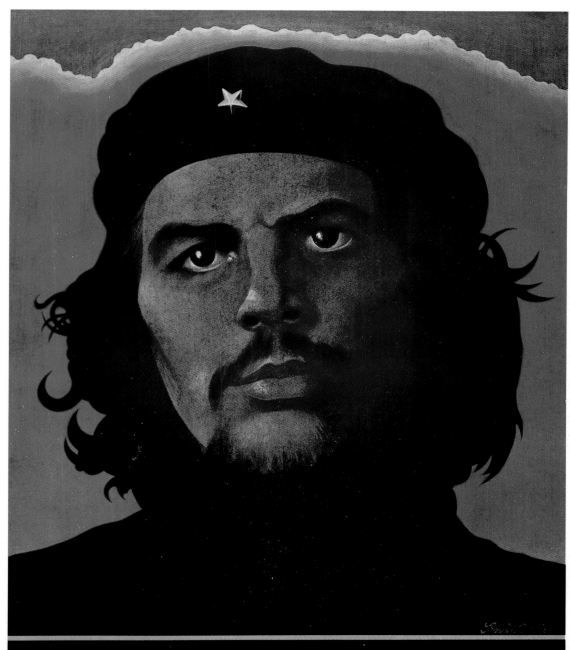

The Spirit of Che
lives in the new Evergreen!

Demand Evergreen at your newsdealer.

Signs of change and
student revolt in
America.
1 'Strike', poster by
the Student Strike
workshop at
Massachusetts College
of Art, 1970.
2 'Stopp', poster for
Students to Organize
Peace Politically, by
the Student Strike
Workshop at
Massachusetts College
of Art (artists: David
Majeau, Felice Regan),
1970.
3 'Amerika is Devouring
its Children' (inspired
by Francisco Goya's
Saturn), silkscreened
image on computer
printout paper
protesting against
the US invasion of
Cambodia. Artist
unknown, published
by the College of
Environment Design,
University of California
at Berkeley, 1970.
4 Advertisement for
the Evergreen Review
magazine, showing
the charismatic Che
Guevara, a hero-symbol
of revolution to many
American students;
illustrated by Paul
Davis, USA 1968.

4

1

2

Peace, love and revolution: a new visual language

The first signs of a youth revolution appeared on the West Coast of America in the mid-1960s. The younger generation 'dropped out', youth culture went 'underground' and developed a distinctive visual language by which young people could fight 'the system', or at least disassociate themselves from it. They created an identity of their own, for an important part of the rebellion against the establishment was rejection of its tastes and rigid codes for dress and appearance.

Thus the era of peace and love began in California and spread. Music was the great carrier; it transmitted the messages and generated the graphics that spoke for the new alternative culture. Music and drugs inspired psychedelic patterns, logos and colours that were painted onto everything from buildings to bodies. Long hair, jeans and a t-shirt became standard features, as distinct signs of lack of respect for the establishment suit-and-tie. A heady mix of decorative art movements and Far Eastern mysticism spread onto walls and textiles, and the work of artists such as Aubrey Beardsley and Alphonse Mucha became extremely popular, either reproduced in their existing form as popular prints and posters, or distorted to fulfill new decorative purposes.

Most importantly, the popular arts flourished. Posters, underground comics, cartoons in all forms, underground newspapers: all became part of the colourful visual display. Much of the typography was based on the decorated wood-type of old playbills or hand-drawn lettering, and many amateurs happily tried their hand at 'balloon lettering' and decorative borders.

The great masters of this period showed the art of the underground in its highest form: Victor Moscoso's psychedelic rock posters, for instance, or the work of Robert Crumb, Rick Griffin and others involved in underground comics. But the trend towards 'popular art' and personal image-making was equally important; it carried through all the succeeding revolutionary movements (Black Liberation, Women's Liberation, Gay Liberation) providing them with a common bond. Rough collages, crude drawings, cartoon comics and decorated lettering poured out of professionals and amateurs alike. Some of the products were bursting with liberated joy, others were bitter with anger, but all were powerful and full of vitality because of their bold lines, solid shapes and flat colours, often a product of having to print cheaply or by hand. The entire revolutionary period was documented and 'cartooned' through popular media, from the underground press to Women's Lib poster collectives and newsletters. The crude energy and immediacy of this popular art were in strong contrast to the photo-mechanical finesse to be found in corporate design and the Swiss and Germanic design influences of the same period.

The visual language of the revolution therefore popularized the struggles – and even personalized them. The graphic symbols of liberation became personalized icons; these included the female biological sign (for Feminism), black panthers (for Black Power) and raised fists (for everybody, and for all causes). They were all highly reproducible; they had no design blueprint, and thus appeared in

varying renditions. These symbols were popular forms; they belonged to the masses, and were drawn and scribbled everywhere.

The new visual language also celebrated the new heroes and heroines: Che Guevara, Martin Luther King, Angela Davis and others. It was used to redress the imbalances in history; feminist presses researched 'herstory' and brought unsung heroines into view, as shown by the Helaine Victoria postcard press on this page.

The era of peace and love in itself was short-lived, quickly developing cracks from the strain of the many social tensions of the time. Thus an undercurrent of anger and violence also ran through the visual language of all the succeeding movements. The protest movement against the Vietnam War generated a wide range of angry posters, produced by professional studios as well as grassroots workshops. Violence surfaced most blatantly in the images surrounding campus unrest, and particularly racial tension. The Black Liberation and Black Power movements produced images that were full of suppressed tension and energy, ready to lash out at the first opportunity (hence the image of the panther, ready to spring). But very little graphic symbolism was in fact attached to the movement; its imagery dealt mainly with very real and powerful events: the protests in the street, the marches and the demonstrations. The posters of the time carried portraits of the movement's new leaders, and quotations from its main speakers were formed into inspirational slogans.

A more steady, slow and simmering anger was displayed in the clenched fists of Women's Liberation, a movement which used a great deal of graphic symbolism. Literary, artistic and historical references (for instance the legendary woman warrior) were often employed to create powerful images of struggle and fighting. There was also a heavy outpouring of images relating to freedom and release that used a variety of metaphors, such as the breaking of chains or the blossoming of flowers.

The visual language of the revolution was also out to shock: it challenged taboos on sex and nudity. Underground music and its graphics made heavy use of sexual references and nudity, as part of the sexual revolution and the attempt to break free from the repressive attitudes of the Establishment. Bodies were beautiful, sex was beautiful, and the imagery of the underground 'peace and love' era was full of both. Furthermore, the sexual exploitation of women in underground comics, magazines and other publishing vehicles became a contributing element to the anger that fuelled the Women's Liberation movement. Women went on to claim back their nudity, producing their own revolutionary publications such as Britain's *Spare Rib* magazine or America's *Our Bodies Ourselves*, the classic text of the women's health movement published in 1971 by the Boston Women's Health Book Collective. These publications employed body imagery for feminist learning purposes, such as encouraging women to regain control of their bodies and their health. All in all, bodies were very much a part of the revolution and its visual language throughout the 1960s and 1970s.

3

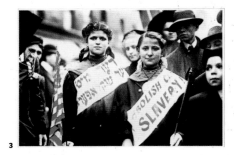

4

5

Rumblings against the Establishment, protest against the Vietnam War, and a host of liberation movements united a new generation.

1 'I Want Out', poster sponsored by the Committee to Help Unsell the War, a group comprising over 30 advertising agencies, USA 1971.

2 'Easy Rider' psychedelic image (a symbol of anti-Establishment attitude and dropping-out), poster by Theobald, USA early 1970s.

3 Postcards celebrating women's achievements from Helaine Victoria Press, established by Jocelyn Cohen in 1973 and still operating in the 1990s, USA.

4 'Women Working', poster sign by the Chicago Women's Graphics Collective, USA 1970-71.

5 Gay Liberation badge, Britain 1973-4.

The morality that guided the publishing of the sexual revolution was also brought into question many times along the way. Two obscenity battles are mentioned on pages 158-9: the fall of *Eros* magazine and the *Oz* trial in Britain. Both were well-known disputes and highly significant in graphic terms. But many similar disputes took place throughout that period – particularly with the underground comics – and it is important to remember that most of the imagery in this chapter caused consternation of one sort or another.

The legacy of the revolution was a far-reaching one, in visual terms. The revolution and its different liberation movements challenged sexual taboos, the use of gender and racial stereotypes – and broke through the all-white media construct, in recognition of the visual demands of a multi-ethnic society. There were new modes of expression and new media forms: underground comics, for example, reflected the spirit of the times and the interests of the drop-out community, while bringing some of America's existing social traumas and contradictions into sharp focus. They also created a new brand of cartoon art that had an international influence (the comics were pirated all over the world) and which gradually softened into subversive mainstream forms, as seen in the cartoon work of B. Kliban, or the film animation of Terry Gilliam and 'Monty Python's Flying Circus'.

The popularization of art, the search for new working structures and the concept of 'community art', generated by the liberation movements throughout the Sixties, brought about the creation of progressive publishing groups and poster collectives, some of which still exist today. However in the revolutions of the following two decades, the sentiments and ideas of the underground came crashing into the overground. The

nervous energy of urban culture and its newer manifestations was readily absorbed and harnessed by the commercial mainstream.

Urban culture: street style and attitude

The next era of 'revolution', in terms of graphics and the media, arose from the activities and counter-cultures of the city streets. Various forces were brewing throughout the 1970s which would bring tremendous change to mainstream design attitudes and tastes, and provide them with a much-needed recharge of energy.

The Punk movement in Britain began the new phase of change. It was similar to the Sixties revolt in America in a number of ways: young people revolted against the Establishment; music carried the message; drugs and sex were the main accompaniments, as well as social critique and shock. But there the similarities end, for as a movement Punk did not have its roots in the desire for ideological and political change; it did not have internationally agreed targets of protest; and in the end, it was not a social revolution with an international reach but more of a local dispute. Nevertheless, in terms of the visual arts, Punk's influence was phenomenal. It grew to be a highly creative cultural movement that encompassed art, music, graphics, fashion and photography, and spread to countries around the world. The designers and products involved in and around it broke existing conventions and continue to wield an influence on graphic design today.

Although not specifically a political movement in itself, Punk was affected by the art-politics of Situationism, a European avant-garde art movement which promoted participation in the creative aspects of city culture (with particular interest in subverting the established order)

1

2

3

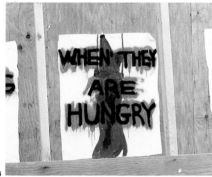

4

THE ADVANTAGES OF BEING A WOMAN ARTIST:

Working without the pressure of success.
Not having to be in shows with men.
Having an escape from the art world in your 4 free-lance jobs.
Knowing your career might pick up after you're eighty.
Being reassured that whatever kind of art you make
 it will be labeled feminine.
Not being stuck in a tenured teaching position.
Seeing your ideas live on in the work of others.
Having the opportunity to choose between career and motherhood.
Not having to choke on those big cigars or paint in Italian suits.
Having more time to work after your mate dumps you
 for someone younger.
Being included in revised versions of art history.
Not having to undergo the embarrassment of being called a genius.
Getting your picture in the art magazines wearing a gorilla suit.

Guerrilla Girls CONSCIENCE OF THE ART WORLD

5

In the 1980s, the emphasis was on street art and urban creativity.
1 'Ice', by Chicago graffiti artist Mario Gonzalez Jr, USA 1991.
2 Invitation to an underground hip hop party, graffiti art by Rafa, USA 1992.
3 'Charm' (10ft x 25ft) by Mario Gonzalez Jr, USA 1989.
4 'Causes of Revolution', series of 12 posters by Jennie Kiessling pasted up in a Chicago Street, USA 1989. The series reads: 'People start an uprising when they are hungry and have nothing left to lose. As long as governments don't function so that people live in dignity there will be revolution.'
5 Poster and postcard by the feminist art activist group Guerrilla Girls, USA c.1990.

while drawing upon the graphic vocabulary of comics, advertising and other modern materials. In Punk terms, this subversion meant playing in bands, not going to work in boring jobs, and publishing street papers or 'fanzines'. The philosophy was transferred to Punk by Malcolm McLaren (manager of the Sex Pistols) and Jamie Reid; both had been involved with the Situationists and were later central figures in the Punk movement in Britain. Jamie Reid in particular, as art director of the Sex Pistols group and creator of all their graphic requirements, created the anarchic visual language associated with Punk. This was characterized by the use of 'ransom' lettering, labelling and other recycled elements; bright brash colours (indicative of supermarket packaging); crude photo-reproduction; aggressive cut-out or torn shapes; and perhaps most importantly, a chaotic and spontaneous layout.

The effect of this anarchic vision on the graphics world at that time was explosive. Graphic design shed its tired image as an élitist corporate tool, and once again became a populist means of personal expression. Punk's do-it-yourself graphics, 'fanzines' and music publicity opened up a new realm of possibilities for self-publishing and street magazines. Not surprisingly this emphasis on urban creativity led

to the 1980s preoccupation with lifestyles, street style and youth-related formats: most notably, British style magazines such as *The Face* and *i-D*. The 1980s were owned and operated by the youth generation: young people had financial power; young designers were at the top of the profession; young people were promoting environmental issues; and young people were redefining 'politics' in their own terms.

It was within this scenario that Band Aid and Live Aid were staged in the mid-1980s, and it's not surprising that their vehicles were youth formats: a record single and a global rock concert. The combination of youth politics and rock/pop music countered 'the establishment' by overriding the inaction of bureaucrats and politicians, and generated unprecedented amounts of famine relief for Africa. In the charitable 'one world' atmosphere that followed, social and political issues found their way onto a much broader range of public formats. Charity and humanitarian aid, animal rights, ecology matters, anti-drug campaigns and other issues were thrown at a receptive public by means of billboards and advertising campaigns, street fashions, street posters and magazines – creating a mood of social awareness that would carry through to the 1990s.

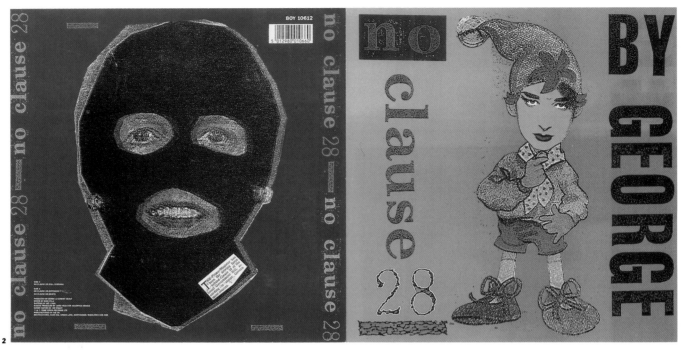

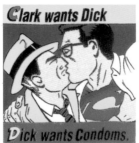

Another form of urban expression that evolved throughout the 1970s was graffiti art. Although graffiti in New York City harked back to street gangs marking out territory in the 1960s, it found a more expressive role in the graffiti writing of the early 1970s when teenagers began to 'tag' subway trains and buildings with their name (usually a pseudonym) and street numbers. This led to tags (stylized signatures) being treated as elaborate logos, and the development of spray painting on a larger scale; by the mid-1970s whole subway cars were being covered. With the development of 'wildstyle' lettering, 3-D effects and added cartoon characters, graffiti scrawls grew into highly sophisticated spray can art – a genre with its own codes, vocabulary, aesthetics, traditions and folk heroes. As a result of the hip hop explosion of the early 1980s, the graffiti/spray can art movement spread beyond New York and also began to impinge on the art gallery scene. In the 1990s a legitimate graffiti-based street art has evolved; what used to be illegal on subway cars as vandalism is now commissioned in some cities as 'street murals' for commercial walls.

It has also found an important role in US inner-city community life. Graffiti art and street murals are used to carry social messages and

warnings in a language that is meaningful to the young inhabitants of the local community; hence graffiti art is seen as a creative alternative to gang involvement. Community programmes also exist which aim to introduce graffiti artists into conventional art or graphic design education. While the trend towards acceptance of graffiti art as a valid art form for galleries has been slow, its substantial influence on the field of graphic design has been readily acknowledged over many years.

Another cultural force came into sharp focus in the late 1970s: rap, the black American popular music that grew out of the hip hop subculture based in New York's Harlem and the Bronx. Rap hit the charts in 1979 and spread internationally, accompanied by other forms of urban expression such as break-dancing, disc jockeying, and graffiti art – all forms that achieved high levels of creativity from very limited resources. A mixture of poetry, music, style, fashion and attitude, rap was a cultural force that became a consciousness-raising vehicle and a political tool for the black community.

As the 1980s moved on, black identity and culture were explored (and celebrated) through an ever-growing variety of visual arts and graphic applications. These included the films of Spike Lee and their

associated products; rap records, magazines, videos and accompanying graphics; pirate radio stations; and hip hop fashion. These vehicles also encouraged renewed interest in Black Nationalism, the heroes of the Sixties and Afrocentrism, an exploration of the historical contribution of African cultures and civilizations to the development of the world.

Other popular movements which fought for liberation in the 1960s found expression throughout the 1980s in both commercial and street graphics. Feminism carried on to achieve great commercial success in the 1980s through publishing houses such as Virago and the Women's Press in London. (The Women's Press was particularly known for its strong visual identity.) Equal graphic strength was shown at street level, through the poster campaigns produced by the Guerrilla Girls attacking discrimination in the New York art gallery world, the banners and photographs of the peace protests of Greenham Common, and other inspired projects.

Feminism rallied to meet one of its greatest conflicts in the American Pro-Life and Pro-Choice disputes of the late 1980s and early 1990s. In a battle that still rages, each side has employed highly contrasting graphic strategies. The Pro-Life movement has operated large, highly-organized visual propaganda campaigns that spread the movement's doctrine through a variety of 'selling' techniques – ranging from a 'clinical' approach incorporating statistics and medical research, to the hard-sell tactics of slapping slogans on everything from bracelets to balloons. The Pro-Choice movement, on the other hand, has been less of a propaganda machine; their strategy has been to argue through isolated projects of personal conviction. It has generated works ranging from the bold strength of Barbara Kruger's 'Your body is a battleground' to Ilona Granet's humourous 'State Womb': an image which mocks government possession or control of a woman's womb (page 173).

The lesbian and gay communities also moved from ground-breaking liberation to assertive pride in the 1980s. Having had to fight for so long for recognition of their sexuality, the 1980s became the decade when visual imagery in support of gay and lesbian lifestyles really began to flower. It was also the decade that brought us the AIDS crisis. Acutely aware of the vulnerability of its members, the gay community took the lead in AIDS activism, constantly pushing it from the marginalized sidelines into the very centre of political debate.

The surge in the popular arts during the 1960s, and the rise of urban creativity and its graphic forms in the late 1970s and 1980s, were extremely important developmental stages in the growing use of graphics for personal expression and the visual communication of 'attitude' by people in the street. Now anti-establishment attitudes and popular movements are widely expressed through visual culture. Graphics have merged with style, fashion, music, film and other creative arts to produce a vibrant show of the power of the people. After three decades of consciousness-raising and awareness activities, the 1990s has become the era of 'personal politics', and design and style are viewed as ways of expressing identity and awareness.

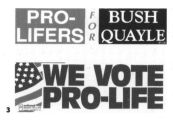

3

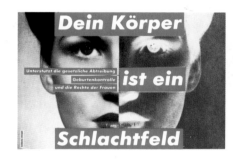

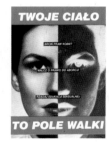

4

Debates about sexuality continue into the 1980s and 1990s.
1 T-shirt produced by the Golden Gate chapter of the AIDS activist group ACT UP, USA 1992.
2 'No Clause 28' record sleeve for pop singer Boy George, designed by Jamie Reid and Joe Ewart, 1988 – one of many protests against Clause 28, the British bill forbidding the 'promotion' of homosexuality.
3 Pro-Life bumperstickers, USA 1992 (Presidential election year).
4 Poster for the 1989 Pro-Choice March on Washington, by Barbara Kruger. The image was also used to promote women's rights issues in other countries: shown here are a subway poster from Berlin and a street poster from Warsaw (both 1991).

1

The underground: peace and love

In the early 1960s a new young generation rebelled against the values and goals of 'the establishment'. Youth culture went 'underground', devising its own vision of an alternative society and finding cultural expression through music, sex and drugs. California became the epicentre of this youth revolution, and the birthplace of many of the new art and media forms.

The visual styles that emerged encapsulated the energy and free-wheeling spirit of the time. The most dominant visual style was 'psychedelia', which dazzled the eyes by twisting lurid day-glo colours into complex patterns reminiscent of drug experiences. Comics, cartoons and 'pop art', the paintings and icons of Far Eastern mysticism, decorative embellishments from art nouveau and art deco, and the fat, chunky alphabets of old circus and theatre playbills all came into play. This decorative mixture exploded onto clothes, textiles, posters, badges and other products.

The psychedelic posters that advertised rock events rate among the best work of this period (particularly 1965-8), and their bright colours and decorated lettering were soon drawn into the mainstream. The best known exponents of the genre included Victor Moscoso (who studied with Josef Albers at Yale and was responsible for the most vibrant

2

colour contrasts), Wes Wilson, Stanley Mouse, Alton Kelly and Rick Griffin, most of whom were also involved in another important vehicle of the time: underground comics.

A distinct revolt against the American way of life, underground comics flaunted sexuality, drugs, fantasies and street culture all in one package. The late 1960s to mid-1970s was their golden period and there were countless titles. (Robert Crumb's *Zap Comix*, begun in 1967, was probably the most famous series.) Stories and characters revolved around a hippie-style existence of sex and dope; and outrageousness was the main facet of their appeal. Robert Crumb, the most popular of the cartoonists, was responsible for the adventures of such bizarre characters as 'Mr Natural', and his images popularized the well-worn phrase 'Keep On Truckin' which became the hallmark of the West Coast attitude.

4

3

1 One of many 'Keep on Truckin'...' motifs by Robert Crumb.
2 Illustrated cover by Rick Griffin for *Zap Comix No. 3*, 1968-9.
3 Robert Crumb's 'Street Corner Daze', inside spread from *Zap Comix No. 3*, 1968-9.
4 Psychedelic rock poster *(Family Dog No. 81)* by Victor Moscoso, 1967. Family Dog was a producer of rock concerts and dances.

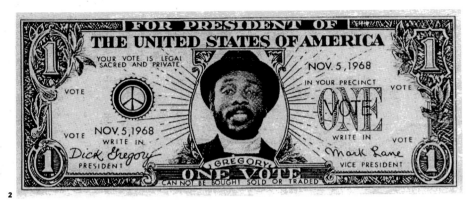

2

The underground press

1

Alternative culture developed its own communication lines, and accessories for daily living. The emerging underground movement needed a medium for expressing itself, and exchanging ideas within (or beyond) the community. Helped greatly by the advent of cheap offset litho printing, the underground press scene soon flourished and included such titles as the *Berkeley Barb*, *LA Free Press*, *San Francisco Oracle* and many other newspapers and magazines produced throughout America.

The underground press movement quickly developed into an international communications network. The prolific American papers made their way overseas, taking protest imagery, cartoons and cries for liberation with them. Europe supplied its own counter culture and magazines (such as *Provo* in Holland or *Ink*, *International Times* and *Oz* in Britain) which carried news of the Paris riots, the *Oz* trial and other events. Ideas spread rapidly; people travelled from country to country, and dropped into news offices or helped out in poster collectives as they were passing through. International connections were an important aspect of alternative culture throughout the 1960s and 1970s, and one of the outstanding characteristics of that period was that the smallest poster group – or the most obscure newspaper – could have an international reach.

3

1 Hippie hand-sign for 'peace', sew-on embroidered patch, *c.*1970.
2 Fake money from the 'Dick Gregory for President' campaign (reputed to operate change machines), 1968.
3 Cigarette rolling papers, more likely to be used for rolling a marijuana joint, 1970.

4 Street poster from the campaign promoting Dick Gregory as the underground's candidate for President in the 1968 election.
5 Front page of the underground newspaper *Berkeley Barb*, 1968.
6 Front page of the underground newspaper *Los Angeles Free Press*, with an illustration by Ron Cobb, 1968.

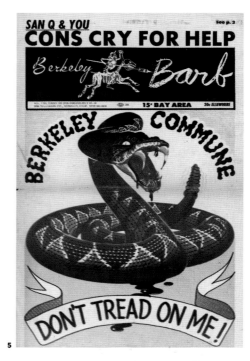

5

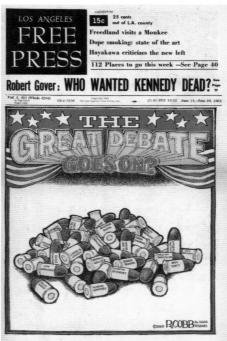

6

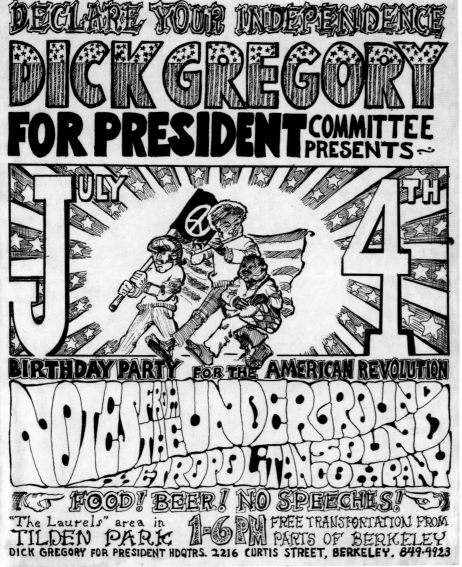

4

1 Poster portrait of Bob Dylan, 1966 (folded into an album sleeve), and poster announcing a performance by singer Mahalia Jackson, 1967. Both were designed by Milton Glaser, co-founder of Push Pin Studios, New York.

2 Visual pioneers John Lennon and Yoko Ono on the back cover of the 'Unfinished Music No. 1: Two Virgins' album, with full-frontal nudity on the front cover and a protective outer sleeve covering all. Released in 1968 by Apple Records.

Icons from the era of peace and love

1

The era of peace and love was characterized by a creative energy that gave rise to many innovations; three icons of that visual revolution are discussed here.

Push Pin Studios brought the best of West Coast psychedelia into East Coast mainstream graphic design. Founded in 1954 by Milton Glaser, Seymour Chwast and Edward Sorel, their use of florid, decorative illustration and a colourful mixture of influences (both past and present) created a bright, punchy and identifiable new genre of graphic design that became highly popular during the 1960s. Among their most influential graphic works were Glaser's *Dylan* and *Mahalia Jackson* and Chwast's anti-Vietnam posters.

How to Keep Your Volkswagen Alive was a car repair manual for maintaining the Volkswagen Beetle (the adopted car of the hippie community), and a landmark in information design. Written by the late John Muir, it pioneered a friendly approach to technology, as well as communicating technical matters in layperson's terms. It assumed no prior expertise, and no special tools were required; these were replaced by homespun methods using commonplace equipment. The humourous, easy-to-follow diagrams matched the laid-back, conversational tone of the text, which advocated communicating with the car, respecting its karma, and carrying out all work with a sense of Love. First published in 1969, *How to Keep Your Volkswagen Alive* has achieved cult status over the years.

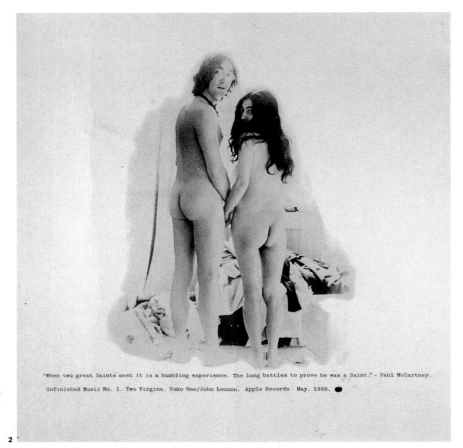

2

"When two great Saints meet it is a humbling experience. The long battles to prove he was a Saint." – Paul McCartney.

Unfinished Music No. 1. Two Virgins. Yoko Ono/John Lennon. Apple Records May. 1968.

John Lennon and Yoko Ono were the first real international rock couple, and dared to push their 'Power to the People' politics into the public view (often in a graphic format). Both were successful artists in their own right, but as a couple they broke barriers that rattled the conservative establishment to the core – particularly in America. They broke the nudity barrier, with their full-frontal nudity on the 'Two Virgins' album cover; they broke the racial barrier, as a mixed-race couple; they broke the age barrier, for when they met in 1966 Lennon was 26 and Ono was 33; and they broke the politics barrier, as rock artists showing a heavy political platform and an anti-Vietnam stance. Their anti-Vietnam protests were world famous, such as the 'love-in' staged in Amsterdam in 1969 when they had themselves photographed in bed as a protest for peace.

3 Cover and inside spreads from *How to Keep Your Volkswagen Alive* by John Muir, with illustrations by Peter Aschwanden; first published in 1969, the 1989 edition is shown here.

4 Many of the original drawings were retained but updated and refined: this illustration from the 1971 version hints at the original's rough charm.

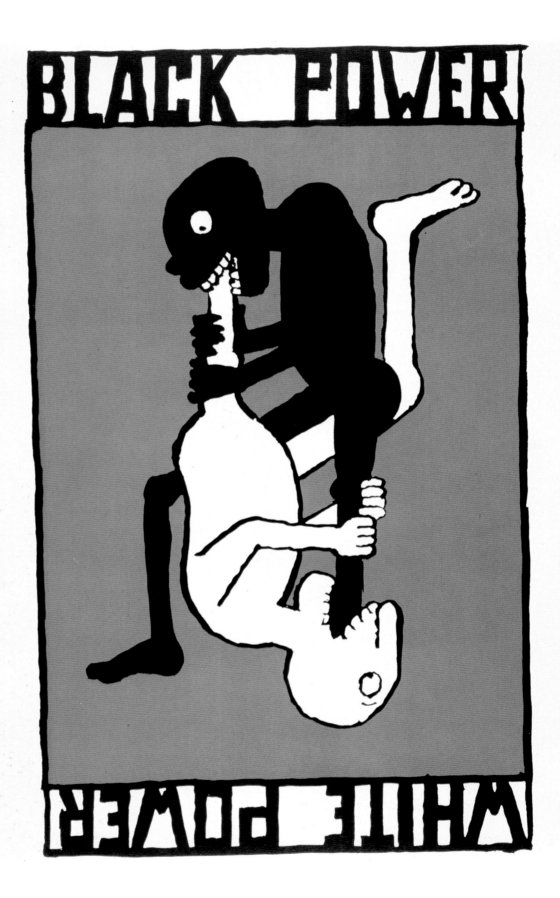

1 'Black Power, White Power', poster comment on US race relations by Tomi Ungerer, 1967.
2 & 3 Images travelled across the ocean: cover and inside spread from British underground magazine *International Times* (No. 133). The cover shows a well-known photograph of a US student demonstration at Columbia University in 1968.
4 'Two More in Mississippi', from a silkscreened poster by the Student Strike Workshop at Massachusetts College of Art showing solidarity with the Black Power movement, USA 1970.

1

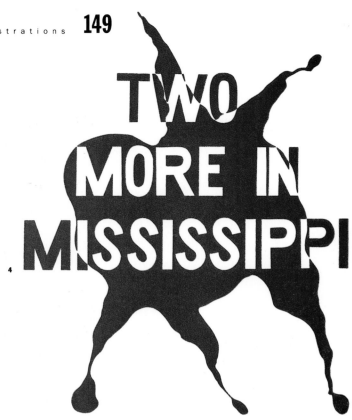

Society in upheaval: images of tension

As the 1960s rolled on, the psychedelic mood of 'flower power' and the era of peace and love gave way to emerging social tensions.

J. F. Kennedy was assassinated in 1963. Civil rights marches grew increasingly strong; in 1965 tensions erupted with racial riots in the Watts area of Los Angeles. President Johnson took American troops into the Vietnam War in 1965 and anti-war protests and demonstrations increased in number and force. Student unrest and campus riots hit their peak during 1969-70 with the American invasion of Cambodia; violence, bloodshed and cries of police brutality grew to be common occurrences. In 1970 there was intense public outcry when four students were killed by National Guardsmen at a demonstration at Kent State University.

Social comment poured from a variety of sources: professional artists, designers and studios rallied; and countless art collectives and student workshops flourished during this period. One of the most famous was the Student Strike Workshop at Massachusetts College of Art founded in 1970 during a one-month anti-Vietnam strike staged by staff and students (the workshop still operates today as the Graphic Workshop in Boston). Many of these groups protested against the war or created public murals, protest projects, or art/publishing facilities for Women's Liberation, Black Liberation, Gay Rights and a broad span of other equality issues – and their imagery was gradually transported to Europe via the underground network.

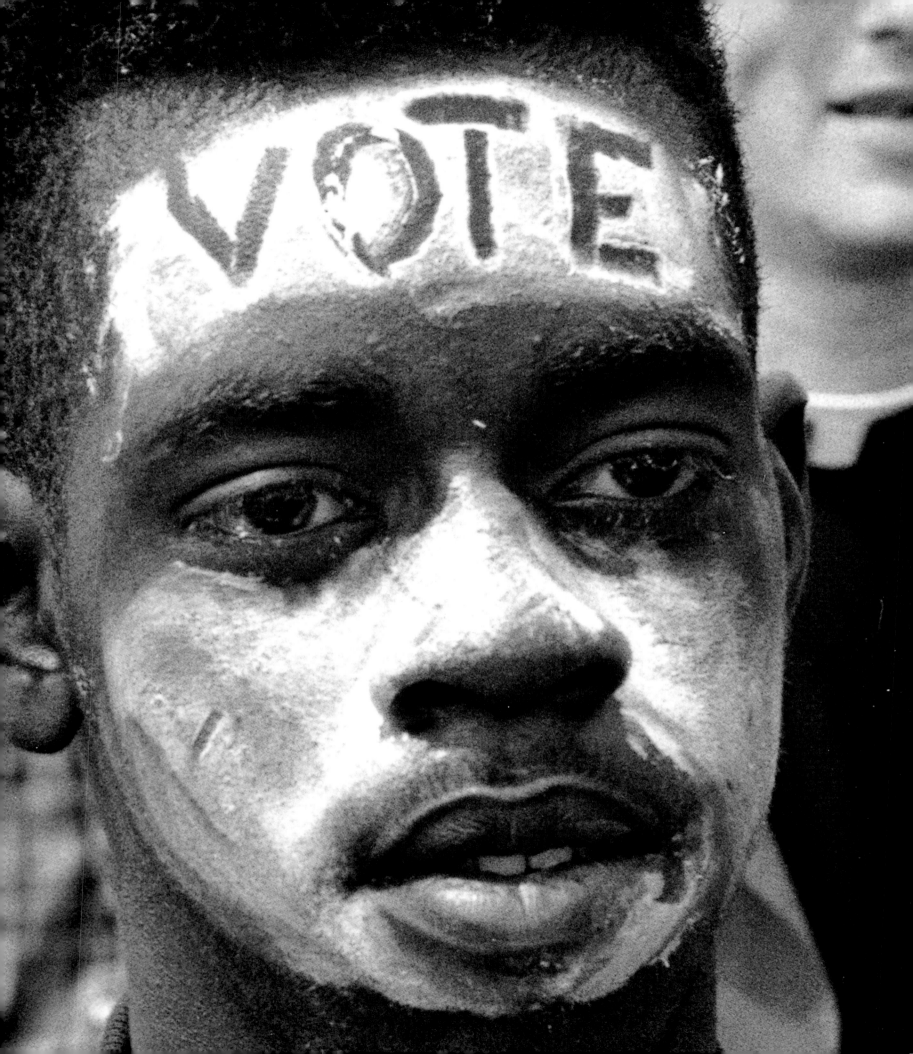

3

Civil Rights, Black Liberation, Black Power

1 Photograph by Matt Herron, taken on the Selma-to-Montgomery march for voting rights, Alabama 1965. Many marchers put zinc oxide on their faces to prevent sunburn during the 54-mile march in the hot sun; this one wrote a message of conviction on his forehead.
2 Dr Martin Luther King memorial poster, produced by the Southern Christian Leadership Conference, USA 1968.
3 The mark of the Black Panther Party for Self-Defense, founded in 1966 in the wake of the Watts riots in LA.
4 'Free Bobby' (Bobby Seale, co-founder of the Black Panther Party), poster by the Student Strike Workshop at Massachusetts College of Art (artist: James DiSilvestro), USA 1970.
5 Poster carrying the liberation slogan 'Black is Beautiful', USA c.1968.
6 'I am a Black Woman', poster in support of the imprisoned Black Panther activist Angela Davis, designed and produced by Richard McCrary, USA 1971.

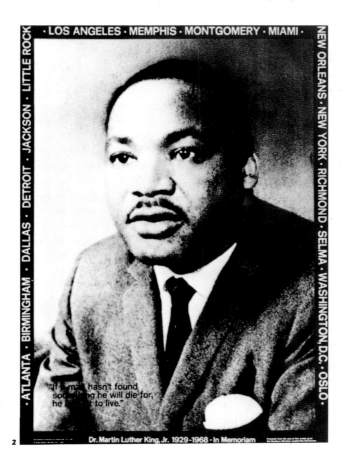

In the mid-1950s the Civil Rights movement gained a leader in the Reverend Martin Luther King, and began the long, slow struggle for equality. There were to be many traumas and conflicts over the next two decades. Riots occurred over the enrolment of the first black student, James Meredith, at the University of Mississippi in 1962. Weeks of city rioting and protest in 1963 climaxed in a peaceful demonstration in Washington DC, where Martin Luther King delivered his 'I have a dream' speech, presenting his inspired vision of dignity and equality for black Americans.

King himself led the march in 1965 from Selma to Montgomery, Alabama, to call for voting rights; and the summer brought the race riots in the Watts district of Los Angeles in which 34 people were killed. In that same year the revolutionary leader Malcolm X was shot and killed in New York, and in 1968 Martin Luther King was assassinated in Memphis, Tennessee. The movement reached boiling point, and there it remained into the 1970s. With the added thrust of Black Consciousness emanating from Africa, the Black Liberation movement was born.

The graphics associated with these developments mourned the leaders that the movement lost along the way, but brought solidarity and exposure to activists and groups such as the Black Panthers (a Black Power group formed by Bobby Seale and Huey Newton in 1966), and reinforced the assertiveness of Black Pride while popularizing slogans such as 'Black is Beautiful'.

1

Women's Liberation: sweet freedom and celebration

The call for women's equality and rights surged through the decade with all the other protests – and in the mid- to late 1960s, a mass movement was born. Women's Liberation called upon all women as a group to challenge the existing politics of male/female power relations.

Over the decade of the 1970s, the movement brought about many changes in the way women were viewed by society, and themselves. The revolution came through consciousness-raising groups, protests and many other vehicles. 'Women's issues' included women regaining control over their bodies and health; making choices over pregnancy and childbirth; gaining equal opportunities and equal pay at work; and combating violence against women. The movement was also characterized by international networking. Women's groups and feminist presses existed all over the world, and rallied around International Women's Day on 8 March.

Through feminist publishing a new focus was placed on women's creative work and writing, and attempts were made to start addressing the imbalance in reporting and assessing women's achievements throughout history. The movement benefited from a strong graphic symbol and from the protest graphics of poster collectives, college presses and women's groups; the most important of the time included the Chicago Women's Graphics Collective in America and the See Red Poster Collective in Britain.

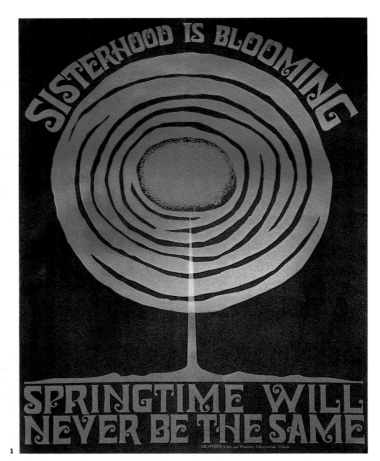

In America Sheila de Bretteville pioneered a relationship between design and Feminism. She initiated the Women's Design Program at the California Institute of the Arts in Los Angeles in 1971, the first course of its kind. In 1973 she co-founded and directed the Woman's Building, a public centre for women's culture in Los Angeles, and within it the Women's Graphic Center which offered teaching and print facilities to women and women's groups. Both the Building and the Graphic Center became internationally known, and still exist today.

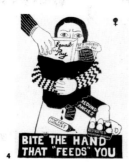

4

6

7

8

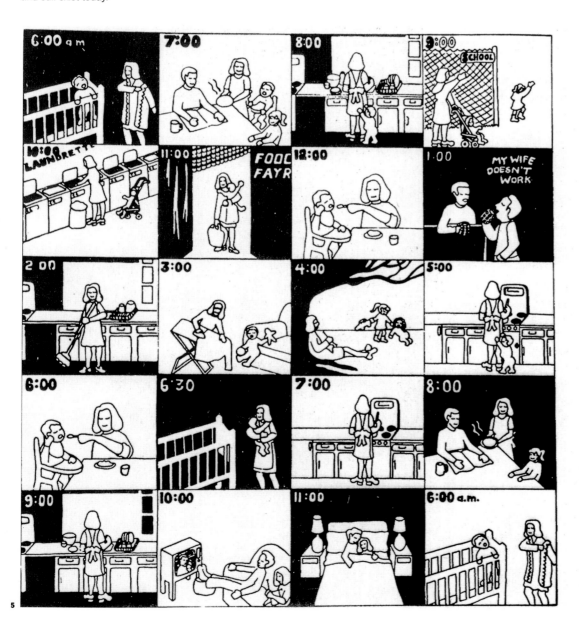

5

1 'Sisterhood is Blooming', poster by the Chicago Women's Graphics Collective, USA *c.*1970.
2 Poster for the conference 'Women in Design: the next decade' by Sheila Levrant de Bretteville, USA 1975.
3 Front cover of the graphic design magazine *Print*, USA 1970.
4 & 5 Posters from 'See Red' women's poster collective, Britain *c.*1974. Shown are 'Bite the Hand That Feeds You' (i.e. the bureaucracy) and 'My Wife Doesn't Work'.
6, 7 & 8 Images from early days in the movement showing variations on the Women's Liberation symbol.

1

2

4

The demand for women's liberation produced imagery that often underlined the violence of the struggle, or employed symbolism to powerful effect.
1 Badge, mid 1970s.
2 Front cover of Germaine Greer's influential book *The Female Eunuch*, published in Great Britain in 1970.
3 'Great Mother Sphinx', highly controversial poster by artist and writer Monica Sjöö, Britain 1969.
4 'In Celebration of Amazons', poster using the popular image of the female warrior, by the Chicago Women's Graphics Collective, USA 1974.

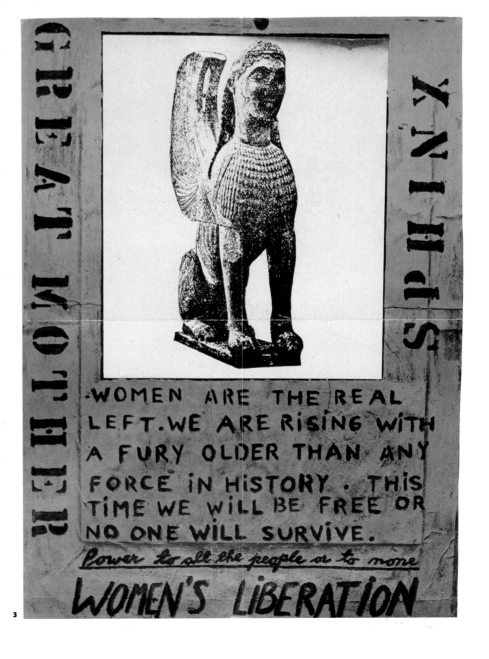

WOMEN ARE THE REAL LEFT. WE ARE RISING WITH A FURY OLDER THAN ANY FORCE IN HISTORY. THIS TIME WE WILL BE FREE OR NO ONE WILL SURVIVE.
Power to all the people or to none
WOMEN'S LIBERATION

3

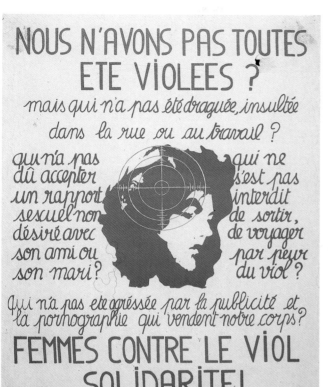

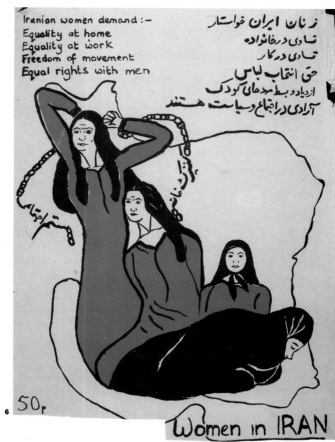

5

6

50p

Iranian women demand :—
Equality at home
Equality at work
Freedom of movement
Equal rights with men

Women in IRAN

5 'Women Against Rape
Unite!'. Poster
announcing meetings
of the Women Against
Rape collective, France
1970s.
6 Poster, artist
unknown, 1970s.
7 Front and back cover
of a special issue of the
Cambridge University
students' literary
magazine *Granta*,
humorously depicting
the feminist
transformation from
dolly-bird to
revolutionary, Britain
*c.*1971.

7

Britain: challenging taboos of sex and class

The Sixties mood of change in Europe brought
the breakdown of the old social order,
expressed in full force in the renowned Paris
street riots of May 1968 (page 54). Britain
however had been experiencing a slow erosion
since the start of the decade, or even before.

The introduction of the Pill, the lifting of
the publication ban on D.H. Lawrence's *Lady
Chatterley's Lover*, the satire boom and the
Profumo affair were just a few of the
disturbances in the early 1960s that caused
cracks to appear in the structures of the 'old
guard'. By the middle of the decade 'Swinging
London' was underway: a period of youth,
energy and affluence marked by new forms of

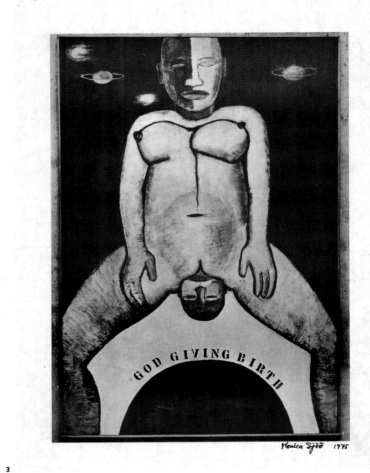

3

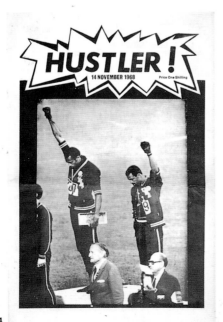

1

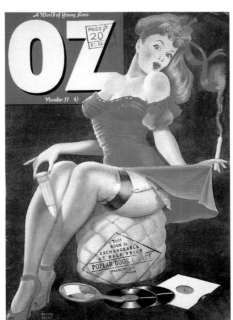

2

expression. The Beatles, Carnaby Street and innovations in fashion, film and photography brought worldwide attention, and within a few years 'the underground' was in operation. The psychedelic art forms of the American West Coast arrived and left their mark, and relaxed attitudes towards sex and morality permeated the imagery of this period.

America's tensions and revolutions also spread to Britain, transferred through both mainstream media and the underground

press. By the early 1970s, Women's Liberation and other movements had caught on. But the buzz of optimism and hope, and the visions of a freer society crashed to the ground as the world moved into economic recession. Britain's radical spirit placed its strength behind the new libertarian movements and the urgent issues of home politics, and produced a whole generation of radical poster collectives, printshops and community art groups.

1 Front cover of British newspaper *Hustler*, showing the medal awards ceremony at the 1968 Olympics in Mexico, when two American athletes gave the Black Power salute.
2 Front cover of *Oz*, Britain's most famous underground magazine.
3 Poster reproduction of Monica Sjöö's painting *God Giving Birth*,

Britain, 1968. The image came under threat for 'obscenity and blasphemy' and became an important feminist icon.
4 Front and back cover of *Bloody Women*, a publication by Scarlet Women (a women's liberation group in or around Cambridge University), Britain c.1971.

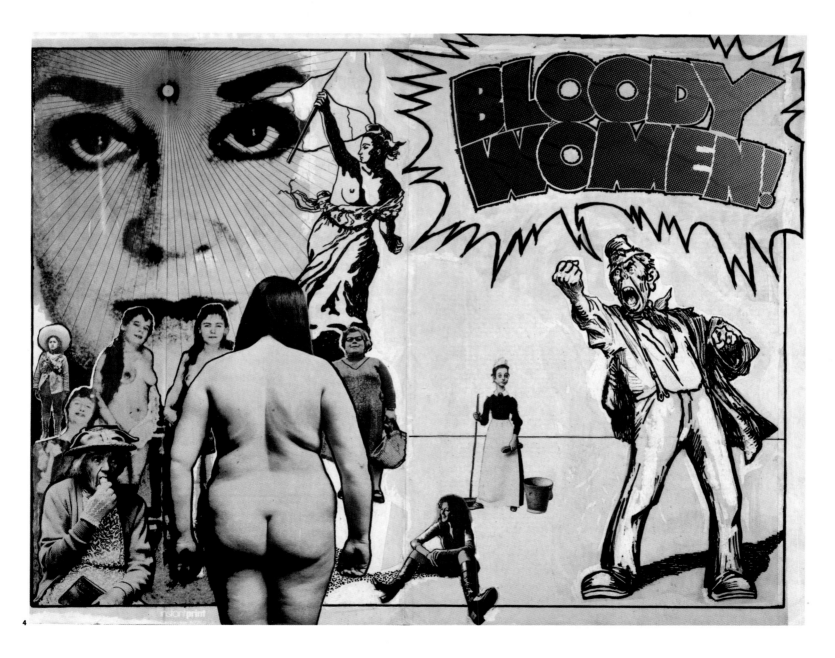

4

The obscenity battles of Eros and Oz

The sexual revolution that occurred in the
1960s and 1970s had its casualties. Many
cries of obscenity erupted against the new art
and media forms; two battles are mentioned
here for their particular relevance to the
graphics world.

Eros magazine, an expensively produced
hardcover quarterly journal, was launched in
the USA in 1962. Edited and published by
Ralph Ginzburg, it was intended to be an
intelligent publication on sex, love and
romance, available by post on subscription.
Illustration sources ranged from Salvador Dali
to Albrecht Dürer; literature from *Mother
Goose* to the Bible. It also benefited from the
brilliance of the renowned graphic designer
and lettering artist Herb Lubalin, whose
expertise ensured that the magazine received
many art direction awards at the time and has
been hailed as one of the classics of Sixties
publication design ever since. (Ginzburg and
Lubalin also collaborated on *Fact* and *Avant
Garde* magazines.)

More a lavish art journal than a 'dirty
magazine', *Eros* had only produced four issues
when Ginzburg was indicted for using the mail
to distribute obscene materials. An appeal to
the Supreme Court brought a conviction in
1966 and after five more years of appealing,
Ginzburg was finally convicted of 'commercial
exploitation', 'titillation' and 'pandering'. In
1972, after a ten-year fight, Ginzburg finally
went to jail and served 18 months. The sexual
revolution had lost a major battle, as well as
an extraordinary publication.

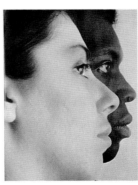

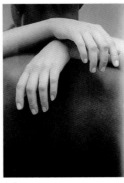

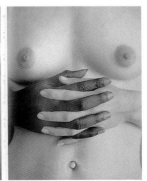

1

The rise and fall of *Oz* was a very different matter. Launched in 1967, *Oz* was Britain's most renowned underground magazine. It was rude and offensive (to the Establishment) and used sex as a revolutionary tool: to shock. Its content was a mixture of radical discussion of ecology and the new liberation movements, and underground interests such as drugs, music and mysticism. But its greatest asset was its anarchic appearance, the product of designers such as Martin Sharp and Jon Goodchild and their experimentation with the newly-developed offset litho printing process. The result was 'mind-blowing': whole pages of psychedelic splendour, with coloured text laid onto lurid backgrounds (at times completely unreadable).

The magazine reached its peak when in 1971 the 'School Kids' issue (produced by a guest editorial team of adolescents) was seized by police. The three *Oz* editors – Richard Neville, Jim Anderson and Felix Dennis – were charged with 'conspiracy to corrupt public morals'. There followed a six-week obscenity trial – the longest in British legal history – which turned into a battle between the Establishment and the 'permissive society'. There was public outcry and protest, and press and TV coverage from around the world. The three editors were cleared of conspiracy but *Oz* was condemned as obscene. The editors were sentenced, but were later acquitted upon appeal. The final issue was produced in 1973, and the magazine has remained an enduring symbol of social revolution.

4

5

1 Covers and spreads from *Eros* magazine, summer, autumn and winter 1962, including a portfolio of Bert Stern's studio photographs of Marilyn Monroe taken shortly before her death, and 'Black & White in Color', a photographic essay by Ralph M. Hattersley Jr.
2 Page from *Oz* relating to the results of the magazine's obscenity trial in 1971.
3 The 'School Kids' issue of *Oz* magazine that provoked the obscenity trial.
4 Inside spread from *Oz*, showing the magazine's renowned psychedelic printing effects.
5 Cover of *Oz* by Martin Sharp, Britain 1967.

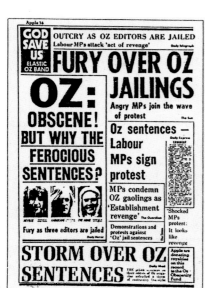

2

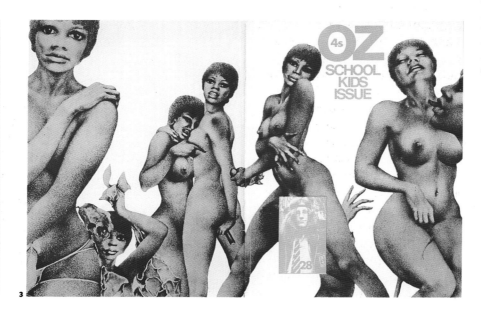

3

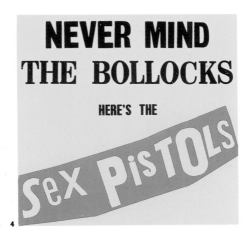

Punk graphics and street style

The British Punk movement of the mid-1970s was a distinct move away from the affluence and slick professionalism of the 1960s, and back to the energy of the streets. It borrowed its sense of subversion and politics from the French art/politics movement known as Situationism – particularly the notions of subverting the status quo by having fun, and developing the creative aspects of city culture. In Punk terms, this meant playing in or listening to aggressive bands in small, sweaty clubs (bands such as the Sex Pistols, the Buzzcocks, the Clash and Siouxsie and the Banshees); putting together small papers or magazines ('fanzines') and selling them in the streets; and having a good time while creating a subversive counter-culture in the midst of a severe British economic depression.

With unemployment, gloom and disillusionment in the air, anarchy was seen to be creative. Style and fashion became an important means of self-expression (the more exhibitionistic, the better), and was led by fashion innovator and creator of bondage-wear Vivienne Westwood. Punk was maintained by the 'enterprise' and energy of 'kids' and the rejection of all that was boring and paternalistic. It was a highly visual movement that challenged the popular image of fashion and culture, and its subversive attitudes had a dramatic effect on art, music, graphics, fashion and photography.

Jamie Reid designed all of the graphic requirements (such as posters, album sleeves and t-shirts) for the first and most notorious Punk group, the Sex Pistols. In the process, he gave Punk its identifiable and aggressive graphic vocabulary: mixed typefaces and cut-out letters (ransom lettering), bright soapbox colours, crude photo-reproduction, cut-out or torn shapes, and spontaneous layout. This anarchic and irreverent design sense had an enormous impact on the restrained attitudes of mainstream design. It introduced a looser, freer vision; less restrictive ways of working; and new interest in self-publishing and street magazines. The graphic design world is still operating under its revolutionary influence.

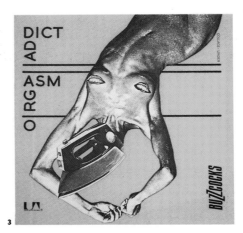

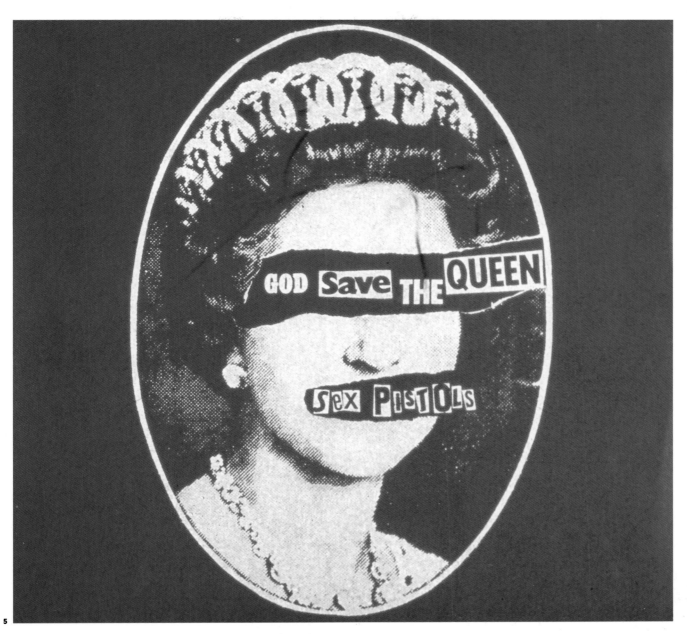

5

1

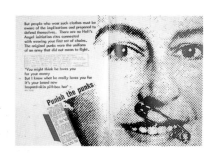

2

From Punk fanzines to style magazines

Punk had many modes of expression. One of the most important was the production of fanzines – products of the creative energy and 'enterprise' so crucial to the Punk movement. The flood of Punk fanzines, appearing in their hundreds from 1976 onwards, opened up a whole new genre of street publications and self-publishing projects. Anyone with a photocopy machine and a few bits of sticky tape could 'publish'. Fanzines were produced on many subjects – from 'gigs' to pubs – and were produced in cities and towns throughout Britain, as well as the rest of the world. (British Punk was by no means restricted to London; there was very heavy Punk activity in other cities such as Manchester.)

The emphasis on urban creativity and do-it-yourself publishing led to the 1980s preoccupation with street style. Terry Jones transferred Punk street style and anarchic graphics into the commercial avant-garde with his landmark publication *Not Another Punk Book* (London 1978). He soon followed it in 1980 with the launch of his magazine *i-D*, a catalogue of street style which hyped ordinary clothes and people in the street as fashion, and also employed 'instant design' methods and arbitrary, cluttered post-Punk layout. *The Face* magazine was also launched in 1980 and achieved fame through the radical art direction of Neville Brody. Both *i-D* and *The Face* became the most influential style magazines of the youth-orientated 1980s; and later in the 1990s expanded into art and design activism and youth politics.

1 Punk fanzines and street publishing, including Pete Polanyk's *Ded Yampy* ('really crazy'), a fanzine on Coventry pub culture, and others from the late 1970s and early 1980s.
2 Punk as street fashion: cover and spreads from Terry Jones' *Not Another Punk Book*, 1978.
3 Covers of influential style magazines *i-D*, art directed by Terry Jones, and *The Face*, art directed (1981-6) by Neville Brody.

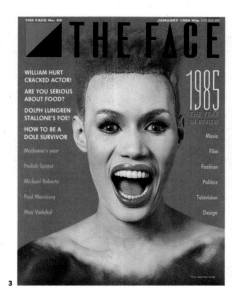
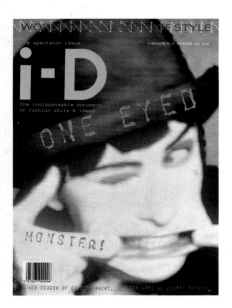

3

The culture of Black Awareness

1

The most powerful expression of urban culture to surface in the 1980s was rap music, a product of the hip hop subculture based in New York City. Rap and associated 'street arts' such as break-dancing, disc jockeying and graffiti art all formed part of the hip hop cultural explosion of the early 1980s that spread through countries from America to Japan. As the decade progressed, rap became a far-reaching vehicle for Black Awareness, and rap groups, such as the militant Public Enemy, voiced the turmoil and temperature of young African-Americans while also influencing the young black community around the world.

The music generated graphics in the form of distinctive record labels, typography and logos, and hip hop fashion became a highly commercialized uniform of baseball caps, jackets, hooded tops, track suits and particularly trainers, often endorsed by black rap or sports stars. As the 1980s moved on, Spike Lee's films focussed on black identity, revitalized the political heroes of the Sixties and encouraged a growing resurgence of Black Consciousness. They also became the source of intensive merchandising; the Spike Lee film *Malcolm X* (1992) generated a mini-industry of memorabilia, from baseball-hats to pendants and watches. In addition, posters accompanying Spike Lee films became highly valued graphic icons.

Also part of the energetic and highly visual cultural scene were rap videos – many of them carrying moral or anti-drug messages –

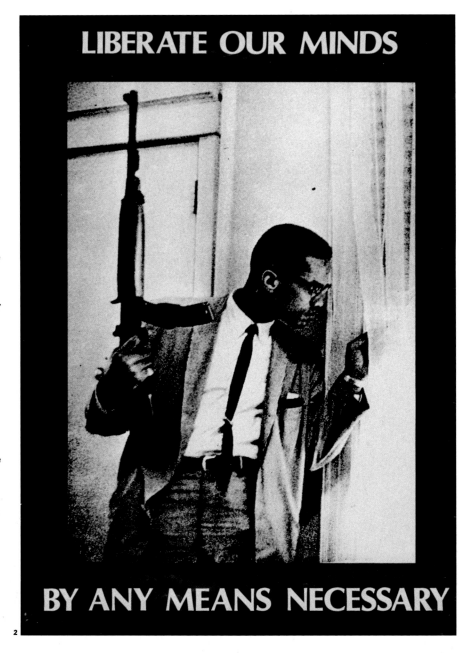

2

and rap magazines such as *The Source*, *Black Beat* and *Right On*, all from the USA. Pirate radio stations that focussed on black music added to the crucial mix. Afrocentrism (which challenged the Eurocentric version of history) also became a popular educational and inspirational force. All have become part of a growing movement of renewed black pride in the 1990s, which has been aided by innovative projects in film, photography and graphics that find new ways to celebrate black culture and promote awareness in the black community worldwide.

4

5

6

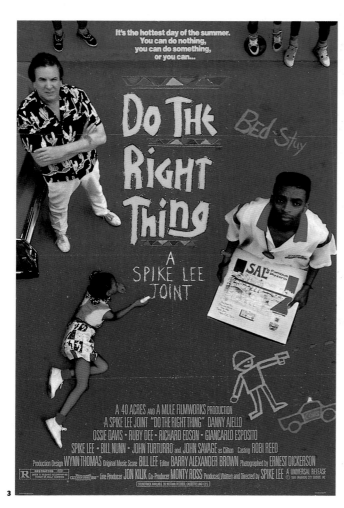

3

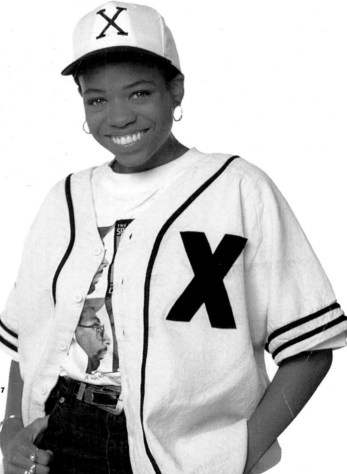

7

1 Poster publicizing the opening of the Spike Lee film *Malcolm X* (USA 1992).
2 Poster, Britain 1992. This photograph of Malcolm X, accompanied by the quote 'by any means necessary', has become an enduring image of black radicalism. Similar posters are produced by community printshops and other organizations in the USA and internationally.
3 Film poster for Spike Lee's *Do the Right Thing* (USA 1989).
4 Poster for the Spike Lee film *Jungle Fever* (USA 1991).
5 Spike Lee t-shirt message inspired by the words of Malcolm X.
6 The logo for Spike Lee's film company, Forty Acres and a Mule (named after the promise given to slaves in America on their emancipation).
7 *Malcolm X* merchandise, USA 1992.

3

1 Cover and inside
spreads from the first
issue of *Origin* magazine
(December-January
1992), aiming to pro-
mote an awakening of
black culture in the
1990s; designed by
E-sensual Design (Arhon
Thomas and Gary Riley),
Britain.
2 & 3 Posters from
the ad campaign to
launch the newly
legalized dancefloor
station Kiss FM
(formerly a popular
pirate station, with
emphasis on soul, rave
and rap music), by Tom
Carty and Walter
Campbell of AMV BBDO
ad agency, London
1990. Although not
intended as a black
awareness statement
as such, the campaign
was ground-breaking
in visual terms in its
acknowledgement of
a young multicultural
audience.

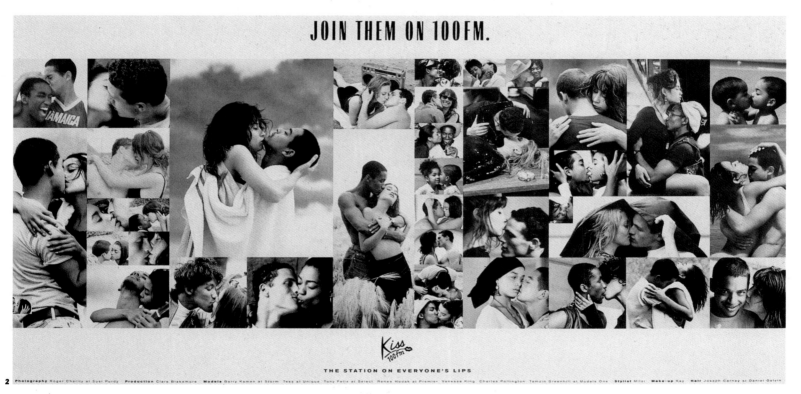

2

On the streets: fighting talk

1

Throughout the 1980s, Feminism was pronounced a dying movement by the British media. Yet the anger and the protests continued. The battle against sexism, and particularly against the use of sexist imagery in advertising, was waged through very public formats. Graffiti was sprayed onto London walls and billboards; stickers shouting 'This Degrades Women' were applied to sexist book covers, ads or posters; and feminist groups such as Spare Rib magazine encouraged actions and marches. Jill Posener's photographs of graffitied billboards were widely reproduced, and became symbolic of women's grassroots resistance against the public images that dominated their lives.

A more recent battle of the streets (and one that is still in force) has been waged by the American feminist art activist group known as Guerrilla Girls. They have been exposing sexual and racial discrimination in the New York art world since 1985. Carrying on the tradition of the spontaneous street poster (often posted illegally at night), they attack the business practices of the New York galleries and museums through the use of salient facts, statistics and the 'naming of names' – usually conveyed with sharp ironic humour. The audiences they most often address are the artists and the public that support these establishments. One of their most popular posters, 'Do women have to be naked to get into the Met. Museum?' was originally refused space as a billboard and so instead became a bus ad.

Closely-guarded anonymity is an important part of the Guerrilla Girls' operation. It keeps the focus on issues rather than personalities or status, safeguards members against retribution and also adds to the group's mystique and notoriety. No one knows their identity; they always appear in gorilla masks or full gorilla suits. But they are rumoured to include some of the USA's top female artists, as well as curators and critics from within the art establishment itself.

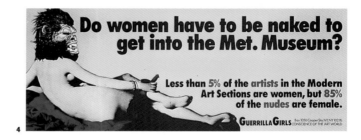

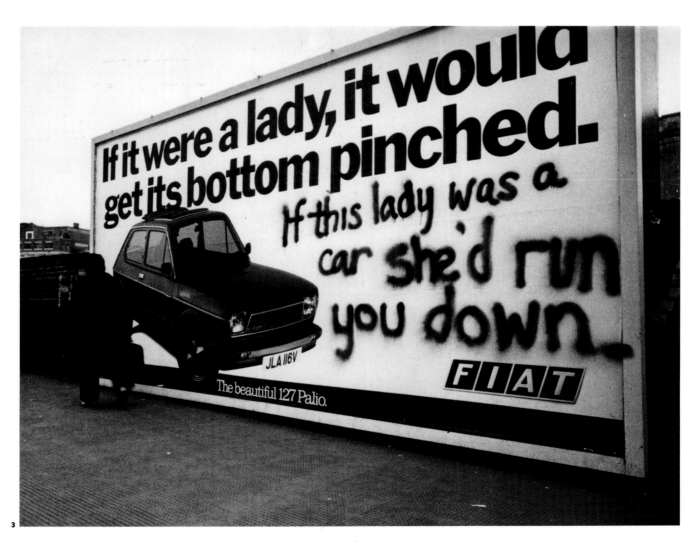

1 Badge created by Carole Spedding to help finance the feminist magazine *Spare Rib*, during the year of the royal wedding of Charles and Diana, Britain 1981.
2 Sticker and street posters from the Guerrilla Girls, attacking discrimination in the New York art establishment and other issues, USA *c*.1990.
3 Guerrilla graffiti as photographed and documented by Jill Posener, Britain 1979.
4 One of the most popular Guerrilla Girl posters. It was originally refused billboard space and so became a bus ad and street poster, USA late 1980s.

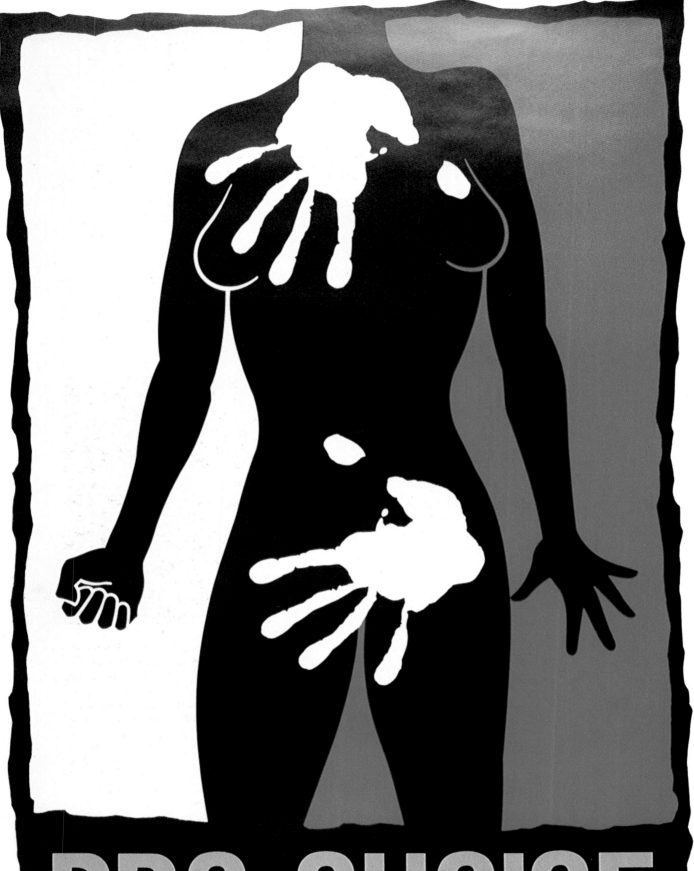

PRO CHOICE

Fight Rape. Fight Racism.

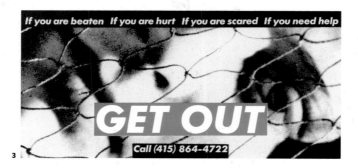

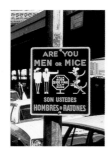

On the streets: fighting talk

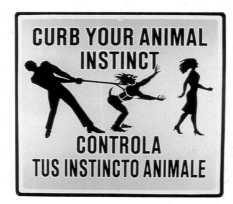

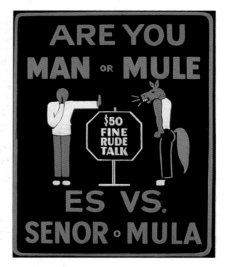

Further examples of 'fighting talk' from the late 1980s included protests against violence towards women. The Rape Line poster shown here by Lanny Sommese provided a direct aid to victims of violence and rape, symbolizing the trauma and distress of rape through the image of a fractured body. The use of a body in a more angry and defiant posture appeared in a poster and t-shirt image by Rob Cheung, which juxtaposed a number of violations of freedom and hinted at the connections between them.

Barbara Kruger's billboard 'Get Out' captures the caged-in terror of domestic violence, with a cropped image that creates a sharp sense of urgency. The dramatic cropping of photographs, an expressive technique used in much of Kruger's work, stems from her background in editorial design.

The street signs shown here are from the 'Emily Post series' created from 1985-8 by New York artist Ilona Granet as an expression of her irritation with the cat-calls, whistles and suggestive comments that can bombard women pedestrians in certain areas of New York City. (Emily Post was one of America's best-known authorities on good manners and proper behaviour.) Posted for a period of six months on selected streets in lower Manhattan, they were bilingual (English/Spanish) for the benefit of their New York City audience and also displayed the wit and humour that has been a hallmark of Ilona Granet's work.

1 Pro-Choice poster using hand-prints to symbolize violation by laws and systems as well as by individuals, by Rob Cheung, USA 1989.
2 Poster for a rape help-line by Lanny Sommese, USA *c.*1988.
3 Billboard in San Francisco aiming to fight violence against women, by Barbara Kruger, USA 1992.

4 Street signs (approx. 2ft x 2ft) from the 'Emily Post series' by New York artist Ilona Granet, aiming to curb sexist street behaviour and bring back 'good manners'. Shown here are: 'Curb Your Animal Instinct', 1986; 'Are You Man or Mule', 1986; 'Are You Man or Martian', 1986; 'Are You Men or Mice', 1988.

BE MY VALENTINE

BUT LET'S PLAY SAFE

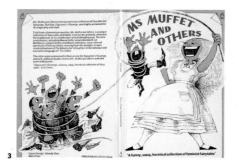

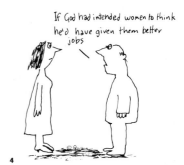

Sexual politics with a sense of humour

Humour can be used to make a sharp, satirical attack, or offer a means of 'letting off steam', particularly during long, drawn-out battles. If used carelessly, it can trivialize issues of importance. Much of the time however it can offer a welcome release, and the chance to momentarily laugh at life's problems and cares.

A new species emerged in the late 1970s and early 1980s: the feminist cartoonist, represented here by Viv Quillin's popular anti-sexist comment. Feminist publishing overall was approaching a period of great popularity and strength at this time, and flaunted a strong sense of humour while overcoming prevailing conservative attitudes. Fine examples of feminist wit included book covers for the feminist fairy tales published by the renowned Attic Press in Ireland (shown here), and the logo for the Women's Press in London: a domestic iron, often accompanied by the line 'steaming ahead'.

The Gay Pride movement also had its moments of humour. The 'Defend the Meat Cleaver Seven' badge that is shown here protested against the arrest of a group of seven Gay Pride marchers (c.1982) in a campaign led by Julian Hows, known often to appear on marches in extravagant costumes. On this particular occasion Hows had worn a hat decorated with old gramophone records, and co-marcher Frank Egan had sewn a meat cleaver into his hat, to symbolize the oppression or 'butchering' of men in drag. At one particularly heated moment in the march, Egan was ordered by police to remove the meat cleaver from his hat. On doing so (and obediently placing it in his bag), he was arrested for carrying an offensive weapon. There were further arrests, and a consequent rush to the marchers' defence – but all were released soon after. It is a humorous story now, but a sad remark on attitudes back then.

The issue of safe sex receives humorous treatment here, as does the highly emotive subject of abortion. The Pro-Choice and Pro-Life disputes of the late 1980s (and the question of the US government's stance on abortion) were the subject of Ilona Granet's 'State Womb' billboard, featuring a White House in the Womb and the symbolic American Eagle clutching two frightened sperm in its claws. It is a hilarious but biting comment on an extremely volatile issue.

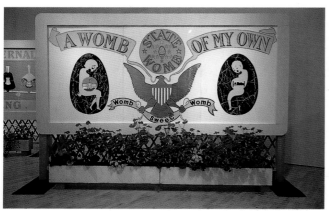

1 Safe sex Valentine postcard by South Atlantic Souvenirs (drawing by Steve Hardstaff), Britain 1986.
2 'Defend the Meat Cleaver Seven' badge, c.1982.
3 Front and back cover for a book of fairy tales for feminists published by Attic Press in Dublin, cover design by Wendy Shea, 1986.
4 Cartoon by Viv Quillin, from the book *Women Draw* (Women's Press, London 1984).
5 'State Womb' billboard, a Pro-Choice comment by artist Ilona Granet, USA 1989.
6 The graphic identity for the Women's Press in London (art director: Suzanne Perkins) symbolized the strength of feminist publishing in the 1980s.

LESBIANS IGNITE

1

The graphics of Lesbian and Gay Pride

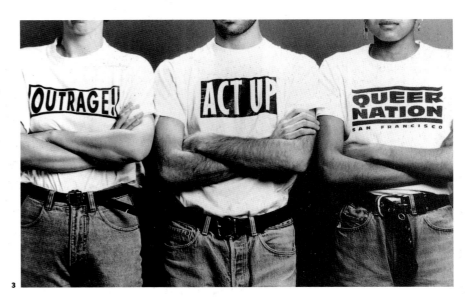

2

The Stonewall Riots – a show of resistance to police raids on gay bars in New York City in 1969 – marked the beginning of the Gay Liberation Front, a movement aiming to combat society's oppressive attitudes towards homosexuals. The long fight for equality and legal reform has over the years encompassed issues such as the age of consent, the right to express sexuality publicly, equal opportunities and rights at work, parenting, and attacks on gay people.

Campaigning, marching and direct action have played an important part in a liberation movement that has had to continually defend its ground and demand its rights. Consequently, the movement's most memorable images tend to be street and demo-graphics (placards, posters and stickers as part of demonstrations or marches), as well as personal identity statements such as t-shirts and badges, and projects that support particular protests or campaigns.

The AIDS crisis has been a severe blow for the gay community, and the most difficult battle to date: a fight for recognition of the problem, safe sex education, and a host of other issues surrounding the illness. Although AIDS has provided yet another opportunity for societal prejudice and misunderstanding, it has also turned the gay community into a unified force. For it is the anger of the gay community that gave rise to AIDS activism, one of the most powerful popular movements of recent decades and a point over which all communities have locked arms.

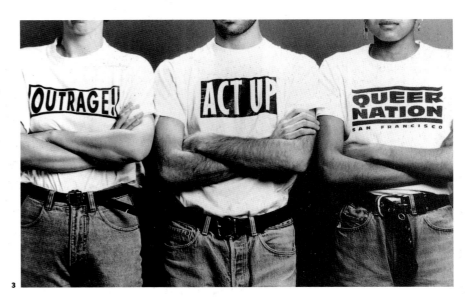

3

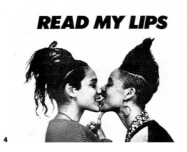
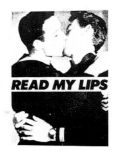

4

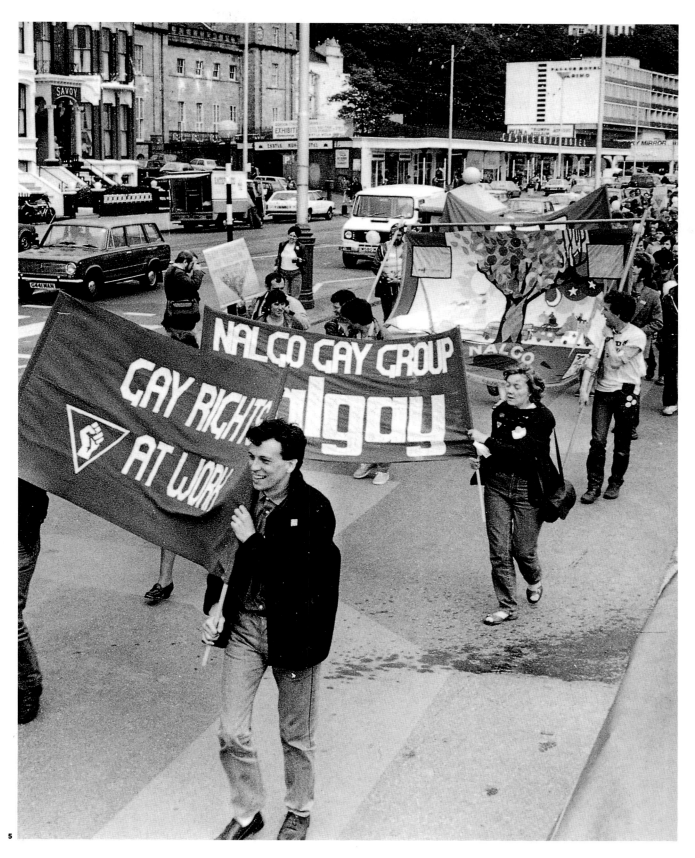

1 'Lesbians Ignite' badge, 1980.
2 Gay Liberation badges. (The Gay Liberation Front badge dates from 1972.)
3 T-shirts from organizations forming the vanguard of the AIDS activism/gay rights movement of the 1990s, USA and Britain 1992.
4 Images used on posters and t-shirts created by the AIDS activist art collective Gran Fury, USA 1988-90.
5 Trade union members on the march: photograph and badge from a Gay Solidarity demonstration week held in Douglas, Isle of Man. Issues covered included homosexual law reform and rights at work; 1983.

2

1

The caring society

Health, education and welfare

3

4

At the start of the decade, the 1990s was heralded as a new era of social responsibility: the 'caring, sharing decade'. Despite this tone of benevolent calm, the 1990s have been rocked by the continual surfacing of social crises, some of which have been highly explosive. The effects of the global threat of AIDS (its impact, for example, on the populations and economies of Africa) have become a haunting spectre, and promise a difficult future for those nations affected. In the West, growing urban poverty, strained health care systems, unemployment and homelessness are all problems that have been worsened by global recession and failing economies. The structures set up for ensuring the care and well-being of society have come under more strain than ever before. Consequently social issues – or the 'values' which in the 1990s define social well-being – have become a battleground. They rest high on the political agendas of governments; are argued and debated through the media; and have brought renewed interest in the concepts of social responsibility in design and community art.

This chapter is concerned with the graphics generated by the organizations that deal with social well-being – from large government departments to small charities – and encompasses projects or

campaigns that put across messages broadly relating to health and welfare. It also includes graphics created by individuals or groups who challenge those messages, or the way that they are communicated. These challengers may create their own messages or forms, or even subvert or 'rework' existing imagery. As a consequence both the official voice of 'the establishment', and the unofficial voice that may criticize or question it, are present here.

The power and influence of advertising and the media are important points of focus throughout this chapter. Whereas in the past advertising and media channels mainly existed to extend the power of the commercial world, they are now also employed by organizations for public service or 'awareness' messages, or by protestors and artists for activist purposes – to subvert the status quo. A fine example of the latter is 'Death' cigarettes, a brand which challenges the lies and hypocrisy of cigarette advertising by projecting a totally 'honest' and upfront message. It represents a new progressive form of anti-smoking message, and the manufacturers donate a percentage of their profits to cancer research and related charities as part of their 'Pay as you Burn' policy (reminding their smoking customers that they are highly likely to

need the benefits of such organizations one day). The 'Death' message is an obvious distortion of advertising tactics, used to drive home a harrowing message. Doug Minkler's poster, shown opposite, makes a different and equally effective comment on the power of advertising and image-building. It warns of the dangers for children taken in by cartoon cigarette ads and other stylish devices, and depicts a fantasy-horror of what may lie behind the 'cool' image.

The power struggles of this chapter therefore relate to the fight for (or against) the control of advertising/media channels. The power of commercial advertising to programme lifestyles and mould social attitudes is slowly being eroded – for its communication channels are now being used simultaneously to question those attitudes or to promote alternative views (sometimes by the hijacking of existing ads). The channels are no longer one-way power lines, they now contain mixed messages and mixed motives.

Changing attitudes and targeting audiences

Social attitudes have changed dramatically over the past three decades – and with them, the way that we visually or graphically handle health issues, social problems and 'public service' information. It began as a long, slow process of challenging taboos. The social revolutions of the 1960s and 1970s brought visions of a freer and more open society, and a bold new era of 'changing attitudes'. A product of this climate was a new breed of information and advertising campaigns. While America led the way in creative commercial advertising in the 1960s, Britain pioneered a daring new form of public service information. The best of the innovative campaigns included Cramer Saatchi's poster of a pregnant man, promoting contraception on behalf of the Health Education Council, and the shocking David Holmes/Terence Donovan poster of a distressed pregnant child, produced for the Salvation Army. This 'age of daring' reached its peak in Britain in the early 1970s with the Clunk-Click seatbelt campaign, the first time sensationalism and shock tactics were used for the public good in a national campaign.

Other groups exploited the new climate of liberation. Women faced new liberated attitudes to sex, and took control of their bodies and health care. Feminist groups and public health organizations produced a flood of graphic informational material on contraception, reproduction, sexually-related diseases and rape, which was handed out in liberal-minded community clinics and women's health centres. In the mid-1970s, too, the disabled began to fight for their rights, and soft-spoken charities adopted the new label of 'pressure group'. Publications for the disabled, promoting self-care and independence, began to receive heavy media coverage and support. There was new interest in providing wheelchair access to buildings, public transport and entertainment venues; ergonomics and social responsibility in design were hallmarks of this period. Significantly, the disabled at this time began finally to acquire visual representation in the media, and a place in public considerations. In visual terms, society was becoming more than a white, male, middle-class, able-bodied group.

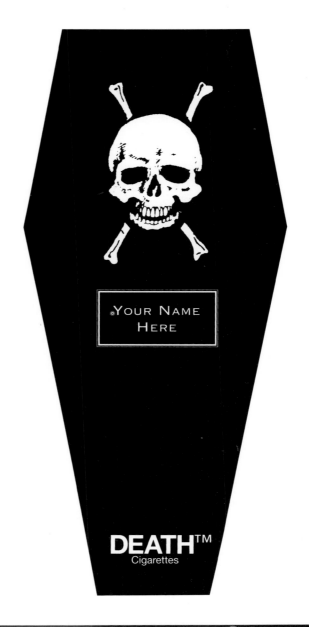

YOUR NAME HERE

DEATH™
Cigarettes

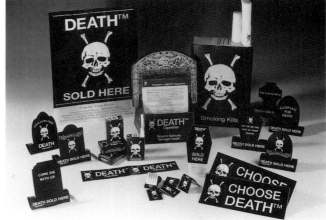

5

1 An anti-smoking poster which parodies existing cartoon-style cigarette ads, USA 1992. The poster was created by Doug Minkler for Doctors Ought to Care, a national organization of doctors in the USA focussing on preventive medicine.
2, 3 & 4 Pioneering statements in shock: campaign to promote contraception by ad agency Cramer Saatchi for the Health Education Council, Britain 1970-71; poster promoting the work of the Salvation Army, by agency Kingsley Manton & Palmer (photo: Terence Donovan), Britain 1967; poster from the landmark Clunk-Click campaign to promote the use of seatbelts, conducted by the Central Office of Information for the Ministry of Transport, Britain 1971-3 (first test phase), then continued until 1980.
5 Publicity paraphernalia, including coffin-shaped packaging, for Death cigarettes, Britain 1991.

1

But despite these advances, certain areas remained curiously unchecked. Drugs were still considered to be a 'containable' problem in most countries in the 1960s and 1970s, and apart from isolated campaigns produced by government departments or charitable organizations, received little graphic attention. In America in particular, drugs were part of the underground youth culture, as well as a broader social scene that was looking for fun and experimentation. Marijuana was affordable and popular, and even cocaine was considered a 'party drug' until the late 1970s. It was not until the early 1980s that the first signs of a broader problem began to appear. Hard drugs became cheaper, addiction and the effects of long-term drug abuse began to surface, and drugs soon became heavily crime-related. The mid-1980s brought a new development in the form of crack (crack cocaine), not a social 'high', but an extremely addictive, often crime-related street drug. At that point drugs shifted onto the political agenda and America turned to face a national problem.

In 1986 the Partnership for a Drug-Free America set up as a coalition of volunteers from the communications industries and set about the problem of 'unselling' illegal drugs. Their efforts have created the largest public service media initiative in America's history. 'Anti-drug messages' are the heart of their mission, and with unprecedented participation by the media, they can claim that every American sees at least one anti-drug message per day. Participation is wide-ranging – from TV networks (the three major networks have contributed over 10,000 spots) to newspapers, theatres and home video companies – and messages are carefully targeted to specific audiences such as children or parents. According to the Partnership's research, their

crusade has produced results: their annual national tracking studies show significant attitude shifts away from drugs since 1987. Furthermore, drug abuse centres and clinics have now become commonplace. Federal and local government devote much of their time and money to prevention, and the entire problem has become part of the social fabric. In addition, definitions have been broadened: alcohol and drug dependency (hard or soft) are viewed as one and the same. Lobby groups such as MADD (Mothers Against Drunk Driving) now have substantial clout and are able to exert great pressure on legislators to tighten laws.

In other countries, where programmes relating to drug use lack the Partnership's financial resources and power, the most interesting efforts are still those which tend to target a specific audience and localize their message, as well as their media and visual language. Their approaches to the subject, however, can differ greatly. For example, the non-judgemental drug-related information provided by the Youth Awareness Programme (YAP) of the Newham Drugs Advice Project in London (pages 186-7) is targeted to the tastes, interests and street-life of young people, from the age of ten upwards, and speaks to them in a visual language they will relate to and understand. NDAP are close to their audience and its needs, taking their expertise into local schools, housing estates and youth clubs; they also target groups normally neglected by drug treatment agencies, especially the Asian and black British and African communities. The British mainstream drugs information strategy, on the other hand, is typified by the overly broad and condemnatory approach of the poster 'Skin Care by Heroin' on page 187, or the sensationalized needles and scars shown here.

"I ignore them."

"I don't want to look like this."

"I'd rather stick anchovies in my ears."

"Take a chill pill..."

"I respect my body, man."

5

"Grrrr"

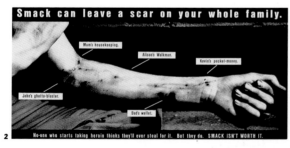

2

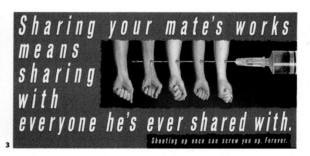

3

4

The approaches used in communicating social messages range from shock tactics to friendly familiarity.
1 Anti-drugs poster by Alexandr Faldin and Alexandr Segal, USSR 1987.
2 'Smack', street poster from a campaign against drug abuse by

ad agency TBWA for the Central Office of Information (COI), Britain 1988.
3 'Kebab', poster from a campaign against drug abuse by Yellowhammer agency for the COI, Britain c.1988.
4 Poster warning about drug use and AIDS, USSR 1990.

5 Stills from computer-animated TV spot: an anti-drug message targeted at eight- to eleven-year-olds, by Richard Hsu (New York) for the Partnership for a Drug-Free America, 1991. The characters shown were asked 'When others ask you to do drugs, what do you say?'

Other examples of sharp targeting of audiences include the work of Bob Linney's charitable organization Health Images, which was founded in Britain in the mid-1980s. Health Images conducts poster and print workshops in underdeveloped countries, and teaches local health workers to create their own health materials and visual aids, thereby incorporating local customs, superstitions, symbolism and other issues which determine the way that images are read. In Australia, Redback Graphix provides a broad range of educational/information graphics, especially in consultation with Aboriginal communities and other specific groups. Their no-smoking and drinking message aimed at pregnant mothers (page 188) was designed to illustrate a story developed by health workers in conjunction with Aboriginal communities. They also devised a number of messages warning against the effects of Grog (alcohol), as shown here, in the form of picture stories or narrative strips for use in communities where people didn't necessarily speak, read or write English – and which were reminiscent of an Aboriginal style, and its use of symbolism.

As many of the examples in this chapter show, there was a growing awareness in the early 1980s of escalating social problems in the countries of the West, with many groups and individuals working to find radical solutions, despite the inaction of conservative governments. In the mid-1980s a number of forces converged, creating a new mood of public awareness and concern. The Live Aid rock concert of 1985 generated famine relief for Africa and saw people in 152 countries join forces in televised international solidarity. In the climate of social awareness that followed, advertising agencies were commissioned to produce media campaigns on social issues and ecology, and public formats normally reserved for commercial use were press-ganged into social use. Animal rights were popularized when the Lynx poster campaign (page 221) made wearing fur unfashionable; reports of a 'greenhouse effect' and the depletion of the ozone layer suddenly made ecology a publicly-acknowledged fight for survival; and the spectre of AIDS became not only a health crisis, but a communication crisis. How to change people's social and sexual behaviour after years of liberated permissiveness became the ultimate education and information design problem. The old 1970s trend towards social responsibility in design had returned, in an updated and highly urgent form.

AIDS education: the missing strategy

The spread of the HIV virus and the illness it can cause (known as AIDS) has created the public health crisis of the century. Now recognized as an epidemic seated in countries around the world, it presents challenges on many levels: medical and scientific (in the search for new and better drugs); economic (from the collapsing medical system of America, to the collapse of economies in Africa); cultural (for sex and morality are central issues and subject to tradition and religious influences); legal (in the attempt to ensure the rights of people with AIDS); and social (in terms of the effect of AIDS on relationships with lovers, family, and the community).

Despite the complexity and scale of the problem, there is a general lack worldwide of national strategies for AIDS education. The examples shown in this chapter are largely from poster campaigns, which play an important role in AIDS/safe sex education in that they offer support and promote discussion. But they do not compensate for the lack of a national strategy that incorporates a broad range of media, with clear and up-to-date information, specific targeting and evaluation tests for effectiveness. (What America does for anti-drug matters, for example, with the Partnership for a Drug-Free America, it does not do for AIDS and HIV.) Consequently, the best AIDS education is shouldered to a great extent by grassroots campaigners and organizations.

However poster campaigns do exist worldwide, and vary dramatically with regard to cultural traditions and audiences. They tend to be generated by two types of sources: government agencies and institutions; or community/voluntary groups and concerned individuals. The two sources operate very different approaches. Government agencies normally address a broad general audience; worried about offending the status quo, or aligning themselves to issues that may prove to be politically embarrassing during an election campaign, they tend to talk from a distance, using generalized and often bland imagery conjured up by large ad agencies. The community sector, on the other hand, is obviously more directly involved; it will target a specific audience or community and attempt to communicate with that audience on its own terms.

The community sector will also search for new audiences – very important in such a fast-changing milieu – and will attempt to respond to the needs of neglected communities, such as gay teenagers. The Swedish Federation for Gay and Lesbian Rights (RFSL) is a good example of an organization that uses careful targeting. Their safe sex posters are produced to be sited in very specific settings and to provoke reaction and discussion; their imagery therefore tends to be bold, humorous or shocking: and just right for the job. They also have a very specific aim, for although knowledge about the HIV virus in Sweden is widespread, the level of new infections particularly among young gay men is still high. A selection of their posters is shown below.

Thus in targeting specific audiences, the community sector tends to cover groups the government fails to address properly: lesbians and gay men, the young, the sexually active – in short, all those people most at risk. As one of our greatest information challenges to date, AIDS and safe sex education demands imagination and modern design strategies that will change attitudes and behaviour and at the same time combat the effects of misinformation, sensationalism and prejudice – the trademarks of much government strategy until now.

4

1 'Beat the Grog' (alcohol), poster by Redback Graphix for the Central Australian Aboriginal Media Association, Alice Springs, Australia 1986.
2 'Are you in good health?', anti-smoking poster by Margus Haavamägi, Estonia 1988.
3 A series of posters produced by the Swedish Federation for Gay and Lesbian Rights (RFSL) targeted for use in specific settings: (left) for sex clubs and other places where men meet for occasional sex; (centre) for use in nurses' offices and surgeries in schools and similar contexts; (right) mainly for schools. All of the images were used in gay bars and restaurants around the country, as part of a large campaign, Sweden 1992.
4 Stickers from RFSL, Sweden 1992.

TAKE CARE · BE SAFE

Take care be safe

Take Care - Be Safe

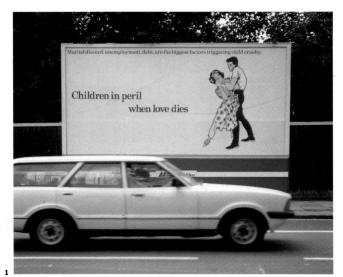

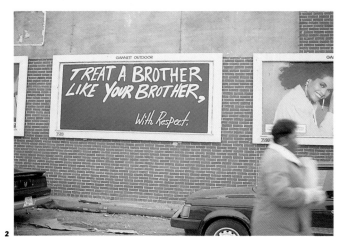

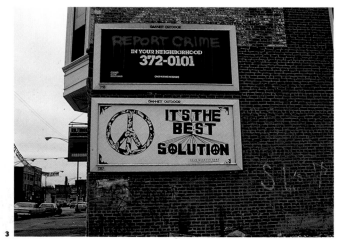

Billboards have become an important public format for protest and social issues.
1 Billboard project by British artist Philippa Beale to raise public awareness of child abuse, for the benefit of various children's societies; site: London, 1987.
2 & 3 Billboards from the Randolph Street Gallery project in Chicago 1990 entitled 'Your Message Here', which aimed to provide a means of communication and an awareness of issues within inner-city communities: 'Treat a brother like your brother, with respect' designed by Julian Akins of Artists of Color United/School of the Art Institute of Chicago; 'It's the best solution' (peace and an end to street violence) by Sam Gomez, with Kharl Walker of GATE (Graphic Arts Through Education), a programme designed to help introduce and guide young street graffitists into the art gallery and education world.

The billboard: from commercial ad to public forum

Since the early 1980s billboards have become an increasingly popular format for agitation and social comment, and a powerful demonstration of the subversion of advertising power by non-commercial groups or an angry public. Billboards are one of advertising's most imposing vehicles, whether sited in city streets or in the countryside for long-distance viewing by a captive audience of highway motorists. Since they command such a direct and overbearing place in people's sights and thoughts, it is not surprising that guerrilla artists and groups have formed over the years to interfere with this process – to reclaim an imposition on public space, stop the cluttering of the environment, attack adverts or concepts they find offensive, or strike back at the faceless commercial authority and materialism that billboards represent. As the voice of commercial 'programming', billboards are an authoritative and exploitative device, a one-way form of communication. Defacing and graffiti magically transform this into a two-way conversation: the voice of authority is overtaken by the voice of resistance, and commercial power is subverted to people power.

This form of subversion has a strong tradition. In the late 1970s, while graffiti art was reaching its prime in New York City, political 'guerrilla graffiti' was being developed in other countries by groups or individuals expressing the social movements of the time. Spray-can comments or defacings normally came from 'street writers', often feminists, peace protestors, anti-racists and other activists reacting to the offensive content of existing ads, or expressing personal resistance to current politics. (As this form of defacing was usually a criminal offence, they were often operating at great risk.) Photographer Jill Posener carefully documented the range of these activities in Britain, and also the existence of groups such as BUGA UP (Billboard Utilizing Graffitists Against Unhealthy Promotions) in Australia, founded in 1979 and dedicated to assaulting corporate advertising. BUGA UP exercised a particular loathing for the tobacco industry, but in fact retaliated against all advertising and its growing imposition on everyday life.

The 1980s brought a move towards self-publishing and urban expression. Art activists such as Jenny Holzer and Barbara Kruger began to put across social messages through a wide variety of environmental formats: electronic signs, billboards, stickers or invented street signs. At the same time (and in the charitable atmosphere following Live Aid) London advertising agencies were producing charity campaigns on social and environmental issues which were displayed on billboards, the most famous being the Lynx '40 dumb animals' poster.

By the late 1980s and early 1990s, both artists and ad agencies were communicating social issues and protest comment by billboard, providing occasional disruption to the usual commercial patter. More extreme disruptions for commercial advertisers also arrived, in the form of new-generation guerrilla-graffitists who no longer worked in the mode of 'defacing' but of 'refacing'. A number of examples of this art of 'visual intervention' were carried out by the company Saatchi and Someone: in reality, an individual named David Collins, operating with a few helpers.

Saatchi and Someone aimed to hijack the images and production values of high-profile advertising imagery; and the quality of their 'seamless' alterations often subjected viewers to a 'double-take' effect. They reworked 15 billboards in the Leeds and Bradford area between the summers of 1990 and 1991. Needless to say, most of the interventions were done at night; they usually lasted for one or two weeks before being pasted over with a different poster.

Commercial advertisers have also tried to promote social concerns through public formats with varying results. In 1991 global fashion companies Benetton and Esprit took on 'global problems' and began to produce socially-conscious campaigns aimed at young people on issues such as racism, violence, literacy and AIDS. Esprit's press and TV campaign, inviting young people to write in and express their suggestions for a better world, created a flood of earnest and sometimes witty responses; while Benetton's use of highly controversial photographs on billboards and in the press evoked intense public debate, outcry and protest (page 205). A more interesting use of commercial billboard advertising stemmed from the unusual concept of 'recycled advertising' created by London ad agency Chiat/Day to promote Ecover environmentally-conscious household products. In April 1991, an advertising campaign was devised which involved 52 artists, each collaging a billboard image by tearing up redundant advertising posters. Prizes were awarded and the new billboards appeared all over London – an extraordinary way of creating ads without waste, while promoting green products and a green philosophy (pages 232-3).

Yet another function assigned to billboards in the 1990s has been that of public forum, whereby commercial advertising sites are acquired (sometimes donated) for public art projects that address issues relevant to inner-city communities. The billboard project 'Your Message Here', for example, was co-ordinated by the Randolph Street Gallery in Chicago in co-operation with the artists' collective Group Material. It produced and printed 40 designs from community-based organizations and individuals, and posted them for three months (changing their location each month), thus providing an opportunity for people and groups to address each other, or the public. Thus the billboards were used to carry hand-written messages from the homeless; promote peace in the streets, protest against unjust treatment of immigrants; celebrate diverse ethnic backgrounds; or simply talk about having respect for the neighbourhood.

The growing use of billboards, posters and other public formats as a means of expression, represents an attempt to claim the communication power and presence of these formats for use by people in the street. Such a movement offers everyone the opportunity to have a voice, argue issues, and confront crises; and presents a challenge to commercial control systems and the dominant voice of traditional news media. Street graphics and other public formats look set to become an increasingly important alternative channel for involvement and education on political issues.

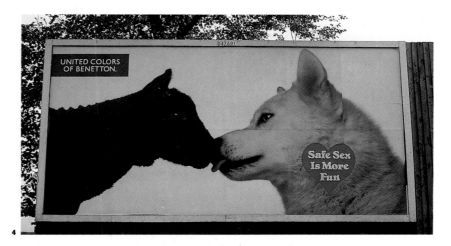

4

4 Reworked Benetton ad by Saatchi & Someone, 1990-91, site: Leeds, Britain.
5 The Saatchi & Someone logo.

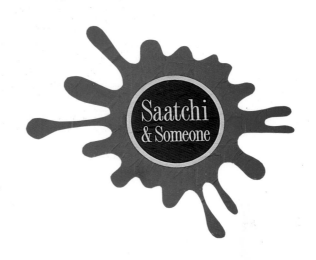

5

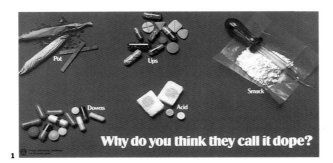

Why do you think they call it dope?

1

On the road to a drug-free America

Although occasional anti-drug statements were produced in the US in the 1970s, it was in the 1980s that America declared a national problem and waged an all-out war against drugs. The communications industries rallied with the formation in 1985 of the Partnership for a Drug-Free America, a voluntary coalition of professionals from advertising, public relations, entertainment and associated areas all working together to expose the dangers of illegal drugs. They create and disseminate 'anti-drug messages' with the help of massive contributions of *pro bono* design work, information and research services and donated broadcast time and press space; they now claim to be the largest public service media campaign in history.

Each message is targeted to a specific audience, and reviewed for accuracy, appropriateness and effectiveness. Targeted audiences receiving the heaviest attention tend to be children (from aged eight upwards) and teenagers; but messages are also produced for parents, managers and employees, healthcare professionals and minority communities. The Partnership's strategy also includes an increasing use of non-traditional media to carry anti-drugs messages, which may appear for example in school packs and on children's toys, sports equipment, direct mail materials, book covers and video games.

7. Drugs can get you in big trouble.

8. You could go to the principle's office.

9. ...

10. Or go to jail.

14. Drugs are bad. I wouldn't do drugs.

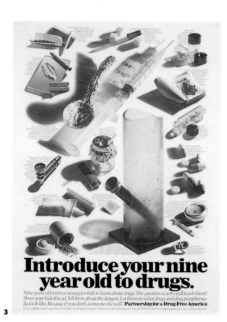

Introduce your nine year old to drugs.

Nine year old isn't too young for kids to learn about drugs. The question is, who will teach them? Show your kids this ad. Tell them about the dangers. Let them see what drugs and drug paraphernalia look like. Because if you don't, someone else will. **Partnership for a Drug-Free America**

3

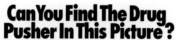

This is the weed that Jack bought. Jack got it from Bobby. Bobby is Jack's best friend. Bobby bought it from his pal at school. Tony. Tony knew this neighborhood connection—Sid or someone. Sid made a deal with a guy downtown who scored it from some dude down south who flew away two cops to get it over the border. Just for Jack.

POT HOOKS YOU UP WITH A WHOLE NEW CIRCLE OF FRIENDS.

PARTNERSHIP FOR A DRUG-FREE AMERICA

4

ENCOURAGE YOUR KID'S HABIT.

KIDS NEED SOMETHING BETTER TO DO THAN DRUGS. LIKE SPORTS, DANCE, OR MUSIC. BECAUSE GOOD THINGS CAN BE HABIT-FORMING, TOO. SO GET THEM INTO A GOOD HABIT, TODAY. OR THEY MAY GET INTO A VERY BAD ONE.

PARTNERSHIP FOR A DRUG-FREE AMERICA

5

Use drugs? "I'd rather stick anchovies in my ears"

Partnership for a Drug-Free America

6

Can You Find The Drug Pusher In This Picture?

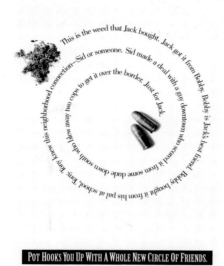

We all know what drug pushers look like. We've seen them often enough on television. But the frightening thing is, a kid is more likely to be pushed into drugs by some innocent-looking classmate.
Studies show that kids are eight times more likely to use drugs if their friends use drugs. As a parent, how do you beat odds like that?

First, realize that your preteen children are at risk. Then, find out everything you can about drug abuse. Next, talk to your kids. Let them know how you feel about drugs. Find out how they feel. Then, and this is very important, get to know your kids' friends—and their parents.
In other words, if you're in the picture, chances are a pusher won't be.

Partnership for a Drug-Free America

7

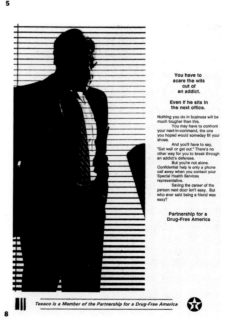

You have to scare the wits out of an addict.

Even if he sits in the next office.

Nothing you do in business will be much tougher than this.
You may have to confront your next-in-command, the one you hoped would someday fill your shoes.
And you'll have to say, "Get well or get out." There's no other way for you to break through an addict's defenses.
But you're not alone. Confidential help is only a phone call away when you contact your Special Health Services representative.
Saving the career of the person next door isn't easy. But who ever said being a friend was easy?

Partnership for a Drug-Free America

Texaco is a Member of the Partnership for a Drug-Free America

8

1 Drug abuse message by the Advertising Council of America, USA 1971.
Anti-drug messages from the Partnership for a Drug-Free America:
2 Sequence of stills from a television spot featuring 'Penny', a popular character from 'Pee Wee's Playhouse'. Target: six- to eight-year-old children.
3 Full-page newspaper ad. Target: parents.
4 An ad which makes a connection between drug use and a crime network. Target: teenagers.
5 Print ad included in all of the basketball packaging used by a sporting goods company. Target: young adults and parents.
6 One of six posters in an educational pack for teachers. Target: five- to nine-year-olds.
7 Print ad. Target: parents.
8 Print ad for Texaco. Target: managers and co-workers.

Approaches to drugs, alcohol and smoking

1

An assortment of graphic imagery relating to drugs, alcohol and smoking is shown on the following pages, representing a variety of audiences, approaches and countries.

The examples on this spread show strategies for communicating with the young through their own language and culture. For example, Studio Graphiti in Italy makes use of the popularity of comics and spray stencils among young Italians; the British fashion designer Katharine Hamnett politicizes a youthful fashion scene; and E-sensual Design produce attention-grabbing visual effects for YAP, the Youth Awareness Programme of Newham Drugs Advice Project in London. The collection also demonstrates an interesting variation in aim and tone, ranging from the scare tactics of campaigns such as 'Skin Care by Heroin' to the street-wise straight-talking of the YAP graphics, which offer advice and help.

A broader selection of audiences appears on pages 188-9. Some of the work is specifically targeted, as in the 'Pregnancy' poster aimed at Aboriginal communities in Australia, while other images – for example, the anti-smoking poster from Singapore – make a more general appeal.

2

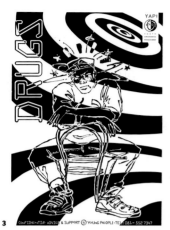

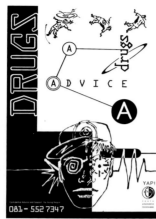

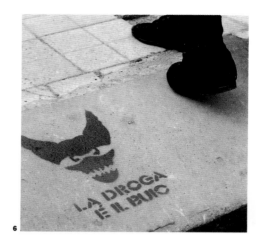

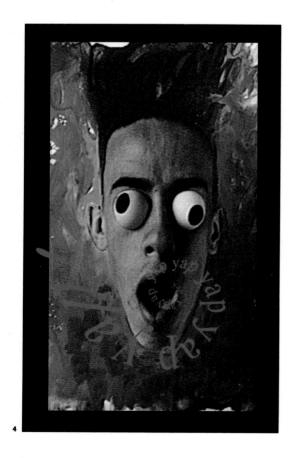

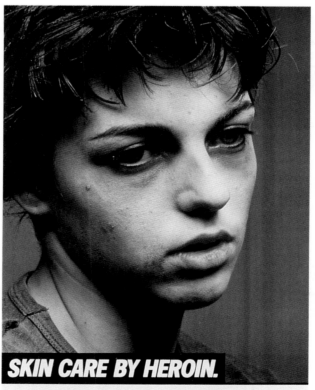

SKIN CARE BY HEROIN.

Take heroin and before long you'll start looking ill, losing weight and feeling like death. So, if you're offered heroin, you know what to say. **HEROIN SCREWS YOU UP**

1 'Stay Alive in 85', t-shirt by fashion designer Katharine Hamnett for an anti-heroin campaign, Britain 1985.
2, 3 & 4 Created by young people, for young people: non-judgemental drugs-related information from YAP, the Youth Awareness Programme of Newham Drugs Advice Project in London. Designed by E-sensual Design (Arhon Thomas and Gary Riley), 1992. Shown here are information cards, posters and a postcard.
5 'Skin Care by Heroin', ad campaign by Yellowhammer agency for the Central Office of Information, Britain 1989.
6 'Drugs are the dark and frightening unknown', road stencil and poster image from the 'Drugs Out' campaign, illustration by Angelo Stano, design by Andrea Rauch of Graphiti studio in Florence, Italy 1992.

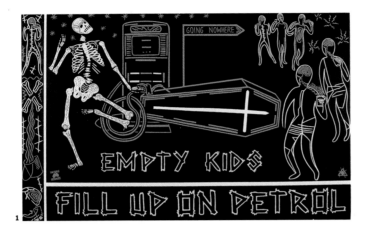

1

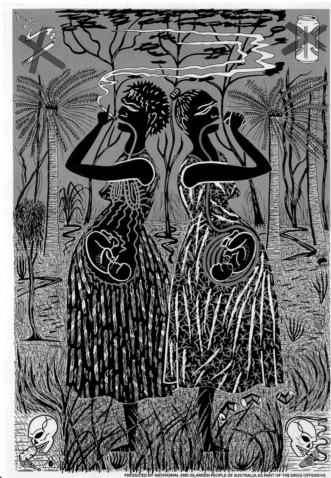

2

PRODUCED BY ABORIGINAL AND ISLANDER PEOPLE OF AUSTRALIA AS PART OF THE DRUG OFFENSIVE.

1 'Empty Kids', poster by Redback Graphix (design: Marie McMahon; printer: Peter Curtis) for the National Campaign Against Drug Abuse in Canberra; Australia 1987.

2 'Pregnancy', poster by Redback Graphix (design: Marie McMahon; printer: Alison Alder) for the National Campaign Against Drug Abuse in Canberra; Australia 1988.

3 Anti-smoking poster by Miroslav Jiránek, Czechoslovakia.

4 'Don't Drink!', poster by Alexandr Gelfenboim, Russia, 1990.

5 'Bad Habits Die Hard', poster by Ketchum Advertising (design by Gordon Tan, Jim Aitchison and Heintje Moo) for the Ministry of Health in Singapore, 1992.

PUFF PUFF
PUFF PUFF
PUFF COUGH PUFF
PUFF COUGH
COUGH PUFF
COUGH COUGH
COUGH COUGH
COUGH COUGH

3

4

🚭 **BAD HABITS DIE HARD**

 Ministry of Health

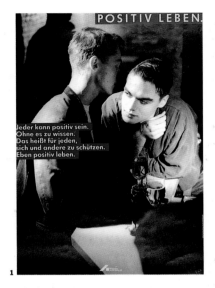

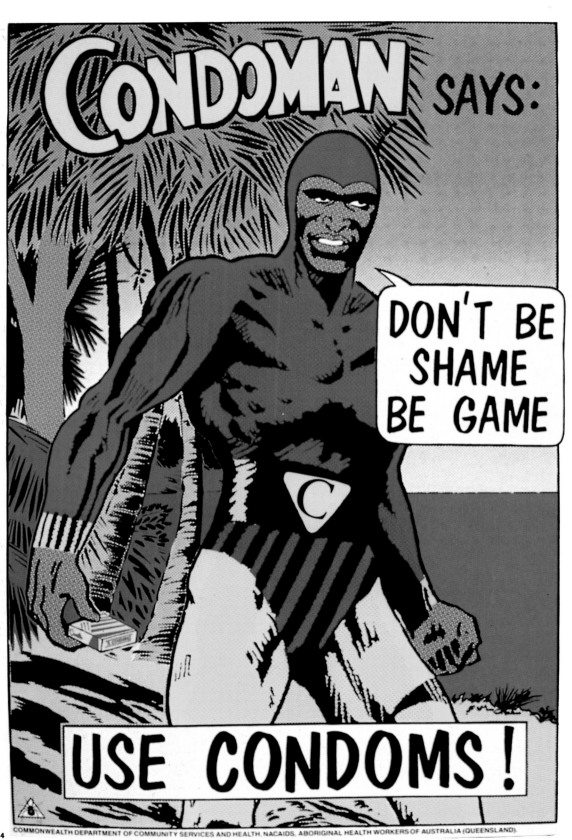

Safe sex and AIDS education

The term AIDS entered our vocabulary as early as 1980, but it took another five years for the apathy, misinformation and inaction of governments to reach a point where a grassroots reaction in America was forced into play – and yet another five years to bring acknowledgement of the global spread of the disease. Over ten years after the arrival of the problem, AIDS education is still in its infancy.

AIDS education materials are however produced worldwide and vary dramatically in approach and style. Poster campaigns continue to play an important role, produced either by government agencies or by community groups and concerned individuals.

A scan over the examples shown gives some indication of the complexity of the design issues involved. Target audiences can vary from country to country (in Africa, heterosexuals are most vulnerable; in Northern Europe, gay men) and cultural background, visual language and tastes will differ. Tolerance levels differ with regard to 'indecent' imagery, often resulting in the use of visual metaphors, while the atmosphere conveyed can range from ice-cold British sophistication to the sinister symbolism of Russia and Eastern Europe.

The campaigns for safe sex on pages 192-3 take an adventurous and modern tack. Rather than revert to moralizing, scare tactics or an attempt to impose restrictive behaviour, these images are seductive, lustful and full of fun: they are a tempting invitation to safe sex, aimed at a modern and sexually-active audience.

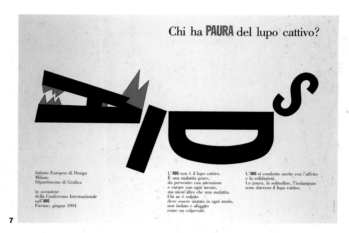

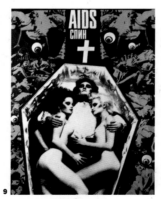

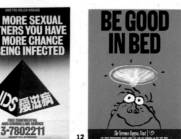

1 'Live Positively', supportive poster series on gay values and living by Deutsche AIDS-Hilfe; design: Detlev Pusch, photo: Jörg Reichard, Germany 1992.
2 AIDS poster by Genadiy Belozorov, Omsk 1989-90.
3 AIDS poster designed by Andrey Isayev, Khmelnitskiy, Ukraine 1989-90.
4 'Condoman', poster by Redback Graphix for NACAIDS, Canberra, Australia 1987.
5 Logo for the World Health Organization Special Program on AIDS, by American designer Milton Glaser, 1988.
6 'Si-da, No-da', stills from a campaign on AIDS prevention by Contrapunto S.A. ad agency in Madrid, for the Ministry of Health, Spain 1988.
7 'Who's Afraid of the Big Bad Wolf?', poster for an international AIDS congress, designed by Andrea Rauch of Graphiti studio, Italy 1991.
8 Magazine ad for the Health Education Authority, by ad agency BMP Davidson Pearce, photo by David Bailey, Britain c.1989.
9 'AIDS', poster by Saso Kamenov, Bulgaria 1986.
10 Poster by Barbara Kruger, USA 1992.
11 AIDS poster, Hong Kong.
12 Safe sex poster produced by the Terrence Higgins Trust, Britain 1992.
13 Front cover of *The Sunday Times Magazine*, 27 June 1987, Britain.

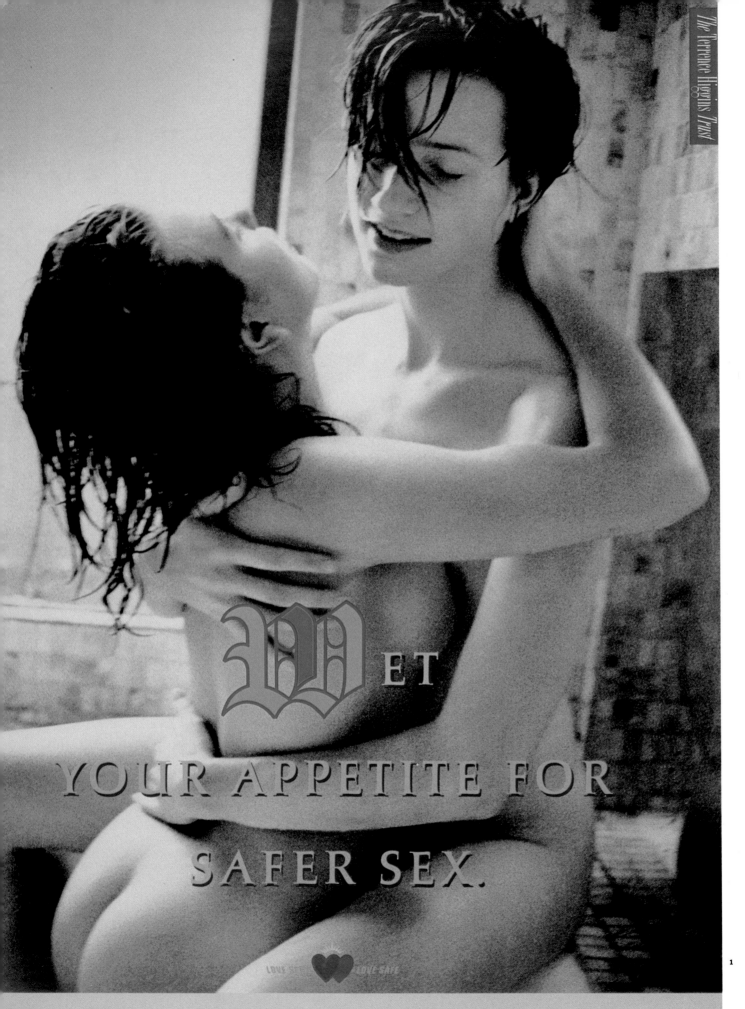

Wet YOUR APPETITE FOR SAFER SEX.

Safer sex protects us all from HIV (the virus that can lead to AIDS), STDs and unwanted pregnancy.
Call the Terrence Higgins Trust Helpline on 01-242 1010, 3pm-10pm.

2 3

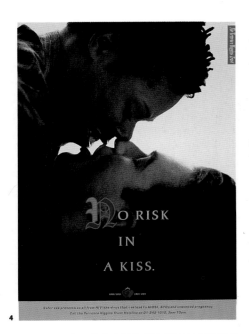

4

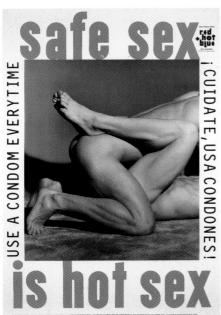

6

1, 2, 3 & 4 Safe sex posters (from a series of six) designed by Big-Active for the Terrence Higgins Trust, Britain 1992.
5 Poster from the Take Care Be Safe campaign by the Swedish Federation for Gay and Lesbian Rights (RFSL), design by Ola Johansson, photography by Robert Nettarp, Sweden 1992.
6 Poster promoting 'Red Hot + Blue', an AIDS benefit album of Cole Porter songs. Design by Helene Silverman, photography by Steven Meisel, USA 1991.
7 Magazine ad produced by the Health Education Authority, Britain 1993.

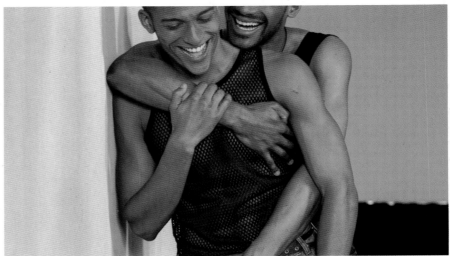

5

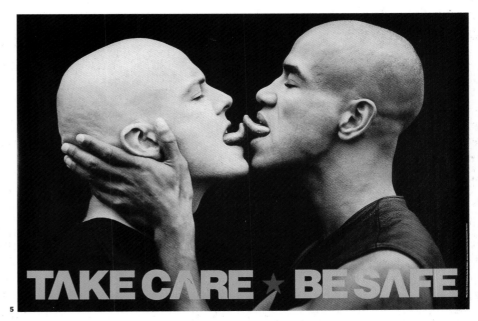

7

HE'S INTO SAFER SEX, SO WHY NOT GIVE HIM A HAND?

A matter of life and death

Poster campaigns for AIDS education rightly focus on changing social attitudes or sexual behaviour. But there are also other roles for graphics to play, for example the dissemination of life-saving information through more everyday graphic forms, as shown here by The Kitchen calendar, an events listing for a New York arts venue.

Another communication role can be seen in the 'Images for Survival II' project created by designer and educator Charles Helmken. The project involved 31 graphic designers; all produced AIDS posters in 1989 for an exhibition intended to tour Korea (only just beginning to discover cases of the virus) as part of a campaign to increase public awareness of the problem. Helmken's own poster contribution appears here.

Memorials and interpretative pieces have been another type of activity over the years, to honour the memory of loved ones lost through AIDS. The most famous expression of the humanity behind the statistics has been the NAMES Project, America's national AIDS memorial, which takes the form of a huge quilt. Started in Sacramento in 1987, the quilt consists of thousands of panels: each panel measuring 3ft x 6ft, and each representing an AIDS victim. In 1988 the panels numbered 35,000 and were still rising. The project has continued as an artistic venture unparalleled in size and emotion, and an overwhelming expression of human loss and love.

Although not a piece of graphics in itself, the quilt has inspired further forms of graphic

1

2

expression such as films, photographs, and posters – for instance Joseph P. Ansell's 'Eternal Summer' designed in 1989, which couples William Shakespeare's sonnet with a photograph of the quilt by David M. Green. (Green not long after died from AIDS; there are now two panels in his memory in the NAMES Project quilt). The poster, like the quilt, is a reminder that AIDS is robbing the world of interesting, creative people and, in Ansell's words, 'a promise to those who have already died and those who may yet die – they will not be forgotten'.

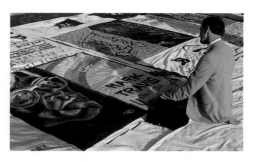

4

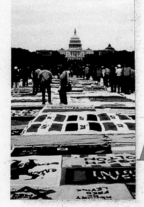

3

*B*ut thy eternal summer shall not fade,
Nor lose possession of that fair thou owest;
Nor shall *D*eath brag thou wander'st
in his shade,
*W*hen in eternal lines to time thou growest;
So long as men can breathe, or eyes can see,
So long lives this, and this gives life to thee.

Wm. Shakespeare
Sonnet XVIII

1 Street poster announcing events for The Kitchen (a performing arts centre in New York) while also publicizing a help line number for the AIDS Drug Assistance Program, which provides help for people needing drugs for the treatment of HIV. Design by Bureau (Marlene McCarty and Don Moffit), USA 1990.
2 Poster by Charles Helmken for the 'Images for Survival II' project on AIDS awareness, USA 1989.
3 'Eternal Summer', poster designed by Joseph P. Ansell using a photograph by David M. Green, for the 'Images for Survival II' project, USA 1989.
4 Photographs by Marc Geller of the NAMES Project quilt, USA 1987-8.

1

The politics of food, nutrition and health

Problems relating to food, nutrition, medicine and health care differ greatly from country to country; most however are entangled in a web of politics and economics. In the Third World in particular, food is a fiercely political issue and is inextricably linked with the imbalance of wealth between the underdeveloped countries and the industrialized West.

It is not surprising then that the posters in this section are a mixture of straightforward health instruction and bitter political comment. Projects shown include posters from a Food and Nutrition kit designed in 1982 for the Organization of Consumer Unions in Malaysia by Chaz Maviyane-Davies (head of the Maviyane Project in Zimbabwe,

page 77). They mix harsh statements about the industrialized world's economic exploitation of underdeveloped countries with comments about sanitation and nutrition. The visual language however is damning: energy crises are depicted as a starving child peering out of the shadows of the control panel of a car (symbol of the rich, petrol-guzzling West), and further messages of persuasion or protest are conveyed through obvious signs of Westernization such as pills or dollar bills.

Bob Linney's poster on the activities of transnational food companies makes equally harsh comment. His British-based charity, Health Images, conducts poster and graphic workshops in the poor countries of the world.

They teach community health workers to design and produce their own health materials and visual aids, thereby incorporating relevant symbolism, customs, colours, local art, and other issues affecting the reading of an image. For example, both the Hindu goddess Kali and the Hindu elephant god are used to carry health messages in the posters shown here, which were produced by local health workers in the slum of Dharavi in Bombay.

But political comment is never far away. A Health Images workshop was held in 1989 in association with the Asamblea de Barrios, a grassroots group in Mexico City that pressurizes the Mexican government on a wide range of issues. Their figurehead is

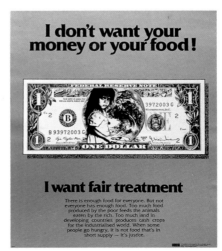

2

Superbarrio (a costumed ex-wrestler) who campaigns against homelessness, poor sanitation and air pollution, and features on one of the posters produced by local people attending the Health Images workshop, shown on page 199.

Other matters relating to health and well-being on pages 198-9 include irradiated food, anorexia and culture clash, as shown in the nutrition poster by Redback Graphix in Australia which focusses on those forced to exist between two different cultures, and urges children to 'Eat Good Food'.

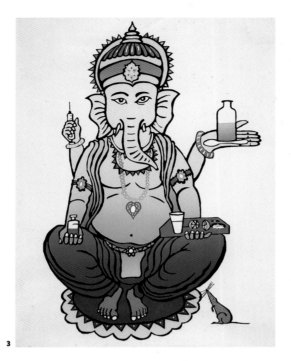

3

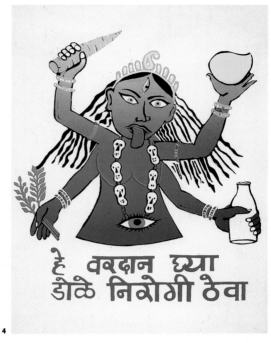

4

5

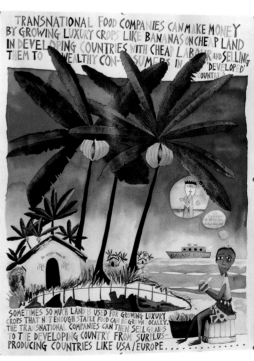

6

1 & 2 Posters from a Food and Nutrition kit for the International Organization of Consumer Unions in Malaysia, designed by Chaz Maviyane-Davies of Zimbabwe, 1982.
3 & 4 The products of Health Images poster workshops: two posters produced in the large slum of Dharavi in Bombay by local health workers, 1988. Ganapati, the Hindu elephant god, is holding a syringe (for immunization), vitamin A solution, de-worming **solution and oral rehydration solution. The Hindu goddess Kali is holding a mango, milk, a carrot and some dark green leafy vegetables. These are all good sources of vitamin A, a deficiency of which causes xerophthalmia and eventually blindness in children.**
5 Front cover of Health Images information leaflet.
6 Poster by Bob Linney on the socio-political causes of low health status, Britain 1980s.

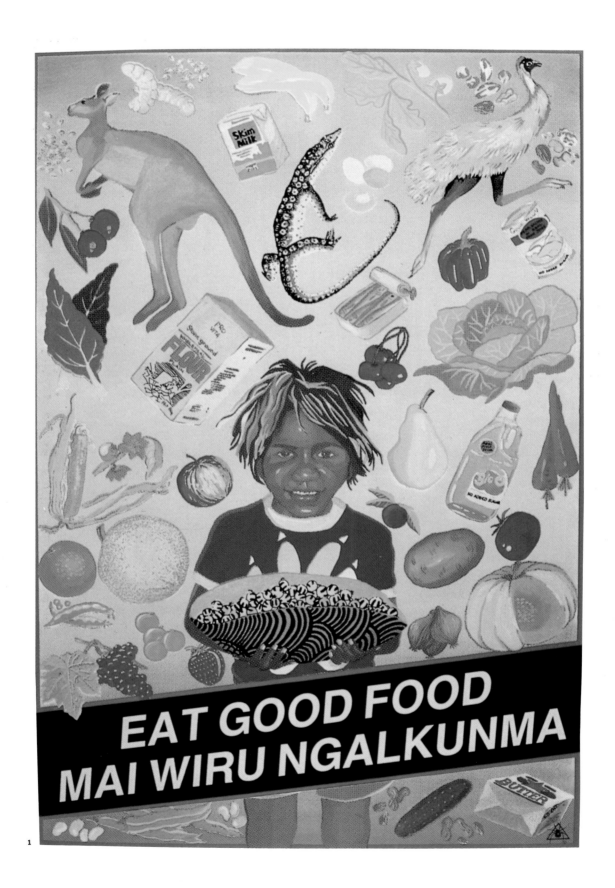

1

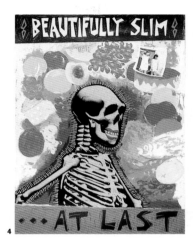

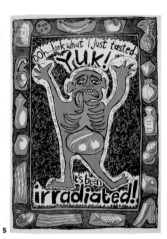

4

5

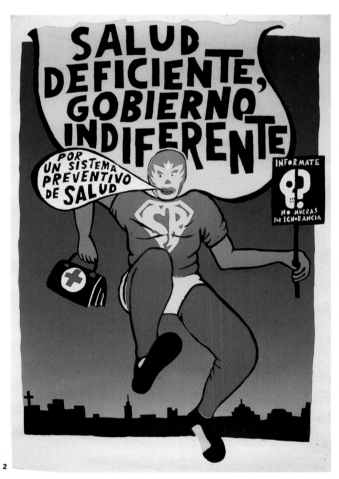

2

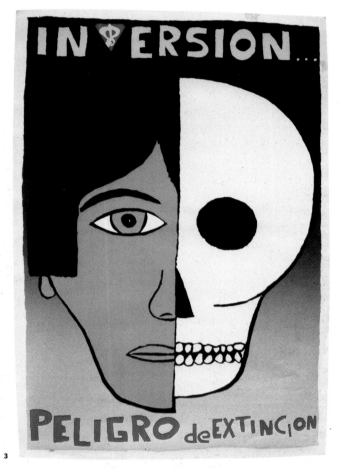

3

1 'Eat Good Food' by Redback Graphix (design: Leonie Lane; printer: Peter Curtis) aimed at children in bush communities, Australia 1987.

2 & 3 Two posters printed and designed by local participants of a Health Images workshop (see page 196) held in association with the grassroots pressure group Asamblea de Barrios, Mexico City 1989. Left: featuring the group's figurehead Superbarrio, an ex-wrestler who appears dressed up in a Superman suit at the Asamblea's demonstrations and meetings. The slogan says 'Deficient Health, Indifferent Government'.

Right: poster about the severe problem of air pollution in the city (*contaminación*). The words at the bottom say 'In Danger of Extinction'.

4 'Beautifully Slim, at Last' by Carol Porter of Red Planet arts workshop, a silkscreened poster on anorexia and women's self-perceptions, Australia 1992.

5 'Yuk', a poster comment on food irradiation by Sue Anderson of Red Planet arts workshop, Australia 1989.

The Road to Social Success

Education

Unemployment

Employment

Financial Insecurity

Financial Security

Reduced Consumer Power

Consumer Power

Home Ownership

Urban Deprivation

Poor Housing

Greater Consumer Power

Social Alienation

Superior Social Standing

Financial Disaster

Civil order and social welfare: from housing to homelessness

1

2

Poverty and homelessness have increased over the past three decades, and promise to be the plague of the 'caring 1990s'. Whereas the 1970s brought attempts to deal with the alienation and poverty of public housing plans and estates, the 1990s has brought homelessness and *The Big Issue* (a newspaper produced on behalf of the homeless), as well as concern over social services unable to cope.

Social critique and protest centering on unemployment, strained health systems and rising crime, is therefore increasing, as are attempts to provide the homeless with an identity in order that they are not simply forgotten. In America, community art projects are now seen as a way of combating gangland violence in cities and producing local pride in inner-city neighbourhoods, while handgun control still remains a hotly-debated issue.

3

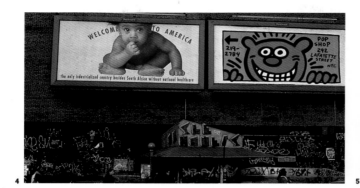

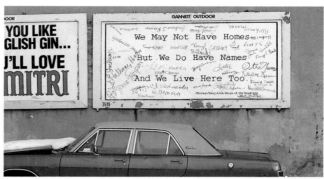

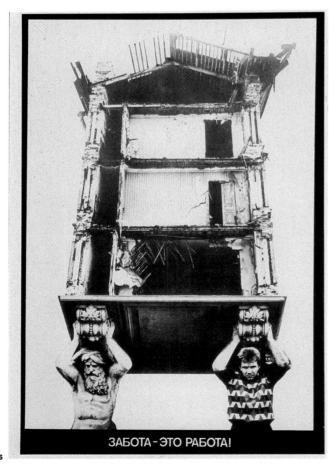

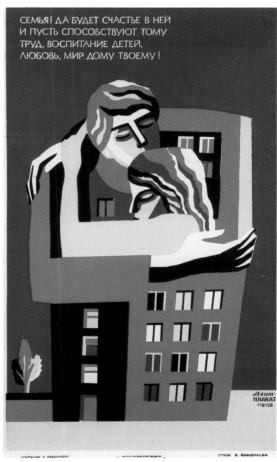

1 'Benefits', poster alluding to life on housing estates, London 1970s.

2 *The Big Issue*, newspaper produced on behalf of the homeless, Britain 1992.

3 Young designer's comment on future prospects in the British recession (the symbols are derived from British road signs), Chris Shuff, Britain 1990.

4 'Welcome to America: the only industrialized country besides South Africa without national healthcare', billboard by Gran Fury, USA 1990.

5 Billboard from the public art project 'Your Message Here', showing a mass of signatures of homeless people. Created by Greg Boozel and Sara Fredrickson for the Union of the Homeless, USA 1990.

6 'Caring is hard work!', poster in support of the restoration of historic architecture, by Alexander Vasilchenko, USSR 1988.

7 Poster concerning the housing shortage and its harmful effects on family life in the USSR, by Levshunova, USSR 1980s.

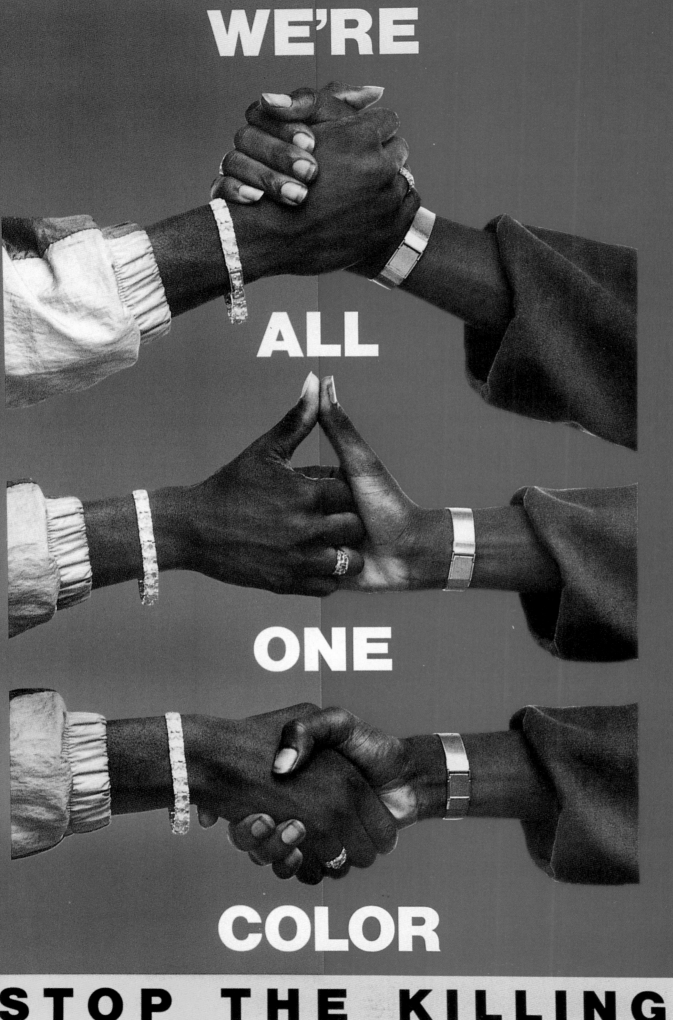

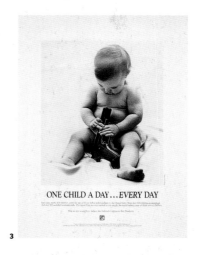

3

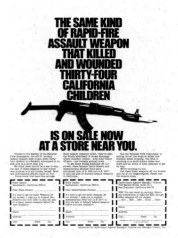

4

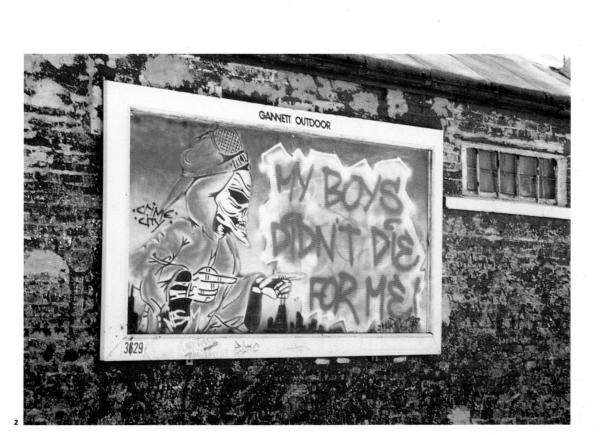

2

5

Controversies
surrounding the right
to carry arms.
1 'We're All One Color',
poster calling for a stop
to Los Angeles gang
violence and depicting
a soul handshake by
members of different
LA gangs. Designed by
Robbie Conal and
Debbie Ross, USA 1989.
2 'My Boys Didn't Die for
Me', billboard

message against gang
violence by graffiti artist
Mario Gonzalez Jr, as
part of the Randolph
Street Gallery's public
art project 'Your
Message Here', which
placed 40 billboards
around Chicago
neighbourhoods in
1990.
3 'One Child a Day',
poster produced by the
National Coalition to

Ban Handguns, USA
1992. Photograph by
James Wood. The text
refers to the number of
children reported to be
killed annually with
handguns in the USA.
4 Press ad calling for
support to stop the sale
of military assault
weapons in California;
created by the Public
Media Center, USA
1990.

5 Issues of safety and
self-defence are given
glossy graphic
treatment in *Women &
Guns* magazine, USA
1992.

Global issues and global promotions

The year 1991 brought a new form of advertising: global issues were used to promote commercial products as part of socially-responsible business philosophies.

San Francisco-based Esprit, one of the world's largest manufacturers of women's and children's clothes, decided to develop a dialogue with its customers through television and print advertising by asking the question 'What would you do?' (to change the world) – and reeled from the weight of response it received on a wide range of social issues, from the rainforest to abortion. Their heavily publicized aim was to give their customers a chance to 'get involved' in issues, as part of a socially-conscious corporate philosophy.

Benetton, also one of the world's largest casual clothing companies, decided to 'make people think' by displaying 'universal' and socially-orientated photographs as part of a global corporate image communicating to audiences in a hundred different countries. Although an international perspective had marked their campaigns throughout the 1980s (leading to the adoption of their slogan 'United Colors of Benetton' in 1989), by the 1990s the ads had become increasingly provocative. Clothes no longer featured; instead there were controversial social images aimed at promoting awareness of world issues – and the Benetton name. Some audiences were infuriated by the combination; others were not. An image of a black woman breastfeeding a white baby was banned in the US; it won awards in five other countries.

1

A blood-spattered newborn baby went up on billboards in Britain – and promptly came back down, due to public outcry. A photograph of a deathbed scene involving AIDS sufferer David Kirby threw British magazine editors into moral dilemmas, and caused outrage by AIDS activists such as ACT UP, who immediately boycotted Benetton shops.

There is no denying that both Esprit and Benetton broke new ground in advertising;

Benetton in particular, for better or worse, opened up a debate on how images are used in the public domain, and for what purposes. But the underlying controversy remains: in the caring 1990s, social and political 'involvement' has become enmeshed with commercial sales strategy. It is an uncomfortable mating no matter how well it is handled, and one that will continue to elicit mixed reactions and protest from the public.

1 Press ads from the 'What would you do?' campaign by Esprit clothing company, USA 1991.
Benetton's provocative ad campaigns produced a mixed response from their international public:
2 Reworked billboard ad by Saatchi & Someone (original text: 'United Colors of Benetton'),
Britain 1990-91.
3, 4 & 5 Controversial Benetton ad showing a dying AIDS sufferer. *The Face* magazine carried the ad but insisted that any revenue gained should go to charity; *Elle* magazine refused and left a blank space and explanation to its readers; AIDS activists ACT UP boycotted Benetton shops and produced this poster for display on streets and in bus shelters.

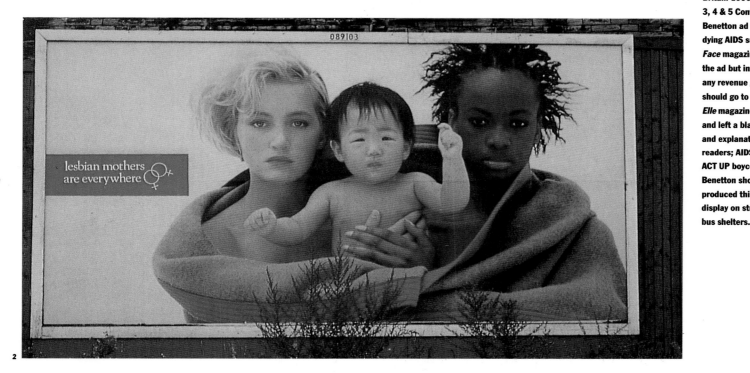

2

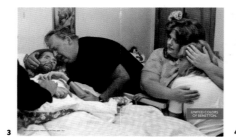

3

4

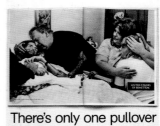

There's only one pullover this photograph should be used to sell.

5

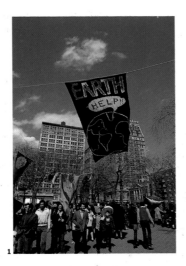

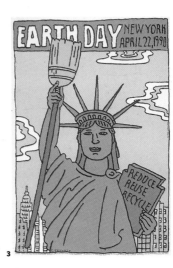

Saving the earth
Ecology and the Green movement

The disruption of eco-systems and exhaustion of natural resources are not new issues, even for the design world; the rumblings and warnings have been fairly constant over the past few decades. The forerunners of today's Greens were not only present in the science corridors of universities and colleges, but also in the drop-out hippie culture of the 1960s, when living in a commune was the path to self-sufficiency and a better relationship with Mother Earth. This consciousness continued to develop into the 1970s cult for 'alternatives', spurred on by the world oil crisis of 1973 and subsequent shortage scares. People began not only to take a critical look at their own lifestyles and values but also to develop a sense of responsibility for their society and the planet. Ecology, alternative technology and survival began to be seen as the passwords to the future.

This chapter takes a brief look at those early days of the 'Earth movement', when the foundations for many present-day attitudes were laid. But it then jumps quickly to the 1980s, for that was the decade when 'Greening' really became a viable force: in politics, pressure groups, business and consumerism, education and daily habits. The effect of this change in attitude, in what ad agencies now refer to as

'the great Green boom' of the mid-1980s, was phenomenal – and it revolutionized the way in which artists and designers viewed and handled environmental subjects.

The power struggles examined in this chapter are between conflicting attitudes: consumption vs. conservation; industrial and economic expediency vs. planning for the future; government complacency vs. popular protest or individual determination. The conflicts do not divide neatly between the Establishment and the agitators; they encompass everyone and at all levels – personal, national and global. A graphic revolution of sorts has also taken place, in the sense that Green issues have now penetrated our everyday thoughts, tastes and visual language.

Beginnings of the Earth movement
Much of the imagery and philosophy from the early days emanated from America. The first Earth Day was held on 22 April 1970 to focus public attention on environmental concern, and consolidate a new and fast-growing movement. Robert Rauschenberg's poster for the event was a design classic; and the aggressively staring eagle became a

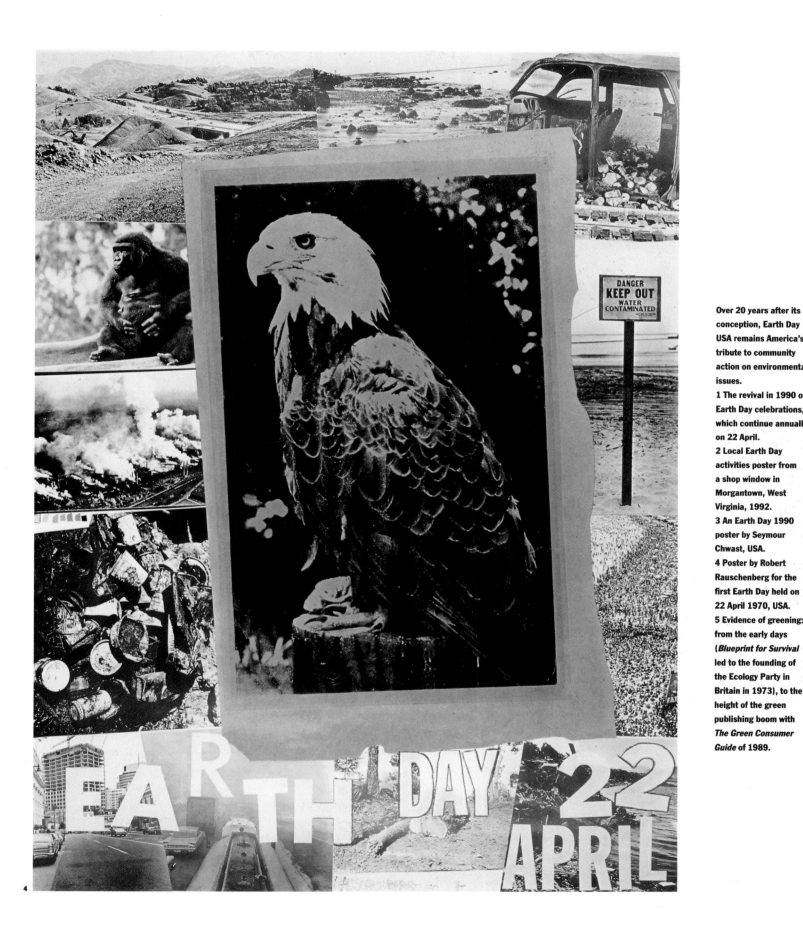

Over 20 years after its conception, Earth Day USA remains America's tribute to community action on environmental issues.

1 The revival in 1990 of Earth Day celebrations, which continue annually on 22 April.

2 Local Earth Day activities poster from a shop window in Morgantown, West Virginia, 1992.

3 An Earth Day 1990 poster by Seymour Chwast, USA.

4 Poster by Robert Rauschenberg for the first Earth Day held on 22 April 1970, USA.

5 Evidence of greening: from the early days (*Blueprint for Survival* led to the founding of the Ecology Party in Britain in 1973), to the height of the green publishing boom with *The Green Consumer Guide* of 1989.

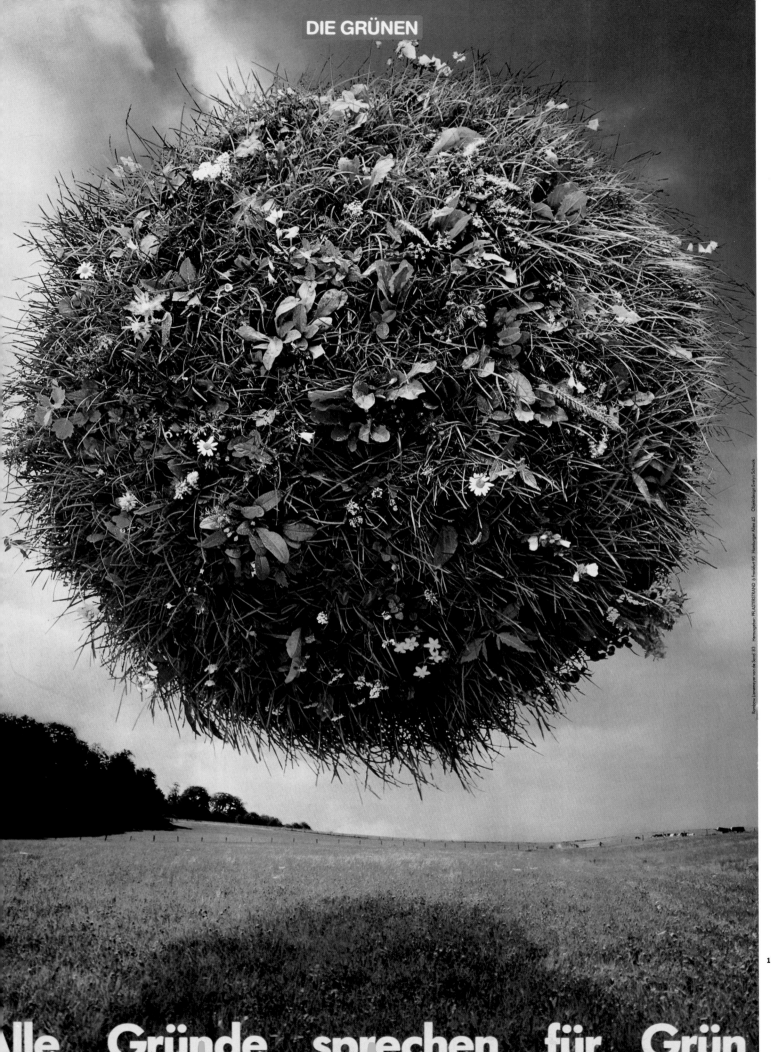

DIE GRÜNEN

Alle Gründe sprechen für Grün

1

The Green movement
took a particularly
strong hold in Germany
where it received
enthusiastic support
from artists and
designers.
1 Poster publicizing Die
Grünen, the Green
political party in West
Germany, by Gunter
Rambow, 1983. The
bottom line reads:
'All of nature supports
the Greens'.
2 Postcard by Egon
Kramer, West Germany
1984.
3 'No Place for Trees',
a poster comment on
how trees have difficulty
surviving in city
environments, by
Manfred Butzmann,
East Germany 1990.
4 Postcard by Egon
Kramer, West Germany
1988.
5 Poster promoting
Green politics, by
Manfred Butzmann,
Germany 1990.

symbolic guardian of the Earth movement – and a symbol for survival. US Earth Day was revived on its twentieth anniversary in 1990, with the more specific aim of building environmental commitment through personal action. Although global in scope – some 200 million people in 140 countries participated in 1990 – it remains America's annual tribute to the value of local, community effort on environmental issues.

The early movement also had its champions and theoreticians. These included consumer rights crusader Ralph Nader (see page 213); the Club of Rome, an international group of scientists and industrialists intent on persuading governments, industrial leaders and trade unions throughout the world to take heed of global environmental problems; the British Ecology Party, formed in 1973 (the first in Europe); and later the German Green party, Die Grünen – led by the dynamic Petra Kelly – which made an impact in West German politics in the national elections of 1983, and then entered the European Parliament in 1984.

Casting a heavy influence on design education in the 1970s were Buckminster Fuller with his geodesic domes and concept of 'Spaceship Earth', and Victor Papanek and his treatise on moral responsibility vs. industrial design, *Design for the Real World*. Together they introduced a generation of students to the concept of 'economy of means' and the plight of the Third World. Valuable work was carried out by organizations such as UNICEF in the study of literacy and health problems, as well as the communication of health matters to non-literate groups through the use of pictures and drawings. This began a pioneering phase in the visual design of instructional information and educational aids.

Alternative living also had its bibles, for example Charles Reich's *The Greening of America* (1970), Stewart Brand's many versions of the *Whole Earth Catalog* (1968-85), E. F. Schumacher's *Small is Beautiful* (1973), and Robert Pirsig's *Zen and the Art of Motorcycle Maintenance* (1974) which achieved a massive cult following. They all influenced and fed the prevailing mood of 'social conscience', and the move towards socially-responsible design. Ergonomics was the buzz word of the day, and equally popular were the notions of recycling, alternative technology and economical use of materials and energy. The graphic design world also strove to be socially relevant, showing new interest in community art, photo-journalism, design for special needs, health education, literacy and readability. Attention was focussed on the audience or user, and the concept of 'user feedback'. Graphic design

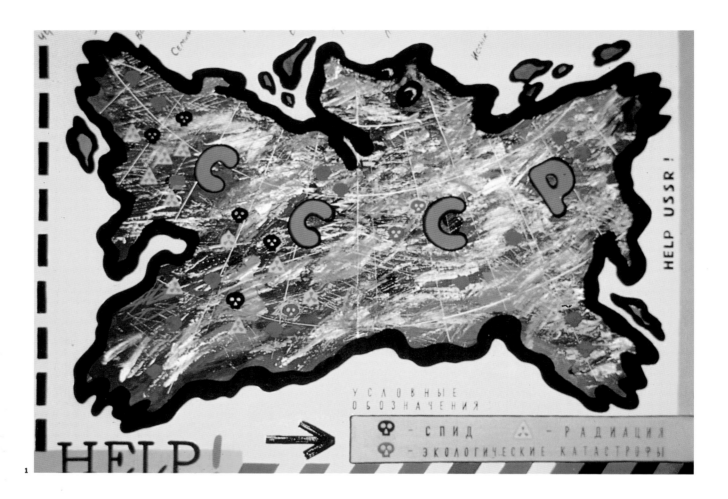

1

2

3

education responded to all these interests with a flowering of college courses specializing in information design, teaching a research-and-analysis approach to communication graphics and, for better or worse, widening the existing gap between graphic design and advertising.

But despite such educational trends, ecology and its concerns were still marginalized. They had no political weight, and were ignored by industry and the broader general public. The visual handling of environmental issues consequently suffered from not being taken very seriously, and at best offered a soft-centred approach, or a clichéd conservationist-hippie attitude. Although Rauschenberg's eagle had cast a rather sinister, watchful eye over the decade, the imagery from the 1970s was generally not hard-hitting enough to impose a dramatic shift in attitude. The vision of a gentler and more caring planet failed to make sufficient impact on dog-eat-dog industrial society.

The Green movement and new attitudes

With Thatcher elected in 1979, Reagan elected in 1980, NATO rearmament underway and other evidence of a shift in world politics to the Right, the alternative politics of the Left began to rise with a

vengeance. In alignment with the growing anti-nuclear lobby came the rise of the Green movement, and in 1984 Petra Kelly and Germany's Die Grünen made their significant move into the European Parliament, accompanied by a bright, punchy visual identity.

The period of change had begun. The pressure group Greenpeace acquired an international profile as nature's vigilantes through televised reports of their courageous 'direct actions'. Although Greenpeace never operated a global corporate identity, their name came to have tremendous impact and authority. The graphic campaigns associated with Greenpeace also took on this confrontational stance. Their famous offshoot Lynx, the anti-fur trade campaigners, teamed up with Yellowhammer ad agency in London to produce the '40 dumb animals' campaign in 1985 (page 221). The campaign was a landmark in modern graphic design history, and helped create a widespread stigma against wearing fur (nearly ruining the British fashion-fur industry).

The Live Aid rock concert that took place in July 1985 was another crucial force in the period of change. Through the medium of a globally-televised rock concert, it helped create a new mood of 'public awareness'. Although the concert was specifically for famine relief in

Africa, it heightened public sensibilities and consciousness of global problems. Within a few years life-threatening crises such as the greenhouse effect and global warming also loomed into view, along with disasters such as the world's worst ever nuclear accident at Chernobyl in 1986 and the Exxon Valdez oil spill in 1989. With growing reports of pollution and irreparable damage to forests and wildlife, ecology suddenly became a battle for the survival of humankind and the planet.

Accompanying this shift in attitude came a crucial change in visual strategy. Environmental campaigns stopped concentrating on the pleasanter aspects of conservation; they instead started focussing on the destruction and stupidity taking place. They began 'talking tough', and seeking help from ad agencies to get their message across. Pollution became a more urgent and popular topic, producing clever twists in approach, as in the litmus paper billboard shown on page 223. By this time (and with the Lynx campaign setting an example) advertising agencies had also realized that much kudos was to be gained in hard-hitting environmental campaigns. Consequently such campaigns were eagerly snatched up by the media industry.

Oil spill disasters around the world brought intense public outcry and an inspired form of despair and protest from creative artists, including the fantasized image 'Changing the Face of America (Genetically Speaking)' by Alaska Visual (page 223) and fashion stylist Judy Blame's controversial and harrowing sequence 'Dying Waters' (pages 224-5). Pollution, animal rights, endangered species and other environmental campaigns would never be the same.

In addition, educational efforts were targeted at the young (shown on page 229 in the form of Britain's Captain Eco, and America's

Captain Planet and the Planeteers) and Green marketing and consumerism came into existence with the creation of 'Green companies' such as Anita Roddick's Body Shop. Consumers increasingly began to turn to 'natural' products, from food and clothing to beauty-without-cruelty cosmetics. As specifiers of paper and print, and as visual communicators (able to help mould the attitudes of consumers and clients alike), graphic designers themselves found an instrumental role to play in the 'selling' of the whole issue of recycling.

The 1990s have seen environmental issues find their way onto the agendas of mainstream political parties, and the 1992 Earth Summit in Rio marked an important attempt to see them enter the arena of international politics, even though the outcome may have disappointed many. But if the environmental politics of governments ultimately fail to go global, perhaps protest will. The 'Visualize the Future' event held in 1992 by Parco – the youth subsidiary of Seibu department store in Tokyo – was intended to raise ecological consciousness in Japan, but also points to a potential future format for graphic agitation. Parco's event took the form of an open art exhibition where artists, designers, illustrators and students from all over the world produced slogans, designs or pieces of art relating to their vision of the future. These were faxed directly to the exhibition, or sent on computer disk and printed out and displayed. In addition to encouraging new types of environmental statements, such an event also suggests a futuristic scenario – where revolutions might no longer take place in the streets, but instead take the form of global movements of protest and solidarity, carried by a network of messages, images and manifestos, shot round the world through fax signals and computer technology.

Ecology imagery takes on a greater urgency in the 1980s.
1 'Help!' (the legend reads: AIDS; Radioactivity; Ecological catastrophe), poster relating to the USSR's urgent problems, designer unknown, USSR 1989.
2 'Chernobyl 1986', poster by Dan Reisinger, Israel.
3 'It's better to live nuclear free', poster by Stefano Rovai of Graphiti studio, Italy 1987.
4 'The Proof of the Pudding...is in the Heating', postcard showing nuclear reprocessing plant as a Christmas pudding, by South Atlantic Souvenirs, Britain 1985-6. On the back it carries a humorous recipe for a (lethal) party cocktail entitled 'Meltdown'.
5 Poster picturing mankind as a greedy pig destroying the world, by Bokser, USSR 1989.

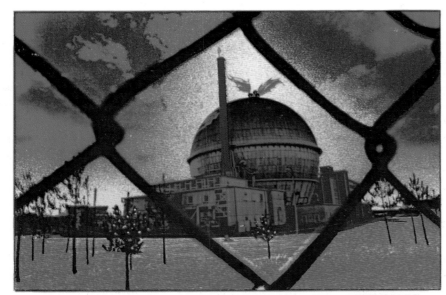

THE PROOF OF THE PUDDING····

4

5

ECOLOGY NOW!

Forerunners of the Green movement

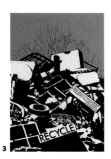

The search for alternative lifestyles and technology, and the growing climate of 'social conscience', provided the foundation for the early days of the Earth movement in America. It was a movement heavy with philosophy, publications and personalities, all of which influenced design directions and attitudes for years to come.

Highlights from that period included the crusading lawyer Ralph Nader, who emerged in the early 1960s as the watchdog of consumer rights and protection. He was particularly known for taking Chevrolet to task over the production of the rear-engine Corvair, which he declared unsafe – a legal battle described in the 1965 publication *Unsafe at any Speed*. Having made a historic confrontation with a major corporation, Nader was instrumental in strengthening the consumer movement in America and influencing issues of environmental and social import for a long time after.

Design education also declared its gurus and bibles. There was the architect and inventor Buckminster Fuller, best known for his geodesic domes, concept of 'Spaceship Earth', and dedication to the development of modern technology and science for the good of humankind. Designer and educator Victor Papanek authored *Design for the Real World* which examined moral responsibility in design, and promoted alternative, energy-saving methods. In 1968 Stewart Brand started the 'access-to-tools' compendium known as the *Whole Earth Catalog*. Six versions were completed up to 1985, including *The Last Whole Earth Catalog* (1971) shown here: a directory of sources, places and people relating to alternative living and a monumental collection of research that aimed to make technology accessible to everyone.

Ecology posters also emanated from diverse sources, including the Graphic Workshop in Boston, a group founded in 1970 as the Student Strike Workshop at Massachusetts College of Art and renowned for their protest graphics on a number of issues in the early 1970s (see page 149).

A nuclear catastrophe is too big a price for our electric bill.

Ralph Nader calls a national meeting of citizens to stop the development of nuclear power until it can be proven safe.

Critical Mass74

A national gathering of the citizens movement to stop nuclear power.
November 15-17 Statler Hilton Hotel Washington, D.C. Phone 202-546-4936

5

1 Victor Papanek's book *Design for the Real World*, with an introduction by R. Buckminster Fuller, first published in 1971.
2 'Ecology Now', poster (artist unknown), USA 1970.
3 Poster for a recycling group by The Graphic Workshop (formerly Student Strike Workshop) in Boston, *c.*1972.
4 One of many versions: *The Last Whole Earth Catalog*, an illustrated compendium of technology and research for alternative living, USA 1971.
5 'Critical Mass 74', poster designed by Arnold Saks announcing a national meeting in Washington DC for Ralph Nader's movement against nuclear power, USA 1974.

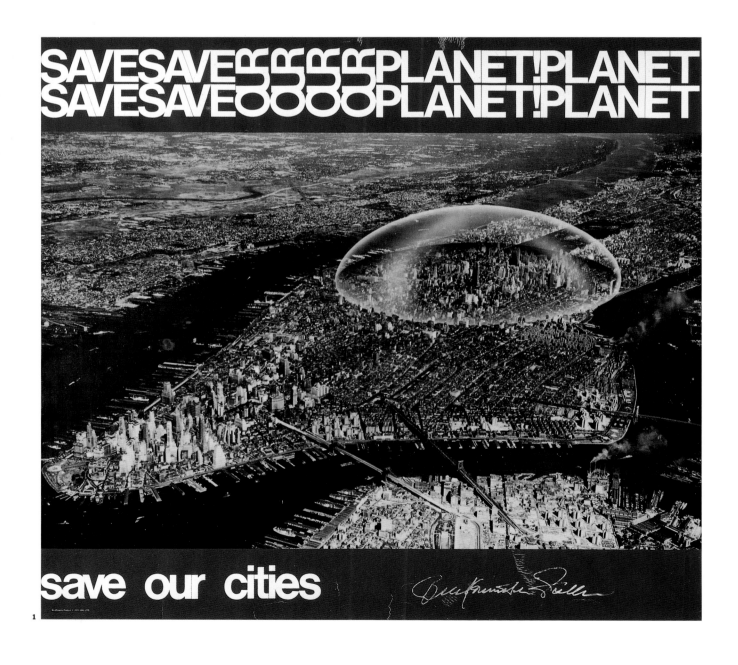

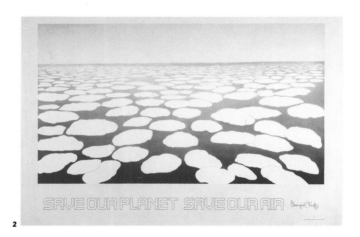

Early Green collaboration: art and business

The 'Save Our Planet' series of six anti-pollution posters by well-known creative artists was sponsored by Olivetti in 1971, representing an early example of collaboration between the art world and large corporations. Olivetti was known for its modern image and innovative graphics and publicity; its alignment with the new movement was in keeping with a progressive corporate vision.

Of the images in the series, three remain outstanding products of that period. Georgia O'Keeffe's 'Save Our Air' is a hypnotic comment on the beauty of pure, never-ending sky and the rhythm of life itself; it is probably the most widely reproduced poster of the series. With appropriate quirkiness and charm, architect Buckminster Fuller's 'Save Our Cities' captures the high-spirited enthusiasm of the man, his theories of 'Spaceship Earth', and his commitment to harnessing technology for the good of all. Roy Lichtenstein's 'Save Our Water' however is perhaps the most startling image, for his enlarged Ben Day dots hint at mechanization, technology and other potential evils that are hovering above the water line.

The 'Save Our Planet' series sponsored by Olivetti, 1971.
1 'Save Our Cities' by Buckminster Fuller.
2 'Save Our Air' by Georgia O'Keeffe.
3 'Save Our Water' by Roy Lichtenstein.

1

The rise of Green politics in Europe

2

The Ecology (or Earth) movement began to develop as an alternative political grouping in Europe in the 1970s. The British Ecology Party was formed in 1973; and soon after Petra Kelly set about founding a political party in Germany, where Green issues were beginning to have tremendous impact. The West German Die Grünen (Green Party) was thereby formed to stand as a nationwide party in the European parliamentary elections in 1979. They made a great show of strength in the national elections of 1983 (gaining 27 seats), and in 1984 entered the European parliament. By the mid-1980s the enthusiasm had spread, and most Western European countries had Green parties.

From their founding in 1979, Die Grünen employed the emblem of a bright, bold sunflower, and made use of the emotional appeal of graphics derived from children's illustrations, as well as handwritten slogans. Die Grünen also benefited from the allegiance of world-renowned artists and designers, including Joseph Beuys and Andy Warhol.

The East German Green Party was later able to draw upon the greater resources of the European Green network and produced a sophisticated photographic poster by Holger Matthies to contest the March 1990 East German free elections; the image, shown here, is still in use by Die Grünen today. Also represented is a poster by Manfred Butzmann for the left-wing ecology pressure group Grüne Liga, used to help promote green politics in the March 1990 elections.

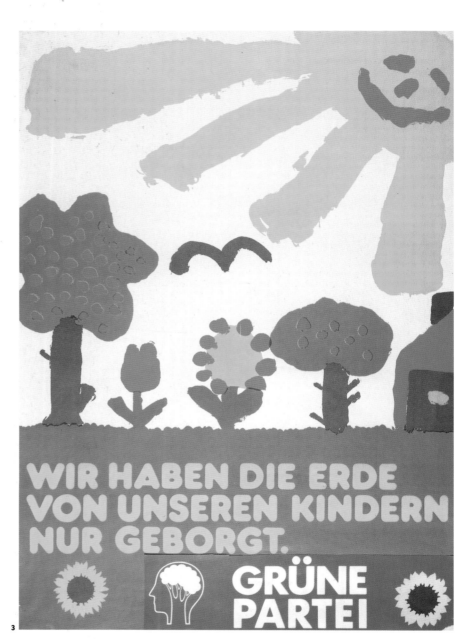

3

5 Alle Gründe sprechen für Grün

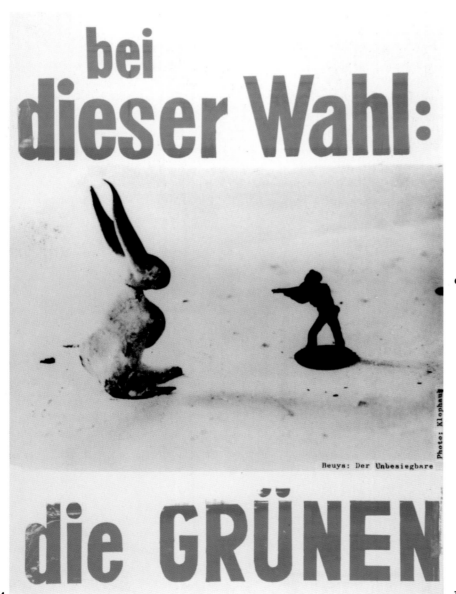

bei
dieser Wahl:

Beuys: Der Unbesiegbare

die GRÜNEN

4

GRÜN!
ROT!

6

UMWELTSCHUTZ

WIR KÄMPFEN UM JEDEN MILLIMETER

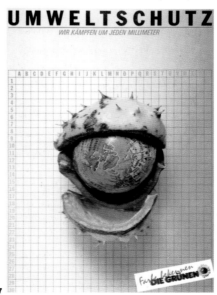

DIE GRÜNEN

7

1 Sticker from the British Green Party, showing the sunflower emblem adapted from the West German symbol, mid-1980s.
2 Anti-nuclear power sticker, early 1980s.
3 'We have only borrowed the Earth', the first major poster produced by Die Grünen, West Germany 1979.
4 'By this election: the Green Party', poster issued by Die Grünen that reproduces a work entitled 'The Invincible' by the artist Joseph Beuys, West Germany 1979.
5 'Come out into the open', poster for Die Grünen by Gunter Rambow, West Germany 1983. The bottom line reads: 'All of nature supports the Greens'.
6 'Green! Red!', poster by Manfred Butzmann for Grüne Liga (Green League), an East German environmental pressure group, 1990.
7 'Protecting the Environment: we fight for every millimetre', poster and postcard issued by Die Grünen, designed by Holger Matthies 1990.

GREENPEACE

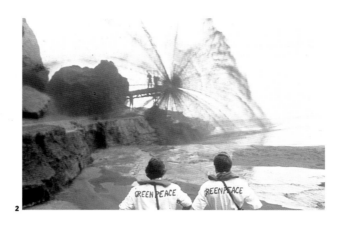

Greenpeace: international environmental action

The international environmental pressure group Greenpeace began their protest activities in 1971. Although they staged important campaigns against nuclear testing and other issues throughout the 1970s, it was in the early 1980s that they moved into the international spotlight. Their dramatic direct actions, when flashed across television screens in news reports, caught the public imagination. Greenpeace became the champions of the natural world, and by the mid-1980s had become a household name.

Since its founding, the organization has grown worldwide, with offices in over 20 countries. Non-violent direct action is employed to pressurize governments and

industries, and the organization's list of accomplishments includes stopping the French testing of nuclear weapons in the Pacific, halting radioactive waste dumping in the Atlantic and bringing an end to legalized commercial whaling. They have also suffered along the way: in 1985 their sea-going vessel, the *Rainbow Warrior* (on a mission to evacuate victims of the French nuclear testing programme) was bombed by the French Secret Service as it lay moored in Auckland harbour, causing the death of the Greenpeace photographer on board.

The main administrative office, Greenpeace International, acts as an umbrella to national offices – but there is no international logo or

corporate image, except for the authority of the name itself. (The logo shown here, for example, is well known in Europe, but not necessarily in America.) The UK national office has a history of producing hard-hitting, openly controversial print campaigns: they initially commissioned Yellowhammer in 1983 as their first full-service ad agency, an association which led to the '40 dumb animals' poster on page 221. From that point onwards, the use of advertising as a means of provocation was one of their hallmarks. By the late 1980s they were pushing media tolerances to the limit, and ad agencies and designers were clamouring to be associated with them.

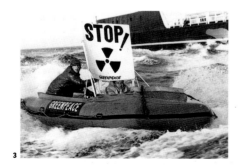

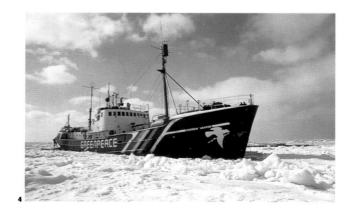

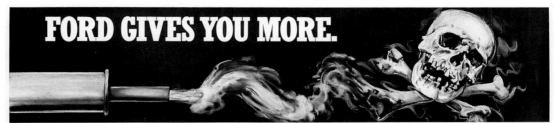

6 A <u>Ford</u> in Britain pumps out 100% more toxic fumes than a <u>Ford</u> back home in America. *GREENPEACE*

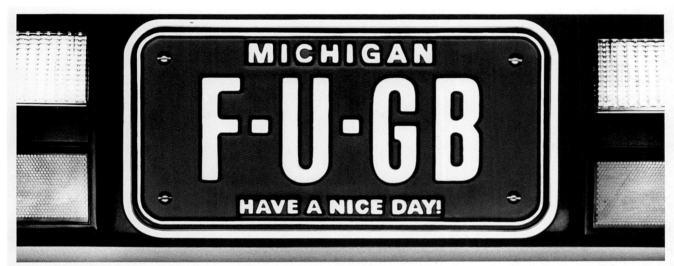

A <u>Ford</u> in Britain pumps out 100% more toxic fumes than a <u>Ford</u> back home in America.

GREENPEACE

5

1 The Greenpeace logo used in Europe; one of a number of versions used around the world.
2 A pipe-blocking action at Portman, Spain (the pipe was dumping solid industrial waste into the Mediterranean), 1986.
3 In the Mediterranean near Gibraltar: a Greenpeace inflatable intercepts a British carrier loaded with nuclear spent fuel from an Italian reactor and bound for Sellafield reprocessing plant in Britain, 1986.
4 The *Rainbow Warrior* in the Gulf of St Lawrence, Canada, as part of a seal cull action, 1982.
5 & 6 Posters for a Greenpeace print campaign in Britain, highlighting the fact that, at the time, Ford motors did not fit catalytic converters on its British cars (as it did in America).

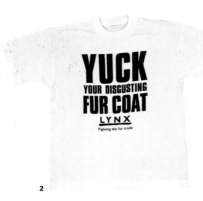

2

Lynx: the anti-fur campaign

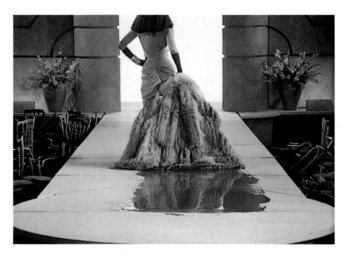

**YUCK!
YOUR
DISGUSTING
FUR COAT**

L Y N X

1

In 1985 Mark Glover formed a splinter group of the environmental organization Greenpeace that was solely devoted to fighting the fur trade. He teamed up with Lynne Kentish and Carol McKenna, and together they formed the main core of Lynx, the national organization campaigning against the fur trade.

Although small in size, the charity made a very big noise with their '40 dumb animals' campaign (originally commissioned by Greenpeace) which involved a billboard poster showing a fashion model dragging a bloody fur coat behind her. It was followed by a cinema ad which simulated a fashion show; models paraded down a catwalk and in the course of twirling round to show off their fur coats, sprayed their audience with blood. (Both were created by London ad agency Yellowhammer at minimal cost, through the *pro bono* work of sympathetic colleagues.) The campaign became one of the classic advertising award-winners of the 1980s and played a role in damaging the industry: fur shops were boycotted, fur sales plummeted and the British public's attitude towards fur-wearing changed significantly.

Other Lynx campaigns followed which were equally hard-hitting, and some much more gruesome, such as the cinema ad named 'Scavengers' which showed a customer pulling a fur coat off a shop mannekin, causing the maggot-infested guts of an animal to spill out onto the floor. Lynx campaigns were continually controversial, and their boldness earned them strong reaction

3

from the fur industry. It all eventually led to a torrent of litigation and Lynx was forced into liquidation.

The ground-breaking effects of their campaigns were substantial: Lynx pioneered a new form of aggressive charity and pushed public tolerances to the limit. Their message was driven home by extensive merchandising, with badges and t-shirts bearing hard-hitting slogans. Their symbiotic working relationship with Yellowhammer started a fast-growing trend that saw ad agencies teaming up with charities, and using charitable issues as a showcase for their creative talents (producing many admirable campaigns as a result). The public communication of social issues was thus changed forever, and the issues acquired a sense of urgency as never before.

5

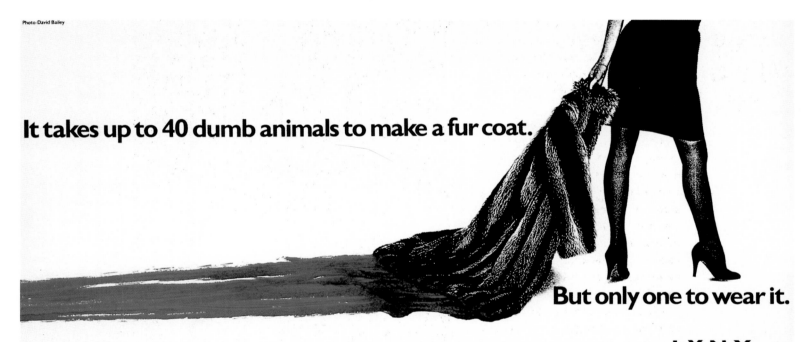

Photo: David Bailey

It takes up to 40 dumb animals to make a fur coat.

But only one to wear it.

4 If you don't want millions of animals tortured and killed in leg-hold traps, don't buy a fur coat.

LYNX
Fighting the fur trade
Visit the Lynx Shop at 79 Long Acre, London WC2.
PO Box 509. Dunmow. Essex. Tel: 0371 2016.

1 & 2 Badge and t-shirt from Lynx merchandising, known for its hard-hitting messages.
3 Cinema ad by Yellowhammer, 1985.
4 History-making billboard and poster for Lynx anti-fur campaign by Yellowhammer (art direction by Jeremy Pemberton; photograph by David Bailey). It was originally commissioned by Greenpeace in 1985.
5 Poster for Lynx by John Silver and Kevin Thomas of TBWA ad agency, 1988.

ACID RAIN

It falls on everyone.

1

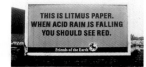

2

1 'Acid Rain', poster
by Takayuki Itoh (art
director) and Chikako
Ogawa (designer),
Japan 1989.
2 Billboard constructed
of litmus paper which
turned from blue to red
in a rain shower,
conceived and
constructed by Roger
Akerman and John Lewis

of McCann-Erickson ad
agency in London for
environmental charity
Friends of the Earth,
Britain 1989-90. The
sequence was filmed
to make a cinema ad.
3 'Save San Francisco
Bay', poster by Doug
Akagi and Kimberly
Powell of Akagi Design,
USA 1992.

4 A sci-fi vision:
postcard and t-shirt
inspired by an oil spill
off the Alaskan coast,
designed by Vern Culp
of Alaska Visual, USA
1989. Most stores in
Alaska refused to carry
the t-shirts for fear of
offending the oil
companies who were
financing the clean-up.

A survival strategy for the 1990s

A new mood of public awareness began in
the mid-1980s that was a product of many
converging forces – among them the global
charity efforts of Live Aid, the activities of
pressure groups such as Greenpeace and
Lynx, the growing threat of AIDS, and the
'great Green boom'. Added pressure came
from disasters such as the nuclear accidents
of Three Mile Island in 1979 and Chernobyl in
1986, the Exxon Valdez oil spill in 1989, and
reports on the greenhouse effect. By the late
1980s, environmental issues had become an
urgent matter of survival.

This shift in attitude dramatically changed
the way that creative artists viewed and
handled environmental issues. No longer
considered 'soft subjects', environmental
issues became part of the cutting edge. Old
graphic clichés – drawings of cute, cuddly
animals and exotic photographics of majestic
wildlife – did not completely lose their
attraction, but the range of environmental
comments, and the visual methods used to
convey them, expanded enormously. The
following pages include a number of unusual
and pioneering statements, such as a litmus
paper billboard; a style and graphics essay by
Judy Blame inspired by a major oil disaster;
and the cartoon characters Captain Eco and
Captain Planet, both aiming to educate new
generations of environmentally-friendly
children (and their parents).

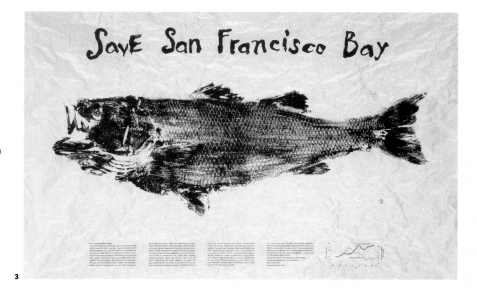

3

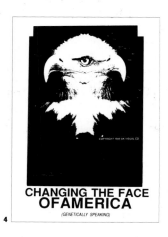

4

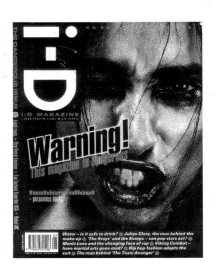

Cover and inside spreads from *i-D* magazine, showing fashion stylist Judy Blame's controversial 'pollution style' essay, inspired by an Alaskan oil disaster (1989) and using human models to symbolize oil-slicked birds. Informative statements about pollution appear throughout the sequence, woven into the murky background; Britain 1990. By the end of the 1980s *i-D* had incorporated the growing trend towards youth politics, and in the 1990s was pioneering the concept of fashion and style as an expression of personal identity and political awareness.

1 'Antarctica', a screenprinted poster on environmental issues related to Antarctica by Carol Porter of Red Planet arts workshop, Australia 1992.
2 Two posters from the Endangered Species series, started in 1975 and still continuing, by The Graphic Workshop in Boston, USA: 'Endangered Cuban Crocodile' (artist: Judy Kensley McKie, 1985) and 'The Kangaroo' (artist: Felice Regan, *c.*1989).
3 'Life and Death', an ecology awareness symbol designed by Svetlana Amoskina, Odessa 1989-90.
4 Ad campaign for the Whale and Dolphin Conservation Society by James Spence and Julie Crawford of Yellowhammer ad agency, Britain 1988.

1

2

3

What the Japanese mean by preserving whales.

WHALE AND DOLPHIN
CONSERVATION SOCIETY

20 WEST LEA ROAD BATH AVON BA1 3RL

Registered Charity No. 298656.

4

2

3

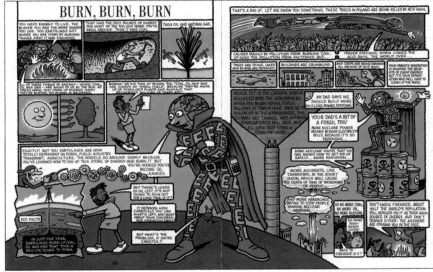

4

1 Poster for the protection of forests by Václav Houf, Czechoslovakia 1987.
2 Captain Planet from *Captain Planet and the Planeteers*, the world's first animated environmental action-adventure TV series which made its debut in 1990. It was syndicated in over 80 countries and became the number one children's show in the USA. Created by Turner Broadcasting System and DIC Enterprises.
3 Title-page and spread from the highly popular *Captain Eco and the Fate of the Earth*, written by Jonathon Porritt and illustrated by Ellis Nadler, Britain 1991.
4 'Memento', anti-pollution poster by Jozef Dóka, Czechoslovakia 1989.

The Green consumer movement

1

The 1980s saw the rise of the Green consumer movement, involving a growing demand for environmentally responsible consumer products, renewed interest in recycling, support for environmental campaigns and a new breed of Green companies with caring images or philosophies.

Most large corporations developed environmental policies to cope with consumer expectations for 'environmentally friendly' goods, and many new companies and products were formed. For example, beauty without cruelty (cosmetics not tested on animals) became a big issue, as part of the general move towards 'natural' products. In the graphics world, attempts were made to minimize unnecessary packaging, encourage recycling and refill systems and explore the possibilities of recycled paper. Graphic designers in particular occupied a position of influence on clients and consumers, and consequently were targeted by paper manufacturers, or took upon themselves the role of catalyst for change.

The 'greening' of the design world has yielded many innovative projects. Shown on pages 232-3 is ad agency Chiat Day's adventurous concept of 'recycled advertising' for Ecover, a Green detergent manufacturer. Faced with the problem of how to get across the environmental message without creating more pollution in doing so, they devised a massive 'street art project' and asked 52 artists to create collaged billboard posters,

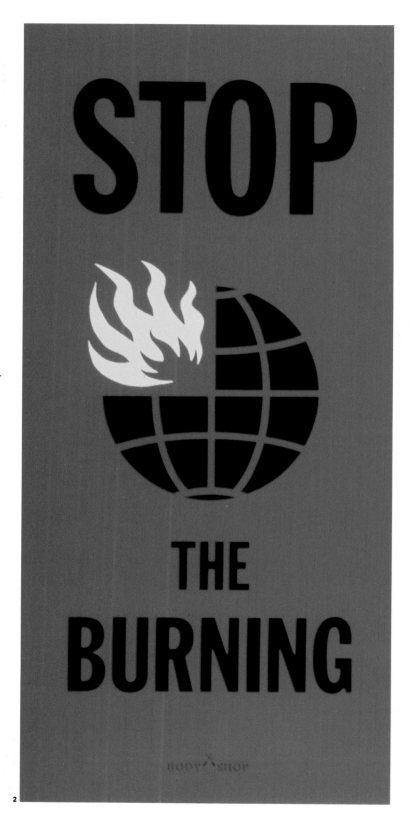

2

made from cutting and tearing up redundant advertising posters; the billboards were then displayed all over London. It was followed by a TV campaign which used old black-and-white commercials from the 1950s, dubbed with new voices and colour packs, thereby delivering an environmental message while making fun of the absurdities of the genre of soap advertising.

Some companies have taken on the heavier mission of environmental education, as well as marketing environmentally responsible products. The most famous UK representative of this is the Body Shop, the international Green company founded in 1976 and managed by Anita Roddick. Now trading in 41 countries, their products for skin and hair are naturally based and no animal testing is allowed. The company operates strict recycling and refilling practices, runs community projects all over the world and interestingly has a policy of no advertising. In addition it has run over 20 issue-led campaigns over the years, from Stop the Burning (of Brazilian Rainforests) to Human Rights for Amnesty International.

5

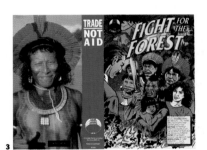

3

1 Poster for the Body Shop's Reuse Refill Recycle campaign to reduce post-consumer waste, design by Richard Browning, 1990.
2 Poster for the Body Shop campaign to stop the burning of the Brazilian rainforest, design by John Crossland, 1989.
3 Informative comic book explaining the

Body Shop's 'Trade Not Aid' relationship with the people of the Brazilian rainforest, and suggesting possible ways of ensuring their survival.
4 Annual report for the Body Shop (and the first annual report in Britain to be produced on recycled paper) designed by Neville Brody, Ian Swift and Liz Gibbons, 1988.

5 Still from promotional video to launch Ark, an environmental charity which markets its own range of ecologically responsible consumer products as well as educating on Green issues. The video features comedienne Dawn French as a scolding Mother Earth; created by Reg Boorer and Kevin Godley, Britain 1988.

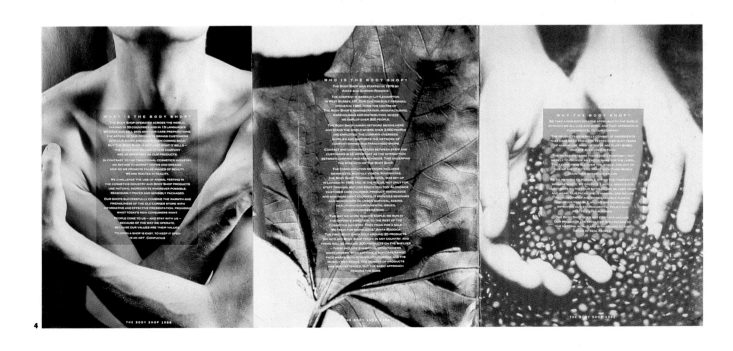

4

1

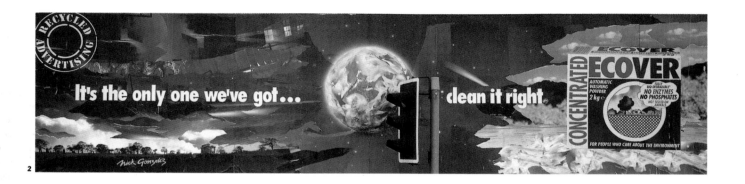

2

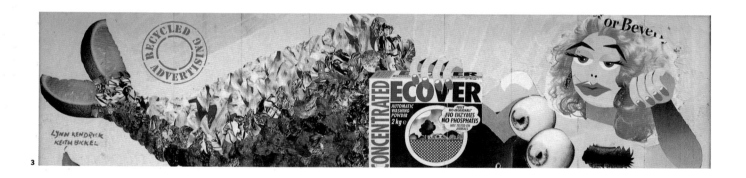

3

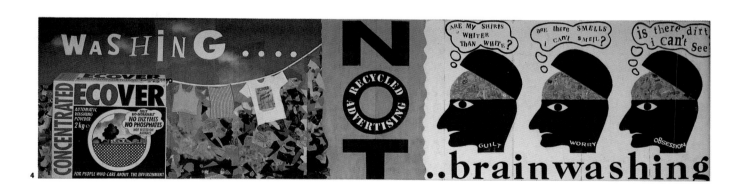

4

5 Kath Jackson

WASHES RIGHTER

6 Save the Planet one drop at a time

7 From your drain to the ocean

Sarah Kelly

8 ON A MISSION TO SAVE THE PLANET.

1 Stills from two TV ads from Green detergent manufacturer Ecover's 'recycled advertising' campaign. Created by the ad agency Chiat Day, Britain 1992.
2-8 Collaged billboard posters from Ecover's 'recycled advertising' street art project, organized by Chiat Day, London 1991. The collages were created by cutting and tearing up redundant advertising posters.
2 Nick Gonzalez
3 Kendrick/Bickel
4 The team at Ecover
5 Kathryn Jackson
6 Rachel Withers
7 Sarah Kelly
8 Robert Stevens

Environmental issues and international connections

The Earth Summit in Rio de Janeiro (Brazil, May 1992) disappointed many in terms of concrete action and the adoption of hard-core policies. But the significance of a meeting of world leaders to discuss environmental issues was beyond dispute. The problem of reconciling economic development with environmental preservation had finally entered the arena of international politics.

Internationalism and global solidarity on environmental issues has become a new and exciting theme for designers, and two examples shown here hint at the potential for global working methods and collaborations. The first is the poster 'The Earth is our Mother', created by Chaz Maviyane-Davies,

the only African representative to the World-wide Visual Celebration for the United Nations Conference in Rio which ran parallel to the Earth Summit. In addition to the poster's symbolic importance as a representative of Africa within that cluster of international artistic statements, it also embodies internationalism in its very creation. It was conceived in Zimbabwe; images were mixed on a graphic paintbox computer in England; they then went back to Zimbabwe for completion of design; and finally the poster travelled to Rio for printing and exhibition. The project brings to fruition the idea of the 'global design studio', a concept which looks set to become increasingly important in the future.

Also displayed at the Rio conference were posters created by Swiss designer Cornel Windlin for the 'Visualize the Future' exhibition/event staged by the Parco company in Japan later that year. In an attempt to raise ecological consciousness in Japan, Parco offered an open invitation to artists and designers around the world to send their environmental messages (in artwork or slogans) by fax or on computer disk for display in the exhibition. The event provided a prime opportunity for designers to explore the global potential for social and political comment through information and computer technologies, as well as allowing them to link into a network of concerned creative people.

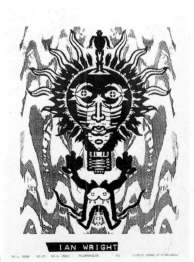

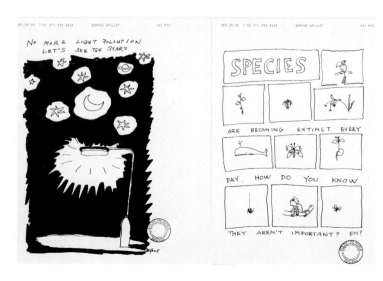

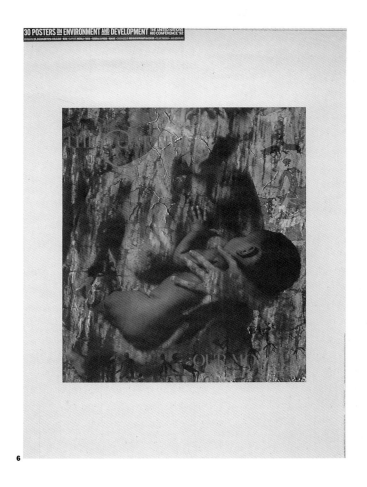

6

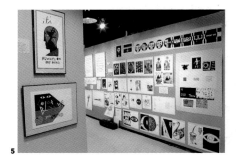
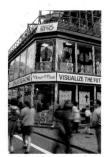

5

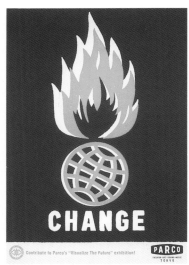

4

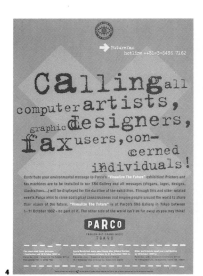

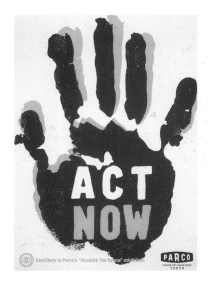

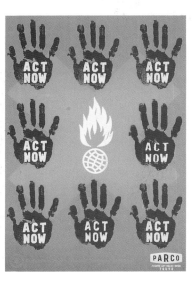

Selected bibliography and further reading

Atelier Populaire. *Mai 68: Posters from the Revolution, Paris, May 1968*, London 1969. Texts and posters by Atelier Populaire.

Barnicoat, John. *Posters: A Concise History*, London 1972.

Bertsch, Georg C. et al. *SED: Schones Einheits-Design – Stunning Eastern Design*, Cologne 1990.

Blinderman, Barry et al. *Keith Haring: Future Primeval*, New York 1990. Exhibition catalogue.

Brand, Stewart (ed.). *The Last Whole Earth Catalog*, New York and London 1971.

Briggs, Raymond. *The Tin-Pot Foreign General and the Old Iron Woman*, London 1984.

Coe, Sue and Metz, Holly. *How to Commit Suicide in South Africa*, New York 1983. Illustrations by Sue Coe, text by Holly Metz.

Conal, Robbie. *Art Attack: The Midnight Politics of a Guerrilla Artist*, New York 1992.

Cooper, Martha and Chalfant, Henry. *Subway Art*, London 1984.

Cries of Freedom: Women in Detention in South Africa, London 1988. Originally published as *A woman's place is in the struggle, not behind bars* by DPSC/Descom (Detainees' Parents Support Committee and the Detainees Support Committees), Johannesburg, February 1988. Within weeks of publication, the DPSC and the book itself were banned.

Dormer, Peter et al. *The Illustrated Dictionary of Twentieth Century Designers*, London 1991.

Dyrenforth, James and Kester, Mark. *Adolf in Blunderland: A Political Parody of Lewis Carroll's Famous Story*, London 1939. Illustrated by Norman Mansbridge.

Elkington, John and Hailes, Julia. *The Green Consumer Guide*, London 1988.

Elliott, David (ed.). *Alexander Rodchenko*, Oxford 1979. With essays by Alexander Lavrentiev (grandson of A. Rodchenko) et al.

English Caricature: 1620 to the Present, London 1984. Exhibition catalogue.

Estren, Mark James. *A History of Underground Comics*, Berkeley, California 1986 (revised edition 1989).

Evans, David and Gohl, Sylvia. *Photomontage: A Political Weapon*, London 1986.

Feaver, William. *Masters of Caricature: from Hogarth and Gillray to Scarfe and Levine*, London 1981.

Friedman, Mildred et al. *Graphic Design in America: A Visual Language History*, Minneapolis and New York 1989. Exhibition catalogue.

Garrigan, John et al. *Images of an Era: The American Poster 1945-75*, Washington DC 1975. Exhibition catalogue.

Griffiths, Philip Jones. *Vietnam Inc.*, New York 1971.

Graphic Communication through Isotype, Reading 1975 (revised edition 1981). Exhibition catalogue. Introduction by Michael Twyman.

Grapus. *Grapus 85: various different attempts*, Utrecht 1985.

Great Propaganda Posters: Paper Bullets, Axis and Allied Countries WWII, New York and London 1977.

Harper, Paula. *War, Revolution & Peace: Propaganda Posters from the Hoover Institution Archives 1914-1945*, Stanford 1969. Exhibition catalogue.

Harsch, Ernest et al. *Art from the Frontline: Contemporary Art from Southern Africa*, London 1990.

Heller, Steven (ed.). *Man Bites Man: Two Decades of Satiric Art*, London 1981. Drawings and cartoons by 22 comic and satiric artists, 1960 to 1980.

Hendrik Nicolaas Werkman 1882-1945: A selection of 'druksels', prints and general printed matter, Amsterdam 1977. Exhibition catalogue.

Henrion, FHK. *AGI Annals*, Zürich 1989.

Henrion, FHK. *Top Graphic Design*, Zürich 1983.

Holborn, Mark. *Beyond Japan: A Photo Theatre*, London 1991.

Holzer, Jenny. *Jenny Holzer: Signs*, London 1988 (revised edition).

Home, Stewart. *The Assault on Culture: Utopian Currents from Lettrisme to Class War*, Stirling 1991.

Hughes, Robert. *The Shock of the New: Art and the Century of Change*, London 1991 (revised edition).

Jacobs, Karrie and Heller, Steven. *Angry Graphics: Protest Posters of the Reagan/Bush Era*, Salt Lake City 1992.

Jungwirth, Nicholas and Kromschrüder, Gerhard. *Die Pubertät der Republik: Die 50er Jahre der Deutschen*, Frankfurt 1978.

Kerry, John and Vietnam Veterans Against the War. *The New Soldier*, New York 1971.

Kruger, Barbara. *Love for Sale: The Words and Pictures of Barbara Kruger*, New York 1990. Text by Kate Linker.

Kunzle, David. *Posters of Protest: The Posters of Political Satire in the US, 1966-1970*, Santa Barbara 1971.

Litvinov, Victor. *The Posters of Glasnost and Perestroika*, London 1989. Introductory articles by Alexander Yegorov and Victor Litvinov.

Lucie-Smith, Edward. *Cultural Calendar of the 20th Century*, Oxford 1979.

Marnham, Patrick. *The Private Eye Story: The First 21 Years*, London 1982.

McDermott, Catherine. *Street Style: British Design in the 80s*, London 1987.

McGinniss, Joe. *The Selling of the President 1968*, London 1969.

McQuiston, Liz and Kitts, Barry. *Graphic Design Source Book*, London 1987.

Millon, Henry A. and Nochlin, Linda (eds.). *Art and Architecture in the Service of Politics*, Cambridge, Mass. 1978. Article: 'Votes for Women: A Graphic Episode in the Battle of the Sexes' by Paula Hays Harper, pp.150-161.

Minick, Scott and Ping, Jiao. *Chinese Graphic Design in the Twentieth Century*, New York 1990.

Muir, John. *How to Keep Your Volkswagen Alive: A Manual of Step by Step Procedures for the Compleat Idiot*, Santa Fe, New Mexico 1969 (revised edition 1989). Illustrations by Peter Aschwanden.

Nader, Ralph. *Unsafe at Any Speed: The Designed-in Dangers of the American Automobile*, New York 1965 (revised edition 1973).

Nicholls, C. S. (ed.). *Power: A Political History of the Twentieth Century*, New York 1990.

Owusu, Kwesi (ed.). *Storms of the Heart: An Anthology of Black Arts and Culture*, London 1988.

Papanek, Victor. *Design for the Real World: Making to Measure*, London 1972.

Philippe, Robert. *Political Graphics: Art as a Weapon*, Oxford 1982.

Pirsig, Robert M. *Zen and the Art of Motorcycle Maintenance*, London 1974.

Porritt, Jonathon and Nadler, Ellis. *Captain Eco and the Fate of the Earth*, London 1991.

Posener, Jill. *Louder Than Words*, London 1986.

Posener, Jill. *Spray It Loud*, London 1982.

Poster Book Collective of the South African History Archive. *Images of Defiance: South African Resistance Posters of the 1980s*, Johannesburg 1991.

Reid, Jamie. *Celtic Survivor: More Incomplete Works of Jamie Reid*, London 1989.

Reid, Jamie. *Up They Rise: The Incomplete Works of Jamie Reid*, London 1987. Text by Jamie Reid and Jon Savage.

Rose, Cynthia. *Design After Dark: The Story of Dancefloor Style*, London 1991.

Rowe, Marsha (ed.). *'Spare Rib' Reader: 100 Issues of Women's Liberation*, Harmondsworth 1982.

Rowland, Kurt. *A History of the Modern Movement: Art Architecture Design*, New York 1973.

Selz, Peter et al. *Photomontages of the Nazi Period: John Heartfield*, London 1977.

Shocks to the System: Social and political issues in recent British art from the Arts Council Collection, London 1991. Exhibition catalogue.

Sparke, Penny et al. *Design Source Book*, London 1986.

Stermer, Dugald. *The Art of Revolution: 96 Posters from Cuba*, London 1970. Introductory essay by Susan Sontag.

Sylvestrová, Marta and Bartelt, Dana. *Art as Activist: Revolutionary Posters from Central and Eastern Europe*, London 1992.

Toop, David. *The Rap Attack: African jive to New York hip hop*, London 1984.

Thompson, Philip and Davenport, Peter. *The Dictionary of Visual Language*, London 1980.

Waldenburg, Hermann. *The Berlin Wall Book*, London 1990.

Wallis, Brian (ed.). *Hans Haacke: Unfinished Business*, New York and Cambridge, Mass. 1986. Exhibition catalogue. Essays by Rosalyn Deutsche et al.

Weill, Alain. *The Poster: A Worldwide Survey and History*, London 1985.

Wenborn, Neil et al. *The 20th Century: A Chronicle in Pictures*, New York 1989.

Wombell, Paul (ed.). *PhotoVideo: Photography in the Age of the Computer*, London 1991.

Wye, Deborah. *Committed to Print: Social and Political Themes in Recent American Printed Art*, New York 1988. Exhibition catalogue.

Yanker, Gary. *Prop Art*, New York 1972.

Photographic Acknowledgements

Abbas/Magnum Photos Ltd: 73l; Advertising Council of America: 184tl; Joseph P. Ansell/photo David M.Green: 195b; © Brian Aris: 122tl; Backnumbers, London: 159br; BBDO: 167; BMP DDB Needham: 191cr; The Body Shop International PLC: 230, 231b&l; Bridgeman Art Library: 14l; © 1984 Raymond Briggs: 50tl; Estelle Carol: 152b; The Center For The Study of Political Graphics: 11l&tr, 88tr, 89; courtesy Channel 4: 174tr; photographer Roger Charity: 167b; © Roman Cieślewicz, France: 57b; © Robbie Conal/courtesy Jayne H. Baum Gallery, New York: 41b, 47tl, 202; Contrapunto, S.A: 191bl; © Paul Davis, New York: 135; Derby Amnesty International Group/East Midlands Arts: 93, 106, 107; © Deutsche AIDS-Hilfe, Berlin (all rights reserved): 190tl; Dorling Kindersley Ltd: 229c; Ecover: 232, 233; photographer Martin Evening, model Wumni Olaiya: 167t; Garage Graphix Community Arts Inc, Emerton: 87b, 94t; Malcolm Garrett: 160br; Marc Geller, San Francisco: 6tr, 195tl&tr; courtesy Barbara Gladstone Gallery, New York: 28tr, 29l, 46tr, 116bl; Milton Glaser Inc., New York: 146l, 191tl; Mario Gonzalez Jr.: 138, 139l; The Graphic Workshop, Boston: 134tl, 149tr, 212cl, 227tl; Greenpeace Communications Ltd: 218; © Philip Jones Griffiths, New York: 44tl; Siegbert Gruchot, Berlin: 126; courtesy *The Guardian*: 72r; © 1993 The Estate of Keith Haring: 7t, 117, 128tr; Heartfield-Archiv, Akademie der Künste zu Berlin: 23; Matt Herron, Box 1860, Sausalito, CA 94966. (415) 479-6994: 150; Lance Hidy, Newburyport, Massachusetts: 104tl; © The Terrence Higgins Trust, used with permission: 191bc; Poster Collection, Hoover Institution Archives, Stanford University: 26b; Imperial War Museum: 42br; Jagusch & Partner, Hamburg: 61r; John Fitzgerald Kennedy Library: 30b; Ketchum Advertising, Singapore: 189l; The Labour Party: 31; reproduced by kind permission of the publishers Last Gasp: 142, 143b; Lauros-Giraudon/Bridgeman Art Library (collection Eduardo Arroyo, Paris): 24; courtesy Lenono Photo Archive: 146r; Bob Linney, Health Images: 197, 199b; Liberation Graphics, Alexandria: 80; Robert Linsky, Clark/Linsky Design Inc, Massachusetts: 71tl&bl, 104cr, 179b, 190cl&bl, 210t; Lords Gallery, London: 17r; photograph Evgeny Matvejev: 72t; Chris Mees, Design Documentation: 18; Eric Miller/Southlight: 75br; collection Minick/Jiao, Paris: 33l, 82r,

83; photograph Eddie Monsoon: 193br; Moravian Gallery, Brno: 32bl, 64t, 65tr&tl, 66tl&bl, 66r, 67, 69bl, 71tr, 104tr, 178, 180r, 189r, 228; © Hank Morgan/Rainbow, Housatonic, MA: 206tl; Murundoo, Fremantle: 86bl; Musées de la Ville de Strasbourg: 2, 42l, 148; The Museum of Modern Art, New York, gift of the Benefit for the Attica Defence Fund: 44c; National Film Archive: 22l; exhibited by Parco Co. Ltd. in *Visualize The Future*, October 1992 at SR6 Gallery, Tokyo: 234, 235c&b; Partnership For A Drug-Free America, New York: 179r, 184r,185; Popperfoto: 33r, 58b; selected work from *Poster Art of the Soviet Union*, a travelling collection organized by the San Diego, California chapter of the American Institute of Graphic Arts, 619-542-0207: 70br, 71br, 201bl&br, 211r; Poster Gallery Wabnitz, Arnhem: 110-113; created by Public Media Center, San Francisco; client: Handgun Control Inc., USA: 203cr; Public Record Office: 25b; The Pushpin Group, New York: 45, 206tr; Randolph Street Gallery, Chicago: 182c&b, 201tr, 203l; Redback Graphix: 5bl, 87tr, 92br, 119bl, 180l, 188, 190r, 198; Jamie Reid: 52b, 95b, 140t, 160t, 160bl, 161; RFSL, Stockholm: 181, 193tr; Saatchi & Saatchi: 31, 49t, 176tl; Arnold Saks Associates Inc., New York: 213; courtesy The Salvation Army: 176cl; The Schlesinger Library, Radcliffe College: 19; Sheffield City Art Galleries: 53b; South African History Archive/*Images of Defiance: South African Resistance Posters of the 1980s*: 74r, 75l; Spitting Image Productions Ltd: 51; Stedelijk Museum, Amsterdam: 21; David Tartakover: 35, 81t, 90r; University of California, Berkeley: 134tr; courtesy John Weber Gallery, New York/photographs Jon Abbott: 125; Women Artists' Slide Library: 153tr, 155t; Women's International League For Peace and Freedom, 1213 Race Street, Philadelphia, PA 19107-1691: 104b; reproduced with permission from *Wut Witz Widerstand* (1989): 8r.

The publishers and author are particularly grateful to the following for their kind help with illustrations for the book: Graeme Atkinson, *Searchlight* magazine; Debbie Kermode; Tess Kingham, War on Want; Robert Linsky; Karen Mahony; Pete Polanyk; Richard Scott & Richard Honey of Leeds Postcards; Lucy Slater; Mike Spike; Dr Marta Sylvestrová; Keith Traywick (USA); Shelley Williams (USA).